Points in Time

Other books by the author

Creative Art in England Stanley Nott, London 1936
Republished as
Creative Art in Britain Macmillan & Co. Ltd, London 1950

Child Art to Man Art Macmillan & Co. Ltd, London 1941
Japanese translation Reimeishobo, Tokyo 1955

William Johnstone

Points in Time

an autobiography

Foreword by Sir Michael Culme-Seymour, Bt

BARRIE AND JENKINS
London Melbourne Sydney Auckland Johannesburg

Barrie & Jenkins Ltd

An imprint of the Hutchinson Publishing Group

3 Fitzroy Square, London WIP 6JD

Hutchinson Group (Australia) Pty Ltd
30–32 Cremorne Street, Richmond South, Victoria 3121
PO Box 151, Broadway, New South Wales 2007

Hutchinson Group (NZ) Ltd
32–34 View Road, PO Box 40–086, Glenfield, Auckland 10

Hutchinson Group (SA) (Pty) Ltd
PO Box 337, Bergvlei 2012, South Africa

First published 1980

© William Johnstone 1980

Set in Monotype Spectrum

Printed in Great Britain by The Anchor Press Ltd
and bound by Wm Brendon & Son Ltd
both of Tiptree, Essex

ISBN 09 142550 6

The publisher acknowledges the financial assistance of the
Scottish Arts Council in the publication of this volume.

Contents

List of illustrations

COLOUR

MONOCHROME

Foreword

'For those of us who are not trained in the study of art, and have neither the opportunity nor the gift to practise it ourselves, it sometimes seems impossibly difficult to distinguish between the good and the bad works of art in our present day; to understand what the artist is trying to achieve; and to respond to the idea within his art. But there is nothing new and nothing surprising in this. In each generation it has been so. What is surprising is that we should expect to understand without any particular effort on our part.

'It has been said that the creative artist is some fifty years ahead of his time. Certainly it is the very fact that he opens our eyes to a new vision and a new understanding that makes him truly creative; and the process of having one's eyes opened to new things is slow, and often painful. It disturbs us; it upsets that on which we have based our values and which makes the world around us familiar and safe. It disturbed our predecessors too. Pictures which to us seem perfectly natural were infinitely upsetting to the people of their day, and often to the art critics themselves. . . .'

I wrote those words some twenty years ago for an important exhibition called 'Art Alive' at Northampton. William Johnstone's paintings had been coming into our home, Rockingham Castle, for several years together with those of other contemporary artists; for we wanted to bring into the house the paintings of today as our contribution, just as our predecessors in the family had brought in paintings, books, furniture, according to their individual interests, but always of their own time. Perhaps they were never rich enough for Grand Tours and buying things of the past. At that time his work

was hardly known to the public for his name had been made in the educational world as Principal of London's foremost art schools, where he introduced new ideas and a wholly new attitude that has largely contributed to the high standard of design prevailing in this country today. Such is the power of the 'media' however that a public image as teacher could never be reconciled to that of creative artist.

Yes, looking back, it was William Johnstone's paintings more than any of the others, lovely as many of them are, that enlarged our understanding. For the contemporary painting to hang with others of the past of true quality, and with furniture and works of art of all time, is a severe test not only of the contemporary but of the things of the past. For us it was an interesting and precious experience. Many of the older pictures failed that test and some of the contemporary too. But William's grew in stature all the time.

He soon became a close friend and his visits with Mary, hi,s wife, immensely stimulating and even exhausting as they were gave enormous pleasure; but his influence first came into the house, I suppose, with his book, *Creative Art in England*. That was written in 1936 and still gives today a clue to the deep understanding which underlies all his work. Whether in the calligraphic, almost Chinese drawing of utmost simplicity, the powerful oil painting of solid construction and rich Venetian colour, or the strange and deeply moving structures in plaster, there is always a Celtic quality of design combined with an inner depth which defies description in words.

It is that search for the inner life, the values that extend beyond human experience, that is really the subject of this book. For I dare to believe that it is an inner search, lying behind the character of ceaseless energy and probing bubbling laughter that we know and love, which has been the true motive of his long life. In his own telling of it may we be allowed to join that search and thereby perhaps find a deeper appreciation of the extraordinary output of work which he is producing still today at 82 with greater strength than ever.

Michael Culme-Seymour
January 1980

Acknowledgements

I would like to acknowledge with very much appreciation the generous help given me over several years by many kind friends and, in particular, I would like to thank the late James Campbell; Hope Scott and Douglas Hall for reading the manuscript and for their many helpful suggestions; Trevor Royle for his most invaluable advice and patient help; Sheena Duffy for her beautiful typing; Dr Hugh MacMaster for his professional care and interest; my daughter Sarah and my wife, Mary, whose encouragement and persistence enabled me to complete this book.

Palace, Crailing
1980

to Hope Scott, with affection and gratitude

1
The eyes of a child

The last Lord Johnstone made the Grand Tour as far as Naples where he died in 1792, unmarried and insane. He lies in Westminster Abbey under an imposing marble panoply, but his only claim to fame is that David Hume was once his unhappy tutor. My grandfather William Johnstone was tall, handsome and impressive. He always wore a top hat and had ambitions of grandeur. His family only just prevented him from putting forward his claim to the Annandale Peerage by pointing out how much money he had already wasted on experimental notions of farming. He may well have had as good a claim as any so, undiscouraged, he attended on Queen Victoria when her train halted at St Boswells Station as Lord Johnstone of Annandale and Marquis of Hartfell.

As a young man William Johnstone dealt in Irish cattle, which were landed on the sands at Dumfries. He married Elizabeth Scott (a relative of Thomas Carlisle, who kept an inn near Ecclefechan and made money from the thirsty navvies working on the new railroad). The young couple left Dumfriesshire to farm in Roxburghshire. Opinionated, impulsive and choleric, my grandfather died suddenly of his bad temper, leaving a large family to quarrel over the small remains of his estate.

My Johnstone forbears, in company with other families on both sides of the Border, were ruthless gangsters as cunning and heartless as the heroes of the Wild West. By nature aggressive and acquisitive, they had followed in the train of William of Normandy to seek land

and fortune in the North. In spite of their land grabbing and political chicanery they yet, during the course of their long history, managed to produce some men of creative talent. Ben Jonson was of this stock; so, too, was William Johnstone who, during the troubles of the eighteenth century, fled to America to become one of the earliest portrait painters of distinction in that country. Another was the Chevalier de Johnstone, one of Prince Charles Edward's aides-de-camp who escaped to France to fight under Montcalm at Quebec, and retired to write his *Memoirs of the Rebellion in 1745 and 1746*. More recently there was Edward Johnston the great scribe and the father of modern calligraphy.

My mother's father, Robert Greenwood, was a very different man from William Johnstone. Born in Rochdale in 1811, he came to Hawick as a textile designer for Wilson and Glenny in about 1833. My grandfather won prizes for his designs from the Board of Manufacturers at the Trustees' Academy in Edinburgh. When the Industrial Revolution reached the Borders, the stocking makers and weavers with their own small businesses were threatened by the new power looms.

After my grandfather had married Mary McBirnie (an Irish girl reputed in Hawick to be something of an heiress), they left the town to settle in Galashiels where Robert was employed setting up power looms. However, the resentment of the handloom weavers and stocking makers was so intense that their lives were endangered and Greenwood decided to return to Hawick to set up his own mill, the Weensland Woollen Mill. Here his energy and vision, his talent for design, his eye for colour and his great skill in dyeing made his business prosper. He made innovations to his looms, technical advances which enabled more colours to be used in weaving rather than the simple 'pepper and salt' shepherds' plaid tweed. His restless, adventurous mind was never still. He employed most of his thirteen children in his mill until they were considered old enough to start businesses of their own, and they all became rich and successful.

However prosperous Robert Greenwood and Company became my grandfather and grandmother always retained their natural simplicity and devotion to work. Greenwood went every Saturday night to the Tower Hotel to drink his beer with the men who, early in his career, had sometimes threatened his life. He returned home late

along the lonely Weensland Road singing his English songs, 'Ilkley Moor' and 'Farmer's Boy', at the top of his lusty voice.

My grandfather brought great prosperity to Hawick and on the day of his funeral all the shops and mills in the town closed as a mark of respect.

Grandfather Johnstone's small farm could not support his growing family so my father, who was the youngest, found work in the Weensland Mill tending the steam engine. There Robert Greenwood discovered that he was a brilliant colourist and moved him to the dyehouse to work under his personal supervision. Dyeing then was not the scientific operation that it is now. The main difficulty was to judge exactly how your dye would dry out in the piece – would the colour be precisely the same as that shown in the sample? My father had a natural ability for this work, so was just the man for whom Greenwood was looking.

When Jane Maria Greenwood (the youngest of Robert's daughters) was eighteen and my father sixteen they were married. Whether my father found himself completely swamped by the massive and energetic family into which he had married, or whether he decided to make his own way in the world without the help of his father-in-law, I do not know, but he set sail for New Zealand to make his fortune, although Robert Greenwood refused to let his daughter leave Hawick on this dangerous journey. The voyage took three months by sailing ship. My father used to tell me about his adventures – of the horror he felt in Rio de Janeiro where he saw a slave auction in progress, of the terrifying experience of sailing round Cape Horn, of loading up in Fiji with indentured labour (he felt this was as bad as slavery). All his life he was something of a radical and his intense dislike of any racial discrimination stemmed, I think, from this period of his life.

In New Zealand he had a variety of jobs. He worked on the sheep stations and looked after the horses for the stage coach to Nelson which came every three days. He prospected for gold, even finding a substantial nugget. (This he hid for fear he should be attacked and the nugget stolen; but alas, when he left Nelson, he could no longer remember where he had buried his gold.) He supervised Chinese labour, digging irrigation tracks in the Province of Canterbury. This

job was highly profitable and his Chinese worked well except for periods of opium smoking when all work came to a complete standstill. He decided to give up the irrigation tracks at the end of his contract. Both his employers and his Chinese begged him to remain but he discovered, when he collected his abnormally high pay, that all three previous overseers had been murdered.

He then worked as engineer and dyer for the Roslyn Woollen Mills in Dunedin where he asked my mother to join him. When she refused, he gave up his idea of settling in New Zealand and came back to Roxburghshire. He had been away for seven years.

On my father's return to Scotland he found that the family farm was in a dilapidated state, desperately needing capital to rescue it from disaster. He was willing to help his father on condition that new machinery and up-to-date equipment was bought to enable the farm to be run on a sound basis. He suggested a mechanical reaper (the self-binder had not then arrived in the Borders), but at this proposition my grandfather nearly had a seizure; for years Irishmen had cut the grain with sickles and that was how it was to continue. All he wanted was my father's money, not his ideas. He did not want his farm run with foreign novelties, so he parted on bad terms with his youngest son.

Disgusted with this stupidity my father bought his own small farm, as well as two butchers' shops, one in Ancrum and the other in the village of Denholm. Here my mother enjoyed herself. She was mistress of her own house at last and was near enough to all her numerous relations and friends in Hawick. She adored clothes and had her two daughters beautifully turned out, but she sometimes went too far with her son. His rages on being forced into a splendid new coat with an astrakhan collar – a fine present from an Irish horse dealer who had stayed the night with us while his horses enjoyed the hospitality of the minister's glebe – were too much even for her, and the coat (no doubt the latest fashion among the travellers in the textile business in London or Bradford) had to be passed on to some less fortunate boy. My father, I think, was none too happy at Denholm; he was not trained as a butcher and was too independent to be a successful tradesman. However, he found solace in his love of horses, regularly attending the local horse fairs.

In 1901 my sister Elizabeth died from typhoid. Gloom and sadness came to the village as other children died. I also became ill and was not expected to live. I remember the hotness, someone always watching, whispers at the door, a little man with sandy hair, my mother's weeping. Eventually the day came when I woke up and wondered just where I had been. I heard the doctor saying I might have some milk or arrowroot, that I could sit on the edge of the bed for a short time. I remember the shock of finding that I could not walk and realizing that I would have to begin all over again. I sat by the window in a chair and it was spring. The sun danced on my walls, I heard people shouting and the voices of children playing in the street. My window world was magic and full of joy. Some months later I joined in the sports in honour of Edward VII's Coronation on our village green. My father was overjoyed when I came in second in the race for under-fives, and he celebrated at the 'Fox and Hounds'.

Despite my recovery, there were still problems at home. My father had lost custom through his outspoken support of the Boers and had had to resign from the Parish Council and the School Board. Life became so difficult at Denholm that he sold the butcher's shop and we moved to the farm of Greenhead, near Selkirk. Our furniture was loaded on to two great 'Waterloo' carts and the house was empty. I had never seen deserted rooms before and I felt alarm and fear; I sensed the horror that is in nothingness, the terror of vacuum. (René Magritte has painted this horror that shuffles out of emptiness to destroy us.)

In the afternoon we went to Greenhead. Coming up the hill towards the farm we arrived in another world. Sunlight shone on the farmhouse, everything was exciting – this new world seemed so big, so rich, so grand. There was a scale to this countryside like a huge canvas.

Perhaps it was something to do with being ill for so long and having to start all over again that made the farm seem so tremendous. I wandered through the steading discovering byres, cattle courts, loose boxes, stables, granaries and lofts and I found the great thick stone walls of what my father told me had once been an old castle of the Kerrs. He said the steading had been built out of the ruins.

On my castle walls I stood, surveying my kingdom stretching across Selkirk to the valleys of Ettrick and Yarrow. All that summer I spent exploring the farm.

Greenhead is about three miles above Selkirk, so when I began school in the autumn my morning walk was all downhill, but in the afternoon it seemed a long, weary way up the hill to the farmhouse. As the afternoons became colder and darker the way home became more frightening, especially when the snow blew drifts across the road. Weasels watched from the dykes and once, one with a family of kits chased me. You could take a short cut across the fields but in the mist you came on unexpected alarums. When I was older, returning late one foggy night with a guilty conscience, I took this short cut and stumbled. To save myself I put out my hands and touched something vast, rough and hairy. It groaned. I fled, with the Devil after me, my heart beating fast as I heard his cloven hoofs coming up the steep brae behind me. In the morning my father said, 'I moved the cows into the field by the road last night.'

Each winter an old aunt of my father's used to come to stay with us; Greenhead was her winter quarters. I see her sitting beside the kitchen fire. A gentle old lady, her head dressed in a mutch, she mended our shirts, turned the sheets sides to middle, and knitted endless pairs of long, warm socks. While she sewed, Aunt Annie told us stories of our Johnstone forbears – the bitter family feuds between Johnstone and Maxwell, Johnstone and Dacre over the Border, deadly rivalries which wasted the countryside and culminated in the massacre at Carlanrigg and the overthrow of the Maxwells at Dryfe Sands. In the spring the old lady returned to Dumfriesshire and we forgot her stories.

My sister Mary was ten years older than I. As she suffered much from ill health I did not consider her a suitable companion, but there were plenty of children of my own age living in the farm cottages with whom I used to play. One spring we made a tent out of grass-seed bags and set this up near the pond. It was deep where the sluice controlled the water for the mill wheel and over this end grew a willow. We crept along the branches hanging over the water to watch a moorhen sitting on her nest. Her eggs were well protected because the branch cracked if we dared advance too far, and this she knew.

We had kicked our shoes off in the sunshine because it was so lovely to feel the soft dust between our toes.

One of the small Hobkirk children kept running along the brick edging of the sluice even though we pulled him off. Then somebody seemed to be missing and suddenly I saw the white hair of this little boy floating on top of the water. I couldn't believe it was possible. I yelled and people came running to pull out the child, but he was dead. He was only four. He just toppled over the edge of the brick wall and he was dead. The police came with the Procurator Fiscal who decided there should have been a fence.

Fear and dread came that day, and with the day of the funeral. Following so closely after the death of my sister and my own near-fatal illness, I became aware of, and was horrified by, the knowledge that death could be so swift and sudden, even in my own peers.

Long after I was afraid of the pond. I had discovered that the water-wheel was a great place for harbouring rats and this made me even more fearful of it, since I loathed the evil creatures. Whenever I dream of rats I know that something terrible is going to happen.

My father could not put up with the ineffective old waterwheel any longer so he ordered a new Tangye engine from England. I rushed home every afternoon to see if the engine was finished but it had not even arrived, although there were mysterious chalk marks on the ground to indicate placings. A man then came to dig out foundations as this monster had to be 'set' in solid cement, and parts of the engine began to arrive. This was a real start and I felt something was bound to happen. How grand it all was that, instead of a toy engine, I was to have a real engine, an engine that would drive the big threshing mill! Three engineers and an apprentice came to put the engine together, and I was determined to be present whilst the work was done, but how to avoid school? My usual tricks were too obvious – a cold, a toothache, a headache. I decided it would be better to 'come clean' and ask if I could stay at home to watch the engine. The answer was a firm 'No'. I appealed to my mother to no avail but in the end my father agreed, on condition that the care and cleaning of the engine would be my responsibility always. The emphasis was on 'always'. That was joy! After each day's threshing the engine had

to be spotless, all the oil wiped off, every speck of dust removed, all polishable parts shining bright, and the wheels had to be absolutely perfect.

My father believed that design was efficient working. He cast doubts on the presumed superiority of Scottish engineering and told me that the reputation of the Clydeside engineering works was vastly overrated, that their engines were solid but lacked smooth precision, that they were famous for bad castings. The great days in Glasgow were when they built the clipper ships.

Each year Irishmen came to single our turnips. One of these, Dan Gallagher, wrote from Roscrea, County Donegal, 'Dear Sir, as you are. He said that singling turnips would be coming and if he was refusing any more he would come', to which my sister replied that we would be expecting him about the second week in June. The same men, Dan, Patrick and Dennis, came every year. They worked hard and long at the turnips, getting drunk in Selkirk on Saturdays. They all slept on the floor in the loft among the hay. I was fascinated by these men who worked so hard, talked poetry and sang so beautifully. Sometimes they would start at 5 a.m., taking their cans of tea with them, and then I would hear them singing in the field their wild, tragic Gaelic songs, moving me far more deeply than any other music I knew. There was a deep seriousness in these songs that held an aura of wonder which spoke of a primitive simplicity far away. After our turnips they moved down to help with the harvest in Berwickshire, returning to us for our harvest a month later.

One year my father said, 'You know, Dan, don't you think it's a great pity to work here with these turnips for six weeks from five o'clock till half past ten at night and take nothing home for it in the end? What happened to you last year when you left in November? How did you get back to Ireland?'

'Well, I got drunk in Glasgow but the captain on the Burns Line knew me and he told the sailors to tie me to the mast at once. So I was tied to the mast till we got to Derry.'

'Did you take any money home?'

'A woman took it off me in Glasgow, so I was back the way I had come, with nothing.'

'What about the others?'

'Well, they're in the same way. Dennis had a few pounds.'

My father started talking about how he had had to get out of his father's farm and go to New Zealand sun-downing and asked, 'Where are you with it all if you haven't any money at the end?' Dan was a young man then so he began to think. Instead of going to Selkirk the three men sat about the steading chatting and singing, and on Sunday afternoon Dan came into the kitchen to have a letter sent home with his money. He then married a good woman, had a family and told my father that he had bought some land to start on his own. He still came to us for two or three years after that, leaving his wife to look after their holding, but eventually decided that he would do better to remain at home on his own farm.

Dan pressed my father to come and see him in Ireland where he assured him that he could buy calves direct from the farmers without having to bother with the dealers, but my father never went, preferring to pick his calves from the big consignments brought by John Sheriden to St Boswells.

He found that he could buy these Irish calves cheaper than rearing young home-bred calves on a pail. They were grazed all summer, wintered on hay and turnips and sold the following spring in very good condition with a very fair profit. My father enjoyed bargaining with Mr Sheriden who, in his turn, preferred to argue about the price outside the auctioneers' ring. My father would walk down the calf pens and Sheriden would pounce on him. They haggled over the price and quality of fifteen calves until the price dropped from £16 to £4 each, and each calf was a good one. Then they shook hands and I drove the calves home.

They were beautifully bred and one winter I took a great interest in them so that by the spring they were perfection. My father had had a bad winter with bronchitis so he sent me to St Boswells with them. I took them into the ring where Mr Swan the auctioneer, who knew the value of everything, greeted me, 'Ah, ha! What have we here?' I handed him the list with the numbers.

'Where is your father, boy?'

'He's ill with bronchitis.'

'Johnstone's not here, he's in bed, but the boy's here. Now where

have I got a man who's looking for something that's properly bred? They're all home-bred, boy?'

'Oh, yes.'

'Out of a pedigree bull?'

'Yes.'

'I could tell that as soon as I saw them come into the ring. Now then, £20 for them! £25 . . . £20 . . . £21 . . . £22 . . . £23 . . . £24 . . . My friend Mr Elliot? Never sold anything nicer than these in this sale ring. Shows what we can do with our own stock, breeding properly.'

I went home to report this to my father.

'You see, William, I've always said it, you'll be a great farmer if you go the right way about it. Mind you, I wouldn't have said that to James Swan myself; he must never find out about it.'

The lamb sales at Hawick caused great excitement. Drovers and shepherds brought their flocks in from the distant hills, sometimes taking two or three days. The herds got drunk, chased the girls up the High Street, trying to turn them up, and forgetting their sheep. The police went after them, their cases were in court next day, and several days went by before all the young herds and their dogs could be gathered together again and returned to the hills. I admired these drovers; they had magnificent dogs, foul language and morals which were said to be far from correct.

My father sent me with the shepherds to drive our lambs from Greenhead. We spent two days on the road, spending a night at a ploughman's cottage. As we neared Hawick on the second day we were joined by other flocks filtering in from the drove roads and by the time we reached Hawick there was pandemonium, men yelling, dogs barking, sheep complaining. The drovers were thirsty and some never came out of the Imperial Bar until the day was over. The sheep became mixed, dogs fought, police came to disentangle us and get the shepherds back to their job, until eventually we had our sheep penned. After the lambs were sold there was still the work of loading them on to the train. At that time there would be thirty special trains leaving Hawick with lambs, an engine on the front and one at the back – wagons and wagons of sheep going off to England.

Wigton horse sale came and my father took me away from school every year to attend it. He only bought a single ticket for me because

if he bought any horses I travelled back with them in the horse box. When they were unbroken colts this was quite frightening as some of them had never had a halter on their heads and were quite wild. On the train I feared they would break down the partition which separated me from them, but after a while they would settle until the truck jerked at stations or slanted round the bends. While my father promised to meet me, he frequently failed to do so and people began to complain that a boy should not be left in charge of these wild young colts, although getting them out of the horse box was really much easier than it seemed. As the colts were tired, I had only to string the halter rope over the lead horse and walk slowly away, and the rest would follow quietly.

Once my father took me up to Edinburgh to All Hallows Fair, a horse fair organized by John Croal & Sons at the bottom of Lady Lawson Street. Here were sold cast off tramway horses, broken down carriage and dray horses, fine young hackneys whose only fault was broken knees. Many horses fell as they pulled the heavy trams over the icy cobbles during the winter in the Edinburgh streets, so were beautiful horses, going cheap. I watched the knackers leaning against the walls of the sale ring; calculating, shifty-eyed men. I wept inwardly and was sick. I hoped my father would never bring me back to this sale.

The years between 1905 and 1911 were critical ones for farmers. Gloom hung over the whole industry and bankruptcies were frequent. The Hiring Fair in Selkirk Market Place was depressed – single ploughmen from £12 to £15 for the half year, younger hands and boys from £5 to £10, and women from £6 to £9. No rise in wages was possible and my father lost the best man he ever had because he would not pay him another sixpence a week. The Government was interested in Free Trade so that it became an endurance test as to who would survive when returns were so low – best Suffolk lambs sold at 12s. 6d. or 12s. 11d. Banks asked farmers in whom they had confidence to take farms at any price just to keep them going so that men with very little money were farming large acreages. The auctioneers, too, had the farmers under observation and firmly in their clutches. My own finances were in a critical state, but I found a rag and bone merchant in Selkirk who would give a penny each for empty whisky

bottles. My father was drinking heavily at the time, and hiding the bottles in odd places so that my mother should not know. A good search could result in as many as six bottles – enough for a whole packet of Wild Woodbines – and I began to build up capital. I soon had enough to buy copper wire to make snares for rabbits. The first time I tried I was not successful, as the rabbits were just that much more advanced than I, but the harsh economics of the situation made me determined. The making and setting of the snares in the afternoon took time and then I had to rise early in the morning to collect any victims before school which was a ploy I abominated. Once, in the evening, in the falling light, I heard a great squealing. Could it be a rabbit in one of my snares? Should I go back to see or should I go home and pretend it never happened? I was a long way from the house, so how was I going to kill the rabbit in the dark? I walked on home but stopped. The rabbit might suffer hours of misery in the snare. I went back, killed it and sadly took it home. My difficulties were not yet over as I still had to gut any rabbit I caught before I could sell it, hide it in school, then take it to the butcher at lunchtime. There was once a trying moment when the teacher, going round the class correcting exercises, came to me and said she noticed a peculiar smell. She promptly opened the window a little more.

Once or twice I went into partnership with Reid, the poacher. One very dark night we netted the edge of a long wood where we made a splendid haul. While Reid killed the rabbits I returned to our stable and, praying that no moon would shine, and that none of the other horses would whinny loud enough to bring my father out to the stables to investigate, I fetched out the pony and trap, carefully muffling the pony's hoofs to stop the clatter over the cobbled yard. We drove quickly into Galashiels with our load of rabbits and all the way I dreaded discovery and feared the tricky business of returning the pony safely back to his stall. Next morning my mother mentioned that she was certain that she had heard a pony and trap moving in the yard last night. She suspected our foreman, Tom Swanson, of stealing oats, but my father replied, 'Nonsense, Jane, you always think of the most ridiculous things.'

Despite hard times among the farming community we had a lot

of fun, particularly after harvest when all the neighbours came to our barn dance. My mother and sister baked for days, my father ordered a barrel of beer and cases of whisky; straw bales were placed round the barn for seats; the fiddlers were replenished with ample food and drink. We danced till daylight, the floor shaking with our heavy boots. My mother adored dancing and nothing delighted her more than when my father took her to one of the Assembly Balls where he would watch her patiently all night but never dance himself.

From 1911 my father at last had some success. He owned one farm, rented Greenhead and drank less. He was adored by women who found him most handsome, while men considered him a good neighbour. He was generous in his success. His land improved greatly over the years, while both his sheep and cattle became well known as first-class stock. For several years a Mr Jenkinson, an English farmer, bought all our top lambs and every year he won prizes with them at Smithfield. One year he decided that the 'tops' were too dear and bought our 'seconds' instead, but was beaten by those very 'tops' he had failed to buy – he never let them go again. In our kitchen there were always hams hanging up, plenty of eggs, good bread and scones, and our own butter. We were measured for our boots once a year by Mr Parkes, the shoemaker from Lilliesleaf, who had a thriving country business. He was a skilled craftsman who took a great pride in his work, but he had a ne'er-do-well son who caused him much trouble, never settling to the shoemakers' bench, but spending his time at the races. Years later I noticed that he had become a racing correspondent.

Another excitement was the arrival of Mr Martin, the packman, who brought my mother a wonderful array of materials – bootlaces, cotton or linen threads, needles and pins, 'long johns' for the winter and light vests for the summer, beautiful lengths of cloth to make dresses and trimmings of every kind.

Although my mother never really recovered from the death of my sister she was naturally a gay person who loved to entertain her family and friends at the farm. There were Greenwoods, Maxwells and Scotts from Hawick, Spaldings and Ropers from America, some from Germany and some from London. I found these much more

interesting than my father's relatives. The Greenwoods and Maxwells were gay and dashing types who wore beautiful clothes, shot and hunted, owned racehorses and even sported a Napier motor car driven by a most distinguished looking chauffeur. My aunt Grace Greenwood married a fine musician who was also a master plumber. John Maxwell was a delightful uncle. He devoted more time to the Hawick Silver Band than he did to his plumbing business, and even more time to drinking. When his business went into bankruptcy he took to the road, leaving his wife to cope with his large family.

With his eldest son John Maxwell made his way south, playing his cornet. In Leeds they found a great crowd gathered for the hanging of Charles Peace. The cornet was in pawn but, undismayed, John rolled up a newspaper and played 'Jerusalem the Golden' while young John went round with the hat.

Young John became a brilliant tweed designer althuogh he drank as heavily as his father. He fought in the Boer War, returning to Hawick with a pension for a wound received in South Africa. A mystery surrounded this wound, as some said that he had saved the life of a General, but John would say nothing about it. When he drew his pension at the Post Office all the riff-raff of Hawick were waiting to help him 'cash' it in the Imperial Bar.

After some of his drinking bouts John came to stay with us at Greenhead, which pleased me as I admired him tremendously. He talked to me about art and design, about his life in the world beyond Greenhead and Hawick; he brought the romance of far adventure to my young life.

Aunt Grace's second son Robert worked with a small firm in Hawick as office boy and clerk. At sixteen he became the traveller for the mill. He was handsome, very young, and had a wonderful way with the women, so that lady buyers were overjoyed to see him and looked forward enthusiastically to his next visit. Mr Knox Cowe, the owner, was so pleased that he promised him the business at his death, but when he died he left it to his widow who in turn promised it to Robert if he stayed with her. Robert, however, wanted his own business. He borrowed £500, set off for London on the Sunday night and was back in Hawick on Tuesday morning, having sold all the tweed he had with him in two hours. His banker then gave him un-

limited credit and the firm of R. G. Maxwell rose apace, so much so that offices were opened in London and by 1914 his income was reputed to be £90,000 a year. He bought his mother a fine house with beautiful furnishings, but she lived there without Uncle John. Robert paid his father a small remittance to stay away from Hawick.

I admired my clever, handsome cousin, I admired his Napier car, and to me, Robert seemed always the most sweet, brave and gentle of men. Then, with Government contracts rolling in and everybody predicting that he would become a great millionaire, Robert Maxwell enlisted in the Argyle and Sutherland Highlanders, went to Mesopotamia and was killed with his regiment. His brother, William, was also killed that year in France and Tommy, the youngest brother, died of tuberculosis. During the winter my friend, young John, was found one morning in the snowy street, drunk and dead. My cousin Grace came from London to see her mother, rode to hounds, was seized by appendicitis and died in Hawick hospital. My aunt came to stay with us at Greenhead. She had a pale lovely face full of character and her kind smile and bright laughing eyes reflected so much life. I could not help wondering about how a human being could endure so much all in one year and still triumph over such tragedies. She was now very rich but this must have meant nothing without her family to enjoy it.

My Aunt Jenny, one of Grandfather Robert Greenwood's daughters, married an engineer called George Scott, so Greenwood set his new son-in-law up in business as a mill furnisher. The business proved most successful; George Scott had almost a monopoly in supplying spare parts to the Border mills. George was an intelligent man, well read in the classics, but he was inclined to be lazy and enjoyed nothing more than a pleasant stroll down Hawick High Street, leaving his business in charge of his foreman. The couple had three children, all of whom were highly intellectual and aesthetic. They could all draw beautifully although Robert was the most gifted as a painter. Maggie loved music and longed to be an actress, but never had the opportunity to develop her talents.

Francis George was a brilliant English scholar with a passion for music, so that instead of returning to Hawick with the much coveted M.A. which would have enabled him to obtain a highly respected

teaching appointment, he spent his time at Edinburgh University studying music. This was considered a disaster by his father. But Francis obtained a job teaching English at Langholm Academy, cycling home every weekend in order to play the organ in the kirk at Hawick. When my father had his butcher's shop in Denholm, Francis used sometimes to accompany him on the van when he did his country rounds. He had a fine ear for language and my father said he used to enliven the journey by his explanation of the derivations of farm names.

As he was ten years older than I we had little to do with each other until I lived in Edinburgh as a student – he must have been very bored with his young cousin whose interests appeared to be solely connected with sheep and cattle. At my Aunt Jenny's funeral my father was deeply affronted by the behaviour of Francis, to the extent that he refused to have anything more to do with him. The rift was caused when Francis professed himself to be unmoved by his mother's death as she persisted in singing the wrong kind of music all her life. I think that my father was unfair to Francis, who was truly fond of his mother and deeply saddened by her death, but was always unwilling to display his true feelings.

Before 1914 there were many travelling theatre companies making one night stands in small towns, and I had a great desire to see one of those performances. My father felt that this was not for boys of my age (I must have been about ten or eleven), and at first refused to take me. The titles of some of those plays indicated strong meat: Miss Inez Howard's company in *Driven from Home*, *While London Sleeps*, *Man to Man*, or melodrama in the open-air theatre (the gaff), which was set up on a vacant lot in the park and advertised *Sweeny Todd* and *Maria Martin* or *Murder in the Red Barn*. At last my father agreed to take me to see *The Face at the Window*, a lurid melodrama. After that I wanted to see more and more but, as I had shouted out with excitement during the performance and quite a few times in my sleep during the night, this was ruled out.

My father said that if a play with fewer murders came, we would go again. My mother thought that *East Lynne* and *Uncle Tom's Cabin* were excellent, and my father thought the same about *The Silver King*, so I saw them all. Durward Lely, a fine tenor and one of the

original Gilbert and Sullivan cast, came on tour with *A Royal Divorce* and Hall Caine's *The Manxman*. Into those works he introduced musical items which I felt he sang most beautifully.

The actors were spectacular characters in the little town; Henry Rushbury with his wide brimmed black hat, his astrakhan collar, cane and spats seemed a very dashing figure in our dusty, unpaved Market Square. I sat next to Mr Lely in the barber's once and marvelled at the large area of his huge face that the barber had to cover with his soap. My sister Mary met a strange young man one day declaiming wildly to our sheep. She fled back to the police station at Selkirk to say that a lunatic had escaped from the local asylum and she was frightened to go home. Next day my father met this young man who apologized earnestly for unsettling the young lady, and explained that he was only learning his lines. His name was Henry Baynton and my father felt that with this amount of application he would go far.

Other theatrical characters worth studying were the town 'worthies'. In Selkirk there was Jocky the Bummy who went round the bars where the men would get him to do his celebrated imitation of a bee. This he could do to perfection – you saw that bee buzzing around until Jocky got tired and caught it with his hat. This was the signal for someone to give him a drink.

Another character was David Laidlaw who was a tall, elegant man with a top hat, reported to have come from a good family. Jocky the Bummy suggested one day that they should go to the Station Hotel for a drink. 'I'll lie down in the road and you run in to Mr Wilson and say there's a man fainted.'

When they got there Jocky lay down in the road and Laidlaw rushed in to the Station Hotel. 'Oh, Mr Wilson, there's a man fainted out there!' Mr Wilson looked out to see.

'Are you sure?'

'Yes, yes, yes.' So Mr Wilson sent his barman out with a glass of whisky to help the man recover. The Bummy was lifted up and, as the whisky disappeared fast, Davie Laidlaw said, 'Stop, stop, stop, there'll be nothing left for me!'

'Away to hell and faint yoursel'!'

My favourite character in Hawick was Magenta Robbie. When he

moved house a friend said to him, 'Robbie, I hear you're "flitting"?'

'Yes.'

'Why are you moving?'

'To be nearer my work.'

'Where is your work?'

'I haven't found that, yet.'

He passed along the street with such furniture as he possessed loaded on a float drawn by an aged horse. Robbie sat on top with his table balanced on his head. Someone asked, 'Robbie, what on earth are you doing with a table on your head?'

'To make it lighter on the horse.'

Another 'worthy' in Hawick was Johnny Gilroy who lived at the bottom of the Howgate. He must have had something like St Vitus's Dance because when he trotted along the pavement he would go off at a tangent, cracking a little whip. An impertinent man named Burns was talking to the Provost and another friend one day as Johnny went by. Burns said, 'Hullo, Johnny!'

'Yeah, yeah, yeah?'

'Did you see the cartload of monkeys going up the loan today?'

Johnny took time to consider this. Then he replied, 'No, did you fall off?'

For me these eccentrics were splendid actors in the real theatre of life.

The pony who had brought us to Greenhead was my first love among my father's horses. Mary's pedigree had been lost in antiquity. She was fat and gentle, with hairy ankles, and she knew her way home from every sale, many times bringing my father home with the reins dragging along the ground. But she was growing old, and my father announced one day that a tinker was coming to take her away. At that time there was a big trade in old horses for the Continent, so there were great protestations from my mother, my sister and myself. We had plenty of fields and felt that what Mary would eat would never be missed. However, a few days later two 'muggers' came to the kitchen door to ask me to tell my father that they had come for the horse. Before they left I yelled at them that I hoped they would break their bloody necks with a kicking horse, then went into the back kitchen to cry. My father would have whipped me if he

thought I had wept about Mary, but I felt he was callous, hard and unsympathetic after Mary had served us so well.

Another old friend was Tyne, the collie. This old dog developed mange which nothing, even immersion in the sheep dip, seemed to cure. One morning, while my father was sitting beside me at breakfast, I heard an unexpected shot. I went to investigate and at the back of the steading I came upon Tyne, hanging by his neck from a tree. The ploughman had put a rope round his neck, pulled him clear of the ground and shot him. My father had made one of the men do his dirty work for him and I could not forgive him. We never had another collie equal to Tyne, never again one so intelligent or so reliable.

After Mary we had a succession of ponies. The state of our dog-cart varied with the quality of pony which my father acquired in his horse dealing enterprises. Apart from Gilnockie who had broken his leg in Denholm, the wildest was Kicking Nancy. She was delightful in her stall but it was impossible to judge whether she would ever start once she was harnessed to the gig. If she decided against starting she backed until the gig hit the wall and disintegrated. This was unpleasant for those sitting in the rear, and my sister was so terrified that she preferred to walk. Sometimes Nancy got away quietly, trotting nicely along the road, and then would suddenly stop. Those sitting in the front went over the splashboard on to her back, whereupon she would kick. As splinters of wood flew from the floorboards, and a shaft was broken, my father lost his temper, but Nancy would continue until she was tired. She took us twice over an embankment and wrecked two dog-carts.

After the Battle of Flodden the little Border towns were ruined, their manpower so seriously depleted that no taxes could be gathered. To help their recovery, grants of land were given by the Crown, each town being responsible for keeping their own marches. Several times I rode a steady old cob of my father's round the marches at the Selkirk Common Riding with the citizens of the town. I could not aspire to be the Standard Bearer as this honour is reserved for those born in the Burgh; you have to be a 'souter'. A neighbour remarked to my father one day that I was the worst-mounted boy at Common

Riding and my father obviously took this to heart as, shortly after, he mentioned that there seemed to be some good horses at Carlisle. We went down to have a look at them and, to my astonishment, a three-year-old thoroughbred was knocked down to my father. What was he going to do with this? 'Give it to you if you promise to look after him.' I took Billy through the Botchergate to the station to get him on the train for Hawick.

The first few months were difficult as Billy had some bad habits. He knew all the different ways of biting, rearing, bucking and kicking. As time went by these outbreaks came less frequently and we eventually got to know each other very well. I still had him during the first two years of the war but then he had to be sold as no one had time to ride any more.

The Common Ridings were events of great importance to the country folk, bringing us in touch with 'civilization' in the shape of city slickers, broken-down jockeys, showmen and other entertainers. Hawick Common Riding was the first of these events in the year, usually taking place in cold, rainy weather. Apart from the fun of riding the marches, there were wrestling matches and other sporting contests. Every family took a picnic on the Town Moor in the afternoon while in the evening there were roundabouts, coconuts and beer at the showground. For me the major event was the 'flapping' race meeting on the Town Moor. While we had our own meeting at Selkirk, Hawick gloried in the Tradesmen's Handicap, run then for forty sovereigns. 'Flapping' meetings are not held under Jockey Club rules and there are some people who wonder whether they are held under any rules at all. Some say that all the horses, jockeys and owners taking part have a 'past'; others say that the doping of horses as practised elsewhere is unnecessary at these race meetings because there are so few horses for the number of events. It is simply a question of dividing the stake money equally among all the owners at the end of the day. Some trainers and jockeys have graduated from our 'flapping' meetings to Doncaster and Newmarket but others, sad to say, have reverted, and the general public remains cynical.

Of all the horses my favourite was Commander, a splendid Irish horse who lived a life of toil in Galashiels. He belonged to Patrick

Foley for whom he pulled a float, loaded in summer with fruit and tomatoes, in winter with herrings. Patrick was a man of keen business acumen, never losing an opportunity for trade. On the day of the race meeting my father and I set out early, and halfway to Hawick we passed Commander pulling his float on the long haul up to Grindestone Heights, laden with bananas. Old Patrick drove him and, sitting on the back of the float, were his two sons Michael and Patrick, his grandson Patrick, a pail for Commander's water, his hay and a pair of riding boots of which the soles had parted company from the uppers.

When they reached the Town Moor, Commander was unhitched and brushed down, the float was eased into position and Old Patrick began selling his fruit. Michael (who was very tall and rode with long stirrups like Fred Archer), changed into his racing colours (a little frayed), being careful to tie up his boots safely with string, and his brother Patrick (a little man with a straw hat without a crown), took charge of the betting operations. However much the racing may have been 'fixed' the Foleys could never resist trying to win if they had a chance. Old Patrick watched the race while selling bananas with one hand, and young Patrick waved his straw brim with excitement, as Michael rode Commander to win the Municipal Handicap. As we drove home we passed Commander returning the twenty miles to Galashiels, pulling his empty float.

Shortly after Hawick Common Riding came our own at Selkirk. As well as riding the marches I had an especial reason for excitement. My father provided grazing for about forty of the showmen's horses in the sixty acre field. The same men came each year with their attractive strings of piebald, palomino or New Forest ponies. They put them in the field, calling at the house to tell my father how many horses they had left, and so I heard the names of foreign places like Guildford or Walworth Road, Camberwell. I particularly looked forward to seeing Mr Biddle and Mr Hughes. The latter had been Mr Biddle's stud groom and now ran a shooting saloon.

Mr Biddle was very tall and handsome with black moustaches, black hair and a charming smile with the whitest teeth you could imagine. He always smoked cigars with large gold bands. Despite this dashing appearance, when he shook hands the feel was that of

rock, so he was clearly a man who worked with his hands. He owned a circus, a ghost show and a very up-to-date bioscope, in which the moving picture lasted fully five minutes. For threepence you could see the funeral of King Edward VII, looking as if it were taking place in a heavy downpour. The show was packed and queues waited to get in while Mrs Biddle sat in front, a steady stream of threepenny bits flowing into her pocket. There were shooting saloons, Mr Wilmot's racing cars, gondolas that swung round about, up and down, shaking your liver up, performing bears and ex-heavyweight boxers. There were great steam engines beautifully polished and elaborately painted. There was Mr Biddle's Ghost Show which included two negro minstrels playing banjos, frightening illusions in mirrors, the horrid sensation of wet hands touching your face in the dark (always to be blamed on one's companion), eerie lights and weird shrieks. Mr Biddle stood outside in his frock coat and top hat with his cigar, waving to the populace. He sported gold cuff links, a diamond pin and several gold rings on his fingers. He told my father that in the big towns bioscopes were being built for continuous performances and that the travelling show would soon have to close, but he believed the circus would always attract patrons.

At the end of the fair we visited the showmen in their caravans where my father collected his dues for the grazing. The caravans were beautifully decorated on the outside with real gold leaf and had lavish interior decoration and it seemed a marvellous world in which to live. These showmen had had little schooling, but their standard of craftsmanship and baroque sense of design were something to be envied. They could paint, signwrite, lay gold leaf, mend engines, fix cables and train animals. They also knew a great deal about animal and human nature. I admired the fronts to their shows painted with marvellous designs 'straight from Paris' and their impressive steam organs decorated with wonderfully draped half-naked mechanical ladies. But Mr Biddle impressed upon me that even though I had to work hard at the farm and at school, the circus would probably mean even harder work, and it would be better if I remained at home. When I was a student I met Mr and Mrs Biddle again. He had retired to become the secretary of the Showmen's Union in Edinburgh, where he had bought Mrs Biddle a very fine

West End flat. There they lived in misery for a year before giving it up to return to their caravan.

We also saw Bostock and Wombwell's Menagerie, William Cody with his Wild West Show (including Annie Oakley), and Sanger's Circus. My father provided hay for the elephants and the magnificent horses. I was so impressed by Pimpo, the clown, that I named a collie pup after him and trained him as a circus dog. Instead of gathering sheep he turned somersaults and when you told him to go 'far out bye' he stood on his head. I spent a lot of time training Pimpo who was an extremely clever puppy but my father became more and more enraged. In the end he gave Pimpo to the first farmer he met who was looking for a dog. He told the man that he could have him for nothing if only he would take him away, hoping never to see man or dog again. About a year later he saw the same farmer at a sale and tried to dodge him, but the man insisted on finding a way of meeting my father to thank him for letting him have the cleverest and most biddable collie he had ever had. My father recovered himself as quickly as he could.

During the winter evenings at Greenhead after turnips had been cut for the cattle, when my pony had been cleaned, fed and bedded, when my father had made his tour of inspection round the horses to see that they were well groomed and properly fed, passing his handkerchief underneath their bellies to see that no dirt was left behind, I could settle down at the kitchen table with an oil lamp and Bibby's calendar. By good fortune my father considered that Bibby's Cattle Cake was the very best for fattening stock so every year I was able to look forward to their calendar which had twelve superb coloured reproductions of very fine paintings. Nothing else at Christmas was so important, and for weeks beforehand I was agog with expectation. There were paintings by Corot, Harpignies, Daubigny, Millet, there were Dutch painters, there was Rembrandt, there were Italian paintings by Veronese, Canaletto and Guardi, there were wonderful Turners and Constables. They were the most beautiful things I could imagine and in some definite way they related to my own life, especially Turner, Millet and Constable.

After many appeals I at last cajoled my mother into buying me a watercolour paintbox costing sixpence, which was considered a great

extravagance. It contained only a few colours and a brush in which the shapeless hairs were stuck into a short quill handle. Later I managed to get a box of oil paints, which was an enormous triumph and I was supremely happy. In excitement I copied Millet's *Angelus* and struggled all winter with *Rain, Speed and Steam* and the *Fighting Temeraire*. The Pre-Raphaelites meant nothing to me – the *Last of England* I thought a waste of time, although I could see that the circumstances must have been most trying.

I copied continuously all winter, each picture requiring tremendous concentration and effort. I painted on board (having heavily coated it with size), using students' oil colours and a megilp medium but, painting with small brushes, the process was slow and long. After I had gone to bed I could not stop thinking about my painting and would creep downstairs with a candle to see how it was getting on and the next afternoon I would rush home from school hoping to finish it. Sometimes there were failures that demanded further intensified effort and additional study of Turner or Constable. I discovered some of the qualities of pigment, how there was thin transparent paint and then thick impasto. I realized how much could be expressed by the paint itself, and that the qualities of paint made the work of art, rather than the view or the subject. When I first started to paint from nature, it seemed that my hard won standard flopped, giving the result a very amateurish look. It was odd and most disappointing.

Then I tried to paint Rock, the collie. The dog itself gave me a clue as to what needed to be emphasized, but the smooth nose, the long hair round the ears, the direction of the hair round the belly and his furry feet I found intellectually beyond me. Painting was something you did with paint but I could do nothing with Holman Hunt because the illustration superseded the qualities of the medium. Another discovery was that if I copied a worthless or inferior New Year card it was possible to give it a new 'life', although it could take on a new character or image. Through learning the techniques of Bibby's Great Masters I was finding new ways of using the medium quite unconsciously – Constable and Turner were elevating my New Year cards to higher things and I was breaking through barriers of difficulty by an intensity of effort.

I learned, too, to differentiate between art and nature – how *very* different and opposed they were. Observation of nature might produce a subject, but it did not produce a painting, nor a work of art. Intensive copying of a great master enabled you to share in his experience and you were no longer simply contemplating the work of art, but you were sharing in the creative struggles of the painter himself. You could begin to understand all the tradition which had made the artist paint in his particular way, how he had enriched that tradition and how you, too, could add something different and new to what you had learned. I discovered that art was a language and that I had to learn how to speak it. Later I learned that William Blake had copied Michelangelo from a portfolio of engravings, working on them for years until he could draw them all from memory and when he could do that he sold the portfolio. Bibby's calendar gave me a standard of quality to which I could always return.

My mother was sympathetic towards my painting and promised me that one day we would go to see some of those pictures which were reproduced in the calendar. When she was a child on visits to Manchester to stay with our relatives she told me that my grandfather had taken her to see some of the great pictures in the City Art Gallery. She did indeed take me into Hawick on one or two occasions to see paintings in the new Hawick Art Gallery in Bridge Street which my grandfather, with Charles Wilson and other manufacturers, had founded.

I still trudged to school some three miles each way as I had done from the age of five. I do not remember much about the other children except that they were wicked, malicious and cruel, just like all children. They had fights and cheated at marbles (a game at which I always lost). Occasionally I fought a child who picked on me and sometimes I won. The teaching was good and thorough, discipline firm, school was no laughing matter. For those who did not pay attention or whose thoughts floated away in cloud-cuckoo land there was the tawse which brought these dreamers swiftly back into the land of reality.

My teachers found my scholastic life erratic, uneven and thoroughly unsatisfactory. It seemed that my homework was not having the

attention it should have had; doubts were expressed whether at the end of the term I would be able to reach the next grade. There was a feeling that perhaps I was not entirely lacking in intelligence, but I was most certainly lacking in application. Life seemed very long. I took some interest in history lessons with Scottish heroes like Wallace and Bruce, but I could never succeed in integrating English history with that of Scotland. Literature also had an appeal, while both my history and English lessons gained an interest through my theatrical experience. Arithmetic was always a disaster. My star turn was in the drawing and painting class. Small postcards were pinned up on the blackboard for us to copy, and although from my seat at the back of the class you could hardly see them, it was a beginning, and I found that I was considered good at this task but was not encouraged to any great extent. Poverty is no seed bed for the appreciation or creation of the arts. At that time Scottish education was biased towards teaching children in a poor country the means to earn their livelihood in the shortest possible time. It was more limited but, I think, more basic than it is now. Its very limitations gave it a greater depth and a more positive character. The teaching profession was held in high respect.

Generally speaking, education seemed confusing as it could not be related to life on my father's farm, and I decided to leave school at the earliest possible date.

At school one day pupils were being sorted out to try for scholarships to the Grammar School. The Headmaster asked all who would be interested to raise their hands. I did not. The Headmaster asked me if I was thinking, or was my head full of sheep? To my astonishment he said that I should try, and as I felt hurt by his reference to sheep, I failed to protest against being made to sit for a scholarship in which I knew I could only fail. With slow and reluctant steps I went to the Grammer School wondering whether I should hand in a blank paper. To me all this education seemed to make life more miserable than it need be, and I felt mine was indeed miserable enough.

My father cared little so when I passed he received the news without comment. Now I should have to stay at school until I was sixteen, but if I had left at fourteen I could have saved a farm worker's wage.

My Grammer School days were less successful in some ways than my elementary school. A start had to be made with lists of manuals and textbooks and it did not take long for the curriculum to take shape. There was an air of seriousness about it which could not be misunderstood and it was obvious to me that I would never cope with it although, to my pleasure, I found that a fair amount of time was allowed for art.

There was a visiting art mistress, which serious people considered a downright waste of money and the beginning of great extravagance. Her name was Miss Brown, known to her pupils as 'Van' Brown from her recipe for pulling together fragmenting forms and colours, without focus or perspective, with a uniform wash of vandyke brown. It was a clever trick and I discovered that after my struggles with Turner and Millet, taking half the winter, this lady could achieve unity with one direct wash of vandyke brown.

We were a collection of gay savages, and spent a happy time tickling the girls underneath the desks with a paintbrush or passing poetic notes to loved ones. During the summer holidays before starting at the Grammar School in September I had entered the world of sex and sin. I had discovered that girls were not nearly as innocent as I had supposed.

Before long I became a star in the art class, helping other boys with their drawings in return for the right answers to my arithmetic. Our Van Brown was bronchial and taught us garbed in boots and two fur coats. One day she was engaged in a heated altercation with the Rector. Both were rather hot-tempered and in the course of the proceedings Miss Brown found that her hair (or that portion of it which did not belong to her) was loose. We watched, enthralled, as it gradually slipped down and down until it fell on the floor in front of us. The class could not contain themselves, but, with complete coolness she bent down, saying, 'Well, children, that's another of my secrets gone.'

The English class, however, was serious. Not only did William Ritchic, M.A., have a very extensive knowledge of his subject, but he knew how to teach it, and he brought life and vitality to everything he discussed. He subscribed to the 'New Age' and he taught me about imagery in poetry by reading William Blake. He introduced me to

the value of words and he showed me, too, a new cunning, a different cunning from that of the farmer or the cattle dealer, that of the scholastic. He also, for a very short period, introduced me to scouting. Someone had seen Baden-Powell's *Scouting for Boys* and Ritchie had been persuaded to be our Scoutmaster.

In July 1910 we camped one fine, hot summer at Henderland, in Meggat Valley. An excursion was planned to climb to Loch Skene, a dark isolated loch above the Grey Mare's Tail in Moffat Water. We should have started in the morning but waited till the cool of the late afternoon before we climbed out of Meggat, and struck out over the peat hags to Loch Skene. Consequently by the time we were eating our provisions by the cold loch, the mist came up to surround us, the moon disappeared, and no one knew the way to Moffat Water. Very gingerly we made our way down, expecting at any moment to disappear into the gully of the Grey Mare's Tail. Suddenly in the mist, a boy in front of us vanished, then the next one, and the next. I found myself lurching forward into space, then jolted down and down till I reached the bottom of a long patch of scree with my knees cut, my pants torn and my seat black and blue. We had found the syke leading down to Moffat Water.

To my disappointment William Ritchie left Selkirk to work in Glasgow. His place was taken by a Cambridge graduate, Mr Humphries, a tall, elegant young man with glasses and great charm of manner. His qualities were very different from Ritchie's; he was gentle, very kind, most cultured and civilized. Mr Humphries held the slightly unorthodox view that we should be treated as serious adults and not as children, and his opening words in class were 'Let us begin!' This was the signal for any member of the class to rise and start reading. The work in hand was 'The Lay of the Last Minstrel'. I stood up and read the opening lines, 'The way was long, the wind was cold . . .' as badly as I could. Mr Humphries said, 'Dreadful. Try again.' Next time was just as bad. He said, 'I fear I must ask you to sit down.'

'I don't want to sit down.'

'Then you must go on reading.' This time I read with more feeling. 'Much better, much better, just read the opening lines again. You have a feeling for it.'

My next effort was a tour-de-force:

> The way was long, the wind was cold,
> The Minstrel was infirm and old;
> His withered cheek and tresses grey,
> Seemed to have known a better day.
> His hair, his size, his mouth, his lugs,
> Shew'd he was nane o' Scotland's dugs;
> But whalpit some place for abroad,
> Whare sailors gang to fish for cod.

There was a great silence in the class then loud laughter as it dawned on everyone that I had mixed up 'The Lay of the Last Minstrel' with Burns's 'Twa Dogs'. Mr Humphries collected himself, saying gently, 'I must insist that you leave the room.'

There was nothing else for it but to go. It had been great fun but the price would have to be paid as I knew that sooner or later the Rector would come along the passage and find me there. He did. 'What are you doing here?'

'I have been asked to leave the room.'

Mr Jeffreys took me firmly back into the classroom to enquire what I had been doing. As Mr Humphries could not bear the thought of any of the boys being caned, he replied with mildness that I had not been well that morning.

'The boy has talent in English and indicates a certain ability to read well.' The Rector did not believe him and took me along to his own room where he told me that I had made very little use of my time and of the scholarship that had been given me and that he would ask me for the very last time to make some effort. He thought perhaps if he called to see my father to talk over the question of my education with him things might improve, as he felt that it was impossible for me to develop as I should if I had to spend my time cutting turnips for cattle and attending sales when I should be at school. The Rector said that he had spoken to Miss Lawson, teacher of mathematics, who had expressed willingness to coach me in the evenings and at weekends without a fee. I was taken aback by all this, and at a loss for what to say. The school had lost the little attraction it had ever had and my only desire was to get out of it, and consequently I used my skill as a mimic in the cause of anarchy and destruction. After

school I hung my bag over my back and walked away up the long hill to my home without talking to anyone.

Even the art class which I had at first so much enjoyed ceased to exert the consuming kind of power I needed. The lessons consisted of a series of recipes of what to do and I felt the vandyke brown wash was nothing but an easy dodge to evade the real issues. I wanted to get back to the fearful struggle and deep compelling interest of copying Turner's *Fighting Temeraire*. For me this was real, like the open road to the sales, the pubs, the auctioneers, the shepherds, dogs and drovers; the arguments with Irish cattle dealers, the race meetings with all the attendant cunning, deceit and lies, and above all, with the freedom. I was thirteen then and felt much older than the boys in my class; older, sadder and much more ignorant. It would be impossible for me to catch up with them in order to continue with some form of further education as I felt that theirs was another world. Mine was the world of farmers and the land; the land of Rembrandt and Vincent van Gogh.

After a year at the Grammar School, when I was fourteen, my father agreed that I could leave to work on the farm. He had never been very impressed with scholarship with the exception of William Ritchie. Once, though, he considered sending me to Fettes or Loretto, but then he wondered whether these schools and teachers were all that they were said to be when it really came to the job of tackling life. Was not the drover more capable of living in this world than many who came out of these schools? He quoted Robert Burns. '. . . Confuse their brains in college-classes! They gang in stirks, and come out asses . . .' For me, at any rate, he was right.

The Grammar School and I parted company with mutual thankfulness. I worked hard throughout the year at the farm, from lambing and sowing, ploughing and harvest, to shawing turnips in the winter with the frost biting my fingers. I enjoyed riding Billy, enjoyed the dances, coming home just in time to start chopping turnips for the cattle's morning feed, enjoyed Charlie Chaplin at the newly opened cinema, and I worked hard at my painting during the winter nights. Life was very good – even my father was pleased and prosperous. Old John Paterson, the beadle, came for walks on Sundays to Greenhead and read Tennyson or Wordsworth to me

and once brought me the *Stones of Venice*. He encouraged me to go on with my painting, to the extent that I was inspired to try and paint his portrait.

Another friend was old Willie Nicol, the signwriter, whose greatest work was the sign for the 'Fox and Hounds' at Denholm. His work had a naïve and vigorous quality and he painted with an innocent eye. About his workshop there was the most delicious smell of paint.

One day my father happened to meet his friend, Mr Walker, in Selkirk and mentioned that I was busy copying Tom Scott's illustrations to Dr Russell's *Reminiscences of Yarrow*. Mr Walker at once said that he would take me to see Tom as he was very fond of him and owned a fine collection of his work. I was a little scared because, although Tom Scott was acknowledged in the town to be a great artist, stories were rife as to his wild goings-on and I did not know what to expect. At this first meeting Tom was most kind. He talked about painting, showed me his watercolours, and asked me about my own paintings. He told me to come back whenever I could and so I ventured back on my own, taking some of my work. Soon these visits became a habit and as often as I could I walked down to Leslie Cottage to see Tom. He showed me how to draw trees (of which he was a master), always darker at the top, how they grow, how the knots came. So I drew trees and took them to him for criticism, although sometimes he would not look, and at other times he would spend a long time talking about them. As he was interested in archaeology my father invited him to stay at Greenhead where we had a splendid Pictish encampment, the Bell Hill Fort. Here Tom showed me how to find flints and arrowheads. My father liked Tom and would take him out to a chosen position to paint, and then worry all day lest he should freeze to death in the bitter wind. When he went to fetch him he would find that Tom had been so intent on his painting that he had never noticed how cold it was. Tom took me with him on many of these excursions but he became exasperated with me one snowy day in Ettrick because my fingers were so stiff with cold that I could do nothing, while he produced a couple of beautiful watercolours even though his brushes and his water froze. I began to think this was worse than shawing turnips. Tom spent much time painting in the valleys of Ettrick and Yarrow. He used to

call to see a lady of ninety who lived with her son in an old thatched butt-and-ben beside the road, taking with him a bottle of whisky. Old Mrs Tait had never been to a town of any size in her life but, like all true country people, there was nothing of interest that she missed. One day she saw the queerest thing that had ever been seen in Yarrow; a man riding a bicycle.

'Jimmy,' she shouted to her son, 'Jimmy, come and see the de'il riding on a gird!'

Tom Scott had been brought up as a tailor in Selkirk following the footsteps of his father, who was a perfectionist and made suits of quality. He had, however, one little weakness – pheasants. When delivering a suit for the Duke of Buccleuch he would set off in his beautifully cut knickerbockers, his Sherlock Holmes hat, spats and gun. He would leave the latter in a safe hiding place, deliver his parcel and return to Selkirk through the woods of Bowhill, seldom empty-handed. He saw in his son Tom a cutter of genius and sent him to Edinburgh to complete his apprenticeship so that he could go to London to make his fortune in Savile Row.

Tom worked hard at his cutting, but in the evenings he attended classes for painting and drawing, and eventually news of this filtered through to Selkirk. Whilst Mr Scott's temper was notorious, this time his rage was awe-inspiring, but despite this, Tom was able to keep himself in Edinburgh while continuing his painting studies. He was fortunate to have Sam Bough, R.S.A., as his tutor and so, from the first, he had direct contact with a distinguished artist who was himself in the great tradition of the English watercolour school.

Sam Bough was a native of Cumberland who spent most of his working life in Edinburgh, teaching at the Royal Scottish Academy life classes. He introduced Tom to Lord Carmichael of Stirling, a brilliant, highly sensitive connoisseur of great judgement and dis-crimination, who was able to send Tom to study on the Continent and to give him valuable guidance.

Tom quickly realized his limitations and knew that he could never be a great painter in oils. Even if he had had the natural ability, he did not have the time to follow a long period of training, and there-fore had to take what was at hand. He loved nature with the same passionate intensity as Millet, Van Gogh or Permeke – the earth and

man being one. Tom painted statements in watercolour about the landscape which he loved and during his Continental trip he did some of his very best work, painting in Holland, in Venice and in the Barbizon countryside. Here he met Daubigny, Lépine, Harpignies, the finest artists of his day. Alas, he also (in common with too many other Scottish painters) came under the influence of Bastien-Lepage, which was a fatal mistake.

When Tom returned he brought a great pile of superb watercolour drawings, fully justifying Lord Carmichael's faith in him. An exhibition was arranged where Tom was a great success. Then followed a productive visit to East Anglia where he met the painter, Charles Conder. Back in Scotland he spent time in the far North painting the wild sea of the Pentland Firth, but he was never long away from the Borders. He became ill with infantile paralysis which left him severely crippled but his devotion to painting never faltered, neither did his insistence on the long discipline and hard work that was needed.

Tom could work with tremendous intensity and concentration for weeks at a time, when his output was enormous, but as suddenly as he had started, so he would stop, and then his drinking would begin. There was no stopping until he had worked this out of his system at the County Hotel. Brunton, the ostler at the County who drove a coach called 'Flower of Yarrow' with a man on top blowing a trumpet, would be called to take Tom home. He would bring his cab round, put Tom inside, and off they would go through the pend onto the main road and down the West Port to Leslie Cottage. On arrival one evening, Brunton looked over the side from his 'dickie' to see whether Tom was getting out. He tied his reins and came down to help, but found there was no Tom inside. He had slipped out of the opposite door of the cab before they left the County.

Tom made a lot of money from his paintings. One day he had been paid nearly £500 and was determined to raise hell. Mrs Scott asked me to try to dissuade him, but he had been drunk all day and nothing was going to put him off. We set out for the County Hotel, but as soon as I reasonably could I suggested that we should go home again. He said, 'Nonsense, nonsense, my old whore of a wife has been putting you up to this, to get me home. To hell with her!'

'I think we should get home.'

'Oh, alright, send for Brunton.' The ostler duly arrived and Tom told him, 'We have to go home, so I say we'll go home, but I have to have a conveyance and I'm not going in the cab.'

Brunton stood absolutely still. 'Yes, sir, I quite understand, sir.'

'No cabs, you understand.'

'We have a dog-cart.'

'To hell with your bloody dog-cart, who the hell's going to sit in your dog-cart? I want a hearse . . . I'm wanting a hearse.'

Brunton explained that the hearse was being painted and repaired, so was unobtainable and eventually persuaded Tom to use the cab. This was brought round, but Tom refused to go inside. 'The skipper never leaves the deck. I've sailed the Pentland Firth from Scrabster to Orkney, by heaven! Captain Burgess crossing the Pentland Firth! Ahoy!'

We were getting Tom up and had him as far as the bush of the wheel when one of the men said, 'Throw the old bugger into the horse trough!'

'By the Holy God I'm coming down again.'

'Keep the old bastard going up!'

We got him up beside Brunton who spread Tom's coat over the seat and sat on it to prevent him falling off. Tom's brown bowler fell down so we sent that up again, and away we went, the children in the High Street shouting, 'Here's Tom Scott, the artist, drunk, hooray!'

Tom Scott was a professional painter; he had to paint for his living. He realized the dangers of commercial art but also the dangers of being over sensitive and aesthetic. He painted to a high standard, which with the years, sadly declined. He knew this and told me, 'In youth, hold high, for you will have to compromise some day.'

When the final decision was made that I could go to Edinburgh to the College of Art, Tom said, 'I have tried to dissuade you. I have suggested you could get much pleasure out of being an amateur, just painting for the pleasure of it. To be able to prophesy is quite beyond me, but you have enough skill to be able to do something

with your talent, and that is more than I can say about others like you who have asked me. The artist's life is a dreary journey, you are eternally alone. It is disappointing, nothing but despondency and gloom. Occasionally a light shines and that moment must make up for all the effort. Look at the great ones. Look at Turner!'

2

The shadow of war

The difficulties of feeding the country during the First World War put farmers in a strong position. From a state of poverty they became affluent, and many a farmer who had not had a new suit of clothes for years had one now. Agriculture, which had been sacrificed for Free Trade, ship-owner millionaires, tinned meat importers and other tycoons, came quickly into its own. The quality of our land suddenly became the best in the world and our farmers, overnight, became the best farmers in the world. But labour was scarce and we had no shepherd, no lambing man, no ploughman. I ploughed a forty-acre field by myself with the two horses.

The spring of 1917 followed a wicked, stormy winter and it was the worst lambing I had known. Days and nights without sleep, hardly able to stand with weariness, and then, when the hardest work seemed over, a great snow storm blew up in the night. I struggled through the blizzard next morning, fighting my way through the snow to see what had happened to our ewes and their hard-won twins. I picked up ninety-one dead lambs and barely made the shelter of a wood before I collapsed with exhaustion. I swore that if I somehow survived this war I would never farm again.

There was only my father and myself left to work 600 acres and he was not able to do very much. My sister came to stay during the harvest and I remember the fury which I felt when my brother-in-law watched us get in that forty-acre field of oats without even once offering to help. Eventually we had a disabled soldier, Tommy McGee, to live in the house.

For three years I was reserved, but in 1918 I was called up and my father was left alone with Tommy, doing his valiant best, to cope with the farm.

My war was not very glorious. By that time the last dregs of humanity seemed to have been collected to be food for rats. Old soldiers who had returned from the front were so disillusioned and debased by Passchendaele and the Somme battles that they were really depraved men, and their influence permeated the barracks. The point of exhaustion had been reached when nobody would lift a hand. They were dead men and the Germans could have run them over; they would have given in without fighting. Those men were simply worn out by the effort; there was no long-long-way-to-Tipperary about it, they walked with dreary gloom on our route marches. You felt you could never survive this terrible influence without sinking into some fearful slough of degeneracy.

We were moved from the barracks of the King's Own Scottish Borderers at Berwick to Fife where we did our training. I was considered a good shot, but on learning that a sniper's chance of survival was very dim, I quickly learned to miss my target.

In 1918 there was no more heroism, no more honour, only a desperate determination to survive, if possible, at all costs. We were sent home on our draft leave and when I arrived I found Reid, the poacher, helping the sick soldier to bring in the harvest. Some mill workers from Selkirk were giving a hand on Saturdays and Sundays, but it was a dreary job with much of the oats ruined with bad weather.

I told my father that if I came back from France I would not come back to farming – I was going to be an artist. We parted stiffly, my mother weeping, my father reserved and serious.

When I returned to barracks I found only ten out of about four hundred men had turned up. The M.P.s had to fetch the rest from all over the country and bring them back under guard but some had reached London and were never seen again. In Perth jail they had almost a whole battalion imprisoned for desertion. There was a tremendous undercurrent of insubordination, a general feeling of misery, lack of confidence in the leadership, lack of confidence in the politicians, no confidence whatever in our Field Marshal. Those who

were back with stripes for being wounded were determined that no ship would ever take them to France again, whatever punishment was meted out.

We were sent to join the other half of our battalion at Dunfermline, and there we were all locked up in a factory shed and provided with some pails. Our officers were frightened (quite justifiably) that if they left the doors open nobody would be there next day. In the morning we were taken out on to the parade ground. The Colonel gave an address to say how very serious the war was, that everybody was tired of it, but that there were men who were still fighting on in France, fighting for their country and dying for it. He thought that we should be determined to help them, to extricate them and eventually to win victory for our country. He felt that we should concentrate on fighting to the end to help each other in this desperate and grim struggle and then at the end (for those who came back) there would be a better place. He added, 'As we march through the town to get the train, carry yourselves like men, have no breakdowns in front of the public, keep up morale!'

Two drunken men standing by me dropped their guns and staggered across the parade ground while the Colonel was speaking and not a soul interfered. Another one walked away in another direction. An officer asked him where he was going. 'Going to shit.' He was followed by a fourth man. They bolted the door of the lavatory and could not be got out.

On the way to the train an orderly officer came over and spoke to the Colonel, then read out, 'Private William Johnstone, number 25467. Report at once to battalion offices.' I was dumbfounded, and just stood there. The man repeated it again, and someone said, 'Man, it's for you!' I thought perhaps my mother had died, or was ill, she seemed so upset when I left home. The officer said, 'Here's a railway voucher for you. You're to leave in the morning for Berwick. You'll leave your gun. Hand it in tonight, but you'll take your uniform and kit as you've been transferred to the agricultural labour corps.'

I could hardly believe this. I was out! I watched all those chaps that I had been with go off to France while I was left.

I stayed in Berwick a few days before I was given my voucher for Selkirk. It was Sunday in Berwick, the papers were saying 'War

nearing its end' and by the time I reached Selkirk on Monday, the Armistice was to be declared at eleven o'clock. My father had not heard that I was coming home, and, not realizing, I was furious that he did not bother to meet me at the station with the dog-cart. I trudged up the hill to Selkirk, then on up the hill to the farm past Shawpark Cemetery. In the warm sunshine I sat down, and leaning against my kitbag, I looked at the fields I had so often worked, ploughing, sowing, reaping, mowing and herding. There it all was, the familiar woods and trees, the meadow with the domestic cow, the sheep I had known individually, the store cattle. The scene where in the great snowstorm of 1917 so many lambs died and where I had thought for a moment that I would perish myself in the blizzard. I could see just where I had reached the thick wood, breathless and exhausted, to get shelter and regain my strength. There was the 'Carrot Brae' high up, from where on a clear day a wide sweep of the Border country in all its grandeur could be seen, Ettrick, Yarrow and Tweed. Sometimes in February, in a break between snowstorms, big, loose clouds would drift in from the Atlantic. These clouds on their way eastwards disintegrated and the sun shone, bringing a foretaste of spring. This would be short lived, the wind would change to north, and then would come the icy winds and heavy falls of snow. It was the scene where I had played all my parts since childhood but, alas, it was no longer a part of me. We had separated and all that had seemed so natural, so at one, was no more. My life could never be the same again. That morning the sun shone in its glory as if it had never shone before and there was a curious unnatural stillness, as if all life had become static. I heard the town clock strike eleven.

The whitewashed farmhouse looked pleasant, almost pretty, in the autumn sunshine, set behind some trees. My mother was so taken aback when I opened the door that she could not be sure whether I was a tramp, a passing soldier or her only son. She began to cry and I said, 'Oh, hell!' which made it worse. Shortly afterwards my father returned from the fields, forewarned, and said I should know that if he had received my telegram they would both have been at the station to meet me. He would speak to the Postmaster about it, but I should realize that the Post Office would be heavily strained with many calls.

Having to cope with the sheep and cattle all by himself he was very tired, there being no one left on the farm and he hoped that I would help him until more labour could be found. When I said I would, he at once became more cheerful, but the next day I heard my mother suggesting that he should go easy with the work and forget about a twelve-hour day, that I might like to go and see some of my friends.

On November 13th my father was in a very good mood, enquiring how I felt now that I had a comfortable bed again, good food and a settled life. The war had surpassed everything in expenditure in life, money and property. It would take a long, long time to get back to normal, if ever things could be normal again, but the war had at least brought profit to farmers who had never had such security since the Napoleonic Wars. Our farm was in grand heart, the crops splendid, more bushels to the acre than ever before, the turnips could not be better, and no overdraft at the bank. In fact my father had nested away quite a bit in investments and was holding a certain amount of War Loan. He thought he ought to have some War Loan as Socialists were asking for confiscation of wealth. Now that we had got rid of the Germans we would be tormented by the Socialists. The damage they could do would be even more than the war.

There was much to do. The forty-acre field was still to be ploughed and no one but myself to do it. My father had made me a half-share partner so that there could be no arguments, and no one could feel he was getting more than the other, but provision would have to be made for my mother who had brought some capital from the rag trade.

During my first few weeks back at the farm, my father began to press me for a decision about my future, whilst constantly trying to push me away from art and towards farming. He thought some of my efforts at copying were quite good, in fact so good you could hardly tell which was the original. But, even so, if I would apply my perfectionism to farming I could be a great farmer on my own land with real status. Art was just the very end of everything. Fashions had changed, people were getting rid of paintings, the better people would not have them in their houses, all that was Victorian and out-

of-date. Sir Edward Landseer could paint, but who wanted him now? Art was going completely out of fashion. There was no future in it except, perhaps, as a hobby. Now, the way we were placed financially, I could have freedom to paint as I always had. In art there must be more ill will than in any other profession, he thought, because the artist was so personally involved. They must always be in open competition with each other with rivalry, intrigues or jealousy.

My mother was sympathetic, feeling that if I was so keen about it I could go up to the Art College in Edinburgh once a week, or go more often to see Tom Scott who painted so beautifully. Tom had said that I would be very welcome at the Arts Club, as a connoisseur and collector where I could sit on committees, enjoy pleasant company and paint quietly in my spare time. All this was not to be confused with being an artist, however, as Tom had told me that you cannot have it both ways, you must either go all out for art, or leave it. There could be no compromise.

My father's God was the land, and he had two enemies – myself and art. I told my father that I would leave the farm to study art in Edinburgh.

That winter was a very miserable one. My father decided to retire and while I helped with the usual farm routine, he brooded. We went to St Boswells one day where dapper little Mr Swann, the auctioneer, greeted my father and said, 'How's that boy of yours?' My father told him that I was leaving the farm to become an artist, whereupon Mr Swann drew himself up and turned stiffly on his heels. Such a thing had never happened before, it was a disgrace to the Border farming community.

As the spring came, and the day of our displenishing sale came nearer, my father became more and more reserved until his gloom spread over everyone. Before the sale he called me into his office to decide how we would settle. From the time I had left school he had paid me 2s. 6d. a week, at sixteen he had raised this to 10s., later to £1. At this stage I had to pay my mother 10s. and keep myself in clothes with the remainder. He checked the years and suggested that five hundred pounds would be my share. This did not seem quite fair as, so far as farmers went, he was by now quite well-to-do. I felt that if

I had remained at the farm my share would have been much more, and that he was penalizing me for doing what I really wanted to do, but I had to accept. He made it clear that I must make my own way and, whilst he would be pleased to see me on my holidays, I must never ask him for any further financial help. A great feeling of sadness came over me as I remembered all the pleasant and terrible experiences, my ponies, my horses, sheep and cattle. Now everything was gone. The land was no longer mine.

May 28th, the sale day, came. My father's stock was well known for quality and many buyers came. We had some beautifully bred Clydesdale horses which had been very carefully broken and had no vice whatever, and when they came up for auction, he refused to go out, but stayed in the house while they were being sold. He grieved for them sorely. There was a white horse, Charlie, who was always paired with a fine blue-grey horse with white hairs. They had shared the same stable since they had come to Greenhead as colts and had always worked together, but they were sold separately. Charlie died that night in his new stable and the grey horse was found dead next morning. The separation broke their hearts.

The day came when we had to move to the small semi-detached house which my father had bought in Selkirk. He refused to come with my mother and me when we took the furniture, but stayed on all day by himself at Greenhead. We took the collie, Rock, with us as we felt that no one could possibly object to him, although my father had not been so certain. We were going to live in a town where the people are very different from those who live in the country, and he thought there might be some objection to the dog. No sooner did we get ourselves installed than Rock jumped over the fence into a neighbour's garden and piddled on the roses. A woman rang the doorbell violently and asked to see my father, to whom she said, 'This animal's been over and made a mess on my roses.' We shut Rock up until he needed to get out again when, by God, instead of going on to our garden where there was some lawn, he jumped over and piddled on the woman's roses again. My father said I had better take the dog to Uncle George, to save the woman getting fussed, so I took Rock away. My uncle George farmed my father's other small farm and had two or three little girls. Rock appropriated them,

herding them to school every day and herding them home in the afternoon. He never let anyone touch them – indeed he once bit a perfectly harmless stranger for talking to them. He protected those children until he died.

The strain of the move and the break with my father began to tell. Instead of being able to do what I liked with acres and acres to do it in, I was restricted to a garden thirty by fifteen yards. On October 1st I would enter the Edinburgh College of Art, but meantime town life was an endurance test. We had neighbours on either side, and whenever we went out someone was looking and other eyes could be seen peering behind curtains on the opposite side of the street. How could I endure this misery of my own making until October? My father busied himself in the garden, read *The Scotsman* and discussed the state of the world. He gave up his farming friends altogether. The intensity of his disappointment must have made it impossible for him to see them without bitterness or regret. I had nothing to do to alleviate my guilty conscience, but luckily I discovered that Mr Ballantyne, the joiner who had always done my father's work at the farm, needed extra help that summer. He had a contract for a long fence between Kirkstead and Dryhope in Yarrow and labour was scarce. With relief I joined his sons, Graham and Campbell, for a summer's fencing. We lodged with the shepherd's wife, fishing in the evenings, playing with the shepherd's dogs and children.

It was a very dry summer. Up in the hills where there was little depth of soil, digging post holes was tough. To sink a post down to three feet was almost impossible and so difficult was it, that on one occasion I took a saw and cut eighteen inches off the top of a post. I made a mistake by chucking the end into the burn, and when the factor arrived to inspect the fence, as he was bound to on such a day, he saw the piece of wood floating down the burn. He wanted to know how many more posts had been treated like this instead of being sunk to the full depth and he told me to take the post out and sink it properly. We argued, and as my hands were blistered and worn with the unaccustomed work, my language was not chosen with care. Fortunately Mr Ballantyne poured oil on troubled waters and my post still stands today. For a few days I had to rest my hands for fear of infection, so I painted constantly. Every day the sun shone, the

skies were without a cloud, the smell of the wild flowers among the hill grass was delightful. I put aside the memories of the long, hard years at Greenhead, the frustrations of the war, and I shed my father's resentment. I was young and hopeful and I would be an artist.

3

Taking the plunge

I presented myself for admittance to the Edinburgh College of Art. The Registrar smirked as he showed me into the Principal's room, and his supercilious glance at my country clothes infuriated me. I felt him looking at my boots, and wondered if any dung remained upon them. However, Mr Morley Fletcher was most considerate. He spent so much time looking at my work that I feared my cause was lost. He said my education was poor, but as I was an ex-serviceman allowance would be made for this. He was in two minds regarding me. He felt that my watercolours were quite outstanding, and as I had achieved so much without any real training, he thought that with so much natural ability I should just continue to paint in the country. The courses at the College led to a Diploma in Art which, in the majority of cases, resulted in a teaching career. This course spread over five years and included architecture, crafts and a Diploma from Moray House Teachers' Training College, much of which I might find very tedious. For someone wanting to be an artist or a craftsman, the long prescribed course was not really necessary, and he felt that I already had the equipment to be an artist in my own hands. Desperately, I pressed my case because I wanted so much to learn how to paint in oils – I even thought I had some talent, so I showed him the painting of my collie dog. At that point he capitulated, accepting me as a student, even making sure that I obtained an ex-army grant.

Morley Fletcher had taught wood engraving at the Central School of Arts and Crafts. He was a disciple of William Richard

Lethaby, the great teacher of the Arts and Crafts movement and encouraged me to read Lethaby's books which interested me enormously.

To improve my education I decided to have some lessons from a tutor who advertised his ability to teach 'Elocution, Public Speaking, Deportment and Theatre'. My first lessons did not inspire me with any confidence. I conscientiously sounded my vowels, with lots of ah's similar to the kind the doctor asks for when he is looking for your tonsils, but when I reached more advanced work I was given a poem by Will Ogilvy to practise on: 'Now work was slack and money was scarce, And love to his heart crept in . . .' After being brought up with the Bible, Shakespeare, Burns, Scott and Stevenson, Will Ogilvy's banality was more than I could accept. My tutor told me that as I had no feeling whatever for the medium I should try singing. I escaped.

In Edinburgh I shared a studio on the top floor of an insurance office in York Place with a fellow student, Arthur Watson, who worked earnestly on his stained glass designs while I painted with equal intensity. We had a fine Adam ceiling and a splendid view of the City. In the room across the landing lived a man and his sister with fourteen terriers which were never allowed outside to exercise and we could hardly get up the stairs for the stench. Every few weeks I went home to get some fresh air and food, when Tom Scott demanded a report on my progress.

During my first term there was a students' exhibition at the College, where Morley Fletcher made some adverse remarks about my painting which I took very keenly. Somebody else thought my effort was pretty crude, even funny, and another student said to me, 'Why don't you go back to the plough? You'll never be an artist.' Discouraged and gloomy, I decided that the teachers at the College were all men who were failures as artists themselves and were merely teaching other people those tricks which had caused their own failure. That, I felt, condemned the whole exercise as useless.

Mr Henry Lintott, one of the senior members of the staff, tried to accost me later, but I saw him coming and dodged along another passage. Again I saw him approaching me and escaped, but one day I ran full tilt into him. 'Ha! . . . errum . . . you spend a lot of time

avoiding me! It's not necessary. I've been trying for the last three weeks to congratulate you on your painting.'

'Really?'

'Yes. You know I was present when our Principal made those remarks about your work which, if he'd known anything about painting or about a young student, he would never have done, don't you think? I've been watching you for a little while. You are the only one that's come here since I came to this College twenty years ago, who's ever shown the least sign of being an artist. As I thought you might be depressed, you might like to know how I felt about it. There's something of the early Gainsborough about you, the kind of thing that made English art great . . . there's a natural feeling . . . Yes, of course . . . it struck me that if we're looking for painting here, it'll be from you that we shall get it. Praising people who've had art masters teaching them how to do still lifes in grammar schools . . . they come in here and show up rather slickly in front of you. Of course it all ends in nothing. Good-bye!'

This was great encouragement. Henry Lintott (1877–1965) was born in Brighton and had come to Edinburgh as a young man straight from the Royal College of Art. He spent the rest of his life in Edinburgh where, to his students, he brought a richly cultivated mind, a wealth of knowledge. His especial loves were Masaccio, Titian, Piero della Francesca and Veronese. He loved, too, the English School, Gainsborough, Bonington, Turner; of the 'moderns' perhaps Puvis de Chavannes was his favourite. His own painting had the quality and sensitivity of the masters he admired, and his pictures had a depth of feeling which was all too often absent from those of his colleagues, who depended so much on a bravura style and a brashness of colour which were quite alien to Lintott's taste. 'Tottie' was tall, lean, sallow, and had a slight limp. He had great 'theatre', making his teaching an impressive 'act'. He also had a delightfully dry, ironic wit – in short, a most civilized man. A shrewd judge of art and of human beings, at heart he was the kindest of men, and his students soon realized this and were devoted to him. Like all fine artists he knew the techniques of painting from the Old Masters to his contemporaries, among whom he thought highly of Sickert and Wilson Steer. His techniques included not only paint in all its variety, but

dust, dirt and other media which he used to build up his paintings.

'Tottie' was a splendid teacher. I enjoyed most his composition class where the most depressing messes were resolved and converted into a satisfying whole. Suddenly, picking up a piece of charcoal and rubbing it on a blank space, he would say, 'It's all there, don't you think? What?' He was able to give the work movement, re-creating its basic vitality. When I went into his class to draw from the Antique, he said, 'You must draw, draw, draw, draw and draw.' One day he went to a girl who was standing next to me, the poor thing shivering and twittering like a leaf, and said, 'Let me see . . . a little charcoal . . . yes, of course. Would you say the line of the back went like that? or like that? Or like this? I think so . . . like that. Does it?' Then he took his handkerchief, and flicked it over the drawing leaving only a suspicion of charcoal behind. Then he came to mine. 'Is this yours?' He took his handkerchief again and my drawing disappeared; there was hardly a thing to be seen. 'Greatly improved, don't you think? Greatly improved.' I perfected a splendid imitation of 'Tottie', and he caught me at it one day, but he passed by with a sly twinkle in his eye. He had been a student once and perhaps he remained something of one still.

Another member of the staff who did his best to encourage me was Walter Greaves, an illustrator to trade, working at Nelsons, the publishers. Walter aspired to paint, even to become a Royal Scottish Academician. He found me one day during the model's rest, leaning against a radiator to warm my seat, alone and dejected, and feeling that I would never succeed. Walter said: 'Cheer up! You're a born painter. You paint by intuition, by feeling. You're the only one here that does.' He was most kind.

My father informed me that he had spoken to several people who told him that nobody bought pictures nowadays, they didn't want them at all and were even giving them away just to be rid of them. The fashion was to have plain walls without paintings. He thought that if I could obtain an art master's job in a school somewhere in the Borders I would become so bored that he might induce me to come back to the land and so he urged me to try harder to get this Diploma as quickly as I could. I did not disillusion him by telling him that I had no intention whatever of becoming a teacher.

To enter Moray House Teachers' Training College you had to pass a preliminary University examination. This alarmed me as I felt that I had no means at all of expressing myself in written English. William Ritchie had returned to Selkirkshire as Director of Education and I sought his help. He told me, 'There's only one way you can get this language up to standard and that is by feeling. Take the Bible and read the Book of Genesis continuously to get the feel of it. If you can be bothered, read it aloud by yourself till you get the hearing of it. Keep away from compound, complicated sentences, and use short, stiff ones instead. Remember the Polish chap who sailed before the mast, Conrad, who became such a great writer in English. His secret was that every time he fired a gun it hit the target with a short sentence, and this will be your saving grace. Read the Bible, if you can, right through once or twice, and when you're tired of that, fall back on Shakespeare. Whenever you get a chance to see a Shakespearian play, go to it.' I found a captive audience at Willie Lees' shop in Selkirk where I declaimed Shakespeare to the tailors, sitting cross-legged on their bench. I recited Genesis over and over again to my family to try to understand the weight and value of each sentence.

I passed the preliminary examination which entitled me to study teaching methods, psychology and pedagogy at Moray House, all subjects which I felt I could easily have done without.

When it came to the final examination I was so nervous that I forgot the subject of the paper altogether, and I thought, 'By God, I am certainly done for.' I had just to sit there while all the rest of the students were writing like mad, until at last it dawned on me that the subject was psychology. I began to write, and I scribbled on and on with neither grammar nor sense. The writing was deplorable but I flew on, trying to put down as much as I could before handing in my paper. I suppose there were forty or fifty in the class, including three Johnstones of one kind or another, and when the results went up on the board I was near the top with plus marks in psychology. I thought it was a mistake and it occurred to me that I could have deprived some other man of those marks so I went to see the Professor who said, 'Come in. Oh, you've done a splendid paper, splendid, congratulations! You really have a feeling for psychology.'

'Well, I'm rather sorry, sir, I hope you will excuse me.'

'Not at all, I'm delighted to see you.'

'I think there's been a mistake.'

'There's no mistake.'

'May I just say this? There are three Johnstones, you see, and I can't help thinking that the marks I've got belong to . . .'

'How dare you come to my room for the purpose of criticizing my judgement? D'you mean to say that you have the audacity to come and tell me I've marked the papers wrong?'

'No, no, I don't think that.'

'Leave the room! When the list is put on the board it is correct. That's the end of it.'

'I'm sorry,' I said, closing the door gently.

I have often wondered about those psychology marks.

Art History at Edinburgh University was conducted by Professor Baldwin Brown who was, in my opinion, perfect, but I did not dare mention this to Tom Scott who regarded the Professor with the utmost contempt. Baldwin Brown looked just the part with his black hat, eye glass with string and black flowing tie – the perfect absent-minded Professor. His course was: 'Art History: its Meaning, Thoughts, Worship, Social Environment; Architecture from Pre-History to Modern Times.' He stopped at Cèzanne. His great subject was Celtic, Scandinavian and Anglo-Saxon arts and crafts in which his knowledge of detail was superb and which he had made his life's study. Generally the staff at the College of Art were entirely in agreement with Mr Scott. Many longed for the day of his retirement when a young man with brighter views might be found who would be able to talk to the students about the art of the world in which we live. Professor Brown, of course, was completely ignorant of all this 'cat'. He was overjoyed by the interest his students showed, and by the fact that it was not necessary to seek students, he had a waiting list. Certainly there were many Professors who would have liked to have had just a quarter of his numbers, and who envied the enthusiasm which his lectures inspired. Being extremely polite, he would never say an unkind word. He was very much aware that the practical teachers at the Art College had very little real knowledge about the history or meaning of their subject. However, as he had more students than he could deal with, it was quite pointless for him to

wander into fields which were not his business. His results in examin-
ations were tremendous, a joy to everyone. Even today the Professor
is remembered and his work respected.

At the time when the Swedes were feeling their way towards a
modern expression in their crafts Professor Baldwin Brown's influ-
ence was considerable. Later, when I began to study the Celtic and
Saxon arts in Britain seriously I re-discovered my old Professor. I
found that his books, particularly *The Arts of Early England*, were a
marvellous storehouse of knowledge. In his day all the corridors in
his Department were decorated with casts of classical sculpture
which, when Herbert Read succeeded to his Chair, were removed at
once. In Stockholm, in 1959, I met the Principal of the Helsinki Art
College where so many fine modern designers were being trained.
We talked about the old Professor and his Celtic ornament and about
his Greek and Roman statues, and the Finnish Principal was horrified
to think that all those had been thrown away. Hs assured me that
such a thing would not happen at Helsinki, and said, 'If all those that
we have were removed, there would be no material from which to
teach!'

Each year at the College a lecture was given by some outstanding
artist and one year Sickert was invited. He was very impressive with
his patent leather shoes and stock, a very elegant gentleman and he
gave a lecture which impressed me deeply. I was in the front seats
for this because I had seen reproductions of Sickert's paintings and
had read of his association with Degas. I admired his work and thought
that his pictures were far better than Augustus John's and that his
drawings were far better, too.

In his lecture, Sickert told us that he got up one morning to find
Camden Town covered with snow, so he took his canvas out to
begin to paint but, as the sun rose, all the colours were changing as
fast as he was putting them on, so he left that canvas. He started on
another one, and then another, but each time the changes of light
were too quick for him. He moved to another studio to paint the sun
sinking in the west, but the same thing happened. We were dealing
with movement – the earth rotating round the sun gives continuous
change, but no matter how you looked at light or shade the effect
was momentary. It was the moments of movement that were so

important, a revelation. At midday, when the sun had risen, the snow had melted and was running down the drains, you were looking at a different scene altogether from that which you saw at eight o'clock in the morning when the snow was falling on the roofs of Camden Town. It was this eye, this seeing eye, impregnating the subject with an intensity of movement, which mattered. The artist should always be looking for some experience, some revelation.

This idea of art as an expression of movement in time (although many writers on art, from Leonardo onwards, have referred to it), was an enlightenment. Sickert may only have been echoing the beliefs of the Impressionists, who had accepted that, as nature was changing all the time, any canvas could only mark a single moment in time. I did not then know about Monet's series of canvases of Rouen Cathedral, for example, which are a record of changing and moving light and it was Sickert who brought this aspect of art home to me for the first time. At the end Mr Alison, the Head of the Drawing and Painting Department, said with profound conviction, that he'd never listened to such a lot of rubbish in his life, which only convinced me more than ever that Mr Sickert was far greater than even I had thought.

Tom Scott was highly suspicious of the teaching at the College. When I eventually showed him what I was doing he said, 'If you are taught to paint like that, whoever taught you should never have lifted a brush. You'd better go up the town to one of the housepainters and start painting some walls or doors.' At about this time Tom held a successful exhibition of his watercolours in Rome. His friends Sir John Lavery and Fiddes Watt were keen that he should have a studio in London which, they assured him, would provide greater opportunities than those obtainable in Selkirk. They pressed him at least to come to visit them as Fiddes Watt very much wanted to paint his portrait. After much persuasion Tom took his departure from Selkirk.

When the time came for me to visit Tom again at Leslie Cottage he had the Fiddes Watt portrait nicely placed. The painting had an austere, restrained quality; it was impressive and an excellent likeness. One day Tom Scott suggested that I should copy this portrait, thereby getting some grasp as to what oil painting was all about.

This was something of a shock and I realized that it would be a harrowing experience but the easel was set up, the battle started. It was not long before Tom appeared. He yelled with rage about my drawing and about my placing of the head on the canvas. He seized my charcoal to start to draw it himself, but as Tom was no figure draughtsman, he soon became exasperated and rubbed it all out and went away. I then started afresh with the drawing, but Tom could not keep away. By then his language was certainly not Parliamentary, containing many unpleasant references to the staff of the Edinburgh College of Art. I hoped that it would soon be lunch so that I might escape.

After lunch Tom had calmed down and was very kind. Mrs Scott must have used a little gentle persuasion suggesting that, after all, I had had very little training and that my chances of seeing as good a painting as the Fiddes Watt had been very rare. Tom thought I should get back to work right away, and he apologized about his drawing, but hoped I would see what he meant. Untruthfully, I assured him that I did, although I feared that when he came back to find that I had not seen what he meant at all, there would be a fearful explosion of temper.

Next day I returned to Leslie Cottage hoping that I might have some success with the portrait. If I could only get the basic drawing correct! Fiddes Watt seemed to me to have placed Tom's head on the canvas in such a way as to give the portrait great dignity. The composition was just right and the head could not have been placed anywhere else. Perhaps this was the secret of getting the painting really started? With high hopes I began again but, alas, I could not place it right. Tom said that I was not to touch the masterpiece, I was not to take it down from the wall, make a tracing or take measurements and so it was baffling. Again I made a determined start, put everything I had into my drawing, hoping for the best.

Eventually I set out my palette ready to begin painting, but Tom showed me that this was wrong. I had put out far too many colours and should have put out an earth palette. With the bit in my teeth I laid on the paint, but Tom was horrified, seized a table knife, scraped all the paint off and made me, with a turpentine rag, bring it back to the drawing.

On my next visit to Tom I started on the portrait in a highly sensitive mood, left the thinly painted background and worked on the head with stealth. I crept round it slowly with as much certainty as I could muster. To me it seemed that I was at last succeeding but, after lunch, when I returned to the easel my hopes were dashed. There was something wrong with it. I scraped some paint off and, by heaven, it was improved.

Next morning Tom was there waiting for me at the door. 'I was looking at that painting of yours last night. It seems to me you are loading the paint in the wrong places. Why the hell can't you look at the bloody thing and paint what you see?' He disappeared. This was a bad start, but I took up my brushes for one last try. When I had finished I put the picture face to the wall, feeling that I was beaten. I heard the familiar footsteps but, as Don Marquis would say, 'What the hell! What the hell!' Tom said, 'I think there is nothing more you can do with this. You will have found out just how much it takes to become an artist. It could have been worse. Leave it behind, will you, as I'd like to look at it from time to time. Maybe you'd leave your paints and brushes for a few days, too.' Tom could not resist using my paints. He painted one of his very few oil paintings with them, and very good it was, too.

From time to time I felt tension and strain at Leslie Cottage. One day Mrs Scott confided to me that during the weekend Joan Miller, a local lady of culture, had visited them. She said that whenever this female arrived there was trouble, as Tom and Miss Miller had long private sessions discussing art from which Mrs Scott was excluded. She naturally resented this and the cultured Miss Miller did not help by ignoring Mrs Scott. In Joan Miller's rarefied atmosphere of art, poetry and music, a practical woman was considered to have no place. Later, sitting on the garden seat with Jock and Jenny, his pet blue tits, Tom gave me his version of the visit. Tom assured me that his wife was too insensitive to understand the feelings and sensibilities of a refined lady like Joan Miller who had suffered fearful humiliation in her young life. He told me how she had given her love to a brilliant young composer who had left her after years of her devotion. Here I began to giggle as I knew he was referring to my cousin Francis George Scott who, in his youth had been extremely fond of the ladies.

Tom said he knew I would agree with him when he said that no matter how brilliant this young composer was, he was a cad. I could hardly control my laughter.

Tom returned to the subject of oil painting, insisting that I should go to Holland to study. I duly went to Leith and found there was a boat taking old horses to Holland for slaughter. It was a very old boat carrying about sixteen horses, poor, worn out, broken-kneed beasts, weary to death. The first mate wore sabots, and steam was leaking out of the boilers in all directions. I was the only passenger and we took three days from Leith to Amsterdam, only one of the horses having to be shot and pushed overboard. Tom had said, 'What you need at the moment is technique; it might be wiser for you to copy Franz Hals, it may be easier for you to learn from him, than from the subtleties of Rembrandt.' I stood before the great Rembrandts in the Rijksmuseum in admiration and in awe, but I copied Franz Hals's *The Jolly Toper*. I was captivated by his vitality and his marvellous technique. This was what painting was all about. I went for sheer skill rather than tackle the deep feeling and presence which Rembrandt's paintings inspired.

While I was still working in Amsterdam, a telegram came from my father to say that the art master's job in Hawick was coming up. If I was away in Holland how was I going to get it? The College authorities told me that if I was lucky enough to get the job I could take my Diploma the following year, so I rushed back to find that the local Education Committee had not the least intention of having me even on the short list. This caused my mother to become very angry as she said that her father and his family had helped to make Hawick something more than just a ramshackle village. Her family pride was hurt and I regretted not having stayed in Amsterdam with Franz Hals.

During my student days in Edinburgh, Tom Scott was a constant encouragement. He never allowed any trials to deflect me from my purpose of learning to be a painter. 'I was glad to have your letter telling me you had got into harness again,' he wrote in 1920. 'Produce, produce, without ceasing. Try and get to the bottom of everything you do. And above all have courage, courage every day to attack your studies with a brave and humble heart. Watch what your

fellow students are doing and do your D— best to beat them. it is all a question of keeping well in front of those your age. Then Father Time in the future will give you his reward . . .' In the spring of 1921 he wrote again, '. . . You will soon again be in harness. Gang on. Feel your way. and depend on it. if you can keep abreast of your fellow students. It is only a matter of time. when your reward will come, but again I say. Gang on. and fear not . . .'

As Tom grew older he developed the bad habit of re-working some of his earlier paintings, greatly to their detriment. One day I found him working over a particularly beautiful one, rubbing the middle-distance with the rough side of a match-box, and otherwise destroying the limpid clarity of the early work. I took courage to remonstrate with him on what seemed to me to be an act of vandalism. Tom paused, but did not as I had fully expected, begin to yell at me or throw a bottle or vase in my direction. The next day he admitted quietly that I was right, that he *was* spoiling many of his earlier watercolours by overworking them. Then he said how much he wished that I had been older, and he younger, so that we could have been students together.

Tom gave me a fine studio easel which he had acquired from J. B. Selkirk, a poet of some local celebrity. This gentleman took a notion to paint in watercolour in emulation of his friend, Mr Scott. He bought the very finest easel money could buy but found that, while such an easel impressed his friends vastly, it was quite useless for supporting the small watercolours which he was attempting to paint, and so he gave it to Tom. For Tom, who so rarely painted in oils, it was also useless and he passed it on to me. I have used this splendid easel for sixty years.

Some few years ago while having tea with a friend in Selkirk the subject of Joan Miller's recent death was mentioned. My friend told me that she had left a portrait of Tom Scott by Fiddes Watt to the National Portrait Gallery in Edinburgh. I had understood that Tom had bequeathed this to the Royal Scottish Academy. (In this I was mistaken as, in fact, it hangs in the Selkirk Public Library.)

When Tom died there was a sale at Leslie Cottage of fragments of pictures, linoleum, and bits and pieces. The very last lot in the sale was purchased on behalf of Mr Lawson, my friend's father, a water-

colour and a portrait. The watercolour was to be a present for his daughter, but they were delighted to have the portrait as well, as it was assumed that this was a sketch by Fiddes Watt for the portrait he had painted of Tom. Everyone in Selkirk knew that Tom had gone to have his portrait painted in London. After Joan Miller learned that Alison Lawson had this portrait she tried in every way to persuade her to give up the picture, either to give it or sell it to her. She assured Alison that it was hers by right as Tom had always wanted her to have it. Alison said that she felt almost fearful at the intensity of desire, at the sorcery which she was convinced was being practised to make her give up the picture. In the end she wrapped up the portrait and sent it to Joan Miller in Hawick. I went to see it hanging in the National Portrait Gallery with a label to say it was painted by Fiddes Watt, and could hardly believe I could have painted such a portrait at the time. Then I remembered my struggles with it and traced all the difficult passages that had driven me to despair. It was indeed my portrait of Tom Scott.

Since the time that he introduced me to Tom Scott, Mr Walker had always taken a friendly interest in my painting. Indeed, he was my very first patron, giving me great encouragement by buying some of my early watercolours. He was the chief accountant of one of Selkirk's most important mills, Gibson and Lumgair, and was my first experience of the compulsive art buyer. Every Sunday after Church, when the weather was fine, Tom Walker would stroll down the Green, across the river, till he came to Leslie Cottage. There he would pause to listen and if Tom Scott was haranguing the morning with obscene invective he would turn back towards the town, disappointed. If all seemed peaceful he would call in to have a talk with Tom and spend the morning looking at his paintings. Seldom did he return to Selkirk without buying a good one.

Another compulsive collector in the town was John Murray whose family owned the large tannery. Mr Murray disliked all forms of business, and instead he devoted his life to the fine arts. He travelled extensively on the Continent, but in his opinion the Great Masters were only to be found in Italy. Locally Mr Murray was considered a great connoisseur, although certain doubts were known to have been expressed as to the authenticity of some of his great works of art.

When he returned from his continental travels he brought back vast canvases, in enormous quantity, to cover the walls of his house so that not an inch of wallpaper was to be seen. As he grew older he became a gentle, absent-minded recluse, devoted more than ever to his art collection. One day cracks appeared in one of his great paintings (was it a Titian?), so John Murray sent for a distinguished expert from Rome to repair this painting. The Italian gentleman took his work most seriously as he was a very great authority. Unfortunately, Jock Wood, the Sweep, had been called in to sweep the chimneys during the Italian's visit. When he had finished his work he bundled up his rods and brushes, tied up a sack of soot, and was leaving the house to get a dram before his next job. He passed the picture restorer carefully painting in the cracks with a fine brush. 'Good morning, Brother Brush', says Jock cheerfully. The Italian was incensed. He screamed with temper and tore at his bow tie; he threatened to fight a duel with Jock; he shrieked that he had never been so insulted. It took all John Murray's gentle conciliation to calm him.

When Mr Murray died all his effects were sold. His Rubens, Veronese, Titian, all in magnificent frames, went for a few pounds. I bought a large painting of a lion gorging itself on some inoffensive quarry which was catalogued as a Rubens. The canvas, of superb quality, was stretched on beautifully made stretcher bars and I painted many pictures on top of that lion until the layers of paint cracked so badly that it had to be thrown away. I used the stretcher for years afterwards until that, too, disintegrated. However, not all Mr Murray's pictures were fakes by any means. I bought a fine Mestag and several other paintings which I was able to sell in Edinburgh at a good profit. I also bought (as a lucky dip), a box of oddments for five shillings, which proved to be full of old mezzotints, engravings and prints, most of them badly spotted with mildew, and I took them out to the garden to put them on the bonfire. As the last of a bundle of drawings curled up in the flames I saw the signature: Thomas Rowlandson. At the bottom of the box was a little stone bas relief of Adam and Eve which I kept for luck.

4

Three borderers

In Edinburgh I met my cousin Francis George Scott again after many years. Francis was teaching music in Glasgow but came through to Edinburgh as often as he could to see his sister as she was one of the few people to whom he could turn for sympathetic encouragement in his music. When Maggie told her brother that I had left the farm to study painting Francis thought this was extraordinary, but he was overjoyed that another member of the family had abandoned the pursuit of money for the stricter discipline of the arts. From that time onwards we had many meetings for we found that we had much in common.

Francis had studied in Bordeaux under Roger-Ducas who had been aghast when Francis told him he was returning to Scotland. 'Scotland! There is no music there! It is impossible . . . no flowers . . . there is no sun. How can music grow without sun?'

Francis loved the French Impressionists, while of the Scottish painters only Peploe and Hunter interested him. We had long talks about painting and like Tom Scott, he was convinced that the sooner I left Edinburgh for Paris the better. We went to one of the Royal Scottish Academy exhibitions although he disliked both the Institute in Glasgow and the R.S.A. in Edinburgh. We stopped before a painting by a famous R.A. Francis hooted, 'He's got the breasts in the wrong place!' His ribald laughter echoed through the galleries while everyone stopped to stare at this irreverent behaviour.

Francis said that I must meet his erstwhile pupil from Langholm Academy, Christopher Grieve (Hugh MacDiarmid), who had re-

turned from Gallipoli to write magnificent poetry. Much as Francis loved France and French culture he was always striving to find the essential quality of Scotland. He was now convinced that something really Scottish would come out of the work of Christopher and myself.

Apart from music, to which he introduced me, Francis had a great knowledge of English and Scottish literature. As a student he had studied under Professor George Saintsbury and had been nominated for the Tait poetry prize. Unfortunately his passion for music interrupted his English studies so that he returned to Hawick with only a Teacher's Diploma from Moray House instead of the expected M.A. in English Literature. Poor Francis then had to take his degree in music from Durham University while teaching English at Langholm Academy. His acute brain could analyse and clarify both music and literature in a way that I found fascinating and he encouraged me to read and read. Between Francis and William Ritchie I felt I was making up for the time I had lost on the farm.

Today, few would dispute the importance of Francis George Scott in Scottish music. Nervous, highly strung, tautly sensitive with quick reactions, he had a powerful brain and was fortunate in that he needed little sleep so that he could work a twenty-four-hour day, showing not the slightest sign of fatigue. Francis taught me with enthusiasm. He became greatly excited by what he saw as the possibility of a splendid revival, a Scottish Renaissance of the arts. We three were to be the core of this Renaissance. He felt that if we all pulled our weight together and tried, Christopher with his poetry, I with my painting and Francis with his music, all having a revolutionary point of view, we could raise the standard of the arts right from the gutter into something that would be really important. He thought that it was a great coincidence that there were three of us, all from the Borders, interested in a great resurgence of art in Scotland – three, like the Pre-Raphaelites. Francis's arrogant contempt for the 'kailyard' school of Scottish writing, the vulgarity of the 'Scots' comedian, the revelling Burns club and the mawkish sentimentality of Sir Hugh Roberton's Orpheus Choir, was prodigious. A competition for young Scottish composers took place under the aegis of Sir Hugh and, while Francis knew well that he would not be considered for the prize, he never-

theless decided to enter the competition. He spent much time and effort in an attempt to produce his best work and, as an afterthought, he rattled off a composition which he signed with a pseudonym. The day after the committee sat in judgement the telephone rang. It was Sir Hugh who informed Francis that he had sent in a splendid composition and had been awarded the second prize. The first had gone to an unknown composer. Had Francis ever heard of this young man? 'Yes,' replied Francis, 'he's Francis George Scott', and banged down the telephone.

Chrisopher Grieve worked as a journalist in Montrose. He brought his poems through to Glasgow for Francis to read and criticize, so that Francis became Christopher's mentor, friend and tutor; indeed, he was Christopher's University. Together they worked on Christopher's poems. Those early poems were published by William Blackwood and were followed by *A Drunk Man Looks at the Thistle*. Francis told me that Christopher arrived one evening at Jordanhill with a collection of poems written on the backs of envelopes, odd scraps of paper and reporters' notebooks. Francis placed a bottle of whisky on the table between them and they spread out *Drunk Man*. Taking drams from the bottle, Christopher soon fell fast asleep on the sofa, not stirring until the morning when Mrs Scott brought in tea, but Francis worked all night, and was still hard at work in the morning. The bottle was empty but Christopher's fragments had been edited and placed in order. The poem needed a conclusion, but they were stuck and Francis in the end wrote the final lines.

A Drunk Man Looks at the Thistle is a major poem. It was built up in short images like the notes in an artist's sketchbook. Each was perfect in itself and could have remained so as each poem had its own identity. They were motifs in search of a vernacular and by unifying them into a complete whole, a masterpiece was born. Christopher has written great poetry, producing beautiful imagery, in a way that no one else has ever written, and with Dunbar and Burns he ranks at the very top of Scotland's poets. He is a world figure. Francis was full of admiration for Christopher's work. He told me that one only had to give Christopher a start and the poetic images just flowed from him. While Christopher certainly received great assistance from Francis's critical encouragement, the poems acted as a tremen-

dous spur for Francis's music. When Francis began to work on settings for Christopher's poems he broke entirely new ground in Scottish music. It was the birth of a twentieth-century Scottish Renaissance.

Against the general apathy of the arts in Scotland in the early twenties, Francis maintained an attitude of superiority and arrogance, but the battlefield was the place for Christopher. He wrote endless 'Letters to the Editor' and did not care whether they were on the front page or the back page, or how small the magazine was as long as what he wrote was published. He had half a dozen different noms-de-plume ('May Miller' was one that I remember), reviewing his own books under these aliases. He began: 'This magnificent new publication of Hugh MacDiarmid's *Six Poems dedicated to William Johnstone* will stand in the very front rank of modern poetry, surpassing Eliot and Joyce.' Of course he had to work in a little criticism of an innocuous nature, then: 'To conclude, this augurs well for the greatness of Scotland and the Renaissance in Scottish culture.'

He knew Compton Mackenzie, Cunningham Grahame and the Duke of Montrose – the Nationalist movement was started. Although Francis was against publicity which he regarded as a bad form of modern vulgarity, he also joined in this Nationalist movement with enthusiasm. But he was frightened that Christopher would become too much involved in publicity, politics and journalism, forgetting or missing the real aim – poetry. Christopher was wayward and difficult to control, although Francis had authority over him and was able to restrain him somewhat. Christopher was flighty, dynamic and outstanding, and Francis feared that his experiences in journalism might prove fatal, since he felt that commercial art, journalism, and film music were all forms of prostitution and could have devastating results. Christopher paid little heed but pushed on with his propaganda, poetry writing and editing. Francis was staggered by the amount of work Christopher could produce and whilst he was thrilled by it, he was doubtful as to where it would lead. How much gold would be left from all the dross?

I learned a great deal from my cousin. He was a born teacher, a missionary who became greatly inspired when he thought you were sympathetically interested. His hair flying, his brilliant eyes ablaze,

he would play his own works over and over, making changes, asking me if I could detect the slightest variation in emphasis or in timing. He worked endlessly, day and night, for perfection. At that time I had little enough knowledge of art, and almost no musical knowledge, so that I could give very little of the support he needed. He showed me how Beethoven composed and how Beethoven's music should be played. Then he turned to Debussy to show me how the composer had changed, away from the classical tradition to the romantic. He made me listen so that I could relate changes in music to changes in painting and changes in poetry.

In my final examination for my Diploma I passed in everything but drawing and this was the cause of some trouble. Sir George Clausen, who judged the students' work, suggested that if the authorities were looking for a painter of real talent then I was their man. Indeed, he wished to award me a travelling scholarship. David Alison (a colleague of his once stopped me on the stairs of the College and said of him, 'There goes David Alison. Nature meant him to be the gaffer on a navvies' squad, but fate made him a portrait manufacturer'), wanted W. G. Gillies to win the Scholarship. Clausen was irritated that, after being invited to come all the way from London, his judgement was to be contradicted by a member of the staff, but none the less Gillies was given the scholarship. (Henry Lintott, who had been present, reported these proceedings to me afterwards.)

I should not have sat for my Diploma that year but I was trying to cram a five-year course into three years. It was recommended that I come back for another year to do nothing but drawing, and I was to attend the Royal Scottish Academy Life Class (the equivalent of the Royal Academy Schools), as well as drawing at the College. I was to put forward drawings only for my Diploma the following year. Through Mr Lintott's help I was given a job one evening a week to teach elementary Antique.

The theatre in Edinburgh was a great excitement. The Macdona Players came to the Lyceum Theatre in a season of Shaw's plays, with Esmé Percy. I went every night and admired Percy tremendously. I saw *Cashel Byron's Profession* which seemed so funny that I could not

stop laughing, the characters resembled my own parents so much. The music hall stars at the Empire who attracted me were Gertie Gitana, Vesta Tilley and Marie Lloyd; I enjoyed Harry Lauder before he became sentimental, and Billy Merson. Other favourites who entertained us were G. H. Eliot, Harry Tate, Houdini, the Great Lafayette who later died in the fire at the Empire Theatre, and the Fred Karno Group. Sir Frank and Lady Benson came in person with his Number One Company. He required students as 'supers' for his visit to the Lyceum Theatre and as I had not forgotten my childhood love of the theatre, I volunteered. Sir Frank did his tours with principals, filling in the minor rôles with local talent. Following the tradition of Irving, he believed entirely in himself as the great centre-piece, the rest of the company having to be in the right place to complete the composition, and to give emphasis to his orations at the appropriate time.

We 'supers' had to be at the theatre not later than 6 p.m. The play was *Richard III*. I was the Archbishop of Canterbury. The stage manager ran through our parts so that by 6.30 p.m. the whole thing had been checked. There was a second run through, then a visit to the wardrobe.

The wardrobe mistress, with great experience and skill, sorted out our costumes, and with the aid of safety pins, tacking and extra buttons, the rags began to take shape. There were last minute adjustments to details, trousers that would not stay up, one shoe without its mate and then Mr Burbage looked in to see that all was well.

The call-boy warned us that Sir Frank and Lady Benson had arrived, and 'All supers on!' and off we went. Since we were up in the dizzy heights of the theatre, there was a great flip-flapping down the stone stairs because our footwear did not fit – some shoes were tied on with string, most were sizes too large. The call-boy shouted, 'Orchestra!', then 'All stars on!' Sir Frank appeared and the curtain went up.

Bar one or two slips the operation seemed to work. Everyone had to stand still until the great man had left the stage; once more then the bell rang again, the call-boy shouted and we all flip-flapped down the stairs.

I had to go on the stage to meet Sir Frank at the exact place which he had arranged. He murmured, 'Here we are. Remember for a moment or two that you *are* the Archbishop of Canterbury.' As he turned to look at the audience . . . I forgot my lines. Quickly he said, 'You've forgotten the lines. Just walk, I will speak both parts.' My mortification and sense of defeat were terrible, sweat broke out on my brow and I hardly knew what I was doing until the end of the scene.

As I was walking off the stage Sir Frank said, 'It happens to all of us. I can see you have the feeling for it.' I fled to the dressing room, sat down and made a decision that I would never again take part in a theatrical performance, whereupon I heard the call-boy crying, 'Archbishop! Archbishop!' Down the stone steps I went flip-flapping, to be asked in a whisper where the devil I had been. At a convenient moment I was pushed on stage.

Even though my appearances were in a very minor capacity, I did get a chance to see the real theatre from the inside. I saw how scenery, props, flies, costumes, and music became one harmonious unit. As I walked round behind the stage it was interesting to read the history of some of the old scenery. One scene, badly torn and much in need of repair said: 'Johnstone Forbs-Robertson, 1897, London.' The wardrobe was a large collection of rags and bits and pieces of tat, with the notable exception of the costumes for the leading players. I learned how much hard work was needed to put on any stage production.

At last I collected my Diploma, a Carnegie Travelling Scholarship, the Keith Award, the Maclean Watters Medal and the Stuart Prize. The Maclean Watters Medal is a splendidly large medal and, in a convivial spirit, I sent it trundling all the way up the aisle during the ceremony. Sir Lawton Wingate disapproved of such levity and I nearly lost my Travelling Scholarship.

Edinburgh had been something of a disappointment, because whilst I had worked hard at the College only Henry Lintott had really impressed me as a teacher, and only Sickert, in his one lecture, had given me much to think about. David Alison had shown me the disastrous results which occurred when teaching becomes a commercial formula – he dogmatically insisted on a recipe of his own which I had refused to accept. He asked how it was that, away from

the Art School, I could paint fairly well but in his class my work was so bad? He suspected someone was helping me to paint those paintings outside the School, that they were not my work at all. In this he was partly right actually because Lintott had told me to go to the National Gallery on the Mound to look at Titian, so whenever I was absent from Alison's classes I was at the Gallery. What an artist! How he could use paint! What skill and sensitivity in the painting of the flesh of his splendid models, what marvellous freedom he used in the floral jungle between the great figures of his compositions, what bravura in that final dash of paint to highlight a little silver pot. In the Painting room at the Art School hung a fine nude by Peploe which I admired (although not, of course, to be compared with the Titian nudes), while another favourite painting in the National Gallery was Goya's *El Medico*. In 1925 Sir James Caw caused a sensation in Edinburgh by buying Gaugin's *Jacob Wrestling with the Angel* (also called *The Vision after the Sermon*) which I considered to be an inspired purchase.

I knew I did not want to paint the sort of pictures that were being endlessly painted in Edinburgh. Both Francis and Tom Scott were constantly urging me towards France and students returning from Paris brought us news of great things going on there. News also filtered through to us from Glasgow about the sort of pictures which Alexander Reid was bringing back from France and selling there. Reid was a remarkable little man. A martinet among dealers, he would attack a client in the street and say, 'I know how much money you made last year; I know you don't know what to spend it on. It's not a question of whether you like the picture or not, you've got to have it. You can't have texts along the wall and let everybody know your father was a miner.' (Sunderland lustre plates with texts were a very common form of decoration in Scotland then.) All sorts of artists took their work into Reid's gallery and he would always look at their pictures. He had great discernment and would never turn an artist away; he had to see everything. Glasgow Art School under Fra Newbery made the only vital contribution in Scotland to the art of its time. He was a disciple of the Arts and Crafts movement. William Lethaby at the Central School of Arts and Crafts in London had changed the whole structure of art education at the beginning

of the century and Newbery, himself no mean painter, held to the tenets of Lethaby and the Art Workers' Guild. His student, Charles Rennie Mackintosh, outshone everyone as a world figure working in Scotland. The Edinburgh College of Art remained merely a painting school, untouched by any new movement stemming either from Glasgow or Vienna. We were very much cut off from the mainstream of effort, and only heard faint rumours of this brilliant architect who worked in Glasgow. One year Tom Scott took me to the Private View at the Royal Scottish Academy where he showed me some very fine watercolours by Mackintosh. Later he took me along to the Arts Club to meet him but, alas, I only met Charles Rennie Mackintosh when he was sad, neglected and bitter.

When I came home on that sunny Armistice Day in 1918 and sat on my kitbag to think, I had determined that I was not going to be trapped any more in a world where everyone was to be exploited. I was sick of it – my father trying to hire men for a shilling a week less, but giving them a suit of clothes at the New Year as a sort of restitution, or selling a cow with a blind teat, a horse with a through-pin or a spavin, all the cheap tricks of men desperately trying to keep afloat in difficult times; the exploitation of animals, the brutality and duplicity of so many men, the shady dealings in which I had taken part. The whole vast fraud of this war erupted as a bloody gash showing the fundamental rottenness of men.

I wanted a new start. During the war political agitators had been busy in the West of Scotland, and the Clydeside Group were active in creating dissension in the country. Strikes had been freqeunt and there was a strong feeling that, while young men were slaughtered by the thousands, those agitators were busy trying to stop war production to deprive the soldiers of the very weapons that might save them. Edwin Muir and William Ritchie had both been involved in Glasgow in Guild Socialism. On Sundays at the Mound in Edinburgh I listened with a great deal of sympathy to Willie Gallagher who said, 'When I come to Edinburgh I have to look up to my old baronial home, the Calton Jail.' Emmanuel Shinwell said that he had seen in the papers that King George had been talking to an old clown in a circus. 'What a day when two clowns meet!' There was a little girl, a miner's daughter from Larkhall, who led a procession along Princes

Street collecting funds for a miners' strike. She was Jennie Lee.

But much as I sympathized, I felt that politics were not for me, and that I should stick to art. In the autumn of 1925 my kind friend from Selkirk, Tom Walker, saw me off on the night train to London to catch the Newhaven–Dieppe ferry the following day for Paris.

5
A winter in Paris

From my train window I looked out on to a bleak landscape. The fields of Normandy were covered with an early autumn snow, and I watched the farmers and their wives fetching their cows into the steading, feeding their sheep before darkness fell. This country was not dissimilar to my own; I recognized the same harshness and struggle on the land. The Gare St Lazare was dreary, wet and damp, and lights accentuated the loneliness of a great city. Paris made me feel a stranger indeed. My French was so extremely limited that communication was difficult. In order to find out how long my money would be likely to last I stayed at the États Unis, a cheap hotel on the Boulevard Montparnasse. Here I considered how to make a start in Paris, how to find some continuity with my previous studies.

Meanwhile I bought a book of tickets at the Grand Chaumière and ventured into the croquis classes to draw. At night I walked in the dark streets. As I was returning one evening along the Boulevard St Germain from Les Deux Magots, I heard someone playing Chopin. The music seemed so wonderful, the pianist's feelings so intense, that I was held entranced in front of the house for a long time. I crossed the street to look in through the window where I saw a beautiful fair-haired girl playing to herself. I went back the following night, convinced that here was the most exquisite thing Paris could offer. Night after night I returned to listen in the dark, feeling that the music provided me with inspiration.

There were various studios where one could study with a chosen master – the Beaux Arts, Julian's, André L'Hôte, Fernand Léger,

Jeanneret (Le Corbusier), or Ozenfant. The Beaux Arts held little attraction for me as I did not want to continue with a similar kind of teaching to that which had already disappointed me in Edinburgh. I went to see Ozenfant because he and Le Corbusier, the originators of the Purist movement, were working on some very fine paintings which I much admired. They had started a new kind of studio which placed emphasis on craft work. From what Ozenfant told me they wanted to relate the disciplines learned in painting to architecture, to furniture, to textiles, indeed to everything that related to the home. These ideas seemed to me to echo some of the principles of William Lethaby at the Central School of Arts and Crafts in London. I liked Ozenfant and was impressed by what he and Le Corbusier were attempting, but felt that I would be moving away from painting too much.

Then I met Fernand Léger of whom everyone spoke highly. His students were devoted to him and I felt that he deserved the great respect in which he was held. Léger looked like a sturdy cab driver, a good honest workman rather than an artist. Unless you looked carefully you would not notice the sensitivity in his face, the artist being disguised behind a mask. He was at once interested when I told him that I was a farmer's son and had worked on my father's farm in Scotland as his father, too, was a farmer and cattle dealer in Normandy. As a teacher his approach was simplicity itself. The stock-in-trade of painters – lemons, bottles, curtains, open books were not used. Corrugated iron, corrugated paper, wheels, parts of machinery were the subject matter, motifs associated with our modern way of life in machinery and technology. His formula was space, the straight line, the curve. A sheet of corrugated iron was a thing of beauty, a new vision, a revolutionary art verging on a new classicism, a product of our time. This departure fron nature and his zealous exhortation of the beauty of urban civilization, the machine age and modern science suggested in some way to me a neo-Pre-Raphaelite approach.

The problems of modern man in relation to his environment, his efforts to adapt himself to modern science and machinery when his whole life history has been a harmonious relationship with the earth, have been perfectly expressed in Chaplin's films and in those of Laurel and Hardy. A new urban art has emerged based on modern

science and city development. Léger seems to me to be the lynch-pin in this change. On the battlefield as a gunner he saw a new beauty in destruction and he painted the portrait of man in this new relationship. Léger was an austere and modest man who, while he had an interest in left-wing politics, always remained a patriot with an intense love for France. Both Léger and L'Hôte attracted a very high grade student, the foreign students mostly having travelling scholarships or grants.

I considered that André L'Hôte's teaching would have more variety and offer greater possibilities of extension. He gave a grammar that could be used as a framework for one's own development. This gave a great elasticity to his teaching, and there was no fear that you would be handed out a recipe. So to André L'Hôte's studio I went, to be accepted by him as a student.

This matter settled, I moved out of the raffish surroundings of the États Unis into the more petit bourgeois premises of the Pension Jeanne. Each morning I went to L'Hôte's from 9.30 until 12.30, then dashed back to the Pension Jeanne for lunch, and at two o'clock I began to draw either at the Grand Chaumière or at Colorrossi's. My ticket entitled me to draw until 8.30 p.m. in the evening. It was said that Picasso had been known to do this, that he could draw from 2 till 8.30 for days at a stretch, but I could only work till 7.30 or 7.45 when I had to give it up. Sometimes I would draw till six o'clock, go out for a break, then continue till 8.30. I must have made thousands of drawings. The evenings I spent mostly at the Dôme. On Sunday mornings I went to the Louvre, where I was always spellbound by *Victory of Samothrace* in the entrance, then I moved towards the Egyptian galleries. Egyptian art and early primitive Greek sculpture interested me greatly at this time. The Jeu de Paume and the Musée Cluny were other favourite haunts on Sunday, while visits to Chartres were always a delight. This routine was constant while I worked in Paris.

At the Pension Jeanne I became acquainted with the son of an Armenian carpet dealer. He was a charming young man who was destined to follow his father in the carpet business, but meanwhile was enjoying the delights of Paris. We went to many painting exhibitions together and I found him an engaging companion. We saw

Mistinguette and Maurice Chevalier, although my blasé young Armenian thought these artistes too childish and naïve for his taste. I enjoyed dining with his father, a massive man with very white teeth, and discovered that there was little he did not know about carpets or men. He asked me to meet him at the Louvre where I found he had a magnificent carpet spread out in one of the great galleries for the Curator to see. He asked me to give my opinion of the design of this carpet, which I did to the best of my ability.

Soon afterwards when his son and I were going to see an exhibition the young man began talking about his sister. He told me that his father would like me to consider marrying his daughter. She was only fourteen, still at her convent school, but that was not the point. If his daughter was married to an Englishman, it would help his father to get into the English market. An ample financial arrangement would be made on business lines and my private life would be my own.

This was something of a problem, and the fact that I had never seen the young lady seemed to be of little consequence. There was nothing for it but to face the father on the following day. Fortunately, he had already sensed that the matter was at an end. I asked him why he had chosen me and he explained that in any bargain there is give and take. He had discovered from his son that I was very talented, slightly wayward, with an astute judgement and a first rate background in the fine arts, which were all excellent qualifications from his point of view, so he made me a first-class offer – finances to give me top social status. I would sell my paintings and he would sell his carpets. After all, money will take you where you want to go; poverty never can. We parted amicably and I never saw either father or son again, but I still remember that offer and often wonder where it would have led me.

Max Bernd-Cohen came into my life at this period. Max had taken his degrees in Law and Philosophy at Columbia but had opted out of joining his brothers in their law practice in New York. Through his studies in philosophy he had developed an interest in art and, when I first met him, he was trying to discover whether or not to make painting the main business of his life. We became great companions and have remained life-long friends. We were complementary to

each other. Max had an excellent academic background with a great knowledge of art and social history, and he also had a love and understanding of humanity at all levels coupled with a glorious sense of the comic and the ridiculous. In contrast to his far richer philosophical background, I was able to offer my own experience as an artist, and my practical knowledge of drawing and painting. I could, by my own enthusiasm, interest him in the modern art which was the life of Paris and I was able to show him the merits of the younger school of French painters. For instance, I admired Dufy's drawings and was able to explain to Max exactly why I thought his calligraphy was so superb. We went to the Jeu de Paume to look at Manet, but his painting already belonged to the past – the impact had gone, the shot had been fired, the dust of battle had cleared away. The men who held our enthusiasm with their tremendous vigour were Picasso, Braque, Rouault, le Douanier Rousseau and Modigliani. The average Frenchman, of course, was not at all interested in this new kind of painting, he still enjoyed the *Beaux Arts*. It was only the international types, the Quinns or Gertrude Steins, who bought these modern pictures. One look at the Jeu de Paume and we retreated hastily to Rosenberg's to see what they were showing there.

You could not understand some of it, you could only *feel* the truth in it, but the Salon stuff had lost all vitality and no longer bore any relationship to our time, it was milk and water compared to this new dynamism. Your eye told you what was right, and no discussion was necessary. Even Max, whose mind was always reverting to ancient Greek philosophy with the stubbornness of pure reason instead of allowing his feelings to develop, understood this.

I plunged into this new art. I found it to be a strange paradox that these modern paintings seemed to tell me more about nature as an experienced thing rather than a merely visual notation. This new art had an inner vision, a revelation which was an aspect of painting which all great artists of the past had felt; it was neither novel nor new – indeed French tradition in art is absolutely against any form of novelty for its own sake – but it was an extension of the meaning of perception. We became so excited by a painting at Rosenberg's that I wrote to my father to say that I had a chance to go 'halfers' with Max to buy a picture by Picasso, *Nude with Violin*, for £750. My

father wrote back, 'If that's the last of your money you'll have to swim home but not a damn thing are you going to get from me to buy pictures. If you come home you can get a farm, but you'll leave those pictures alone.' That painting now hangs in the Museum of Modern Art in New York.

After we had finished our work we went most evenings to one or other of the cafés, sometimes to La Closerie des Lilas where Picasso and Braque used to go and where, in a previous decade, Renoir and Monet went also, sometimes to La Rotonde or Le Coupole, but most nights it was to the Dôme. They said there were thirty thousand people studying art in Paris then and sometimes it seemed they were all at the Dôme. Bedlam it may have been, but it was a bedlam with meaning, with vitality, different from ordinary bedlam. Max loved people and conversation (his French was more extensive and imaginative than mine), and he plunged into this seething mass of ideas with vigour.

Paris in the twenties was, of course, something one could never expect to experience again. The relics of the war were there, fragments of cracked humanity, Americans who had never got home and who never intended to go, Russian émigrés, Polish expatriates, dope pedlars, prostitutes, Chinese gamblers, Christian Scientists, Gurdieff (the Rasputin of the Île de France as Cyril Connolly once called him), everything seemed to be contained in this small area. In every way, in literature and science, in art and politics, it was an explosive period. Uncertainty was the keynote of the times; doubt was the necessary catalyst and spur to life. Science and romantic psychology were producing experiences hitherto undreamed. Our environment was tentative; artists were seeking and probing the very depths of imagination. Revolutions (both political and religious), were all around us, violence never far from the surface. Doubt was dangerous, but certainty even more perilous; doubt is the vitality of work, while certainty is death. We belonged to that time, a searching time, a revolutionary time.

Max had a marvellous facility (which I lacked), for meeting people and entering into these great discussions, although I loved to sit and listen. Sometimes we sat with Marc Chagall and his charming wife; Zadkine would be there; Hemingway made a great deal of noise

every night and Giacommetti used to stand (always with his bicycle clips round his trouser legs), amazed and silent, watching this extraordinary, loud-mouthed American. Pascin, Tchelitchev and Kisling joined in the talk. Severini was there; sometimes Serge Poliakoff, who frequented the fashionable salons, came to talk about horse racing. (Paul Berlin and Max were somewhat jealous that this young man was already selling his paintings.) I was intrigued by another Russian, a large man whose name I never knew, who used to stand on the pavement wearing big, foreign boots. He stood in silence waiting patiently until Chagall noticed him, when they would slip away quietly together. Josephine Baker used to come early in the evening, sometimes returning later on after her show with Maurice Chevalier. We admired Josephine enormously and were delighted one night when Ruth Harris (a friend of Max's who wrote art criticism for the *New York Times*), brought her and Jean Cocteau to dine with us.

On Sunday evenings we went to the Opéra where we would sometimes see the little Maurice Utrillo firmly chaperoned by Suzanne Valadon – a picture of a circus trainer leading out a chimpanzee into the ring for a performance. But what a performance, what a beautiful artist!

After the Opéra there was Pigalle's or some other night club. Max restrained me one night from breaking our bottles on the splendid mirrors at Pigalle's and instead, on the way home, we seized some circular marble table tops and trundled them joyously down the street. Returning to the Pension Jeanne early in the morning we were inspired by the neat patterns made by the pairs of shoes outside each bedroom door. We changed them all round, knocked loudly on each door and waited. The chaos and arguments were as glorious as we could have hoped, although we had trouble in making our peace with Monsieur Jeanne.

Max and I went with Zadkine to the Café Nègre. Outwardly this was a small cabmen's café, but behind the façade was a vast room with a gallery all round it. There was a violent band hurling out 'Valencia' and other current hits, and it was so full of people that nobody could move, you just shook like jelly in a great protoplasmic mass. There were homosexuals and dope addicts, some with no clothes on

at all. An American woman became hysterical, yelling to be let out; another one yelled that she wanted to sleep with a negro; dope pedlars found their customers, prostitutes their clientele, forgers their confederates, and the whole seething, sweaty mass became unendurable. Ossip Zadkine was keen on this café; he said he was interested in degenerate life and enjoyed indulging himself in this post-war disillusionment. He made the confident assertion that this chaos symbolized 'US'.

I admired Zadkine's work very much and felt that his drawings and his sculpture were positive statements in the idiom of our time. One night (it was about three o'clock on Monday morning), we looked down through a street grating into a basement room. I said to Max, 'What do you think of this?' Down in the basement there were a lot of men throwing dice. 'They must be playing crap, let's go down and see.' So we went down the area steps and knocked. A man came out, and I said, 'We saw you playing with those dice, can we come in?'

'Surely, come in.'

We could hardly see each other through the tobacco smoke where the chaps were playing round a table. Max was confident of his prowess, and said that, as he had played on the East River in New York, he could play dice with anybody. I had never played the game before, so had neither knowledge nor skill. There seemed to be six of us; one stood behind my back, another behind Max. We sat down at this early hour in the morning, none too sober, and started to throw. It appeared that you had four throws. The Frenchman threw one six, Max threw two sixes, the next man three sixes. Max's excitement was great. 'William, for God's sake throw four!' which, to my surprise, I did. During the play the stakes had been doubled and trebled, but in the silence following my throw, the Frenchman put his hand over the pile of money. There was a pause until Max mentioned that we were thinking of leaving, whereupon the Frenchman said that he thought we were staying to play more. There was another pause, and we started to move, but the man still had his hand over the money.

'William, get to the door, keep your back to the wall, I'll see if my judo will be effective.'

I reached the door, Max shouting, 'Get out of here like hell, I'll get the money!'

Somehow he managed to snatch it, but how we escaped from those men I do not know. I have never thrown four sixes again.

There were many Russians in Paris, both aristocratic émigrées and anarchist/revolutionary types, all waiting to return to their own country after the civil war was over. One night, returning late to the Pension Jeanne, we heard great shouts of laughter and singing rising from a basement in the Rue Montparnasse. We explored and found ourselves in the midst of the Russian New Year. This was a splendid party, where we were received by all the Russian aristocracy then resident in Paris who invited us to join in the celebrations. We spent an enchanted night among this distinguished gathering of the *ancien régime*. Not many days afterwards a Russian drove up to the Dôme in a cab to meet a friend. As he turned to pay the driver he was shot dead. They said it was political.

I enjoyed our nights at the Dôme, and often watched James Joyce sitting quietly by himself. Joyce seemed a lonely man, apart and thoughtful. He was frail, tired and almost blind, but listened with great sensitivity. His hearing was like the light, middle-tone and dark of a painter's canvas. He gave poetry a new dimension and a painter's image. I loved Joyce's books and I found that I could understand what he was trying to say from my early days with Dan Gallagher and the Irish labourers at Greenhead.

There was great discussion at the Dôme regarding the French Derby. Art, literature and music seemed to disappear from the conversation, and the horses took over. Suddenly men who had professed great knowledge of the arts now professed great knowledge of horses. Rumours were rife, stable whispers were everywhere, Paul Berlin had about a score of tips. Max said he did not know anything about horses but what he had heard indicated that they were well left alone. This stirred memories of my flapping racing experience so I gave my tip: 'Asterus'. This was regarded as quite amateur by the specialists as no one had even heard of the horse, but I insisted.

I persuaded Max to go to Chantilly and, as it was pouring with rain, I took a large white sketching umbrella with me. Max grumbled all the way reminding me that every penny counted and that if I

wanted to stay on in Paris, Chantilly was the last place to waste money. It was still raining hard and as soon as we entered the racecourse we raised the umbrella. To my astonishment I was immediately seized by two policemen and put in a police box to await the arrival of the police van. Max raged and demanded that they let me out at once, and I could only watch through a little window as the argument continued with growing ferocity. A higher official was brought and there were more terrible arguments until at length I was released. We had only gone ten yards before I put up the umbrella and was again arrested. Max had another battle royal, and eventually managed to explain that I was an artist and the umbrella was my sketching umbrella. We discovered that no bookmakers were allowed on the course and, with this great white umbrella, I looked exactly like a disreputable member of the profession.

We reached the grandstand, Max complaining about the rain, the police and the likelihood of serious loss before all this was finished. The man standing next to me asked me what I fancied. I said, 'Asterus', and the man said that he thought it would be placed. His son was riding in the race but he had been unable to get in touch with him. 'Asterus' was right out of the betting but it certainly had 'class' breeding, so Max and I put ten francs on for a place, and then went back to watch the race. Max mumbled that there was twenty francs lost for certain.

'They're off!' The shout went up and the race was on. I had never seen Max so excited. Someone said, 'Asterus is out', and Max drooped. Someone else shouted, 'Asterus is in front!' and Max was up again. Then there followed a tussle between Asterus and Madrigal for the lead, and Max was shouting. Madrigal held on to win, and Asterus came in fourth. (He became one of the great stallions in France, his progeny winning innumerable classic races.) We collected our money, and Max demanded that we return to Paris at once. He said we had made our expenses, we had enough left over for a good dinner and a night out, what more did we need?

There was great excitement at the Dôme as they had all lost and could not understand how I had such great insight or from whom I had obtained my secret information. I had neither.

6

Travels with Max

Max and I decided to leave Paris in the spring to take a journey through Spain and Italy. I had to show evidence of study for my travelling scholarship and I intended to make a copy of a painting in the Prado, so we took a train to Carcassone, leaving Paris on February 13th. We had toiled all winter and were elated to be leaving work behind us. The coming spring was delightful, and I thought all the country on the way to the Midi was superbly beautiful.

We found a working man's hotel in the old town for 1s. 10d. a night. The floor was so rotten that one leg of the bed went through it to the ceiling of the room below. When you wanted to relieve yourself you had to climb out of the window and walk along the gutter to where a rope was tied to the chimney. You held on to this and aimed. You had to have a steady hand. The fleas were in thousands, you could hear them barking like dogs; Max caught some in his beard.

Our breakfast was a very crude form of coffee, with bread which seemed to have been baked from pulped wood; we gnawed at this, softening it up in the coffee.

The old men had all their belongings tied up in red handkerchiefs like the Irishmen at Greenhead, and carried their bottle of red wine with them. There were no young men in Carcassonne after the war; most were buried in northern France.

We moved on to Barcelona. In our third-class carriage we were joined by a family of gypsies, all as black as the devil. They wore big gold ear-rings and had hens with them, a parrot, some cages with

small birds and a monkey. We settled down for the journey to Port Bou. Those gypsy girls were very fine and handsome, and in every dark tunnel there were furtive giggles and suggestive movements. When we regained the daylight we were both relieved to find that we had neither lost our wallets nor our virtue. The gypsies sang and laughed and entertained us until, some miles outside Barcelona, the train stopped. King Alphonso was to visit the city and everybody had to be searched for bombs as bomb throwing had become a recurrent fear. We resented the delay as we were hungry and very weary on our hard seat.

In Barcelona Max had an idea. He had discovered that we could obtain *en famille* contract tickets which would enable us to travel half price. It took considerable time and argument to persuade the courteous Spanish manager of the American Express that our claim to travel *en famille* was justified (which it was not). In the end he agreed on condition that we produced six photographs. I had enough photographs, but Max had none so I went to a bank while Max went to buy some. I waited and waited. We had planned a trip round the coast of Spain on a tramp steamer and I was anxious that we should not miss the boat and forfeit our passage money. At last Max rushed up having bought photographs that he felt were sufficiently like him but unfortunately having forgotten that he had grown a beard. The manager, who was very serious, and very proud of the aristo-cratic behaviour of the Spanish people, objected. However, he allowed us to travel with the cheap ticket and we just caught the boat minutes before she left the harbour. She was practically sinking and the fleas were so powerful that my legs were covered in great weals. Each day we stopped at a port, then at night we sailed on with Max and I sleeping on deck. Every little coastal town was more beautiful than the last, but at Almeria we watched children, rickety and famished, coming down to a waterhole near the sea. They filled their heavy pots with fresh water and carried their load up into the mountains as far as we could see, away up to the caves in which they lived. I had never seen such conditions of desperate poverty. Jan Gordon, the art critic (author of *Modern French Painters*, 1923, then the best introduc-tion to the subject), had been staying in Spain and told us that we must see the village of Murcia which, according to him, was so ancient

that it took you straight back to prehistoric times. We took a walk into the country until we came to this village which seemed utterly deserted, like a ghost town in Colorado. Nobody was about, yet we sensed people watching us as we walked down the length of the village street, and we were aware of a feeling of great ill-will. There was impending evil in this ominous stillness. We fled.

From Algeçiras we crossed to Tangier where we stayed at an hotel with a charming tiled patio. We sat under the palm trees, sheltered from the noon sunshine, and watched our fellow guests going to and fro across the patio. They were very pretty girls and Max revelled in this delightful pastime. He felt there was a great deal of vitality about the place. Soon we realized there was a pattern in this coming and going, and that each time the young ladies came in, they brought a different boy friend. They were all very polite and hospitable but at night we had to keep out of our room and could only get to bed when business became slack.

We sketched in the market place which we found most entertaining. A snake charmer, making his snakes perform, caused great uproar and resentment because he did not seem to have them under complete control. They tended to escape among the crowd, to be caught by their owner at the very last minute, but perhaps it was all just part of his act. One evening we found a group of Arabs singing in a small room up a stair, who invited us to join them and gave us peppermint tea. We stayed there listening to their strange, evocative music far into the night.

We explored the city, drawing everywhere. At that time big hotels were being built for the luxury tourist trade, and so we sketched the donkeys carrying sand and cement to the building sites. Of course they were grossly overloaded and sometimes a donkey would fall under the weight of his load. Max was enraged by this and, when an Arab started kicking his donkey to make him get up, he in turn kicked the Arab over the top of the donkey. This seemed to be inviting trouble so I thought we should depart.

However, it was March and the sea at Tangier can be unexpectedly rough. We found that no boat would sail, and we were advised to wait for a British battleship which would call and take off any British subjects. When it arrived the captain took one look at us and refused

permission for us to embark, so we were stuck. Next day we tried again and as we walked along the jetty Max was faced with an apparition of 'feminine beauty'. 'William, I've seen something I can hardly believe is true.'

'What have you seen?'

'Come and have a look.'

There was certainly a most beautiful and very fashionable lady there, indeed there were two of them. We put down our haversacks, and Max began, in spite of our disreputable appearance, to talk to me about the disasters which he said had happened to our yacht while we had been sinking in the Mediterranean. Meanwhile we edged nearer the ladies. One lady said, in a most lovely voice, 'I take it you're explorers?'

'Yes, we've been right through darkest Africa.'

'How frightfully interesting!'

'Yes, it was, but unfortunately we've got ourselves in an unpleasant situation. You see, we sent the yacht back when we should not have done so, but it will be quite all right. How nice to meet such charming ladies in this place! Excuse me a moment, I have to see a man. Come on, William . . .'

'What?'

'We've damn near forgotten about those haversacks.'

'Hell, we're going to sail! We'll have to rush for them.'

A six-foot Arab stood over our haversacks, barring our way. Max remembered his judo, we seized our bags and ran for the boat. We went up to find the two ladies sitting on a first-class deck to get fresh air in case they felt sick.

'What happened?'

'Oh, one of my servants made a mistake with the luggage, but we have everything now.'

'Oh, servants are *so* trying.'

Max noticed a sailor coming towards us. 'Excuse me, something's happened about that luggage, but we'll be back very soon . . . most unfortunate . . .', and down the stairs to the steerage we went.

The boat was hardly seaworthy and the Mediterranean was rough. We went up to the fo'c's'le head and a great wave came smack over the top of us. The bow sank right down, the sea came over in tons

and we were absolutely drenched. Luggage started rolling about, and a wardrobe trunk went by. 'Look at this, it's Alice Delysia, the dancer's luggage. That's who she is, upstairs!' cried Max. Sailors came down and tried to get us to help rescue the luggage, but we hung on tightly to some sort of standard. We felt we should be swept overboard as well as the trunks, so we watched them sliding backwards and forwards as the boat lurched up and down. Eventually the storm subsided and we crept into Algeçiras in a leaking condition, steam pouring out from the most unlikely places.

We lunched in a most sumptuous way at the best hotel in Algeçiras with Miss Delysia and her friend. Max explained what a difficult situation had arisen with the luggage and how much he had personally contributed to saving hers, for which she was most grateful. She assured us that it was the most hair-raising and frightening experience she had ever had.

We left our beautiful companions at Ronda and made our way through exquisite country to Granada to see the Alhambra, which was filled with mystery and peace. We were determined to reach Seville for the Passion Week. The train was packed but (with the aid of our kilometric ticket), we found ourselves a most comfortable first-class compartment. Just as the train was leaving the station an American gentleman jumped in with a considerable amount of luggage. He looked up to see two most alarming characters in the carriage beside him, and I saw an expression of apprehension cross his face. He tried to read his paper, then he glanced at me, then at Max. In the end he spoke to us in French, then decided to risk English. He obviously wanted to make himself feel more at ease as it was a long journey. We explained that we were artists making our way to Seville for the Passion Week and, having heard our story, he became most kind. He worried that we had no hotel booked and could not conceive that we would consider sleeping out on a park bench. We begged him not to concern himself about us, but he insisted that we lunched with him. His name was Mr Dick and he owned all the newspapers in Manila.

At Seville a small boy made off with Max's haversack and dived under a horse-cab. We could not get him out, it was like trying to get the cat out from below the bed. Meanwhile the little boy opened

the haversack, found two shirts and bolted. I seized the bag while Max caught the boy and retrieved his shirts. The cab-horse was one of the kind they use at bull fights. It could hardly stand, far less trot, but it took us to rooms in a house built round a square with a fountain in the middle. We felt this fountain to be truly luxurious and romantic but found that our beds, which stood on the bare earth, were not so promising.

We went to find Mr Dick, who cheered us up with cigars and brandy, and told him how we had found this hotel with a beautiful fountain in the middle of a courtyard and that we felt we should paint there in the time off from the Passion if we could only obtain a model. Mr Dick thought we should be able to find a model at Nova Dades so we all set off for this establishment. Mr Dick took a stage box and explained to the manager (in perfect Spanish), that we were artists and would like to obtain a model, a most beautiful woman, whom we could paint. 'We have the most superb women here, they are all beautiful. How many shall I bring? Three or four?'

Max began to be alarmed as Mr Dick assured us that we must be most polite to those ladies as the honour of the manager of the Nova Dades would be at stake, if not the honour of Spain. We began to feel that our request had been rash when the door of our box opened and the manager announced, 'Señors, the beautiful women!' They were so staggering that I could hardly get my breath and Max was absolutely stupefied. Each woman must have weighed a ton and their proportions were phenomenal. We were appalled and there was an embarrassing pause. The expression on the manager's face was formidable, and clearly his pride was mortally offended. The Nova Dades was famous for its great tradition of flamenco dancing and its beautiful women. Every man that had anything between his legs had appreciated this and here were a couple of clowns who couldn't tell a beautiful woman from an elephant!

Mr Dick said that he would try to deal with this contretemps. He assured the manager that he had the most exquisite taste in beautiful women, certainly these were unsurpassed. He (Mr Dick) had never seen anything like them before, but unfortunately there had been some misunderstanding. It appeared that the American gentleman had not really wanted a model at all. The fat women began talking

to each other in a very excited manner, and their eyes showed their utmost contempt for my comrade and myself. Not only could we not tell beautiful women, but no beautiful woman would want the like of us. Many apologies were given and it was explained that the young artists had some strange pictures in mind that appeared to have nothing to do with beautiful women at all. Mr Dick left the box to confer with the manager about terms. The box was filled with these enormous women, there was no room to turn, and they were absolutely furious, their eyes glaring with rage. I felt they would take me by the scruff of my neck and throw me out of the box on to the stage below.

Mr Dick settled for (it seemed to me), an absolutely monstrous price and as the fat women retreated they spat at us with contempt. At this point Mr Dick thought we should leave, but Max insisted on staying to see the flamenco troupe, who were very good. Among them was a most attractive young dancer, and we felt this was more what we needed for our model. Mr Dick was persuaded to arrange the matter.

Next morning the young girl came to pose beside our fountain but her mother came too, so we had to pay for two models. When we had finished our paintings we left our kind friend, Mr Dick, behind us in Seville and began our journey towards Madrid.

Before going to Madrid I was anxious to see El Greco's house at Toledo. I admired his paintings and was fascinated to see how this great artist worked and how he lived. In his lovely house we could see how he arranged his studio – where he would paint, where he would sit, where he would sleep, where his food was cooked. The house radiated the cultured aristocratic life of Spain, and here was how an artist lived in the days of her great wealth and splendour.

It was so beautiful at Toledo that we spent our days working in the countryside around the town. One day a charming young girl came up to see what we were painting. She brought us delicate bouquets of wild flowers and invited us to visit her parents. For me Toledo was wonderful, and the dignity and kindness of these Spanish people left a deep impression. Their courteous behaviour suggested a past steeped in a far richer culture than anything which I had experienced in Scotland.

In Madrid we stayed near the Prado in a little hotel much frequented by bullfighters. At Seville I had made an attempt to see a bullfight but had been repelled by the stench of blood as we neared the corrida. Here in Madrid, we drank our coffee with the matadors, picadors and their shady hangers-on. Their shabby threadbare jackets, the gilt tarnished, the slashes barely mended in their trousers, their broken shoes, all proclaimed a life of seedy need and shifty necessity – glamour had vanished.

All day we worked in the Prado, from opening till closing time, and in the evening we explored Madrid. One evening we saw a little girl, about twelve years old, soliciting. A chap was knocking her about, and Max could not stand this, so tried to stop him. The man turned to give Max a fearful clout, changed his mind and ran like hell, leaving the child in the street. Poverty was ugly in Madrid. Usually I took a short cut to the Prado down some back streets, passing Goya's house. One morning a small crowd of about twenty-five people had gathered; it seemed to be some sort of political meeting. Suddenly, from each end of the street, mounted police galloped straight on to these people, smashing right into them. Terrified, I never went back that way again.

In Edinburgh there had been a great emphasis on technique in art. Technique means one thing to one person and something quite different to another. At that time the slightly superficial technique of Sargent was in vogue in Edinburgh and was considered to be the very highest accomplishment. Sargent was compared to Manet and even to Velasquez. His work certainly had a dramatic bravura which was attractive, although such emphasis on this particular flamboyant type of painting tended to obscure the work of any artist who might have had more depth of feeling but whose talent was expressed in a more restrained method of painting. Naturally my approach to painting had changed vastly since my stay in Paris, and my evaluation of what made a great artist was different.

In the vast galleries of the Prado it was hard to isolate the paintings which were important to one's own personal development. In looking for something that I felt would take me further in my studies, I spent several days trying to decide what I should copy. I developed a great admiration for Goya, but in the end I decided to copy Velasquez'

portrait of 'Aesop'. I set up my easel, a canvas the exact size, and a carpet to catch the drips, all arranged with a suitable lighting. On such a vast scale it was obvious that to include everything would be difficult. Undeterred, I proceeded to sketch in the picture with my charcoal, until in the evening I left the gallery very disconsolate.

Next day I thought I would draw in Aesop using a sepia brush with a lot of turpentine. The great thing was the use of monochrome which had been demonstrated in Edinburgh, using Velasquez as an example. After some time I discovered that my placing had been weak, so I wiped out all my work, very discouraged. I had allowed myself a month in the Prado in order to send this copy back to Edinburgh to satisfy the authorities who had given me my travelling scholarship, and already two or three days had been lost.

I tried a different approach by squaring up the design on paper and then transferring this to my canvas. I found this method to be more practical and, in so doing, I began to discover what a really great master Velasquez was, and how little I knew. I worked on this mechanical squaring up till I had everything more or less in place. I learnt the foolishness of depending on one's eye for a composition of this size – just taking up your brush and beginning to paint was useless. It required careful preparations and precision. The swinging lines of Aesop's cloak which at first had looked so easy I found to be as full of subtle curves as a piece of oriental porcelain. It became more and more obvious what a great geometrician Velasquez had been. There was nothing hit or miss in his highly intellectual approach. Underneath the apparently 'easy' painting there was a strict form of architectural construction. I struggled with the golden sections and found that I had let myself in for very serious problems. When I had at last achieved my basic structure I still had to paint it and this, I realized, would be very difficult. Following L'Hôte's advice I began to paint from the edges of the canvas. Illogically, I remembered that my father had once told me: 'When you're firing boilers, keep your coals up the sides to keep a draught. The coals fall into the middle themselves to give steam power.'

I had plenty of problems. I worked on the edges with great care starting with thin paint. Aesop was painted with very heavy impasto and it was obvious that I had a very long way to go to get that weight

of pigment, the various transparencies, culminating in the very heavy opaque passages. I lost a lot of time on the edges and, in the end, I had to re-draw the basic construction from the centre of the canvas outwards. I became apprehensive lest I should never be able to complete the work. I felt I was riding a horse that had come half-way across a river and I had to take my life in my hands to make for the other side.

Now I made careful marks so that when I lost the drawing under my sepia washes I could find it again. I loaded the paint at the extremities of the canvas, then I started to work with a heavier pigment which seemed to match up to the weight of Velasquez' paint. I discovered (or so I thought), that Velasquez himself had changed the composition and this made my task no easier, but none the less the painting began to take a shape. I found that when he had started off with a thin ground he had changed from this to thick paint. He had used glazes of thin paint over thick paint and what had been opaque he had turned into a transparent passage. He had used the canvas as a great orchestration of paint. At my most despairing moment I was exasperated by two visitors who said how clever I was and they could not tell the difference between my copy and the original!

I began to understand what Velasquez could do with the few earth colours which he used, with thin glazes, with scumbles, with thick loaded pigment. By scaling down tones while in other places making them light, light and still more light, he could just about do anything that he wanted with his paints. I began to enjoy myself and once I really began to understand what Velasquez was doing it was an experience of unending pleasure. In the painting of the cloak I think I was able to get something of the intensity and solidity, even something of the subtle movement of it. When I had finished the canvas I was very disappointed with it and, too late, I realized what I should have done, could have done, might have done.

If I ended by being a chastened and humbled student I certainly learned a tremendous amount about painting from this salutary experience and I have never forgotten it. With hindsight, I think it would have been easier if I had discovered the geometric construction of Velasquez' painting *Infanta* before embarking on Aesop. Based on a double golden section the little *Infanta* is possibly Velasquez'

greatest abstract picture, in which he shows clearly 'how to do it'. This would have linked up more closely with my recent cubist training in Paris. Velasquez has a double fascination, his great intellectual equipment and his masterly (almost tachiste), use of pigment: this latter quality appealed to me most.

The museum authorities kindly arranged to send my painting back to Edinburgh and Max and I left Spain with great regret. After my introduction to Velasquez I had learnt to treat every Spaniard with respect.

We made our way to Italy, but found that the Italian Customs officials at Ventimiglia did not welcome us. They refused to allow us to bring our drawings into Italy until we paid a tax on them, which led to arguments. Our Customs official brought in two more officials and in the end they said they would lock us up till we came to our senses. At this very critical point Max became most plausible. He suddenly discovered that we had been speaking different languages and that there was nothing to argue about as we had been in complete agreement from the start. This mollified the Italians as we had accepted responsibility for making some mistakes in their beautiful language. Nevertheless, every drawing would have to be weighed. This took a long time as it was very difficult to weigh the drawings without fine scales. At last they were stamped, duty was levied (which was to be refunded when we left Italy), and eventually we got away in the evening having arrived at ten o'clock that morning.

I left Max in Pisa and made a quick trip to Rome, Naples, Pompeii, Vesuvius and Capri, rejoining him in Assisi where we set to work on Giotto. We studied all the frescoes in the Franciscan church doing our best to make out all that Giotto had tried to do. Then we painted in the old town, in the back streets and alleyways.

We made a lot of drawings in Assisi before we moved on to Venice. Venice seemed an anticlimax after the Italian hill towns. We did not care for St Marks, and the Grand Canal stank of garbage. Max said, 'Have you looked at your pocket book, William?'

'Have you looked at yours? Because when we get to Milan I will have nothing left.'

'I'm in the same boat. How are we going to get on?'

'I have the fifty-odd lire to reclaim for the drawings and once we

get that we can get something to eat, but till then we are in a fearful dilemma.' We had tickets, but nothing else, so in Milan we set down our haversacks in the park and spread ourselves out on two benches, our feet hanging over the end. Lying on the bench in the park, in the warm sunshine, we fell asleep. I woke up to see a little man with a black hat and a black valise trotting along the path as gaily as the birds in spring. He passed me, stopped, came back again and gave me ten lire. '*Grazie mucho*. Max, look what I've got!'

'My God, it means we'll have coffee.' We ran to the coffee stall.

We hoped the train would stop long enough at the border to get our duty money refunded. We both had money in Paris but it is a long, hungry journey there from Milan. At Domodossola on the Swiss frontier, while the engine was being changed, we rushed to the Customs office, produced our stamped drawings, and reclaimed our money. We were safe.

In our carriage sat a fashionably dressed lady wearing expensive jewellery. Unlike some of the other travellers whom we had met she did not seem in the least concerned at having to travel in the same carriage with two such disreputable characters as us. Max thought there might be the possibility of a sale to this beautiful young lady, and he decided to show her our drawings. So Max chatted her up and there was much laughter and conversation. I sat in the corner seat, listening, until he reached the point where he thought she should see the wonderful drawings I had done. We had placed our haversacks on the rack above this lady and mine was stuffed full of drawings and Keatings powder. Max said he would get the drawings out, he reached up, tilted the haversack forward, and drenched the lady. We could not stop coughing and sneezing, and all hopes of picture sales were gone. The more we dusted the stuff off, the more we sneezed and coughed, but the lady was charming. She said she would still see the drawings, but she was so covered with Keatings that she could not take her mind off her clothes, so Max put the drawings away.

It was after midnight when we returned to the Pension Jeanne. We had both grown beards and still stank of Keatings powder. Max's overcoat trailed on the ground (it was split down the back from the collar to the hem), and had splashes of paint all over it. We rang the

night bell which opened the front door, crept inside with all our impedimenta, and quietly walked along the passage in the dark. Suddenly the lights went on and Monsieur Jeanne was there in his dressing gown with a revolver. '*Halte! Arrêtez!*'

'*Monsieur Jeanne, c'est Monsieur Johnstone et Monsieur Cohen.*'

'Ah, what a mess! Oh, I'm so nervous, I thought you were burglars. Monsieur Cohen, where have you been? Your mother has been here, she will be horrified. You must have a bath at once.' That was the end of our journey.

7

Twenties in Paris

It was hard to settle down to work again after our travels. Max took a studio underneath Man Ray's in order to work for an exhibition he was to hold at Durand-Ruel's and I went back to L'Hôte's, the Grand Chaumière and Colorrossi, joining him in the evening at the Dôme.

Before leaving Edinburgh I had become friendly with a beautiful, charming and very talented American student, Flora Macdonald, who had come to the Edinburgh College of Art from Paris in order to study stone carving. This seemed unlikely until I learned that someone in Paris had told her that there was a man in Edinburgh who knew about the subject. This man was Alexander Carrick, R.S.A., a stone mason turned sculptor, who knew about granite and could carve. Flora Macdonald seemed to me to be a very Highland name, although she turned out not to be very Highland at all. Her grandmother's name was Van Pelt, a family which had been among the early Dutch settlers on Manhattan Island. Somewhere in her ancestry was one of Columbus's Spanish sailors and an American Indian; her mother's name was Elizabeth Younger; her Macdonald father and grandfather appeared to have had flamboyant careers in the West.

Flora was amazed at our ignorance of French artists in Edinburgh, at how provincial we were. She told me about the important Mexican artists, about the new West Coast painters and of the great new school of painting that would surely arise in America. She assured me that she was going to return to Paris as soon as she had learned the rudi-

ments of stone carving from Alexander Carrick. I was attracted to this lovely girl and was determined to meet her again in Paris.

Flora was working very, very hard at Bourdelle's in most trying circumstances. Old clay stuck around on the stands until it was like iron, then it was thrown into one of the barrels standing outside. In the winter students had to break the ice on top of the barrel, stick their arms into the freezing water and haul out the clay, some bits of which were slimy, some hard as rock and some just a glutinous mess. They then had to mix the clay as best they could. There was no mamby-pamby nonsense about this, no studio assistant preparing clay to the correct consistency. Some, of course, were lucky and found the soft stuff at the bottom of the barrel.

This clay mess in the barrels and the clay mess on the studio floor was the cause of much dissension. There was one student, Giacommetti, who, the others felt, caused the mess to be far greater than was necessary, and they went *en masse* to the Master to complain. Monsieur Bourdelle said that they were right to complain, as the person concerned had very little talent, but his father was a very fine artist and had been one of the Impressionists. He was also a very dear personal friend and it would therefore be very hard to have his son put out, but he would speak to the man. The students complained that it was not only the mess he made but the disturbance he caused, since he had strange theories about sculpture. He had more than one armature set up at a time and he was never still, running backwards and forwards to the barrels, rushing back with hard lumps of wet clay and water running through his hands, to smash the whole incongruous mass onto the top of one of his armatures. After taking up two or three armatures, using someone else's plaster and spreading confusion everywhere, he retired. He explained to the other students that they were wasting their time doing clay modelling like nature which (as they knew), had very little to do with art. It was the object in space that mattered and the space relationships.

In the afternoon at the Grand Chaumière, Giacommetti turned up again. No sooner had the model posed than he knocked down somebody's easel to get out. He objected because he had expected a much taller model and this one was entirely wrong. He was looking for relative proportions, the elongation of an object in space.

After an hour or so at the Dôme he returned. While thinking about it he had decided that this model did have something after all which he should draw, but after one or two tentative starts he again left, depressed. He was drawing a concept in his imagination, surrounded by unseen movement, an unseen being. When he actually looked at the model, disillusion with reality was complete and so he became depressed. He was a nuisance, and I was in the minority in thinking that there might be something in his attitude. The concept or dream is opposed to what we think is real.

Flora had a friend at the studio called Germaine Richier, whose work I greatly admired, and she joined us sometimes at the Dôme. Germaine was a pleasant, 'comfortable' body, radiating fertility and indeed, during the time they were students at Bourdelle's Flora was one of the students sympathetic towards Giacommetti, even being influenced by him. Monsieur Bourdelle felt that both Flora and Germaine were highly talented, and that they were then his very best students.

Bourdelle himself was an admirable Frenchman. He was a proud (some said conceited), little man, a great disciplinarian. One of Rodin's finest students, he was a master of his craft and a fine scholar and there was little in the history of stone carving or modelling that he did not know. In his drawings he played with lines, using a quality of utmost delicacy and acute sensitivity, seemingly without conscious thought. Form developed from these drawings in an apparently haphazard way and this extension of movement continued into his sculpture. He seemed to step outside traditional sculpture. His model seemed to some extent to be useless as the art was within himself. His great pride was in his students and, if he felt one to be worthwhile, that was his success.

Flora also worked with the famous wood engraver, David Gallyanis, who looked like the Mad Hatter in *Alice in Wonderland*. He used to work in André L'Hôte's studio during the afternoons and held classes there in the evenings.

André L'Hôte was a tiny man with much force of character. He arrived at the studio on Monday morning to set up the model and he left us to do the best we could until he returned on Saturday morning. You did all you could with the model – sometimes you

saw another student who had found something to say in the medium that seemed different from that which you had seen before; sometimes you felt that you had stuck entirely.

Monsieur L'Hôte announced on Saturday that he would make a demonstration. He would take a painting to illustrate his point and then we could try to think his proposition out for ourselves, to see how rational or how logical it was. The walls of the studio were decorated with fine quality reproductions (all reproductions are bad, but L'Hôte had the best available), of works by Rembrandt, Uccello Veronese, Velasquez, Cranach, Clouet, Cezanne and many other great masters. These he constantly used to illustrate his talks. He might have Rembrandt's *Portrait of an Oriental* (the old man with the turban in the Chatsworth Collection), and he would also take a canvas from a student who had painted our model from roughly the same position as that of the old Jew. He would point out how Rembrandt had used a cool passage of blue and green right across the canvas. L'Hôte would accentuate this on the student's canvas as if it had been a poster. In the Rembrandt it was not like that because the simple shape had been covered up with other detail, gold watches and chains, fur or gold embroideries. L'Hôte would take an area in the painting, an area in space (the area itself was abstract in that it was a pattern or a definition of an area in space), then he would take another area, a warm area, and show how Rembrandt had run this into a cool area. He showed how colour varied as it was juxtaposed with a warm or cool tone. He worked out the whole portrait to a great simplification, running each area out to the edges of the canvas. He left us with the proposition that all great pictures in the world have been light pictures with a small dark area in them, or dark pictures with a small light area, although there are always exceptions. He suggested that we went down to the Louvre or the Jeu de Paume to look at the pictures that are all dark with a small light area and relate their various movements to our own work.

The next Saturday he would take up somebody's nude – he always took the worst one, when he could be very cruel and very fearful. Once it was mine. I had worked badly that week so he held up my effort to ridicule, using great slabs of my white paint to show how I should simplify the light and dark areas. He left me with the com-

mand to simplify and to keep my eye on the model, to remember that Rembrandt regarded every painting as a new adventure. Next week you would return to the studio feeling that at last you understood what all this was about – how, when the model sat in the chair, the light came across her face, how the shadow was on the side so that you missed out that bit and caught it up again at the light, or you took it right through, across the canvas – but this week all was different. L'Hôte had set up the model so that the lighting was completely changed and all the problems which you thought you had resolved last week did not apply to this new situation. You had to begin all over again to study how the shadows varied and how the light, while it might be cold when it was at the fireplace, was warm when it got to the dado, warmer still when it got to the chair, so these hot or warmer colours moved in orchestration and then moved back into colder colours that ran out at the edge of the canvas.

He would discuss Ingres or Cranach, suggesting we look carefully at Cranach's peculiar ladies, at their different proportions and at various accentuations which gave them interest. He said we should look at the figures on Greek vases, or at pottery objects made for fun using the human figure as an identification and symbol of fertility and mother-worship. One great function of an artist is to take all sorts of different objects and cause them to come together in unity. This is one aspect of the act of creation. There is a creativity to be extended to all things, so L'Hôte set up a new group of models – books, shoes, rags, blotting paper, shovels, spoons, spades, anything that did not relate. Then he took Vermeer's *Lady at the Piano* in which spaces are painted and maintained without being broken up, the division of space taking on an architectural quality, in order to teach his students to use space relationships without illustrations, simply painting patterns in space. He reminded us that the simplification of Manet was a simplification of light, it wasn't a simplification of, say, anatomy.

L'Hôte could not speak English and used to say that if we could not understand French we could go to the Sorbonne to the evening classes to learn how to speak it. Otherwise we should get the other students to explain his meaning. He thought that if the students had to explain what he said, it would help them to clarify their minds.

Occasionally, as he left the studio, he would take his brush and, like Henry Lintott, say (having brushed out all your efforts with turpentine), 'It's better!'

L'Hôte did not like his students to stay too long, and turned you out when he felt that he had taught you as much as you needed. He did not suffer fools gladly, still less did he suffer laziness. He had a long waiting list of first-rate students wanting to study with him. His idea was to give you a grammar, the root of his teaching. He gave his students a new freedom, but also a new restriction; he gave an understanding of the endless possibilities in variations of analysis, and then he turned you out to find your own motif. If you stayed too long he was afraid that you might become an imitation of himself. In different parts of the world I have met artists who were students at L'Hôte's, and seen many exhibitions of very well-known painters who studied with him. None imitated their master, but all had been able to use his grammar to nurture their own talent and develop it in widely differing ways. As Sickert said, 'His own talent, if you can help him find it, is the most interesting gift you can make to a student.'

L'Hôte's teaching had nothing static or binding about it, neither did he ever lose sight of humanity in art, as I have sometimes felt that Léger did, greater artist though he was. This seems to me to epitomize the importance of the teaching of the School of Paris. Students came from so many countries, took away what they could learn in Paris, but always retained a quality of their own nationality in their paintings. I think of Tamayo, the Mexican painter, of Van Dongen, of Modigliani. Who but a Spaniard could have painted *Guernica*? At an exhibition I had at Messrs Reid and Lefèvre in 1958, Henri Kahnweiler came in to see McNeill Reid, the Director of the gallery. He did not know my painting, so paused to have a look before going into McNeill's private office. He said, 'School of Paris, but northern – Scandinavian, perhaps?'

At Colorrossi (or perhaps it was at the Grand Chaumière), I often talked to the Spanish sculptor, Julio Gonzales. I liked him very much. He used to look at my painting and one day when I had produced a somewhat luscious nude he said, 'You're clever, are you not? But you do not need to come to Paris to show this. What you have to do

is to show us what you can do *with* your talent. Something just that different, something that seems a little more. You have the equipment, so do something with it.' Gonzales himself at that time was in a mood of uncertainty. He was changing from painting to sculpture, to the metal sculpture which so much later made his name famous and became the basis for so much work done in our time. What Gonzales said stuck in my mind; it reiterated what Francis George Scott had told me before I went to Paris.

Flora Macdonald's maternal step-grandmother had a fine apartment in Paris, to which we were always cordially invited. 'Dearest' was a charming lady who had been the widow of the railroad millionaire, Leyland Stamford, the founder of Stamford University. When he died she had married Flora's grandfather, William Younger. Dr Younger was a famous dentist (he had been consulting dentist to the Kaiser), and in his youth he had been one of the Vigilantes in San Francisco and had bought up large areas of the sand and mud flats round the Bay area, on which the city later expanded. When they came to Paris it was something of a regal progress. 'Dearest's' salon was filled with painters, art dealers, musicians and poets. She herself was a sensitive musician. She financed Lily Pons in her singing career and was a great friend of Stravinsky. Nancy Cunard was often at 'Dearest's' and was, I believe, some kind of protégée of hers.

Sometimes Picasso went, or Braque, and others of the 'great' of the time. Gertrude Stein (who also came from San Francisco) was there and the Duncans (Isadora in her flying garments and Roland with his dressing gown and sandals). Gertrude Stein was not for my taste but I liked her brother Leo, although he was extremely suspicious of this 'modern' art which interested his sister so much. What he wanted to do was to learn to paint like old fashioned artists, as his friend Matisse (whom he greatly admired), had done and so he sat at the Grand Chaumière day after day, struggling with the difficulties of the model. I disagreed with Leo's admiration for Matisse. I felt that he had not lived up to the promise which his early copyist work in the Louvre had forecast – that his much lauded sense of space, instead of expressing great spatial dimensions, too often was an admission of a paucity of ideas, an emptiness rather than a sense of interval. Matisse had considerable early difficulties with his drawing and it

seemed to me that, after much struggling, with disappointing re-
sults, he had found a formula on which he cunningly avoided his
own worst pitfalls. Thereby he gained much fame as a draughtsman.

'Dearest' tried her best to interest Flora and me in all this. She said
that I should be introduced to people of note, to prospective patrons,
to art dealers who would support my work and, of course, she was
right. Flora's view was that it was the old tale of the rich American
widow in Paris with her 'hangers-on', there in force. I was so im-
mersed in my work that I felt it was of much greater importance to
me if I could produce ten good drawings at Colorrossi's than to meet
Stravinsky or any other *habitué* of 'Dearest's' salon. Flora and I turned
our backs on this easy entré into the profitable salon society of Paris
and escaped to the Dôme to talk.

The scene was dominated by the great Cubists who had become,
to some extent, abstract painters. Was abstract art dead? Perhaps
Malevitch's paintings of white on white were just another way of
painting the vast, white Russian winters? Cubism was moving for-
ward along different fronts but there was a desire for something re-
presentational, something romantic in opposition to what was
thought to be the arid vacuum of abstract work. There were argu-
ments of great feeling and intense emotion, ending in fisticuffs and
riot, about this abstract art being absolutely useless, decadent, rotten,
bolshevik and sterile. What was fairly obvious, I thought, was that
the Cubists had made tremendous innovations in painting and
variations in new forms. We listened to the new poets of surrealism.

Surrealism, in contrast to the classical understatement of Cubism,
dug into our subconscious, awakening all the erotic dirt that lay
under the surface we called civilization, which was as thin as tissue
paper anyway. It seemed to probe the undercurrents of the feeling
of our time. When a man is drunk and vomits on the pavement you
can see what he has been eating. It all came up with surrealism. One
is a product of one's environment, a product of the economics of one's
time. Politics are really secondary to the intuitive part that makes art
of any value. What about politics and art? I felt that when politics
dictate, art dies from strangulation.

At that same time a more anarchist approach to art was developing
through Marcel Duchamp. Reverberations were still felt at the

III

Dôme from the episode in New York in 1917, when Duchamp had exhibited his urinal, signed R. Mutt, as *Fountain*. I had a certain sympathy with this anti-art movement. After all, painting was only a personal striving to relieve oneself of inner complexities and was of no other value whatever to anyone, including the perpetrator. All art should be destroyed. What kept it going were the vast number of parasites earning their living off the artist – critics, art dealers, connoisseurs, middlemen of all descriptions. These composed an enormous trading organization which had nothing to do with the artist himself or his work. Art is really worthless, although to some people as necessary as going to the lavatory. To exhibit paintings was a form of vulgarity, an irreligious activity. But as Max put it, 'Hell, the more nude figures, cupids and sphinxes that are taken off the gates and the tops of pillars, and the more plasterwork that comes off walls, the more the artist is being deprived of work. From my point of view,' he said, 'there are not half enough nude women in the world.'

So we watched Picasso going past with his long, trailing raincoat, a little frayed at the edges, or Roualt striding by with his great cross swinging to and fro to work on his lithographic stones at L'Hôte's studio in the afternoons. Or Vlaminck, a stocky man with a bullfrog face, cracked like a walnut shell, stopping to talk to a friend; while Braque paid a visit to Man Ray's studio which was above the one which Max rented. Flora was terrified every time Marie Laurencin's strange ghost-like face peered over her shoulders at Colorrossi, to look at her drawings. Why indeed should we bother with 'Dearest's' salon?

Flora and I were married at the British Consulate in Paris in the spring of 1927. Although I had no money, Flora felt that we should be able to live on her income until such time as we would make names for ourselves in the art world. So, as a temporary measure, we returned to Selkirk where Dr Graham (our family doctor) lent us an empty war office hut as a studio. Here we settled down to paint and sculpt in earnest. We worked as we had never done before. Flora made sculptured portraits of babies and children, while I tried to work out all that I had learned in Paris, all that we had argued about, all the theories to which we had listened. In 1925, when I had gone

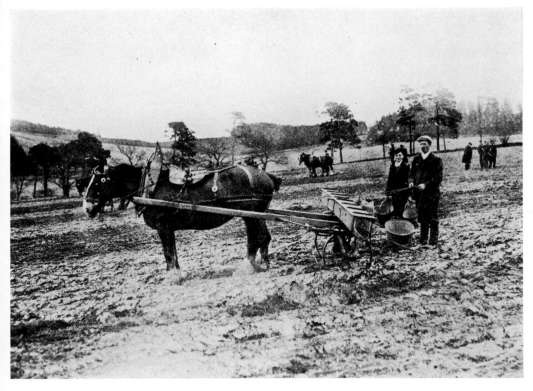

Greenhead Farm, 1912. The author as ploughboy.

With my parents, my daughter Elizabeth, Flora, and my mother's maid at Selkirk, 1936.

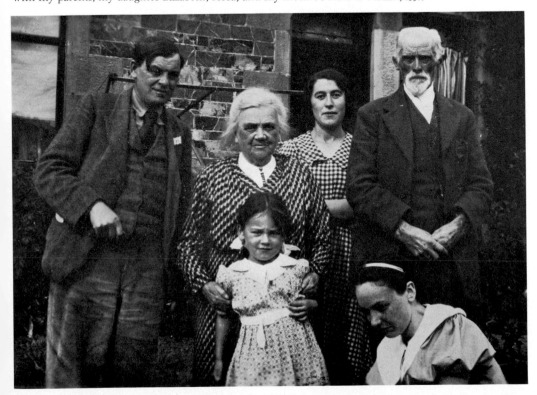

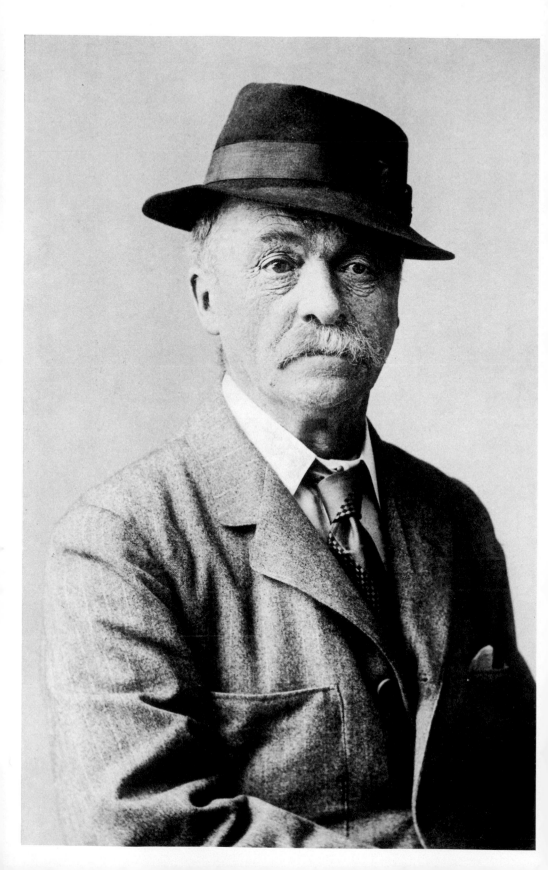

Above: A five-minute drawing done at André L'Hôte's studio, Paris, 1926.
Left: Tom Scott R.S.A., 1912.

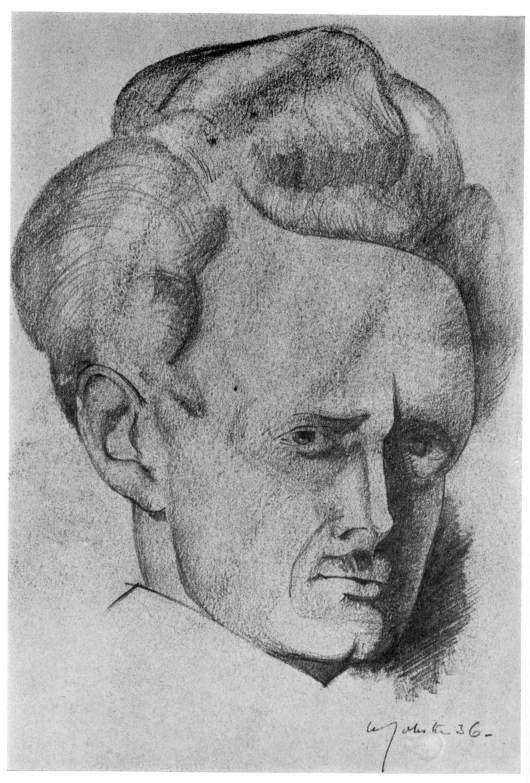

Drawing of Hugh MacDiarmid, 1936.

to Paris, abstract art was already under criticism. Cubism had shown a positive relation to science, a breaking down and joining together. It had never been wholly abstract, rather it was a mixture of Classicism and romanticism expressing an inner psychological power. But this movement, so revolutionary at the beginning of the century, was losing vitality and there was need for a change.

The influence of the Symbolists was felt. As Gustave Moreau expressed it, 'I believe only what I do not see, and solely in what I feel.' This was the romantic movement out of which developed the unconscious 'real' or 'super real' of the Surrealists. At André L'Hôte's studio the teaching was based on an analysis of the Old Masters in relation to a modern idiom (Cubism). I followed a course of abstraction and for a time painted what would be called 'Abstract' pictures. My earlier paintings in Scotland had shown a natural and unconscious tendency towards symbolism. All the influences of the School of Paris were most valuable but one thing had to be remembered and that was that the main point of the exercise was the finding of myself. What did I have that was mine? This was what I had to discover.

On leaving Paris I was thrown back on my own resources. I determined to explore the artistic heritage of my own country to try to discover whether there was something in it valid for me. There seemed to me to be no immediate tradition in Scottish art worth talking about, so I turned to the study of the great Pictish and Celtic stone monuments with their magnificent carving and beautiful incised line drawings. These made a powerful impression on me and much of this primitive art seemed to be an earlier form of symbolism or surrealism – the surrealism of God the Father when he used Adam's rib to create a woman.

In the summer of 1926, I painted some post-Cubist landscapes which, while they did not satisfy me, did supplement my Paris 'abstract' paintings. The difficulty was that these two aspects, the romantic and the abstract, just would not stick together. That summer, too, I had worked on an abstract painting based (I think unconsciously), on a Celtic rhythmic theme. This was later known as *Selkirk, Summer, 1927*, not because it had anything to do with either the town or the season, but simply that it was finished during the summer of 1927. When I painted from nature the results seemed to me to be

unsatisfactory, they were merely 'good' painting, so with greater stress and effort I attempted to bring together my Paris experiences, my knowledge of the countryside and the history of art via André L'Hôte, to produce landscapes of greater intensity and depth. I used my native landscape as a basis for a free development of movement and direction. My feeling of release in these pictures was intense. I was edging away from the 'view' and feeling or groping for something deeper, more fundamental. They were dark, sombre pictures in which I tried to show the primeval strength of my Border hills.

On Sunday evenings in Paris, Max and I used to go to the Folies Bergère or Pigalle's where we were greatly amused. It occurred to me that I should like to paint a composition based on the Folies Bergère. After all, Toulouse Lautrec and many other painters had used this subject, why not I? I felt I had the technical equipment if I could only use it, but how to tackle the subject? Naturalism, photography, imitation were all 'out'. The medium and technique would have to be of the School of Paris. Before going to Paris I had painted an imaginative picture which I later called *Celtic Totem* and this gave me a basis for my *Folies Bergère*. At home in Selkirk *Folies Bergère* kept floating in my mind. I went for walks, lay about, stagnated. I felt this picture must be all or nothing and I heard the voice of Francis George Scott, 'You have got to do something to it', and Julio Gonzales saying, 'The Venus de Milo and great classical art is only useful to put pins in it.'

I started to paint *Folies Bergères* in a fine state of madness caring little what other people said or what the result would be. I was inspired by Robert Burns: '. . . But how the subject-theme may gang, Let time and chance determine: Perhaps it may turn out a song: Perhaps turn out a sermon.' My first strokes of paint were arbitrary. I worked from the edges of the canvas and disregarded all College of Art prescriptions of 'how to do it'. The structure of the painting was basically Third Stage Cubism but I allowed all my feelings and intuitions to move me to excess. A feeling of mystery pervaded the composition and, by an odd chance, the legs and feet in the lower half of the picture made a great contribution to the whole by producing a contrasting rhythm and movement to the upper half. I felt this painting was my greatest achievement so far.

As a contrast I painted a picture called *Knight*, a composition leaning heavily on a Celtic linear pattern with overtones of the Border reivers' visored headpieces. Then I took a painting which I had done in Edinburgh as a student in 1923, which I felt had not been successful, and applied to it what I had learned through painting *Folies Bergères* and something of my studies from Giotto. This picture, which I called *Sanctuary* occupied me for a long time. Flora and I both worked on the preparation of two large panels which she planned to use for compositions based on life at the Dôme. It was a long and slow process. We glued scrim (cheese cloth), to our half-inch plyboard and then applied gesso, which had to be worked down with sandpaper to a perfect smooth surface. Two other coats of gesso were applied and worked down so that our final surface was as beautiful as ivory.

It seemed almost sacrilegious to destroy this surface when we drew in the designs from Flora's cartoons. She used egg tempera to paint them, leaving large areas of gesso unpainted. In certain areas she used gold leaf, and in some places painted in oil over the tempera. Our recipe for these panels came out of Lawrie's book *Painters and Painters Materials* and the experience we gained from them was a tremendous education. Later, I varied the technique to use sand and other media to give variations in the surface of the panels I painted, and much experimentation was tried before I finally finished *Sanctuary*.

By 1927-8 I had made many small paintings developing studies in space and rhythm, then larger paintings such as *Ode to the North Wind*, *Conception*, *Seed* and *Garden of the Hesperides*. These pictures began to be motivated from an inner being, the subconscious, and had no relation to the visual world as seen by the photographic eye. I was trying to bring form back into painting as I felt too much importance had been given to line and pattern. Some of these paintings, too, represented a feeling of disillusion after the war which had, of course, made a deep impression upon me. This tremendous, unnecessary slaughter of human beings dug into me, and to paint pretty pictures revolted me. I felt that the carnage was certainly not at an end, that it was continuous and only a matter of time before the next holocaust began. This undercurrent influenced all my work at the time. It was strained and harsh and in some pictures I used a deliberately coarse

drawing (rather than a drawing of refinement as Botticelli used in his Venus), indicating the brutality of the time.

This constant practice of painting taught me to look beyond the object, the visual world, into the other inner world which was me. The concept of nature as something seen changed, to become something absorbed into my inner being. I understood that art is greater than life, also that art is much greater than technique, which can be accomplished by sedulous practice. Through painting I began to understand a concept of eternity in which always and forever there is illimitable change, a continuous metamorphosis and new identification. An osmosis occurs when I, the painter, become my subject; I am as much a part of nature as my subject; my inner vision is shared between nature as an external object and nature as myself. The culmination of this period of painting were three large (54" × 96") pictures called *Point in Time*, *Golgotha* and *Valley*. These paintings grew out of my horror of the disease of war, of the anticipation of future tragedy – they were never intended for drawing rooms. By now I had given up any idea I might once have had of making a career in painting, of being a famous artist. There was God and there was Mammon. What I needed now was more and more dedication and in this I was supported wholeheartedly by Flora.

One morning Dr Graham looked in to see us working in his shed – he was appalled. He dashed out again to his car and drove off down the hill. 'Quick, Flora, come on, he's gone down to see my father. We'd better go and hear what he says.'

We collided with Dr Graham coming out of my house in a great flurry, and went in to find my father very despondent. 'Dr Graham has just been in.'

'We know.'

'He tells me that madness and genius are so closely allied as to be almost indistinguishable. He thinks you are mad!'

Margaret, my mother's servant, was hanging out the washing on the back green. In her raucous voice she shouted to a neighbour who was busy with the same occupation, for all of Selkirk to hear, 'The young maister's back. The Maister says he can neither make heid nor tail of his pictures. He's been away in hot countries and the heat's gone to his heid. He's fair daft, he'll ne'er be the same again!'

But my mother was convinced that her son was a genius, what-ever her neighbours in Selkirk might say. She felt she was on firm ground here as had not her father, Robert Greenwood, helped found an Art Gallery in Hawick and had not she, when a child, been taken to see the great Pre-Raphaelite paintings in the Manchester City Art Gallery? She affirmed, 'Not one of these people who criticize you, William, know anything about the subject at all.' To Dr Graham who suggested that, as there were a very great number of nude drawings about the house, I must have too much carnal knowledge, she re-plied, 'Doctor, you'll have a fair number of nude women under your hands yourself, in a professional way.'

We had a great ally and friend in Mrs Norah Graham; indeed, she was the only person in Selkirk to have any interest at all in art. As a child she had lived in the artistic milieu of Bedford Park (which her father helped to build), opposite the Yeats family, and Norah was sent to take drawing lessons from Jack Yeats. She remembered the family as being very kind to her except that every day, on entering the front door, she was expected to stick one pin into a picture of Queen Victoria and another pin into that of Mr Disraeli. The con-viction that the Irish loved hatred remained with her. She attended the Central School of Arts and Crafts in its early days and, when I knew her in Selkirk, had an enthusiastic devotion to the arts.

I had painted two portraits of my father while I was a student in Edinburgh. The first had been painted with a quick intensity in one sitting of about three hours, and the second, painted a couple of years later, had 'composition' – my father was sitting reading on a chair against a background which I had made part of the picture, as opposed to my earlier attempt in which the head was merely stuck on to the canvas. Naturally enough, Norah was horrified by the manifestations of my Paris training, but when she saw the second portrait of my father she felt I had possibilities. She was quite con-vinced that my path was strewn with roses as a fashionable portrait painter and she set out determined to find me patrons. She ferreted out everyone on the Borders who had the slightest interest in art (even some who did not know what it was), and sorted out the more hopeful ones whom she felt needed their portraits painted. Having first borrowed the painting of my father she asked Sir Kenneth

Anderson, Chairman of the Orient Steamship Line, to dinner. Next day Norah rushed down to inform us that Sir Kenneth had been most impressed by my father's portrait and had remarked that a chap like me could make his fortune in London with portraits of this kind. Norah told me that this was my great opportunity. Sir Kenneth came next day in his new little bullet-nosed Morris and gave me a commission to paint his portrait. He told me when he would be free to leave London and spend some time at Yair, his country home. His chauffeur was to come for me, and I was to paint in the morning, have my lunch and be taken home in the afternoon.

The day came, and Sir Kenneth was pleasant indeed. He told me that he had gone over every room in the house to find the correct lighting and had chosen a room with a north light where we would have absolute quiet. He had found a platform on which he had placed a suitable chair. He gave me the key of the room so that no one could possibly disturb any of my painting equipment.

I started on the portrait, and my God, it was difficult! I found out, as many a portrait painter must have discovered before me, that a painter can only have success with the particular type of sitter who suits him. If he attempts to paint another type of head he will have a catastrophe. Sargent, in his great days, only chose sitters who were suitable for his technique, those who had certain characteristic features in their face or body which suited his bravura. I realized very quickly that Sir Kenneth was not the type for me. I enjoyed his company as he was a most intelligent and interesting host and a most kind and considerate sitter, but my painting made heavy weather. I worked for several days without getting very much further with it. One morning, Sir Kenneth wanted to see how it was progressing. He had a chalk mark on the floor round the chair legs to keep it positively in the right place, and I noticed that he pushed the chair back a little as he rose to come across to the easel. He looked at the portrait and saw this time that there was some sign of improvement, that a great march forward had come that morning. Pleased, he returned to the chair, and I pointed out that it had moved. Sir Kenneth was infuriated and was convinced that someone had entered the room contrary to his instructions. He wrenched the bell pull with such force that all the fine tassles and embroidery fell to the floor

and I was so shaken with laughter that I had to hide behind the easel.

I did my best with the portrait but a point was reached where, as in my copy of Fiddes Watt, I could do no more. It was certainly not like the portrait of my father, but Sir Kenneth kindly paid me £50.

I did not see Sir Kenneth for some time, but Norah came to tell me that I had certainly made a mess of it. She told me that all his relations had seen it and were horrified. They thought that I had made my sitter look like an ex-convict. Norah explained that my portrait was too accurate, too good a likeness; that I had been stupid and painted the portrait sincerely and truthfully, thus destroying any chances I might have of going to London to paint boardroom portraits of City millionaires. 'Couldn't you have put him in a place where you could hardly see him and just brought out a few highlights? How tiresome it all is. We don't live by sincerity, William, we live by insincerity.' I was quite positive that the life of a fashionable portrait painter was not for me.

My father made a final attempt to lure me back to farming, offering to buy Bridgelands, a good stock farm with a most attractive house. We walked out to see it, but Flora would have none of it. We were to become artists, not farmers.

William Ritchie, who was then Director of Education for Selkirk-shire, asked me to give some lectures during the winter of 1927 to be held under the auspices of the Workers Educational Association. I was also to teach day release students at the South of Scotland Techni-cal College. I was not very keen about this, but I needed the money and I supposed this teaching would provide some experience which might, one day, prove useful. I consulted Ritchie on how to approach the subject and he gave me the following advice. To stand still when you enter the class, look at the ceiling as if you had seem something crawling on it, then pause as if making an effort to remember a point of interest, and start talking about your subject gently and in a low voice so that those in the back seats can scarcely hear. Nothing is so annoying as a voice speaking too low to be fully audible, so that those sitting in the back then demand that the others be quiet so that they can hear. You then have your discipline. After that it is up to you to produce something of interest to which they will continue to listen.

It was the first time that I had had to organize my thoughts, an

essential discipline. I had to make clear in my own mind the multi-farious pieces of knowledge which I had accumulated. Did ancient works of art have any relevance to modern art? What was tradition? Why bother with history of art at all? I had no intention whatever of teaching what I had previously been taught at the Selkirk High School. I wanted to teach with the new approach to art which I had learned in Paris, and I felt I had the experience to make my teaching constructive not only to my students but to myself; instead of handing out a formula (weaker with every dose) I intended to strengthen the dose with every spoonful so that my teaching should be a really creative process, and furthermore, that my students should give something back and teach me.

So I introduced a method (not used at that time in this country), of teaching art from abstract shapes, from a series of patterns, from a series of relationships. I introduced my students to varying approaches in which the student could see for himself the extensions that could be made. I included, for the benefit of my day release students (some of whom were signwriters), an exhaustive and analytical study of the Roman alphabet, trying to get them to understand not only the shapes enclosed by the letters but the shapes of the surrounding space. For want of a better word, I introduced what is now termed a 'basic design' or 'foundation' course, and this turned out to be a great success. I had to submit my synopsis for twelve lectures to William Ritchie, and he sent for me to discuss these. 'The first three headings alone will last a long, long time. Go home, take the three headings and spread them out, and then bring back your proposals. What you have to say will last throughout your life. You will have to learn to hand it out to your students in small portions.'

But painting was my vocation. I had never, ever, had any serious intention of teaching art, and when Flora and I were married, we hoped that by careful housekeeping this could be avoided. After that winter in Selkirk we planned to paint in the South of France.

In the spring we set off for Cagnes-sur-Mer. There we met Soutine, a most amusing man, nearly always drunk, although I believe at that time he had a fine patron in the American collector, Barnes. He slept in the wineshop halfway down the hill. One night he fell asleep in the cellar, leaving the tap of one of the great wine barrels open and

by the morning all the wine had run out of the barrel and was pouring out of the cellar and down the street. Soutine nearly drowned and the woman who owned the shop was furious. We met a great uproar in the street, when she was threatening to throw Soutine out and never have him back again. While I could see her point, I said that I was all for the artist and thought that she was too extreme in her views. In the end she calmed down and allowed Soutine back. Lower down the steep street there was the horse butcher's shop where Soutine used to paint. One day he was there painting a horse's head and he was very drunk. He stepped back from his easel but could not steady himself until he hit a stone wall, when he rebounded against his painting on the easel. The horse's head, his easel, his wine bottle, his paints and himself lay scattered over the ground. He was covered with paint and blood from head to foot. He was set up on his backside against a wall to see whether he would 'come to' and there we left him.

We were enjoying ourselves painting in the lovely Midi countryside, when we had a letter from our bank manager in Selkirk asking us to return at once. Bad news had come from San Francisco, there had been a financial crisis and it appeared that Flora's money was lost. We could hardly believe this disaster and had to begin making our way sadly home.

Back in Scotland the full force of our dilemma struck us. I answered endless advertisements for an art teaching post, twenty-five in all, I think, and only twice did I get as far as the short list. Once, in Bathgate, I was interviewed and told that, although my application was very good, they did not think that I would have any interest whatever in elementary school children. They did not want art, but some one to look after the children, so they gave the job to a young lady straight out of Moray House Training College. I applied for jobs in England with no better success. Flora became impatient and the financial situation in America regarding her own and her mother's property became more critical.

In this despondent situation we left for America, leaving my mother weeping. She felt that I would never be able to settle down to make any sort of constructive life. My father was heart-broken and would barely come to the door to say good-bye. He had looked forward to

seeing me as a well-to-do farmer with a good position in the country-side and here I was, confused with art, speaking an incoherent jargon about incomprehensible matters, with an American wife who was as foreign as a Chinese lady. There had been no stability since the war and the case was simply hopeless. Perhaps in a foreign country something would turn up?

8
America 1928-9

Amidst gloom we sailed from Glasgow on the Cunard/Donaldson ship S.S. *Caledonia*. She picked up Irish emigrants, then sailed into the Arctic regions of the North Atlantic. We glided past the coast of Labrador, watching whales and icebergs until it was hardly possible to remain on deck in the bitter cold.

We reached Chicago, staying at a low-grade hotel in the Loop. The elevator was filled with the most terrible-looking crooks I had ever seen in my life. We had a lot of luggage, rolls of paintings, a folding easel, the usual clutter that artists always have. While we were getting these into our room I left the door open and a tough-looking dame (slightly cleaner than our companions in the elevator) said, 'Buddy, didn't you notice you've got a lock on your door?' I paid no attention because I still had some rolls of paintings to bring up. Eventually we struggled up in the elevator with our last load. Again this dame said, 'I told you, bud, you've got a lock on your door.'

'I know.'

'Well, you'd better lock it. You've got a pretty girl in there, your wife – you'd better get inside and keep it locked. If you don't know where you are I guess you'll soon find out.' I thought this sounded rough.

We dined with my father-in-law, who took us for a wonderful drive through Chicago along the lake shore before leaving us in Madison Avenue at the end of the Loop. It was a beautiful night and as we began the walk back to the hotel, I told Flora that I thought Chicago seemed much quieter than one would think with Scarface

Capone and all this sort of stuff you read about. It seemed so pleasant in the evening – hot, right enough, but very pleasant. I had just finished speaking when there was one hell of a crack and glass fell down right and left. We were covered from head to foot as if we had been in a snowstorm. The whole of Marshall Field's windows were blown out. What a hullaballoo, sirens, ambulances and policemen. A cordon was put round it, and a man ran into me nearly knocking me flying, he was so keen to get away. He was running like a race-horse and he ran right into my stomach. The whole place was in an uproar. We thought we would move on next day to California.

We got our coffee in the morning to find that a lot more thugs had moved into our hotel. This dame appeared again. 'You'd better get out, buddy.'

'We are on our way.' I was relieved when the cab driver took us straight to the station.

It was a wonderful experience crossing the great plains right away out to the West over the Rockies. The heat was intense (no air conditioning then) but dry and exciting. The train rocked over the Great Salt Lake. At midnight we saw the brilliantly lit town of Reno, going full blast, never stopping, like the fun fair at Battersea Park on a grand scale. We passed through Nevada into California, running down the Sacramento Valley. It was magnificent.

Trains stopped at that time at Oakland, so we took the ferry across the Bay to San Francisco, where Flora's mother met us to take us to Los Gatos. This was a dream. Flora's Aunt Maud had a charming house perched high on a mountain ledge overlooking the Pacific. At Los Gatos there were orange trees, rattlesnakes, king snakes, lizards, bob-cats and pumas (mountain lions). At night, to save the taxi fare from the station, I used to walk up to the house, a distance of about three miles. The dirt road spiralled up and up round the mountainside, and in the dark I saw lights, a pair in front of me, a pair on either side. I kept walking on, pretending the pumas were not there, but every time I glanced round there would be another pair of eyes. The mountain lions followed me right up to the house. Every night we heard them padding round outside, gently breathing.

I loved Los Gatos, but we had to move to San Francisco to find a job. Flora had another charming aunt who managed a block of fur-

nished apartments in Oakland. They were very expensive but Aunt Hilda kindly let us live in one before it was redecorated for an incoming tenant and when the new tenant came we moved on to another one. Life became something of a Keystone Comedy especially as the beds disappeared into the wall at the touch of a finger in the very latest fashion.

We had arrived in San Francisco at the beginning of the Crash and there was a distinct feeling of restraint, a drying up of opportunities. The Depression was seeping in.

Aunt Hilda was a good customer of Mr Stein's decorating firm. She felt that with my training in art, both in Edinburgh and Paris, I might be valuable to Mr Stein. He was disinclined to believe this, feeling certain that mine was a different kind of painting altogether, but he offered me a labouring job, starting at 6.30 a.m. on Monday morning. This meant a 5.30 a.m. start to reach his premises in time to load up the lorries, ready to drive straight back to Aunt Hilda's apartment block where there were two vacant apartments ready to be painted. Then we moved on to an office block of thirty storeys, where each ceiling was about 14 feet by 12 feet. Trestles and planks were produced, and a huge young German brought our implements – a pail and two sponges each. We were allowed eight minutes to wash each ceiling. The unsteady platform wiggled so that I had a great feeling of insecurity without ever touching the ceiling. Arms out, arms in, arms out, we shifted the planks every minute. My German colleague was very helpful but when Mr Stein appeared we had fallen behind our schedule by one minute. The German said we would make it up on our next ceiling but, alas, with me as his partner, we lost more time. The next day Mr Stein put me on to cleaning windows, but this job was nearly fatal for me. There was a safety belt, but you had to see to it that the window was fixed before leaning against it from the inside, and I failed to do this. The window went away with me, thirty storeys up, and I only just caught myself from falling. I scrambled back in again and sat down to recover. Mr Stein felt that I was hopeless.

However, on the following day they were moving a frame house from one area of San Francisco to another so perhaps I could assist in this work. The house was lifted off the ground with jacks, so he

thought I could count the screws and move round the jacks with another man, continuously fetching the whole up level without breaking its back. This I managed to do as it took plenty of time, there was no rush in turning the jacks and watching that the house did not crack; in fact, the less speed the better. It was lifted bodily off the ground on to a low trolley to be moved to its new quarters where it was set down. I had the job, in company with a cigar-smoking Dane, to clean and polish the hard-wood floors with wire wool and wood alcohol. A notice was stuck up: 'No Smoking'. I struggled on with the wire wool and housemaid's knees. The Dane rested for a moment, looked at me scornfully and guessed that someone would be fired soon – then he lit his cigar. Stein fired him for smoking in the middle of the wood alcohol while I battled on with the floor by myself. My hands were completely black with wire-wool splinters, which got under the skin and below my nails. Nothing would get them out.

I had nearly reached the end of my endurance when a message came from the California School of Arts and Crafts asking if I would go for an interview with the Director. Dr Meyer came from Germany to build up this School with perseverance and enthusiasm and although he had established a link with the University of California for some of the teaching courses, the School was chronically short of funds. He could only promise me a very short engagement, but the morning and afternoon teaching he offered came to about the same amount as I was getting for nearly killing myself as a labourer in Stein's paint outfit so I jumped at the chance.

Professor Xavier Martinez, who had been a student of Whistler's in Paris, was the leading artist at the School. He was in touch with European painting and was considered a great man in San Francisco. Professor Martinez was a Mexican with a black band round his brow and a small feather sticking up at the back. He wore a little velvet coat which had once been a frock coat but had become very worn. He carried a pair of scissors in his pocket, and when his coat became too fuzzy and frayed at the edges, he would cut another little bit off all the way round so that when I met him it was more like an Eton jacket than a frock coat.

He was charming, welcoming me to California. He thought it was

entirely my pleasure whether I taught drawing or whether I taught painting. I discovered that the Professor had his own special system of teaching. He had a long cane, about seven or eight feet long, and students whom he had previously corrected received an unexpected rap over their fingers if they continued to do their work badly.

Neither my mother-in-law nor Aunt Hilda were very happy about my working with Xavier. They said that he was considered to be most dangerous and very, very inflammable. He carried a sawn-off shotgun in his trouser leg which he might draw at any moment. They felt that the less one had to do with the Professor, the better, but Xavier never drew his gun on me. I found him a delightful man and my work at the School was most enjoyable. Xavier talked often of his days with Whistler in Paris and always spoke of him with great affection and respect. His Mexican background gave his work a depth of feeling and richness of quality, and although his natural Mexican/ Spanish culture had been overlaid with the teaching of Whistler and the Impressionists this never destroyed its intrinsic power and virility. After Paris, Xavier returned to Mexico rich in ideas and full of en-couragement for the younger painters who were his friends – Diego Rivera, Orozco, Siqueiros. These painters had been lucky in the en-couragement they received from the Minister of Education, José Vasconcelos (one of Latin America's outstanding intellectual figures), when he engaged them to paint murals on the walls of schools and public buildings interpreting the history of Mexico for a preponder-antly illiterate people. I looked forward to meeting these artists when they came to visit Xavier in San Francisco.

Christmas came, and to Xavier's disgust, I had to leave the Art School. The money with which Dr Meyer paid me had run out and he could not raise any more at that time. I was sad to leave as both Dr and Mrs Meyer were very fine people.

While I was working in San Francisco, I would sometimes go to see Freemont Older, a rough cigar-smoking tycoon, who was the editor of the *San Francisco Call Bulletin*. He lived out near Gilroy, at that time a charming little town down the coast, and when he went to San Francisco, the train stopped for him in a field near his house. Free-mont Older said that however smart an apartment you had in San Francisco or London it was always a slum and that the only place a

civilized man could live was in the country, no matter how far he had to travel. His pet hobbies were Alcatraz and the reform of the prison system, including the abolition of hanging. (California did not use the electric chair at that time.) He spent a lot of time trying to organize the release of Tom Mooney, an Irishman who was under sentence of death. This man was alleged to have thrown a bomb during a demonstration on behalf of the longshoremen. Unfortunately someone died as a result but it was never satisfactorily proven that Mooney was actually responsible. It became a celebrated case in San Francisco, agitation for and against hanging Mooney became blurred by arguments for and against Socialism, and in the end Mooney was given a life sentence. He was released only a few years ago.

Older took a great interest in the Mooney case, always bringing it up in his newspaper and he visited Alcatraz quite often. He took all the parolemen down to his ranch to work, although unkind people remarked that this was how he got cheap labour. He sometimes had most distinguished convicts, among them being a big bank robber, out on parole, who later went to Metro-Goldwyn-Mayer as their chief crime adviser. There was one tremendous party that Older gave at his ranch for the writers of America, to which about eighteen hundred people turned up and all the cauliflower ear boys from Alcatraz were there as waiters.

At that party I met Gregor Duncan. He was young, solemn, very restrained and slightly depressed because he had dreamed one time of being a serious artist rather than a newspaper cartoonist. A delicate, sensitive man, he had to work with this tycoon, who had a cigar burning his moustache and a whole bucketful of cigar butts smouldering by his desk.

A young man called Reilly had held up a bank in Market Street and shot a policeman. At his trial he was sentenced to death. Freemont Older sent for Gregor, and said, 'I've got an idea, you're going to like this, Duncan. I'm going to arrange to get all the scaffolding ready and I'm going to arrange for you to go over to Alcatraz and you're going to have the whole thing drawn ready and all you'll need to do at the actual hanging will be to put Reilly in. Don't you faint or do anything stupid like that at the last minute because I'm

hoping to roll that stuff off by the ton, and this is why I'm arranging for you to draw this all beforehand. All you need to do is to put the man in before they pull the bolt. Are you clear? For God's sake don't faint.'

Gregor said to me, 'I can hardly sleep at night for thinking about it. Older's got these arrangements at Alcatraz for me to go over two days before this man's hanged, to draw the scaffold; he's written the caption: LAST SCENES AT ALCATRAZ. SEE REILLY ON THE SCAFFOLD. This is to go all over the front page. The machines are all set to run it off.'

'Much as I'd like to help you, Gregor, I'm not going near that at any price, and if it comes to fainting, the chances are that I'd faint first.'

'You won't come?'

'No.'

'It'll be terrible if I faint, won't it?'

'You can faint for yourself, if you like, but I'm not going to that.'

Gregor fainted, as it was sure as death he would.

'Good God,' said Older, 'I knew he would do something stupid, didn't I tell him to get that all done ready? Let me see. Bring up S—, he's in the Linotype. He looks about the size of Reilly. Some string! We'll get him on a block. You stand there. Duncan's bound to recover, it can't be long before he gets back.' When Duncan returned he felt low. 'Forget it, forget it. I've got this man on a box and there's the string round his neck. Now you draw him in; see, you just draw him in there.'

Gregor drew the man in and the paper went out, boys running up and down the streets: 'SAN FRANCISCO CALL-BULLETIN! LAST SCENES ON THE SCAFFOLD! DRAWING OF REILLY IN HIS LAST HOUR BY GREGOR DUNCAN! SAN FRANCISCO CALL-BULLETIN!' Mr Older went away home with his cigars to Gilroy for the night.

Freemont Older was not a mean man providing he was getting what he wanted, but not a penny otherwise. He needed art, so he employed first rate artists on his staff, and Gregor Duncan was a beautiful draughtsman. Older's fashion drawings were done by the Bruton sisters, two very distinguished artists who had both trained in Paris. Their work was brilliant, far ahead of anything else I had

seen at that time in this field. I realized that to print these fine draw-
ings Older must have had most excellent printing machinery, far in
advance of that used in Britain. He asked me to paint his portrait.

Sometimes I would cross the Bay to visit Ashfield Stowe at his
shipping office in Market Street. Ashfield had married a cousin of
Flora's who patronized artists. He was a director of the Hawaiian
Steamship Company and considered to be a great authority on
marine insurance. I was always hoping that he would give me a
steamship poster to design, but Ashfield was a real rough Western
American, very difficult to handle. He was a big man, afraid of no-
thing. People said that he was often held up by the same bandit on
his way home from work. He took it as pretty near routine, handing
the man five or ten dollars and pushing his gun away. His father had
been one of the early truckster bosses in San Francisco, taking cargo
from the boats into the city.

During one of my visits to his shipping office, Ashfield said,
'William, I can do nothing with art, nothing.' He laid one of his large
cigars down on the table. 'What you've got to do is simple. If you
want to be in San Francisco you've got to go down on the waterfront
with Jim McCullock and you've got to watch those boys loading and
unloading the ships at night. Those longshoremen are rough men.
Jim says if you can't get on with them they'll throw you in the sea.
You've got to learn to handle those men, great rough Irishmen,
Poles, Germans, Scotsmen, whatever. On to that waterfront you'll
have to go. Mind you, if you last six months on the waterfront you
can last your lifetime in the office, but on to the waterfront you must
go. If you make a success of it I'm perfectly willing to fetch you all
the way up in the shipping business, to be my assistant. You'll get a
lot of money. But about art, I know nothing. I like yachting. Think
it over. Any time, William, you're welcome to come, welcome to
come! Guess you just get down on the waterfront, get on the night
work there and see those boats getting loaded and getting emptied.
Seen Aunt Alice? Very handsome woman, Alice; my God, you must
say that, William, eh? Well, good-bye, William, if ever you change
your mind there's an offer. You'll never make as much at art.'

Aunt Alice was indeed a very beautiful and charming woman who
had been married to a Baron Nugent, an Hungarian. She now lived

at Carmel-by-the-Sea so suggested that Flora and I go there to stay. Carmel was the great artists' colony in California, little more than an overgrown village set between the lovely Pacific coast and the pinewoods. Interesting people lived there many of whom became well known. John Steinbeck wrote about Carmel in *Tortilla Flats*; Ford Stirling, Eddie O'Brien, Joe E. Brown and other Hollywood types stayed there; Tony Lucan, the Indian who had married Mabel Dodge the automobile heiress, lived there. D. H. Lawrence visited Carmel; the poet, Robinson Jeffers, lived in a home which he had built for himself out of boulders from Pebble Beach. (The odd shapes and sizes of these rough stones gave the house a very distinctive appearance.) Edward Weston, the photographer, had his studio near the Golden Bough Theatre.

The centre of the village was, of course, the Post Office where everybody came in to collect their mail and gossip.

Since I was unable to find any employment in the art world, Aunt Alice suggested that I work for a great friend of hers, John Catlin. John, who had once been an attorney, lived at the Forge-in-the-Forest where he made andirons for wealthy ladies at Pebble Beach. John came from the same family as the painter, George Catlin, who was considered the great authority on the American Indian. John himself was partly Indian, and sometimes he would feel the need to go away into the mountains by himself, taking only his blanket with him as a protection against the cold nights in the hills. He was a handsome man with his Anglo-Saxon-Indian head. It took John about two years to make a set of andirons, but that was neither here nor there; Aunt Alice did not worry. I went across to the Forge-in-the-Forest to help with the 'sledging' of these andirons. Mostly we sat on our backsides while John rolled cigarettes and told me about the time of the earthquake in San Francisco when he had been sitting on his bed admiring his new pair of patent-leather shoes. One moment he was sitting opposite a wall, the next he was looking across the Bay – his wall had disappeared. He also used to talk about his time in the Yukon, where, in a bar in Dawson City an Irishman shot him through the side. This wound never really healed so that he was greatly handicapped.

Then we went down to the ice-cream parlour for milkshakes; sat

in the lovely sunshine and talked. Mrs Curtis, the wife of the owner, came from Scotland, so whenever I went in she started to cry with sentimental longing for the gardens in Princes Street and Edinburgh Castle. Her husband demanded why in hell's name did she want to return to Edinburgh when she had plenty of dollars in California? 'Mr Johnstone, will you get your milkshake and get away back with John Catlin, away from my wife? She'll have to lie down on the bed for a bit to recover.' As I went back to the forge I could hear Mrs Curtis playing her sentimental Scots songs on her gramophone.

Adjoining John Catlin's forge was Mr Murphy's woodyard where he employed Mexicans to saw up logs for the winter. Old Matthew Murphy was a frontiersman who had lived all his life with American Indians. He had known many of their chiefs who had taught him much about their religious beliefs, cultural background and the history of their tribes. When I knew him he must have been eighty, so he had been in the West when it was very young and wild. He told me that the Indians certainly resented the white man coming with guns from the East, but there had never been any real war – that only existed in the magazines and in Hollywood.

Murphy had collected great quantities of drawings from Indian sand paintings. He must have had two or three hundred of these which I used to study as they interested me profoundly. Just before Flora and I went to Carmel there had been an exhibition in San Francisco of the work of Klee and Kandinsky. I think this was organized by the Bruton sisters who must have persuaded these artists to exhibit in the West. Whether or not Klee or Kandinsky ever went to California I am not sure, but they certainly knew of, or had seen, examples of these Indian sand paintings. One can see clearly how their own paintings changed from this time (about 1928). Matthew Murphy, I believe, gave his fine collection to the Museum at Albuquerque in New Mexico. I thought a lot about Matthew Murphy's Indian paintings and I used often to go round to his place to see them. He had fine Navajo rugs, too, made before they were wanted by tourists and these works had deep symbolic meanings. Mr Murphy told me how he used to teach the Indians drawing in the sand; next morning they would erase their pictures before moving on from their camping site. Nature must never be desecrated, no

disturbance of the earth must be left to show where the encampment had been.

The Mexicans who worked in the woodyard stood, leaning on their axes, watching. They were big, handsome men with interesting faces – great big sensitive mouths, long moustaches, yellow whites to their eyes – and they looked very picturesque in their great sombrero hats. I found them most pleasant. John Catlin said that they would help you in all sorts of ways provided you treated them with proper respect and never lied to them. Sometimes they came into the forge to temper their picks, and in return for the use of the equipment they would make andirons.

During this period I unintentionally started an art school on a vacant lot. I had set up my easel and begun painting when a man came along and said that he had seen one of my paintings at the Carmel Art Gallery. He was very keen about my work and so Ray Woodward became my first pupil. He lent me his studio and soon I had several students, among them Charles Roberts Aldrich. Charlie was related to the Rockefellers and the MacCormacks. He was a brilliant man, devoted to painting and my painting, at that. He had been through some hectic times, and would occasionally be lost for a day or two until someone found him unconscious in the wilder parts of Monterey, dead drunk on hootch. Charlie's father had been Solicitor General of the United States, and he himself had enjoyed a brilliant career as an international lawyer until he abandoned it in order to study psychology with Carl Jung. In Vienna he married Baroness von Wert who was working in an art gallery. (She also joined my painting class.) Jung had been impressed with Charlie's ability so had asked him to write his biography. Naturally Charlie had been excited by this proposition and he was able to obtain a grant and started work. It became a book called *The Primitive Mind and Modern Civilization* which was published by Kegan Paul. While this opened up interesting fields of research for Charlie it was not the biography that Jung had expected.

Aldrich regarded me as one of the best natural psychologists he had met. He was a very great help and support to both Flora and myself during our stay in Carmel. Charlie always hoped that some of his wealthy relatives would take an interest in my painting so he

introduced me to Chancy Goodrich who was, at that time, one of the foremost collectors of modern art in America. But Chancy never bought any of my pictures, he only cared for French painting. I fully sympathized with this point of view as, if I had been in his fortunate position, I also would have bought from the School of Paris.

My students worked hard, painting from nature among the pine forests and along the sand dunes at Point Lobos. We became ambitious and hired a model, which created a sensation in the village. As we walked down the main street with our model, to paint among the pine woods, John Steinbeck, Eddie O'Brien, Edward Weston and other men with time on their hands yelled rude remarks after us. Eddie shouted, 'You dirty old man, Charlie, you're not going out to paint, you're only going to look at that girl in the nude, you dirty old man!' Everybody turned to watch us. A nude model in Carmel!

We went quite often to meet the Bruton sisters, Armin Hanson (who painted seascapes and harbour scenes) and Clayton Price in Monterey. At the Stevenson House, where Robert Louis Stevenson was supposed to have stayed, we had a warm welcome from the artists who lived there. We discussed and argued about the new movements in avant garde art, about the work of Mark Tobey and Charles Graves on the West Coast.

Two weekly papers were produced in Carmel, the *Carmelite* and the *Pinecone*. The *Pinecone* was for the elite of Pebble Beach while the more intellectual types of Carmel bought the *Carmelite* which was, naturally, chronically insolvent. The famous radical journalist, J. Lincoln Steffans, wrote for it (he had been to Russia immediately after the Revolution and returned to America saying, 'I have seen the future, and it works!'). I did drawings for both papers without pay as this was considered to be good publicity. Charles Lindbergh came to Carmel and Pebble Beach where he was welcomed as an American hero after flying the Atlantic. The *Carmelite* editor felt that I should do a drawing of Colonel Lindbergh for their cover. Lindbergh had no time to sit for this portrait so I had to take a chance from memory and a bad photograph. Instead of barely selling one edition, they had to run off two or three extra editions, nearly using up all their paper supply for the year. Everybody had to have this drawing of Colonel

Lindbergh and the current financial crisis was averted. Another successful cover which I drew was a portrait of D. H. Lawrence, but in general I felt I was not good at this type of work.

John Catlin looked in one morning to tell me that a pretty rough looking man had come to the Forge about 6.30 a.m. He had brought a woman across from Monterey to see me. John said that her handbag was stuffed with silver dollars, and would I please come to the Forge to see her? I went down to the Forge and there she was, a dark Sicilian-looking woman, about fourteen stone in weight. Her name was Mrs Amenta.

'I guess I've just got one thing to do,' she said, 'I want to paint Jesus. I go to the Carmel Mission at five o'clock every morning: I pray to the Virgin for help to try to paint Jesus. I'm willing to pay you handsomely, Professor; just tell me how many lessons I'll need and how much they're going to cost.' She put down a deposit.

So Mrs Amenta joined the class. She tried very hard but her painting was atrocious. I suggested she bought a book of anatomy to try to study the structure of bones, or even better, she might buy part of a skeleton from the shop in San Francisco which supplied the medical students. Soon she was back with the anatomy book, but she could make neither head nor tail of this and her drawing of Jesus remained as flabby as ever.

A few days went by when there was a terrific knocking at our door. I was painting, so Flora went to answer it. There stood John Catlin who said, 'something happened early this morning. A couple of very rough men got me out of bed at five o'clock with a parcel from Mrs. Amenta. She's got you a pair of skeletons. I wish you'd never bothered with this damned anatomy. I guess she's had them dug up out of an Indian cemetery.' I went across to see them and I didn't think they were as fresh as all that, not to cause John so much anxiety. Mrs. Amenta looked in and saw that I was worried.

'If you don't like 'em we'll have to get them away, but you said you wanted them. Up in the corner nobody is going to see. That old policeman, Gus England, is not going to come. I promise you that.'

'How do you know?'

'Professor, don't ask questions. I simply say that the police will not come in here.'

We hung the skeletons up at the back of the Forge. Mrs. Amenta studied the bones earnestly and worked on anatomy until her drawing really did gain some structure.

I helped her improve it enough to be shown in our exhibition, at which she was delighted. She wondered what she should call her painting. Charlie Aldrich passed by at that moment, twiddling the string of his eyeglass, and suggested *The Sailor's Dream*. Mrs Amenta gathered her painting materials, flounced out, departing from the class for good. This was a blow as she was paying me good money. However, I sometimes went across to Monterey to give her private lessons. Here she lived in considerable style in a house within easy reach of the harbour. Mrs Amenta was a most enterprising lady. She ran the bootlegging business, she ran her house as a brothel with her 'nieces', and she ran a protection racket. When I arrived, she lined up her employees for my inspection, and they were the toughest collection you could ever hope to see. They had cauliflower ears and running noses, squint eyes and scarred faces. As I shook hands with them she said, 'Now you'll know the Professor if you see him in Monterey. You've got to look after him.'

Hugh Comstock was building the new offices for the Monterey County Trust and Savings Bank in Carmel. It was to be artistic, in the Spanish tradition of the country, embellished with carved heads of the conquistadores and the missionary priest, fr. Junipero Serra. John Catlin saw this as an opportunity for Flora and me; even though I was no sculptor, Flora was very able and he felt that carving the heads would give us a great chance. The subcontractor told us to start on the project straight away and we worked with great enthusiasm on these heads. After difficulties with the masons, they were eventually put into position and we were quite pleased with the result.

Everybody working on the building was paid, but we received nothing, so I went to see Mr Overhause, the sub-contractor, in Pacific Grove (a somewhat seamy district in Monterey). He said, 'You can forget about it. I never gave you any agreement to pay you money. You're just the beginning of an art student, so it was good practice for you.' This was serious, particularly as Flora had had to have an emergency operation and our money had almost run out.

Jack Jewel, the Builders' Union leader, assured us that we would never get any money as artists, but that there was a Californian law protecting workers, craftsmen or artisans; that no building could be opened until all workmen employed on the site had been paid. So we counted up the heads and worked out a price to cover the carving, the casting and other expenses – the number of hours at the highest rate for plastering ornament, not just plastering a wall. We found we had two days in which to operate before the Bank was due to open. Charlie Aldrich remembered that he was still an attorney and decided to act for us. He said: 'We will go to Salinas where we will get a lien on the Bank to demand its closure; or certainly cancel this opening. There are only two judges in the State that ever tried a case on its merits, and one's Jorgenson at Salinas.' All three of us rushed off and reached Salinas fifteen minutes before the Court closed for the day (Monday would have been too late), and got the lien on the Bank.

In the morning we returned to Carmel, where it seemed that everybody was running round trying to find me to get my pay settled. Mr Comstock himself came with a cheque, but Charlie Aldrich said we could not accept it as we had closed the Bank. Then Mrs Amenta appeared, and said, 'I guess, Professor, you should stick to art. Now, Professor, I don't want you to get into any trouble as I wouldn't want to see you hurt. I've come across to see if you would take this money from me, to forget all about this business.'

'How do you come into this?'

'Mr Johnstone, just like the skeletons, you should never ask questions. Professor, I control more of the Lower Peninsula here than you could ever imagine. Remember, Professor, you must never aggravate me. You know, Overhause belongs to me. He's had a disappointed life. He reckons he's going to get you. Now, Professor, what would you like me to do?'

'Well, the thing's out of my hands now, Mrs Amenta, I can do nothing about it. If I'm not satisfied by the judgement at Salinas it will be taken to the Federal Court.'

At night Flora and I heard her lorries driving down to the coast to meet the cutters. We thought of her grim looking thugs and were very frightened indeed.

The day came for my full settlement, and when I went to collect my money, I found Mr Comstock, Overhause and a gang of bruisers waiting for me in the contractor's hut. They did not look good. Ray Woodward (who had given me a cigar to chew on) and Charlie came with me. I was glad of their company as the atmosphere in the hut was very menacing. One man moved to hit me. 'Assault and battery in the Federal Court if you touch him,' cried Charlie. I got my money, signed for it, and we departed hastily. I had eaten the cigar but Ray assured me that I had established myself as a good and true American for ever after.

We were glad of that money as our own had completely run out; for several days we had been very hungry, indeed I had not had anything to eat for three days.

Most art students stay as art students; they never change. They are unable to add anything to that early experience. I had reached the stage where I was an efficient artist, with all the technique, but I had to do something with it, something that was my own. I puzzled about what Gonzales had said in Paris, 'You have to do something that has come out of your guts, which belongs to you. You have training, you have language, but you'll have to find what to do with it.'

I thought about this often and it worried me. I looked back to see what was in the Scottish tradition that was worn out, or that had never been found – something that could relate to my own needs. I thought about the Scottish tradition in painting which seemed so often to have merely had a root and never a flower, but there seemed to be nothing of importance there. When I studied those Indian paintings, so simple, with such depths of intensity in the abstract patterns, I was reminded of the old Scottish and Pictish carved stones which we had studied in Edinburgh. I remembered the great Celtic and Saxon carvings; I remembered the Book of Kells and the Lindisfarne Gospels; I remembered the Bewcastle and Ruthwell crosses, the Burghhead Bull, St Cuthbert's coffin in Durham. I realized that, in this early Northern art, there *was* something for me. I decided to return home to study this earlier heritage again, to see whether or not it was important to me as an artist. I thought I had found the clue for which I had been searching.

It was a very sad day when we left Carmel. I had won my battle with Overhause & Co. and everybody felt that I would now go right ahead. If John Steinbeck could write his books in Carmel and they could be sold in London, my pictures could just as well be sold in New York. So I left my paintings with Ray Woodward, intending to come back in a year's time and we set off up the coast to Washington, Oregon and British Columbia. We sailed from Montreal. Every mile of the journey I regretted leaving Carmel, and all through the rough, cold passage I missed the sun of California. When we arrived in Glasgow it was raining and very cold. I wanted help with my luggage and a polite Scotsman said, 'Why the hell d'you want help with that stuff? You can carry it yourself.' I preferred the Mexicans at the Forge-in-the-Forest.

As the train left Glasgow the rain poured, the corn stooks leaned together, drenched and soaking. I thought about the beautiful valley near Gilroy, the wonderful fruit orchards of California, and I was sure that I had made a mistake. The more I saw of the weather, and the general dreariness, the more depressed I became. It seemed that our Bohemian life in the West, precarious as we had found it, was so much more interesting; to die of starvation in the sunshine seemed preferable to rotting away with boredom in the rain. I had made yet another mistake – we should never have left Paris, now we should not have left America.

Ray Woodward was to try to sell my paintings and send us the money, and in this way we hoped to pay for our fares back to California. But Ray was ruined in the Depression, he and his wife were divorced, his studio demolished and my paintings were lost. Poor, unstable Charlie Aldrich took out a gun and was found dead.

9

London: a teacher learns

I applied for a vacancy with the London County Council. Mr R. R. Tomlinson, at that time the Chief Art Inspector for the London County Council, was positive that I was not a complete idiot, which was encouraging after my previous experiences in Scotland where they had been convinced that I must either be mad or a fool. This man in the London County Council thought there might be something in what I had learned abroad. He came out after my interview and said, 'Mr Johnstone, I had the greatest difficulty in persuading the Headmasters of these schools to accept you. They've never seen this sort of work before. They were expecting somebody who would maybe teach the children to draw stuffed birds meticulously, or shade a car, or paint an ink-well with a quill sticking out of it; they can see no connection between your ideas and their boys. But I do think you've got something greatly needed in London. If you're in any difficulty when you come I'll be very pleased to help you. I think a great deal of your work, I've never seen anything like it before. I have tried to impress the two Headmasters that they are going to be in a most fortunate position in having a man like you because even the art schools would not have this kind of work. I'd like to keep in touch with you when you come to London.'

I had been appointed as an assistant art teacher at Lyulph Stanley and Haverstock Central Boys' Schools at a provisional salary of £192 per annum.

William Ritchie felt that all this sounded ominous. He felt that I would find London art education far worse than in Selkirkshire

under Van Brown but, undismayed, Flora and I set off. We travelled south with our cabin trunk filled with blankets, painting equipment, rolls of canvases, china and a camp bed. We found a room, in fact, a derelict garret, in the Portsdown Road, Kilburn. Devoid of furniture, it certainly did have a feeling of space and empty grandeur! We were both strangers to this great city and neither of us could summon up enough courage to go out into the street to look for food.

Next day I set off for the Lyulph and Stanley School – my day for being free to paint at will, free to do as I liked, was over.

The school was near St Pancras Station in a very poor district. The old buildings were rotten and worn out and they stank of humans, decay and poverty. The Headmaster welcomed me and introduced me to his staff who seemed a very pleasant group of men, whom I later discovered to be most serious teachers, keen to do everything they could to bring vitality and interest into the lives of these children. I was to be assistant to an art master of the old school who had never heard of the School of Paris.

I soon realized how heavy was the task of teaching boys every day for five days a week; how much they would be taking out of me each day; how much in the way of replenishment had to be gathered for the next day; on and on and on. To earn enough money to keep us I found I needed to do more than this. I had to give lectures five nights a week at various literary institutes; to prepare these lectures; to collect slides for them on Saturday mornings. In spite of this grind I was determined to regard the work as a creative act, or a creative progression, and to teach my pupils as if they were artists so that I could remain an artist myself instead of being drained completely.

The mass of art education in the early thirties was as dead as a dodo. This not only applied to elementary, secondary and grammar schools, but to art schools as well. Here the great Cubist and Surrealist painters were unheard of, and even public art galleries did not consider buying this avant-garde art. We still suffered from the 'bare walls' fashion of the twenties when to hang a picture on your wall was tantamount to social ostracism. On the Continent there were movements of change in children's education. Important work had

been done by Montessori, Froebel and Cizek, but echoes of their fame were only just being faintly heard across the Channel.

The Headmaster at Haverstock Hill was much more sympathetic and while he did not understand modern art, he was most kind and encouraging. I worked out a programme of how to deal with my classes, so many every hour, four or five hours a day. My wilder boys were not interested in drawing so regarded the art classes as an opportunity for mayhem. Materials for work were mislaid, and half the stock of pencils and rubbers for the term were lost by the end of the first lesson, until I discovered the ringleader. I put him in charge of issuing our equipment at the beginning of each lesson, with responsibility for collecting it again at the end. We lost no more pencils and rubbers. I always have great sympathy for those teachers who have vast classes and still endeavour to give something to each child. It is a very great strain on any human being because children suck so much out of you that to come fresh to the job each day becomes a tremendous exhaustion. I was determined that I would bring a new approach to art teaching which would keep my own interest alive. I taught, not as an art teacher, but as an artist, as if I were inviting the children to paint pictures with me in my studio. I wanted to teach them the art of their own time. The response to my attitude was tremendous.

These new ideas increased their sensitivity and observation. We used patterns and shapes, patterns and forms, stemming from my Cubist training in Paris. We used painting to describe a dramatic event – a fire, thunder and lightning, earthquakes or somebody being operated on in the hospital. They treated these events with great freedom. Then there came an adolescent period when they were more inclined to want to draw objects meticulously, a growing tendency to do more precise, more Pre-Raphaelite work. The great thing was to keep their work from moving too quickly into this phase and to sustain the imaginative approach which had been more natural to them when they were younger. My attitude was that, having passed through puberty, you were reaching a more creative period than ever, but to do that you had to put forward different forms of interest and identification. Again I treated the problem as if I had been at an art school or at a studio like L'Hôte's where you

did not have a teacher coming round to criticize all the time; they could all help each other when needed. They had large sheets of paper to give more room to splash, instead of small neat pieces of paper (fifty years ago the great idea was neatness in drawing, neatness in the shading of each hair of the stuffed squirrel). One thing dominated the situation and that was the element of fun, of play, rather than a sense of work. I was teaching these children, as a creative artist, to be creative people.

In this large city surrounded by the dead hand of academic art, the possibility of selling modern pictures to some dealer seemed completely out of the question, but I felt that modern influences must eventually reach England some time this century. Children brought up in the grammar of such art would be more capable of appreciating the house planning, city planning and other architectural and engineering projects that would develop in future years. I was getting a response from my pupils and there was a purity of expression coming straight from the children themselves without any superimposed culture; the innocent eye which suggested the outlook of more primitive people. I was being reminded of Matthew Murphy's Indian sand paintings in Carmel, of the early Celtic and Pictish work which I had returned to Britain to study more deeply.

A politician with a strong personality, Herbert Morrison, ruled London as an empire in itself, even (on occasion) defying the government. The Education Officer's Department of the London County Council was autonomous with its own Inspectorate, retaining only a polite link with the Ministry of Education. This helped to make London education one of the most progressive in the world. The London County Council made their own teaching appointments with little consultation with the Ministry (although the latter paid a proportion of teachers' salaries). This, of course, did not please officials at the Ministry so that a war of attrition existed between them and their counterparts in the London County Council. The Chief Art Inspector of the London County Council was superior in intelligence and judgement to his opposite number at the Ministry and would override the Ministry officials. In art the London County Council invariably won its skirmishes.

My job was scarcely begun before the Headmaster at Haverstock

Hill told me that an art inspector from the Ministry of Education was going to call, and would like to interview me in the course of his duty. Before long this character appeared carrying an impressive black bag with the faded gold letters G.R. on it. He had an air of importance and, with affected dignity, placed the bag on the table in such a way that I could not fail to see G.R. Ceremoniously he placed his hat and umbrella there, too. I waited. He announced that the Chief Art Inspector of the Ministry of Education would be coming to see me later, but perhaps as a start, I would give him some idea of my background and experience. He hinted that while the London County Council could make appointments the Ministry, after all, had to foot some of the bill.

I had met the first of his kind and unfortunately there were more to follow. One thing was certain – I was convinced that there was not one person at the Ministry of Education dealing with art who had any real knowledge of the subject.

Then came a blow. I received a letter from the Education Officer, telling me that my pay had been cut from £192 per annum to £180 per annum as I did not hold the General Certificate issued by the Ministry of Education. The Ministry of Education had decided that I was a foreigner, that my degrees were not of a suitable standard, and neither had I passed the drawing test for the Ministry of Education. I thought I should see some examples of this test and I was appalled at the low standard required. At the Edinburgh College of Art one would have been ashamed to have produced such drawings even in one's first year. I was furious. I saw the official at the Ministry who dealt with these matters and pointed out that I had my degree from the Edinburgh College of Art, my teaching certificate (with distinction in psychology) from Moray House, a Carnegie Travelling Scholarship as well as other medals and prizes, and two years postgraduate training in the studio of one of the most famous painting teachers in the world. The gentleman said, 'Well, of course, Mr Johnstone, it's as simple as anything. When a man goes to a foreign country his degrees deteriorate.'

'Do you come to the conclusion that my degrees have deteriorated?'

'Exactly.'

'I strongly protest against this.'

'You may protest, Mr Johnstone, but you cannot say that you took your examinations in art in London.'

'No.'

'Well, that's the end of it.'

So I was classified as non-certificated, non-trained and non-graduate and this reduced my salary to less than the school keepers. Mr Tomlinson was sympathetic and tried to do what he could, but the Ministry would not budge. (When I was Principal of the Central School of Arts and Crafts, Scottish students were still listed as 'foreign students' in company with thirty or forty nationalities from overseas who studied at the School.) Mr Fleetcroft, my Headmaster at Haverstock Hill, was most distressed. He was a vigorous type and assailed many different officials on my behalf, to no avail. The London County Council would only pay me as a graduate if the Ministry would agree, and the Ministry would not.

Flora was expecting a baby and I had to find a new flat before its arrival. Mr Fleetcroft arranged that we should live on the top floor of a large derelict house on Haverstock Hill that the London County Council intended to demolish in order to build further classrooms. Flora, the baby and I moved in and whilst it was somewhat grim outside, we had a living room, a little kitchenette, a lavatory and a bathroom. We thought our new home was splendid, even though some of the windows were broken and it was a long way up the stairs.

All went very pleasantly until one evening Flora said to me, 'There's a huge animal in the kitchen. It's far too big to be a mouse.' I looked in and saw the creature – its tail was as thick as my finger and a foot long. 'That's a rat. Put the baby in the other room quietly. Then you stand on the table off the ground. I'll get my sketching umbrella and I'll kill it. If I miss it'll run out into the room, but with the door shut and you on the table, I'll meet it by myself.'

The rat was in the corner behind the garbage pail and I waited at close quarters in the tiny space with my big, sharp-pointed, sketching umbrella. The rat made a rush out of its corner; as it ran past me I skewered it right through the middle and pinned it up against the table leg. It was as big as a cat. 'Take it easy! Bring a large shovel and

open the window!' It landed with a dull thud in the yard. The body was discovered by the boys in the morning.

No sooner had we settled the problem of the rat when the whole district was agog with the excitement of the Chalk Farm Murder. This concerned a rent collector who was murdered by a shopkeeper who then hid the body on his premises and set fire to them. Our empty building was considered the perfect hideout for the murderer. After the police had eventually disappeared we lived happily again and all was peaceful.

Mr Tomlinson decided that I should give up my full-time teaching in order to teach part-time at the Regent Street Polytechnic. This would give me more money and allow me free time in which to paint. He suggested that I taught drawing in the School of Architecture and Design in the Craft School where they had a large department dealing with motor-body building. This covered the construction of both individually made cars with bodywork by Hoopers, and mass-produced cars with bodywork by Briggs Bodies (a section of the Ford Motor Company). I started to work at the Regent Street Polytechnic and found that I disliked the Headmaster intensely. My previous headmasters at the elementary schools had been men of quality, they knew their job and had a notion of how to handle their boys. They were both men of sincerity who held the respect of their staff, but this was a most conceited man who, I felt, did not know much about anything. He sent for me to ask, 'What do you think you're getting paid for?'

'I expect I'm getting paid for what I'm trying to teach.'

'You can stop that because what you're teaching the boys is useless. I'll bring you some cards that you can use to hand out to them to copy. Birds and butterflies and things.'

'You will have some very good birds, I'm sure.'

We were full of good intent at the Polytechnic. We had Scripture reading and hymn singing in the morning. The Headmaster asked, 'Have you any ear for music?'

'I have, but . . .'

'Don't you sing at all? The rest of the staff seem to be able to make some contribution to the singing.'

I worked happily with the architects and the body builders, except

that the Headmaster was always coming in to annoy me. In the machine shop of the building department I found that my childhood training on farm machinery and my father's Tangye engine stood me in good stead. Both the man from Hoopers and the man from Briggs' Bodies were most interesting so that we all got on very well as a team. Some of the boys, especially the older students who came to evening classes, had already had some training which was basically the worst form of 'chi-chi'. They had learned the superficial tricks of how to make motor-car wheels look shiny, of how, by using a spray gun and masking different parts, you could make the car look worth a million dollars. The efficiency of these drawings was splendid and they were brought in reverently covered with tissue paper, in case of dust, for my inspection. They were so superbly brilliant that one could do nothing but make them worse.

Other, more serious questions arose in these classes. While the motor car was basically a cab with an engine in front instead of a horse, there was a growing feeling that, as the motor engine was really different from a horse, the design of the whole car should be different from, say, a hansom cab. It was a transition period. The fashion was just beginning for the car body to slope away both in the front and the back, the great idea being to get away as far as possible from the notion of a carriage on wheels. Hoopers were commissioned by a wealthy Indian Prince to design the carriage work for a new Rolls-Royce, but the Prince stipulated that the result should look like a modern vehicle rather than an eighteenth-century travelling carriage to be pulled by six horses. In a spontaneous way I drew a curve over the chassis from front to back, a lovely line into which everything was to fit. I forgot all about the vacant spaces which this would entail but Hooper's man, a brilliant designer, made this idea into a practical reality. He gave me a ticket for the private view of the Earls Court Motor Show and asked me if I could go as someone had better be there to explain the new design to Queen Mary who was sure to come to the Rolls-Royce stand. Queen Mary came to inspect the Indian Prince's car. She was appalled. 'What a horrid thing! I could never get into it without knocking my head!'

We dealt with form and pattern, with flat patterns and solid forms, with design in relation to engineering. Always there was a continu-

ous consultation between the designer, the engineer and myself. This experience proved of great value to us all. At the Central School of Arts and Crafts in later years I again met my Briggs Bodies colleague when he came to engage students from the Industrial Design Department to work at Ford's. I thought he looked familiar, and then he asked me, 'Are you the same Johnstone who was at the Polytechnic? We'll take any number of your students after those times we had together at Regent Street!'

The young architects, too, had received a certain amount of training in old-fashioned methods. They had also had training in the technique of painting watercolour washes as an aid to making 'presentation' drawings for architectural projects, in order to mesmerize the client into believing in the ultimate beauty of a house, a factory or a road development scheme. The trade of successfully applying flat washes could earn you a position in an architectural office as 'the artist'. I continued to use a similar approach in my teaching to these young men as I had used with my elementary school boys, but they were, of course, able to assimilate my notions of form, of pattern and of space in relation to their architectural work in a most constructive way.

We did very practical exercises such as making squares and oblongs, dividing these up into a shop or office front and colouring the simple shapes – modern buildings are simply shapes and patterns. If you put two shapes together you had two walls, a front and a side wall, then a back and a side wall, and a roof. We put together an endless variety of shapes and sizes in this kind of way, always trying to find new modules rather than the prescribed modules of Greek architecture.

We drew out Doric, Corinthian and Composite columns, and I taught them how to use proportion in different ways – not in imitation, but as a creative process so that there was always progression. We did work to stimulate the imagination, free hand drawing, all kinds of scribbles from which we developed designs and projects. We made life drawings and portraits of each other in which I did not try to teach them the recipe of how you put in the eyes, the eyebrows, the nose – they drew as they wanted, just like writing, without caring about the correct proportions. These portraits were often

extremely characteristic and expressive of the sitter even though they might be wildly 'out of proportion'. I introduced a more modern use of perspective (a debased skill), drawing figures in space and using the old forms of the cube, cone and cylinder in a distant landscape. We used colour in abstract forms, practising the effect of one colour against another, how one colour recedes, how another marches forward to attack; matching colours, contrasting colours, but never using them to paint a banana or a bottle.

We learned proportion like the scales of a piano – by constant practice until it became unconscious. Instead of working on a large drawing of a whole building until one was bored by it, we did a series of drawings of differing proportions. The students never became involved in one large drawing, but produced an enormous quantity of work showing different textures, different angles, different perspectives, different techniques. It was like a man learning to play the violin – little runs, little scales, little tunes, to try to find out how to manipulate his instrument. This gave the students continuous interest because each student was producing something different all the time from the same set of rules, the same set of symbols, the same set of objects.

They were all full of enthusiasm, and their enthusiasm kept me going, helped me to remain an artist. I was always getting something fresh from the students, and they were teaching me on many occasions; I was getting the benefit of the united effort of the classes. I never had to try to make someone interested in a subject they disliked. On one occasion the architect, Eric Mendelsohn, came round the School on his way to America, and I remember him being greatly taken aback by the students' work, surprised to find so much originality, so much freedom. He felt the Bauhaus was too rigid and formal, too scholastic.

The Headmaster decided that my work was more successful than he had expected so he extended my classes to take in hairdressing and tailoring. He said these classes were deplorable as none of the teachers knew anything about art or design, and I was to see what I could do.

Then Mr Tomlinson announced that he had been to see Lady Smith-Dorrien, the Head of the Royal School of Needlework and

suggested that I should go and see her. 'By heaven, what do you think I'm going to do in that?' I replied.

'I don't see any future with this chap here. You're doing very good work and you've greatly improved the standard of design. The students at the Polytechnic Craft School are very good. The architectural drawings and some of the elementary studies are excellent. They're quite new, I've never seen it tackled in this way before. Go along to South Kensington to see Lady Smith-Dorrien. They've had three men there trying to teach the students, working on some kind of design course, and they've all left. They can't get on with the woman that teaches the practical part.'

'Mr Tomlinson, first of all you give me little boys to teach, after I've had a University appointment in California, then you give me tailoring and hairdressing and motor cars, now you're giving me knitting.'

'It's not knitting, nothing of the kind. I never mentioned knitting. It's embroidery. Don't you realize there's been a great tradition of English embroidery, W.J.? Nothing to do with knitting. More than that, it's a Royal appointment. I told Lady Smith-Dorrien that you would be getting in touch with her.'

So I started at the Royal School of Needlework. I admired Lady Smith-Dorrien who was a pear-shaped lady with great pearls on her bosom and a pekinese. In some ways this seemed to be an easy job. There were no special times and nobody asked where I had been if I was out for a while. Tomlinson was right – embroidery was one of the few arts in which England had excelled. The more I studied the craft the more interested I became, and I worked with enthusiasm at this new challenge. Alas, the embroidery teacher seemed to be no more of an enthusiast than my erstwhile Headmaster at the Polytechnic. She believed only in stitchery, and disliked art of any description. She ruled the students with severity, and their stitches had to be perfection.

To introduce a feeling for design among these students needed subtlety and guile. I worked out classes in which they had a continuous change of curriculum and I evaded the issue by teaching them subjects that did not obviously relate to embroidery. I introduced subject matter which foxed my dragon's understanding and com-

pletely passed her comprehension. The School of Paris was coming
into its own. None the less, my dragon suggested that there were
certain subjects which had to be taught so that the students could
get their Diplomas. Examples of the prescribed subjects would have
to be produced for the specimens in their portfolios. Much too much
time was being spent on design and not enough on practical applica-
tion relative to the craft. 'Practical and Relative' was the title of the
Hymn to the Dead in London at this time. I replied that my lectures
on design were relative to the art of embroidery, not to the craft of
embroidery. The Victoria and Albert Museum, with its unrivalled
Textile Department, was across the road, and here we could study
the greatest examples of church and secular embroidery. I, too, im-
proved my own knowledge and, from the students, gleaned an un-
derstanding of stitchery and 'practical' application. The days at the
Victoria and Albert with the students were most enjoyable. I was
being paid to study the most beautiful embroidery in the world and
to this day I have never lost my interest in this wonderful art.

At the first Diploma Day we put up a show that I thought was a
really splendid modern art exhibition. After the ceremony Lady
Smith-Dorrien suggested I explain the work to Princess Helena
Victoria. I sweated – how was I to do this? 'Well, it's fairly simple. In
architecture, for instance, you must have a plan before you can have
an elevation; these are plans and elevations that might some day
become embroidery. It's simply that embroidery and weaving are
architectural, therefore structural, forms. Unless you have this basic
training you can never really begin to design for the craft. You must
have design for embroidery which relates to our time.'

The following day I felt would be my last at the Royal School of
Needlework, but Lady Smith-Dorrien greeted me with, 'What a tre-
mendous day we had, Mr Johnstone. Her Royal Highness was over-
joyed. She said she had never enjoyed our Diploma Day so much
before. She reported everything to the Palace and I have a message
for you from Queen Mary. She is delighted. She says that you are not
to worry whether it's modern or traditional art. Do what you really
want to do, they are all with you. You have a free hand to do what-
ever you want. They are thrilled with it.' So I thought, 'Isn't this
wonderful?'

Mr Tomlinson announced that a really good teacher of life draw-
ing was needed at the Borough Polytechnic Art Department for two
nights a week, and so I applied and got the job. I was at last teaching
art students again. There were six students in the class, but it ended
up with my having thirty or forty of them, four nights a week. They
came from far and near.

Tomlinson suggested that I apply for the Headmastership of the
Hackney Art School, but in this I was unsuccessful. However, very
soon the new Headmaster was appointed to a better job as Principal
of the West Ham Art School, leaving Hackney again vacant. On my
second application I was appointed and, as the Hackney School of
Art only functioned in the evenings, I was able to continue at the
Royal School of Needlework.

At Hackney I could bring in new staff which I promptly proceeded
to do. Richard Guyatt and Mischa Black came there; Rodney Burn
taught drawing; Edwin Callagan, a native of Dundee, taught
graphic art. (He was very talented and an excellent teacher who had
designed the first poster for Watneys using the famous wall: 'What
we want is Watneys'.)

Rodney was a most sensitive draughtsman but somewhat absent-
minded. One day an inspector came from the Ministry, a very pom-
pous ass whom I remembered from my days at Haverstock Hill.

'Johnstone, what's going on here?'

'We're doing our best to help the students.'

'Who's that fool over there who's teaching life drawing? He's for-
gotten to put his tie on.'

'He's a very talented draughtsman.'

'Talented draughtsman be damned, he ought to come properly
dressed. Let's have a look at him.'

Rodney got up; he had forgotten to button the front of his
trousers.

'What a disgraceful man! It's really ridiculous to have this man
here. You must get rid of him at once.' I did not.

Tomlinson came to see me one day to tell me that he had a com-
mission from the 'Studio' to do a book on children's paintings.

'Here, W.J., I've got this commission to do this book. Will you
help me?'

'If I can.'

'If you can get me some of the drawings from the pupils you have, I'll get some from other schools, we'll get it done.'

We worked hard at his book, but were rewarded as it was published under the title of *Picture Making by Children* and was an immediate world success. It is a classic. Art teaching under the London Country Council was acknowledged to be the most enlightened and forward looking in the world.

In between these events I had never given up my studies and research into the arts of early Britain. Any spare moment was spent in the British Museum, the Victoria and Albert, and the London Museum. In those days, before such artefacts were recognized as art objects in their own right, the ethnographic sections of museums kept their treasures in uncatalogued confusion, and the Anglo-Saxon section of the British Museum was no exception; I found objects of incredible beauty hidden away. At the back of a case containing a jumbled collection of Anglo-Saxon tools I saw a marvellous ornamental mace-head of white chalcedony, carved with the greatest sensitivity as well as mathematical precision, a carving which would have inspired the envy of Brancusi. I had to have a photograph of this beautiful abstract carving, but I found the greatest difficulty in persuading a Museum official that such an object existed on a shelf in his Department. Only after much pleading would he agree to come to the gallery to see this mace-head which he was assuring me could not possibly be in the Museum's catalogue. Happily, the work of these early, unknown, abstract artists is now given the respect it deserves and is displayed in splendid surroundings so that we may fully enjoy it.

I had begun to write a book on creative art in England and found that the earlier lectures I had given at Dalston, Marylebone and Holloway Institutes helped me to clarify my thoughts. All my spare time was spent going through every section of the slide departments of the Victoria and Albert and British Museums and the County Hall. When we had any money we would go to Winchester, to Canterbury, to Malmesbury, to see everything we could.

Later on we bought a car and this was a sensation! It was considered terrific for anyone teaching art to have such a thing, just like flying

to heaven! We could now travel further afield on those explorations. I read and re-read Professor Baldwin Brown. I had time to paint again and enough money for canvas and paint. Hackney was flourishing, and I knew I need not kill myself at the Royal School of Needlework. In fact, Lady Smith-Dorrien thought I was too diligent. Somebody had invited me to a celebratory lunch at the Café Royal and when I looked at my watch it was four o'clock. The class at the School of Needlework ended at half past four to allow the young ladies to get home before the rush hour. I dived out of the Café Royal and seized a taxi. The next evening I read in the *Evening Standard* a paragraph which said: 'Who was it that rushed out of the Café Royal yesterday afternoon, hailed a taxi and shouted: "The Royal School of Needlework, and drive like Hell!"?'

10
The arts in London

Flora had kept her American citizenship and at Embassy functions in London we met a number of people interested in the arts. We became friendly with the publisher Stanley Nott and his American wife Rosemary; with Jessie and Alfred Orage; with the Montgomery Butcharts.

Orage, of course, was celebrated. He had earlier edited the *New Age* and was now editing the *New English Weekly*. He had gathered round him many distinguished contributors – T. S. Eliot, H. G. Wells, G. B. Shaw, Major Douglas (of Social Credit fame), Percy Wyndham Lewis, the Sitwells, Ezra Pound, Walter Sickert and Eric Gill. His magazine had a small circulation amongst a very devoted and highly intelligent group of subscribers. Orage refused all forms of advertising which, to him, represented corruption, so it was only possible to publish the *New English Weekly* with the help of generous subsidies from his friends. Orage was all for encouraging young people with ideas who were without a platform, and it seemed almost that if you had any serious or exciting new theories the only man in London who would be prepared to give you consideration was Alfred Orage. Kaikhosru Sorabji, the Parsee composer who was a great friend of Francis George Scott, wrote the music criticism for him, Christopher Grieve (Hugh MacDiarmid) wrote poetry and articles on Scottish nationalism, and Hugh Gordon Porteous wrote the art criticism.

Hugh was a most intelligent, imaginative and creative person. He had a great knowledge of Chinese art and literature, but eked out a living in one room in South London. He had a very tiny income

which he augmented with an even smaller one from the *New English Weekly* and whatever else he could get from reviews or articles in other magazines. We used to meet nearly every week for lunch at a pub in Soho where we were joined by Desmond Hawkins (writing poetry at that time), Rayner Heppenstall, Ronald Duncan, George Orwell, Dylan Thomas and other friends of Porteous. Both Hugh and Desmond saw a good deal of T. S. Eliot who regarded these two young men as the lights that were to shine after him. Any artist or poet needs to see a continuity through some brilliant younger man who, when he himself is growing older, will one day support ideas and dreams for which he himself has worked. Porteous was also devoted to Percy Wyndham Lewis, and felt that he was the only other person outside God and Eliot worth knowing. Nothing else was of any import and Lewis's work was the only thing in the history of British art.

One day Dylan Thomas joined us in a very depressed mood. He had been hoping to have his poems published by Faber and Faber, but T. S. Eliot had indicated that the other directors were not very keen to publish them, although he himself would have done so. We had a gloomy drink before joining Eliot at 'The Mitre', off Shaftesbury Avenue. When Eliot came in he was particularly pleasant and said how sorry he was about Dylan's poems. He felt that as Dylan was young he had a long way to go yet and maybe the time would come when he would have the opportunity of submitting something to Fabers again. Dylan would understand that the directors all had to have their say and that he (Eliot) was in the minority about the poems being published.

All this plausible talk made Dyland feel very low. Some years previously I had read a few of these poems in the *Sunday Referee* when I could make nothing of them, but by now I had a great admiration for this young poet; his exciting new visual imagery and depth of feeling appealed to me strongly. I had seen Richard Church only a few days before when he had been overjoyed because J. M. Dent had just appointed him their poetry editor. Richard was looking for a poet and I thought this was an opportunity, so suggested to Dylan that he should get in touch with Mr Church and take his poems along to Dent's. Richard was very interested in these poems and he

was also very keen to have a new young poet. He sent the poems to Edith Sitwell who replied with great enthusiasm, and Dylan Thomas's poems were published with very great success. I have always thought of Dylan as a religious poet. When he transposed the words of the communion service, 'this bread I break . . . this is my body, this is my blood . . .', words which have been repeated so often that the congregation falls asleep when the minister comes to them, into, 'This bread I break was once the oat, this wine the grape upon a foreign tree. Man broke the grain down, killed the grape's joy . . .', he revitalized the ancient words to give them a new meaning, a new life. This, I think, is the mark of a great artist.

Flora and I needed money. The *New Statesman and Nation* advertised a competition for an essay on teaching industrial design, which was then becoming a common topic in the Press. It was a subject which was supposed to have been sadly neglected in England, and for which no training at all was being provided. I set out to write an article and worked hard at it. Stanley Nott suggested that I should submit it to Alfred Orage who, although a rough and very severe critic, was frank and honest. I took this work to Orage at his office and he said, 'Just leave it there', so I put it on his desk. Later I received a note, 'Very good. I'll publish if and when you say the word.' I thought I had better go to see him because there was the prize of £100 for the best essay on the subject. I said I was very, very flattered that he thought so much of it that he was willing to publish it at once, but I wanted to put it in for this competition with the prize of £100. This made him laugh. 'Well, I can give you the result of that now. You will be unplaced. You will neither receive the first prize, the second prize nor the third prize. I am sorry that you are deciding on this because you are delaying me getting it in first in the *New English Weekly*.'

I insisted that I would like to submit it for the competition, but the result was exactly as Orage had suggested. This was encouraging in one way, but discouraging in another because if there was only one Orage in London and he was supposed, by many people, to be out of step with the general opinion, how was I ever to make my way with my different ideas on art teaching?

We were fortunate in being asked to work for a medical magazine called *New Health* which, apart from carrying splendid advertisements

for all sorts of new medicines and treatments, contained many interesting articles by important authorities on their subjects. The editor wanted very quick pen and ink drawings as illustrations. As they could not afford any kind of colour reproduction, it had to be simple black and white line drawings. Flora and I felt competent to tackle these as, before coming to London, we had illustrated a book on the Virgin Islands by a friend of ours (Hazel Eadie), and felt sure that the technique we had used for these would be the very thing for *New Health*. So it proved, our only difficulty being that proofs of the text arrived by hand late at night, sometimes at ten or eleven o'clock, and it was impossible for me to do more than read the text before I fell asleep with weariness. Sometimes I made rough scribbles which Flora drew out in their final form, but mostly she was responsible for them from start to finish. We were paid 10s. per drawing, so if there were six, that meant £3! As beggars cannot be choosers, this extra money was more than welcome. We did the drawings for a number of years.

At the same time, for my own pleasure, I made many scraper-board drawings, the smooth black surface making a marvellous background for calligraphic line. I also made monoprints which became surrealist expressions of primitive Celtic landscape and these were exhibited at the Mayor Gallery in 1933. During these early years in London I did no oil painting. Too much time and strength had to be spent on earning our living, and anyway, there was no extra money for the cost of canvases and oil paints. However some of my monoprints were exhibited at the Mayor Gallery in 1933. I ghosted two Shell posters for a friend who had been given a commission by Jack Beddington; these found their way into the Victoria & Albert Museum Collection.

Richard Church and his wife Rina became very good friends. Richard had experienced difficult times in his youth. He had suffered from tuberculosis, and he told me that when he came up before the Medical Board during the war, the doctors examining him were so frightened by his condition that they rushed him back into his clothes and packed him off home in a taxi in case he died on their premises. When I knew Richard he lived in a garden flat in Holland Park and was employed in one of the Ministries under the aegis of Sir Edward March and Humbert Wolfe. In the civilized surroundings

of this Ministry poetry and art flourished. Richard worked tremendously hard – he wrote novels, he wrote poetry, he reviewed books. He was always most kind to young writers and would give perhaps more time than he could afford to reading their manuscripts. He gave sympathetic advice and was always humane, gentle and encouraging.

Richard encouraged me to start painting again. I suggested that I should paint his portrait and Richard was enthusiastic. He was never strong and often seemed very tired, but he was a good sitter, and I did my best to make his portrait a success. When we left London for the summer holidays I left the portrait in his flat. I later received a letter from him in which he said: '. . . Rina was deeply moved by the portrait, both by the divination of character and the craftsmanship, and she says that when it is finished it will be one of your best pieces of work. Living with it, one sees its qualities more and more every day, and I find myself rather in the position of Dr Jekyll, living in mortal fear of my Mr Hyde. William, you are a shrewd critic! You should have been a father-confessor!' This was great praise.

I designed also the book-jacket for his novel *High Summer*. Richard and Rina then encouraged me to have an exhibition of the work which I had brought to London from Scotland. Not only did Richard help me to get this exhibition with Mrs Wertheim, but he also persuaded Sir Edward Marsh to come. This was very important because Sir Edward could be counted on to buy a picture if he ever got as far as an exhibition. His powers of resistance varied between his office, his flat at Raymond Buildings, and the exhibition. When he was at his office the temptation to see new paintings was great, when he was on the way home his resistance became stronger, but when he reached Raymond Buildings and realized that his financial position was not as good as he had thought it was, he became adamant and refused to see the new show. However, once inveigled into seeing an exhibition his love of paintings overcame his better judgement and he weakened, his monocle came out and a great time was spent on the examination of each picture. Sir Edward would murmur, 'I can't afford it, I just can't afford to buy any more pictures.' He said to me, 'I think I'm impressed with it, but I haven't any money. I can't buy any more pictures, but I *must* look at them because I can't resist it.'

I had to stand back in attendance while he went round the gallery with his monocle, marking them up in his catalogue, Mrs Wertheim waiting to pounce on him to see that he did not get out of the door without buying one. When he saw her, very formidable, he said, 'No, no, I can't have it, I have no money. I have so many pictures they're spreading over on to the floor . . . well, it must not be a very big one.'

Sir Edward wrote to me: 'Dear Johnstone, I think I had better pay for the picture while I have the money! I shall look forward very much to its coming here, but keep it of course till the show is over . . .' This was a big excitement – my first picture to have been sold in London! So of course I always liked and admired Sir Edward Marsh. He was a man who never forgot you and certainly never forgot your paintings, and whenever I met him he always took an encouraging interest in my work. Years after, when I was Principal of the Central School of Arts and Crafts, he was always a prominent figure at all our School exhibitions. He told a friend of mine that he enjoyed coming. 'Whether it's his own work or whether it's the work of his students at the Central School, he always produces something new, something original, something stimulating that you never get at any other place.'

A courageous effort was made on my behalf by Mr Proudfoot of Aitken, Dott, the Edinburgh art firm. He surprised me by writing to invite me to show the Wertheim exhibition in his gallery. I thought this was very adventurous, so I indicated that I expected the exhibition would be a complete failure. Mr Proudfoot persisted in the idea, and he wrote: 'Of course, quite frankly, picture selling is at a very low ebb in Edinburgh, but who can foretell the result of a show?'

While the exhibition was on he wrote: 'A lot of people, lay and professional, have seen your pictures, but they are beyond them. This is just about the hardest job I have undertaken.' And when it was over: 'I am sorry the exhibition met with no success and I fear that in this part of the world you can look for no future, on your present lines.' Not one picture was sold.

My cousin, Francis George Scott, hooted with mirth. 'What did I tell you! You can't have modern art in Edinburgh! You'll disrupt the whole Establishment!'

When I had returned from Paris as a student Francis had demanded

to see me at once. He wanted to know everything I had been doing; he wanted to hear all about the 'greats' of Paris, Braque, Picasso, Matisse; he wanted also to hear about the younger painters, the surrealists, the abstract painters, the Dadaists. I produced my own paintings for his inspection, and he was overjoyed. 'These relate to me and my music more than anything I've ever seen. It's a new approach; these pictures *are* music. If you'd only learn to sing you could sing my music!' I showed him the painting which I had called *Folies Bergères*: 'Ha! Ha! Look at this! A tile hat sticking on her backside! I'm going to try to write some music for these.'

From the time we lived in London, Flora and I regularly spent the school holidays in Scotland; she admired Francis as much as I did. While I painted his portrait, discussions raged on music and painting, and on the Scottish Renaissance. Excitement was caused by the advent of James White. White was a rich American who came to visit Scotland, and stayed. He opened a bookshop in St Andrews and started a Scottish magazine called the *Modern Scot*. Here at last was something – the three of us and a magazine. Francis could get his music published, Christopher Grieve his poetry, I would have some of my paintings reproduced. But I could not afford to stay in Scotland; Christopher, too, was living in London, and only Francis remained in the North.

Francis was a severe critic. Commenting on my frontispiece for Christopher's poem 'Second Hymn to Lenin' he wrote: '. . . The world's sadly out-of-joint (sounds like Grieve that!) but you've got to have faith at any rate in the thing called intelligence if in nothing else and trust to God that it will be common to all and sundry some day. This leads me to comment on your drawing of Grieve in "Second Hymn to Lenin" that I didn't find much in it. This kind of thing nowadays is simply not intelligent enough – there's not enough brain matter in it – it's an *aperçu*, a glimpse, a keek, anything you like, but it smacks of the merely clever journalism of the daily paper. We've got to get right outside journalese of all kinds whether in poetry, art, music or the novel and begin to think of the big things in a big way and execute them in a big style. Otherwise the Fates are against us and we'll be known to history as "the artists of the gadget era", "Woolworth's 6½d. torchlamp illuminators" or something like that.

So I'm passing on to you, as I've been doing to Grieve, the homely advice of – for God's sake use your brains – and get out of the London stink as soon as possible. I'm beginning to think it an impossibility for any self-respecting artist to have anything to do with London or any other of the big cities (always excepting, of course, making his bread and butter). This all sounds I'm sure like a Presbyterian sermon but what else can I say if we can't arrange a meeting before you return South. You talk of a trio by Grieve, yourself and me – very good idea but not big enough. Why not go over to Films and do the thing in real life size. We're really all very small artists from some points of view and thoroughly out-of-date. A little music, and a little poem and a little illustration and a nice little book for a nice little public. If that's hard-hitting well I'm taking it all to myself . . .'

Christopher lived precariously from the odd poem he managed to have published, some reviewing or an article in the *New English Weekly*. One afternoon in Russell Square, we were discussing the fact that we had no money. Christopher felt that it should be possible to raise some. 'I'll tell you what I'll do. I'll go up and see Eliot. I'll sell him a poem that's included in the *Drunk Man*. You wait here.' I felt we were like Jocky the Bummy and David Laidlaw in Selkirk. Christopher, before leaving, said, 'Of course, Eliot's a pain in the neck. He'll want to talk seriously about poetry; he's so damn serious he may keep me. On the other hand, if I can sell him this poem for thirty quid, we're in funds.' So Christopher set off to see T. S. Eliot. I knew the window that Eliot used to sit at, so I watched and waited and waited, but no Christopher. I wondered if he had taken the road on his own, whether I should just go on home myself, when at long last Christopher appeared. 'Oh hell! I saw Eliot. He's really a Presbyterian old maid. First of all he couldn't have the title *The Prostitute* because he couldn't use that word. He said at Fabers they always have the title of the poem repeated in the first line so that it has to begin: "O wha's been here afore me, lass", then it starts again: "O wha's been here afore me, lass." I got over this and I was waiting to get the money when he says, "Oh, but you don't need to rush, it's a chance to talk to you." The pubs are opening and he's wanting to talk about poetry! I said couldn't we talk another time? "Oh no," he said, "I've got a chance now to talk to you, I haven't seen you for a long time."

Dammit, William, we've been sitting talking – just imagine Eliot talking about poetry anyway! Still, I got the money.'

Percy Wyndham Lewis, the black crow, felt that the great men were Eliot, Pound and Joyce; in art, Picasso and Picabia. I sympathized with this intransigent attitude as, after living in France and America, I had found British art to be predominantly amateur, following ideas which had germinated in other countries at a discreet distance of about twenty years. It was an art (as it still is), of the petit bourgeoisie. Percy, who was gifted both intellectually and visually, had a brilliant and complex personality. Aloof and reserved, the duality of his interests in both science and art made his introverted life far from easy; he could become confused by the multiplicity of his own genius. He was a descendant of the Age of Reason who found great difficulty in allowing the un-reason, the emotional or the surreal aspect of art to develop naturally. His intellectualism caused his whole personality to dam up; once one block was cleared away, he ran into another obstruction. None the less his writing shed an important light on the expression, demonstration and extension of the visual arts at the turn of this century. The Vorticist movement, which (contrary to William Robert's opinion) consisted solely of Percy Wyndham Lewis, was an amalgamation of ideas culled from the Italian Futurists with some undigested complexities and confusions drawn from Cubist sources. Percy was convinced that the great modern art movements could not have been realized solely by emotional or painterly means; that there must be an intellectual basis behind the intuitive or instinctive use of paint or stone to keep art in line with current scientific perception and analysis. Art should function in unison with, or parallel to, for example, the splitting of the atom – there should be a new mathematics of art. Percy was sure that Cubism could be seen only as a series of mathematical problems. He excluded altogether the personal involvement of the artist.

Messrs Reid and Lefèvre were showing some fine Cubist portraits by Braque and Picasso in their gallery. McNeil Reid, the director, was puzzled. He told me that Percy Wyndham Lewis had asked if he could measure up some of Picasso's paintings. He had constructed a theory with his footrule that Picasso had worked on a complicated system of geometry, having some relation to Velasquez. This sounded

quite ludicrous, but Percy measured up how many areas of white, how many areas of half-tones, middle-tones and darks, that Picasso had used. Then he developed his findings into some grand theory which, I am convinced, had nothing whatever to do with the way Picasso had worked. In spite of these aberrations, I have the greatest possible respect for Percy Wyndham Lewis's work as a painter. His drawings are formal with an emphasis, an accentuation, which make them unique, personal statements, while his fine portraits are the work of a master. When the cerebral was overshadowed by the emotional, as happened in response to the convulsion of the war (1914–18), he painted magnificent war pictures which were motivated by very deep feeling. In 1956, when I was living in Holman Hunt's studio in Kensington, Hugh Gordon Porteous came to see me in great distress, and asked if I had heard that Percy was dying? Apparently, he had a cancer growing between his eyes and what's more, he was threatened with eviction from his studio. Next day Mrs Helen Bentwich, the Chairman of the London County Council, called to see me at the Central School of Arts and Crafts. She told me that a big development at Notting Hill Gate was being held up by an artist of no importance and that the London County Council were taking steps to evict a man called Percy Wyndham Lewis. Had I heard of him? He was holding up the whole scheme, as his studio would have to be demolished to get this great plan completed.

I said, 'Mrs Bentwich, they can't possibly do a thing like that, because Percy Wyndham Lewis is one of the greatest artists of our time in Britain; more than that, he's dying with cancer in the eyes. The time he'll live now will be very short.' Percy remained in his studio until his death. There were six mourners at his funeral service. In his lifetime Percy had an intrinsic remoteness which forced him to remain an isolated, anti-establishment presence in art. He had no real disciples, no influence on later students, but he was certainly the greatest figure in British art during my time – a giant among pigmies.

Among our friends were Rosalind Fuller and Francis Bruguière. Rosalind is a tremendously gifted person, vivacious, dynamic, tireless and shrewd. She used to tell me how she and her sister appeared in a nude review at the Folies Bergères when she was sixteen; they were billed as the Fuller Sisters. Rosalind broke away from the music hall

to become a straight actress on the New York stage where she had a great success as Ophelia in John Barrymore's famous production of *Hamlet*. She returned to London as his leading lady. Francis Bruguière came from a French family long settled in San Francisco. He was a very distinguished surrealist photographer who had studied painting in Europe before returning to America to learn photography with Frank Eugene. He was associated with the Photo-Secession. He worked both in San Francisco and New York where he experimented with light and cut paper effects. Before the 1914–18 war, he had worked in Germany for Bernstein, for whom he had made what I believe were the first photo-montage stage sets to be used in the theatre. In his youth, Francis had been influenced by Cubism and Futurism, and I think he always wished he had remained a painter rather than a photographer but, although he was always a talented painter, he was a much more brilliant photographer. (As with Man Ray, the painter helped the photographer.) As he grew older he tended to revert to painting and sculpture.

I worked with Francis on some panels for the Department of Agriculture at the Paris Exhibition of 1938, but these were not wholly successful. Both Francis and Rosalind admired my portrait of Richard Church, so that I was delighted when Rosalind asked me to paint Francis's portrait. I tried very hard to make it a good painting because he was such an enthusiastic and sympathetic sitter, and it turned out to have a life of its own, not a bit like the Church portrait.

Other friends were Maurice and Constant Lambert. Maurice was a sculptor who worked in a semi-modern idiom, while his whole philosophy and outlook was anti-modern. Reid and Lefèvre were fairly successful in selling his work.

His brother Constant was an attractive, highly intelligent and delightful man; a talented composer who had early realized that, however hard he tried, he would never become a Beethoven. Instead he put his virtuosity and energy at the service of the ballet in the early days of Sadlers Wells, where he worked unsparingly.

Constant used to encourage me in my painting; he was convinced that I had a great future as an artist. One day he phoned to ask me to come down to Sadlers Wells to meet Frederick Ashton and Ninette de Valois who were working on *Coppelia*. He was sure I could

do a magnificent backdrop for the ballet in the same style as a painting he had seen in my studio. When I went to the theatre to discuss the project, Frederick Ashton was not keen on the idea. He disagreed altogether with Constant's notion about me in the theatre and did not think there was any indication from my painting that I would be a suitable man for Sadlers Wells. He saw my picture as a thing in itself, which related only to itself and did not relate to a composition of moving figures on the stage. I think he was dead right.

For me and many others, Constant's decline and death was a tragedy of wasted talent.

One of my most assiduous students at my evening lectures at Holloway, Dalston and Marylebone Literary Institute was a young man named Alfred Horne. He had been a brilliant mathematics student at London University but, alas, was an epileptic and was only able to do part-time work in his family's building business. Alfred was tremendously interested in the relationship between art and science. We had lengthy discussions on every aspect of creativity which his exhaustive study suggested to him. His analytical, scientific mind was so different from mine; his questions gave me a cause to search deeply into my own experiences in art.

I found also that this simplification to essentials helped me to reduce the complications in my painting. You could start out with a voluptuous romanticism, analyse this to a more classical approach, until the classical expression became simplified to almost a single line – from the Baroque to the Minimal.

Many of Orage's admirers and devotees were a little taken aback by his interest in the occult, in particular the work of Ousspensky and Gurdieff, the latter seeming to have a great power over him, holding him in a spell. Gurdieff's influence was certainly powerful. This Russian religious man produced a formula by which the human being was taught to progress to higher levels of consciousness and attainment, physical, emotional, intellectual and spiritual. Gurdieff maintained that the human race had lost many of its natural powers and resources, that what was described as civilization (especially urban civilization), had destroyed their being, that they were no longer truly human. The great aim was to reach this *being*. This was necessary for the evolution of the spirit; eventually personality and indi-

viduality were to be lost in *being*. This implied renunciation of the things of this world and the rejection of personality. I had much sympathy with this attitude as I was a great admirer of the writings of Ananda Coomeramaswamy. His question 'Why Exhibit Pictures?' appealed to me. All art should be destroyed. What keeps it alive is mostly humbug – art dealers, art sales and a vast organization of trade and commerce. The painting of pictures to sell can be considered a debasing occupation and is often the reason why so many 'good' artists decline so badly. Repetition kills and competition with other artists is degrading. This made me a reluctant exhibitor and, indeed, for many years I showed no paintings at all.

Rosemary and Stanley Nott were deeply interested in Gurdieff's teaching so Flora and I attended some of these meetings and discussions. Gurdieff's main centre was Paris, while his movement in London was organized by Jane Heap who had been a great friend of Mildred Anderson and, with her, had been sentenced by a New York court for publishing obscene and indecent literature in the *Little Review*, namely, *Ulysses*. In the various exercises of self-examination taught by Gurdieff, it was possible to look backwards to re-live time past, but also equally possible to look forward to time future. It was considered to be, with the proper training and discipline, as easy to see the future as the past, in a kind of visual or inner mental image. At certain times in my life, I had experienced foreknowledge of events in a manner more positive than merely intuitive sensitivity to a future happening. I knew that what Gurdieff postulated was possible. I knew that unknown powers outside oneself could have an effect on one's inner self; that one was surrounded by an aura of space in which one moved, subject to strange pressures.

When I was a student in Paris there was great interest in what is now called Extra Sensory Perception. Among the painters and sculptors, discussions were endless about the meaning of time and space. There was a growing feeling that the area surrounding an object was of more importance than the space occupied by the object itself; that the tensions outside a solid gave solid its form. Such an artist was Giacommetti, who took art into another world of true meaning which defies analysis. With his expression of the human dilemma and the nature of being, he related art to imagery

(rather than nature producing the image), in a way that places him, for me, among the very great. So, among the followers of Gurdieff in London I was considered to be a 'natural' as a disciple. Flora became very interested, but I felt that I had neither the time nor the money to become involved in what appeared to me to be an amalgamation of various oriental religions rearranged into a new synthesis for the benefit of Gurdieff. Of course there was much that was good in his teaching as there must be in all religious teaching, but I preferred to cling to my own doubts.

With a small capital of his own and backing from his friends, Stanley Nott started up a publishing business, an adventurous and speculative undertaking. Orage gave him excellent advice and, through his world-wide literary connection, was able to offer Stanley great help. Stanley Nott published the *Douglas Manual*, Major Douglas's exposition of his scheme for Social Credit, the new theory of economics and finance in opposition to the theories put out by Geoffrey Keynes, and this provided a steady income. Then Stanley published work by Ezra Pound, Christopher Grieve, Paul Eluad; Anton Makarenko's *Road to Life*; essays and critical writing by Orage; the philosophy of Kierkegaard, and cookery books. In short, he had an interesting and varied list, although he had some disastrous flops, from which Stanley was rescued by Patrick Synge.

Stanley and Rosemary had often heard us talking about the researches I was making into the early arts in Britain in which Alfred Orage had greatly encouraged me since our arrival in London. Orage suggested that Stanley should give me a contract to publish my book under the title of *Creative Art in England*. Stanley knew about the lectures which I was giving at the London County Council's Literary Institutes and felt that he had potential customers for the book among the teachers and students who came to these. He gave me an advance of £50! He was then, naturally, keen to receive the manuscript, but the date for this was somewhat speculative as I had so much else to do.

I was now forced to start writing in earnest. Much of the work had already been accumulated, from the researches which I did for my lectures, the study of Celtic and Pictish art which Flora and I had done in Scotland, and our studies of early English wall paintings and

illuminated manuscripts. I tried to work the results of my studies into an explanation of the creative impetus in this country and to provide the groundwork for a revival of this creativity, which I felt to be lying fallow.

Stanley made a beautiful book, and, for a small publisher, spent a great deal of money on the production.

We were thrilled – this was a real achievement at last, the culmination of six years' hard grind; this was why I had persuaded Flora to return to Britain. The book was well received by the critics and I was surprised at the number of copies that were sold. However, Stanley got into hot water and could not meet his debts and Mr Synge, a shrewd man, had a limit to the amount of money he was prepared to risk. Stanley, unfortunately for himself and for me, signed a Trust Deed winding up the firm. The following day he received a cable from Macmillan & Co. of New York ordering 500 copies of *Creative Art in England*, which would have met his debts. Thus, sadly, ended Stanley's publishing career. My book continued to sell, many favourable reviews were received and, in 1950, Macmillan & Co. republished it as *Creative Art in Britain*. Sadly none of this helped Stanley Nott.

Another American friend, active in the literary scene was Montgomery Butchart. He and his wife lived in Bloomsbury Square where they entertained a great many of the up-and-coming young writers and painters as well as stars like Ezra Pound and his wife Dorothy Shakespeare, Eliot and Percy Wyndham Lewis. Among Butchart's young friends was Ronald Duncan who had written *The Way to the Tomb*. Pound was very keen on encouraging the small magazine. Like Orage, he believed that small magazines added up to big ones, and that a new small magazine brought in new ideas, so he gave a lot of encouragement to Ronald Duncan when he started the *Townsman*. This was to be a magazine for town people. The long tradition of painting, sculpture and architecture had been based on nature – trees, fields, identification with living forms, an organic whole. The new art of Marcel Duchamp and his anti-art movement was a complete break with this tradition – nature as a basis or motif for the fine arts was finished. Butchart suggested that I did the cover. Ezra Pound wrote to Butchart and Duncan from Rapallo: '. . . The Johnstone looks active. At any rate *useful*. Of course, it is Ernst and

Arp, unless the colour is something else. Mah!!! Looks 1938 anyway; or at least ten years nearer 1938 than anything else in Eng . . .' The format was most attractive and the magazine contained several good reproductions of my paintings with which we, of course, were delighted, but *Townsman* only had a short life.

After this, Flora and I worked out several subjects which we felt would make interesting books. We showed these to Montgomery Butchart, who was at first delighted, but then became exasperated. 'William, if only you could write these things you teach. If you could just write them down instead of drawing them, we'd have a score of best sellers! Hell, I guess an artist can't explain, he can only do!'

Flora and I had been working on a book dealing with adolescent art, based on my experiences at Haverstock Hill School for Boys. (Flora herself ran a small private class for young children in our studio from which she had splendid results.) My problem had been the decline in spontaneous expression as children reach puberty, and how to bridge the gap between the naïve visions of childhood and the sophisticated, intellectual approach of early adulthood. We called the end result *Child Art to Man Art* and Montgomery was overjoyed with it. He sent the manuscript to Macmillan & Co. who promptly turned it down, but undeterred, Montgomery took it to Mr Harold Macmillan personally. He pointed out that this book was raising completely new ideas and suggesting a new application of art teaching methods, therefore it was of some considerable national and international importance. To turn a thing like this down, which had already been read by people of distinction such as Bertrand Russell, was nonsense. Mr Macmillan said, 'Very well, I'll take it with me over the weekend and I'll read it myself.' Shortly after, we heard that he had agreed to publish the book, but the war intervened. Twice a whole edition was destroyed by bombs and fire at the printers, and it was not until 1941 that *Child Art to Man Art* was published.

When Flora and I first settled in London we knew little about the art world of this great city. My only visits to London had been en route from Scotland to Paris. Flora's background of the avant garde art of America's West Coast and our mutual experience of the new art movements in Paris made us highly critical of the art establishment which we found in London. We were appalled by the products

of the Bloomsbury School, that personification of the parochial and the amateur in the twentieth century. Clive Bell's art criticism in the *New Statesman* we regarded as painfully out-of-date. We were suspicious and intolerant of the archaic teaching at both the Slade and the Royal College, and we wondered at the visual illiteracy of a country which made so much of Augustus John. Flora was scathing about the philistine attitude of the British towards art. She was firm in her opinion that we should return at once to America where, even in a little village like Carmel, they did not think of art as some absurd, cranky appendage, or a social gew-gaw, but as a perfectly valid part of the basis of living. We often thought of returning to Carmel but were warned by our friends there of the impossibility of making a living during the years of the Depression.

What else was to be found in London except the dead fingers of Henry Tonks? Ben Nicholson had begun to make his early abstract patterns, and inspired Cecil Stephenson (who was much cleverer with his hands than Ben). Poor Stephenson, a talented painter, suffered misery from his virago of a wife until E. L. T. Messens took her off his hands. When I was in Paris, I was told that another Englishman was drawing, either at Colorrossi's or at the Grand Chaumière, that his name was Moore. I thought perhaps I should meet this student, so I went to investigate, but learned that Henry Moore had left Paris for Italy. When I saw his work in London it never excited me as did the work of Giacommetti, Ozenfant, Arp, Zadkine, Lipschitz, Gonzales or Germaine Richier. I felt (and still feel), that he lacked the subtlety and sensitivity towards materials that the Continental sculptors had. There seemed to be a time lag of some ten or twenty years before ideas crossed the Channel and were taken up by British artists. None the less I had to admire the tenacity and determination of the younger British artists to get their modern work accepted in the face of the dead hand of the Slade School, the Royal College of Art and the Bloomsbury Group. Those who succeeded in selling their work at all needed to have outstanding genius as salesmen (or opportunist wives with money), as well as having talent as artists. The former qualification seemed to be the most important.

At gatherings in Harold Munro's Poetry Bookshop and other assemblies we used to see a man to whom both Flora and I took a

great dislike. He struck me as a kind of snooper. He was always listening to these young artists and poets but never seemed to contribute anything of interest to the conversation himself. He listened, with his eyes to the ground, ready to pick up any little grains of chaff which fell. I learned that his name was Herbert Read and that he worked at the Victoria and Albert Museum and wrote poetry.

Ulysses was beginning to filter into London; T. S. Eliot, Ezra Pound, E. E. Cummings, Christopher Grieve, David Gascoigne and other up-and-coming young poets were very active. Poetry was going 'concrete', and competition was keen in this field. Read decided to give it up and write about art which I for one, felt he had no sure knowledge about whatever. It was a case of pay as you learn. But Herbert was a joy to the young Hampstead artists trying to make their way against the blank wall of inertia in London, as he could be persuaded to write as much crap as they could feed him. Among the young critics, I felt that Hugh Gordon Porteous had most understanding of what modern art was about; he tackled the subjects on which he wrote with thoughtfulness and care so that his articles were appreciated. Then Hugh became captivated by Herbert Read.

An influential supporter of the *New English Weekly* was Eric Gill, whom I admired as a fine craftsman and typographer. His Gill Sans and Perpetua, designed for the Monotype Corporation, were a great breakthrough in the modern type faces.

Eric Gill held an exhibition of his drawings and sculpture, and Read wrote a criticism of it in the *Criterion* entitled 'Eric, or Little by Little'. This annoyed me because, while I was no great lover of Gill's sculpture, he was a sincere and dedicated artist-craftsman of great quality and to have serious work denigrated in a fatuous manner by such a mediocre critic was deplorable. Worse was to come. Hugh wrote another 'Little by Little' on Eric Gill, taking his lead from Read, to be among the fashionable critics who sneered at Gill's work. Orage wished to have an art critic on the *New English Weekly* who could write really intelligently about twentieth century art. I had agreed to contribute a small sum every week towards his wage while Eric Gill subscribed the rest, but the writer was never to know who was paying his salary. We had agreed not to complain if our art critic disapproved of our work but this article by Porteous was quite un-

like his usual work, and so outrageous, that Eric Gill protested furiously and threatened to stop his support. Philip Mairet asked me if I would come with him to see Gill in order to help calm him down. After discussion, Gill agreed that he would forget the matter, except that Porteous was to put something in the paper modifying his first article and the problem was eased out. Read wrote more art criticism wherever he could get it . . . in *Axis*, in the *Criterion*, in E. L. T. Messens's *London Bulletin*. Unfortunately, Porteous took his line from Read, imitating his manner, thus doing himself tremendous damage – he did not need to imitate anybody. He was a much more able writer than Read with a greater knowledge of his subject.

When Ben Nicholson held an exhibition, Herbert Read said that all art from now on would be abstract art, purely shapes and any other kind of art was finished. The only artist that Britain had had for about a thousand years was Ben Nicholson but rude people said that it looked like the background for an ice parlour. Hugh went all out for Read's opinion. This plagiarism annoyed some of the *New English Weekly* readers because they had also read Read's article and Hugh's status naturally suffered from this. I protested to him, 'Write what you think, what you see, irrespective whether it's good or bad, whether it's fashionable or not; you don't need to follow in Read's footsteps. I keep telling you that abstract art grew out of the Cubist thing in Paris before I was a student there. By the twenties the interest had moved to a more romantic feeling. The younger artists and poets were all talking about Surrealism, about Freud and Jung. Abstract isn't the end of everything in art, Hugh. You know perfectly well that Ben's paintings are just a lot of good taste art with sweety colours! I've been telling you about Kandinsky, Tatlin, Malevich, Klee and these early abstract chaps for ages. This all happened before 1914, it's old hat. Look, around 1900 the big change in modern art was taking place, but before that Vincent Van Gogh was telling McNeil Reid's father that art would be non-representational; colour would do what notes in music do, and that Montecelli was the man to look for. Now, Montecelli may not be your dream as an artist, but he was the man with non-representational stuff. Nicholson is an academic form of Mondrian because it was Mondrian who gave us a new space dimension, a new architecture.'

Abstract art became the fashion in London; then I heard that Herbert Read had written *An Introduction to Surrealism* for Faber in which he said that he had always been a romantic soul and had endeavoured to the best of his ability to penetrate beyond art into the world of the imagination. He really was at heart a lover of Blake and the Romantics. As for abstract art you could put that in the lavatory any day you liked. Surrealism was 'in'.

Henry Moore held a meeting of characters who could be called surrealist (he himself had always been one, of course); they were a miscellaneous collection of artists who really had never had anything to do with the subject. In truth there was not one genuine surrealist artist working in England at this time with the exception of Dr Grace Palethorpe, although some were entertaining themselves with amusing juxtapositions of unlikely objects and naming their work as 'surreal'. Among painters who had worked in Paris and absorbed the new fashion was Roland Penrose, a kindly man of sweet nature whom no one could dislike; from a careful Quaker background he had developed an adventurous interest in the arts. He was able to buy fine modern French pictures and to devote his life to the encouragement of modern art in this country. Penrose was invaluable to both Moore and Read through his connections on the Continent and he became an exceedingly useful ally; they kept him firmly in their clutches so that he could never escape their thrall.

Herbert Read shifted his political faith from liberalism to socialism, his art enthusiasms became outdated almost before his book could be written. The next time he would not be caught – he would be an anarchist and it would take a long time to catch up on that one. He wrote: 'To Hell with Art . . . to Hell with Culture!' In 1934 R. R. Tomlinson had written *Picture Making by Children*. Children's art now became exciting, and Read wrote a book called *Education through Art*, filled with a lot of grand language, references to Freud and Jung, and an excessive amount of quotations from learned scholars. As a practising teacher and artist I felt particularly annoyed by this one. It was crap, but Herbert was making a name for himself. He was read by everyone with pretensions to culture who, even if they had no clue as to the meaning of the subject, were reassured by the format of the books and the amount of footnotes.

In Scotland my old friend William Ritchie had interested me in Blake's poetry, in his strange imagery and beautiful drawings. At about the time of the Surrealist exhibition William Blake was discovered by the London intelligentsia. Everyone was reading Geoffrey Keynes's book – Blake was news. Another enthusiast was Professor Denis Saurat, a great friend of Francis George Scott's in Glasgow, where he had been Professor of French at the University. He was now Professor at King's College as well as being Principal of the French Institute in South Kensington which became, under his aegis, the centre of French culture in London. Denis Saurat was a charming man with a brilliant mind who acted as a magnet for people with the most diverse interests. One of my favourite visitors at the Saurats' was Sir James Frazer, the tiny Glasgow chemist (his wife always bought his shoes from the boys' department in the shoe shop) who had, in between mixing pills and potions in his chemist's shop, managed to write the *Golden Bough*. I admired him enormously.

In spite of (or perhaps because of), his great scholarship, Saurat espoused causes which were considered by some to be odd, even fantastic. For instance, he believed fervently in the lost continent of Atlantis, and in the interdependent economic communion between animals and man. (After the war he was one of the prime movers in raising money to give back to the Lapps the reindeer herds which the Germans had stolen, thus saving that race of people from extinction.) He was a great authority on Milton. With a gleeful twinkle in his eyes he used to explain to me the joy with which Milton had written *Paradise Lost*, but how the poet could hardly conceal the difficulty he had experienced when he tried to Regain his Paradise.

Saurat was deeply versed in William Blake's writings and interested me very much when he attempted to interpret the 'surreal' element in his poetry. Most Frenchmen would not accept William Blake as a surrealist writer, he was considered simply as an oddity. In France and Belgium the Surrealist (and Dadaist) movements were an immediate reaction to the destruction left by the First World War. The result of disillusionment, they were a protest against dud generals, futile politicians and the millions dead. Blake said that any fool could draw and show you what was contained within a circle, but

the only thing that mattered was that which was outside the circle. The artist, if he is a true artist and his intuitive response is of any value at all, will anticipate something of the future. That is his real importance.

Norman Dawson, a painter friend, and his wife used to hold soirées to which artists, musicians and writers were invited as well as their prospective patrons. Somerset Maugham came once or twice and I now regret that I felt no great liking for him. When I read and re-read his *Summing Up*, it seems to me that in this book he is able to express with the utmost clarity and deep understanding the nature of the creative artist; the meaning and the duty which the artist owes both to himself and to his world. At one of these gatherings I met Baron Otto Haas Heije. A tall, handsome, elderly Prussian gentleman who was devoted to the arts, I discovered that he had been married to a sister of the Kaiser's second wife. When we met him he had had his estates confiscated by Hitler and was eking out a living by giving lectures at the Reimann School of Art. Otto used to come to our studio to see my paintings. He clicked his heels in front of *A Point in Time* which was standing on the easel. 'Ah! *Wunderbar!* Villum, I know now that the war will come for certain. This picture tells me so. It is prophetic.'

In a curious way Otto was quite right. I had begun this big picture in 1927, almost unconsciously as an anti-war protest, with memories of the earlier war and of forebodings of the next. It tormented me for years. I wanted to try to bring form into my painting as a contrast to what I felt to be too much flat pattern in the work which I was doing. I felt that after the great burst of creativity begun with the Impressionists and continued by the Cubists, painting had somehow lost the dynamic intensity which had given these movements their powerful impact. Much painting seemed to have resumed a quiet progress, cosy with merely surface expression. After working on the pattern-making aspect of third-stage cubism, I felt an urgency to do something about this absence of form and I made up my mind to attempt a large painting concentrating on the orchestration of pattern, form and line. An activity was set up between pattern and form which gave the picture a sense of the growth of primitive natural forms.

Opposite:
Early abstracts in
oil and mixed
media (plaster,
ghesso, sand etc.)
Painted on board,
1926, 24 in. × 30 in.

Overleaf above: Analytical Landscape.
Oil on board, 1948–53, 18 in. × 22 in.

Overleaf below: Field Patterns. Oil, 1948–53,
25 in. × 30 in. Private collection.

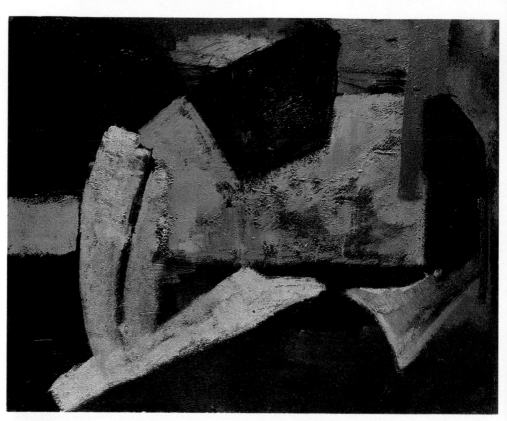

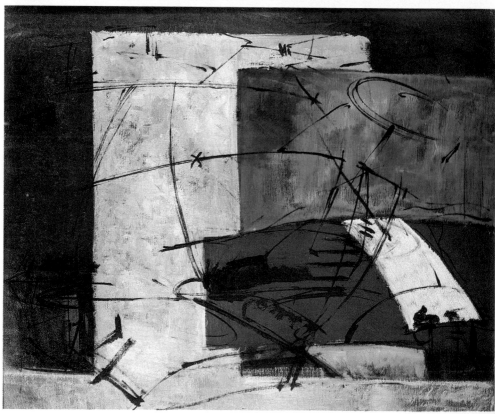

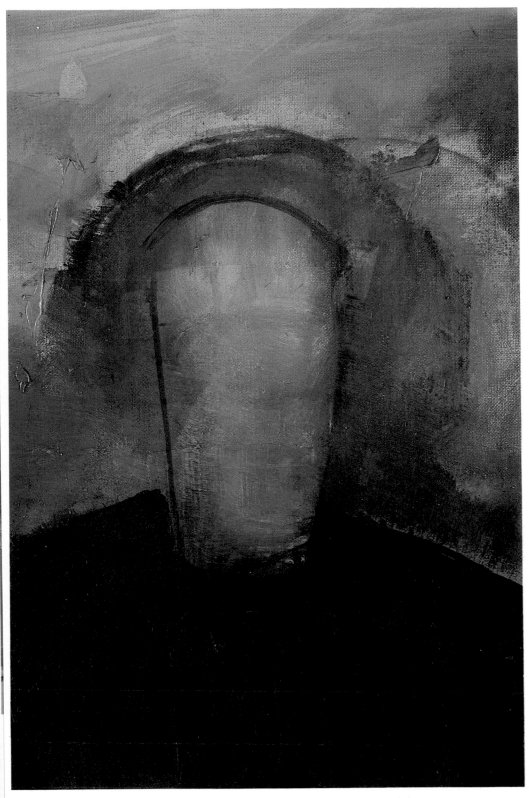

Portrait of HS. Oil, 1974, 12½ in. × 8 in. Property of Mrs Hope Montagu Douglas Scott.

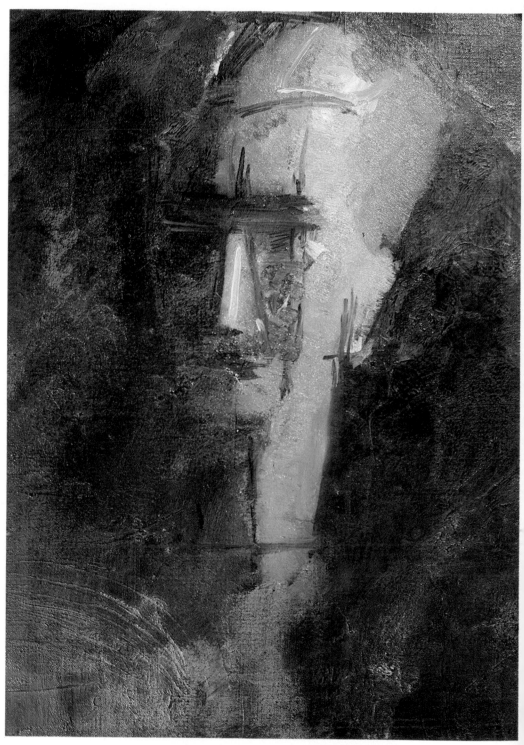

Portrait of Olga Winand. Oil, 1948, 20 in. × 14½ in. Exhibited at
Scottish Arts Council Retrospective Exhibition, 1970. Property
of Mrs Winand.

Scottish Landscape. Oil, 1958, 36 in. × 48 in. Property
of Sir Michael Culme-Seymour Bt.

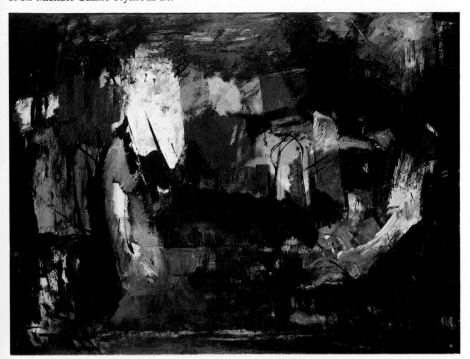

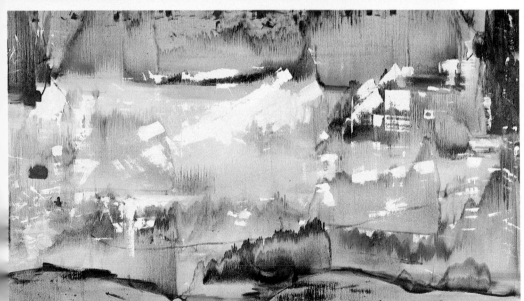

Blossoms. Oil, 1976, 54 in. × 96 in. Exhibited at Talbot Rice Art Centre,
Edinburgh University, 1976.

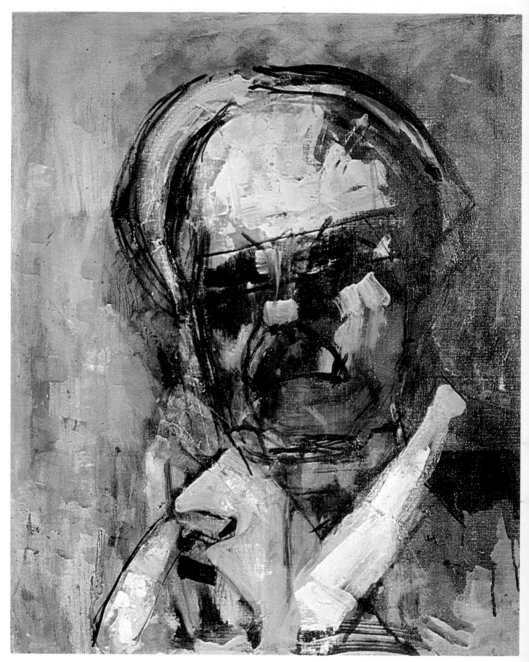

Self portrait. Oil, 1979, 30 in. × 25 in. Property of
Camberwell School of Arts & Crafts

I worked on this picture for two or three years, sometimes changing my forms back to patterns, sometimes reversing the procedure, but always I tried to keep all within a simple unity. In the end the primordial landscape erupted into what Otto felt to be symbolic of anarchic chaos.

In 1938 Gonzales was in London and called at my studio in Hampstead. At first I did not recognize him which surprised and somewhat disappointed him. When he came in and saw the painting which I had called *Point in Time* he exclaimed, 'You've done it! Come back with me tomorrow to Paris. You will get nothing here [England]. It is Paris for you now!' When I told him that I was an art teacher he said it was all the more urgent that I should leave at once. 'Paris is for you, some studio can be found. Picasso will find a dealer for you. You will be a success!'

Guernica had recently been shown in London, so we discussed the painting. I did not realize till then that Gonzales was a friend of Picasso's or that his brother had helped with Picasso's early sculptures until his death, when Gonzales had filled his brother's place and turned from painting to sculpture. I said I thought *Guernica* was one of the very great paintings. He laughed, saying, 'I saw it in production. I made some critical remark about one corner. Picasso handed me a brush and said, "Put it right." So I did and I do not think Picasso ever took it out again.'

Gonzales was reluctant to go away and again pressed me to leave London and return to Paris with him. By an odd coincidence I had another visitor that afternoon – not long after Gonzales had left, Henry Moore knocked on the studio door. I wondered what he could want. 'I hear you have a magnificent painting. May I see it?'

Francis and Christopher had both admired this, *A Point in Time*. Christopher had been so excited that he had written a poem about it. This poem, along with several others he wrote about my work in 1934, was sent to Francis for his opinion. Francis was severe in his judgement of them and pushed them away to the back of a drawer and here they were found after his death when they were published by Kulgan Duval in Edinburgh in 1963.

Otto told me that his brother-in-law, the Kaiser, greatly admired Compton Mackenzie. The Kaiser was intrigued by the fact that his

German agents had never caught up with Mackenzie's secret service work in the Near East, so one weekend Otto took Compton Mackenzie to Doorn to meet the Kaiser. On his return Otto said, 'The next time I go to Doorn you, Villum, will come with me. You will paint a portrait of the Kaiser. It will be splendid!' But by the time my visit was arranged the German army had invaded Holland and all chance of painting the Kaiser was lost.

E. L. T. Mesens ran the London Gallery in Cork Street, providing a focus for the more interesting of the younger artists in London. In 1939 he organized an exhibition called 'Living Art in England' which was to be the first real front shown in Britain of twentieth-century art, although Freddie Mayor had made a valiant, but tentative, attempt by staging an exhibition of contemporay art in his gallery in 1933. (Thirty years later I was amazed to find that he remembered some drawings of mine which he had hung at this exhibition.) Surrealists, expressionists, constructivists and independent types who could not ally themselves to any particular group although they were felt to embody something of the forward looking art of our time, were to be included – to this latter section I belonged. Among the British artists shown were Norman Dawson, Conroy Maddox, F. E. McWilliam, Reuben Mednikoff, Henry Moore, Ben Nicholson, Paul Nash, Grace Palethorpe and Edward Wadsworth. Among the foreign artists were Naum Gabo, John Heartfield, Henghes, Oskar Kokoschka and Piet Mondrian. While this exhibition was in preparation news reached someone's ears that Sir Kenneth Clark had established a group of artists in London for the express purpose of frustrating the rise of 'Bolshevist' art in Britain. Isolation and insularity was the cry. The Euston Road Group, as it was known, was basically composed of Victor Pasmore, William Coldstream and Claud Rogers. Their duty was to keep intact the Englishness of English art. This news caused consternation and an urgent meeting was organized at the London Gallery. I said that I thought a man holding public office such as the Director of the National Gallery (an academic form of life), should not take part in living art movements. If he took up one side or the other, modern or old-fashioned, he would put tremendous pressure in favour of that particular

group through the very nature of his official appointment. In this case the modern artists were bound to suffer and there was naturally a great agitation amongst us about this news. Several artists intended to go on a deputation to the National Gallery to see Sir Kenneth Clark and ask him to stop this scheme of his. Flora thought that, if Sir Kenneth could be seen, and it was pointed out to him what a mistake it was to support one section of the art world against another, Clark (being human), could change his mind. She suggested that someone should ring up Sir Kenneth and arrange to have an appointment with him whereupon Henry Moore suddenly left the room. I said to Flora, 'Let's go quickly, you'll find him in the telephone box in Vigo Street.' And there he was. The following week we held another meeting, when Mesens told us that Henry Moore had had an interview with Sir Kenneth, who had agreed that artists may wish to differ from the style of the Euston Road Group or the Bolshevists. From that time, Sir Kenneth never liked to do anything without first consulting Henry Moore.

According to Norman Dawson, he and Henry Moore had been great friends at the Royal College of Art. Later they both lived in Hampstead and took long walks together over the Heath, planning when they should hold an exhibition together. Mr Zwemmer, who had a small gallery near his bookshop in Charing Cross Road, was approached and agreed to such an exhibition, but soon Norman learned that it was only to be Moore's sculpture and would not include his paintings. So Moore had this small exhibition in Zwemmer's gallery in Litchfield Street. I was in the bookshop after the war looking at books for the Central School Library when Mr Zwemmer asked me if I wanted the new Henry Moore book. When I said I did not, Zwemmer told me that he had first published it in 1934, to sell at 7s. 6d. He was greatly amused that, in a slightly different format, the same book now sold for £5. He told me that before Moore's exhibition at his gallery, he had suggested that if the sculptor could find somebody to write an article of about 2,500 words in praise of his work, preferably comparing it favourably to Michelangelo, and if Moore would provide the photographs, he (Zwemmer) would publish it in book form. Herbert Read was introduced to Mr Zwemmer and agreed to write the copy for £30. I looked at the beautifully

produced book while Zwemmer laughed to think it had originally cost him £30.

Someone who is in need of a subject for a thesis should write about the extraordinary influence which Mr Zwemmer had upon modern art in Britain throughout the twenties and thirties. Through his bookshop, his publishing activities and his gallery, he introduced to London all the different advanced movements in art from the Continent. It almost seemed that every aspiring young artist learned his trade by propping up the bookshelves in Mr Zwemmer's shop in the Charing Cross Road. It was the centre for the dispersal of artistic fashion.

11

Camberwell: the uneasy years

In 1938 Mr Thoroughgood retired as Principal of the Camberwell School of Arts and Crafts. R. R. Tomlinson suggested I apply for the job but warned me that there would be tough competition from Cosmo Clarke, the Head of the Drawing and Painting Department, who had been a war artist during the 1914–18 war and had been in the Middle East with Lawrence of Arabia. Hitler's war was coming nearer and I feared that I would be completely penniless and out on my neck as at that time I was Headmaster of the Hackney Art School which functioned four nights a week and I had the Royal School of Needlework in the daytime two days a week. This gave me enough to keep us, time for me to paint and time for Flora to sculpt, but would probably not be considered vital war work. I had become deeply interested in art education, and I also firmly believed that painting was something for oneself alone, that the skill needed to sell pictures to art dealers and private patrons was an extremely difficult art, an art to which I had no clue.

I applied for the Principalship of the Camberwell School of Arts and Crafts and, to my delight, got it. The Governors must have been men of courage as it was considered ridiculous at that time for a man under forty-five to be appointed to such a position. I told them I would not take the appointment unless I was given an absolutely free hand to do whatever I considered necessary to bring the School up to the standard of a completely modern art school. The Governors agreed to this and generously supported me throughout my years at Camberwell. The movement for the foundation of an art

centre in South London had had the support of Sir Edward Burne-Jones, Lord Leighton, Walter Crane and G. F. Watts, and through the donation of W. Passmore Edwards, the Camberwell School of Arts and Crafts was opened in 1898 by Sir Edward Poynter, P.R.A.

Camberwell was a school with between eight and nine hundred students. These included part-time evening students, junior students, day-release printing students and thirty full-time art students – well below the capacity of the School. The Printing Department was the largest unit in the School. Camberwell is a district well known for its printers, its music-hall artistes and its 'petermen' (safe-blowers). Before the summer holidays I went over the School with Tomlinson to inspect the machinery in the Printing Department. My knowledge of printing was negligible.

When we went to Selkirk for the summer, I saw Guthrie Thompson who owned a very successful little printing business. Guthrie had notices in his paper, *The Saturday Advertiser*, about my being appointed to this big college. He felt the whole town was alight with me, but my father disagreed with this view. He said, 'Johnstone, I suppose you expect me to congratulate you on this appointment? Until this generation no Johnstone has been a servant. You are a servant of the London County Council. You will have to do *what* they want you to do, *when* they want you to do it. It's better to be a match-seller in Piccadilly. You are your own boss, then, and nobody's servant.'

Guthrie asked what he could do for me. I replied that it would help me greatly if he would allow me to come up during the summer holidays to see the machines working. By the end of the summer Guthrie had been able to give me a rough understanding of the problems of my new Printing Department. I learned about a Miele, a Platten, a Heidelberg, about different type faces, about lithography (I had come across lithography at the Edinburgh College of Art but it had been a long, long time ago). Guthrie and I enjoyed ourselves and I went back to Camberwell with a fair amount of confidence on the basis of this very sketchy knowledge. Among much valuable advice William Ritchie gave me was that I, as Principal, had to inspire confidence in parents, in my Governors and in the Ministry officials. I had to have a successful 'act'. Whether my staff had long hair, dirty

shirts or unbuttoned trousers, the Principal had to have a respectable suit, a black hat, a black umbrella, a sober tie. With this warning in mind I bought myself a black umbrella with a gold band, a dark tie and a black homburg hat.

I felt that Camberwell was my opportunity. I examined all the departments to see what they could do and what they could not do. The painting was sound but unimaginative; the printing was good but pedestrian – the Head of the Department was a technician interested only in getting students to pass the City and Guilds examinations – not much hope there. Cosmo Clarke soon left to be in charge of Rural Industries, so there was a vacancy for an artist. The Pottery Department, which had once had a great reputation under W. B. Dalton, was moribund – the two Hopkins brothers (one of whom was a splendid thrower of pots) taught in this department, although they had not spoken to each other for years. There was also a large Junior Art School.

I began to work out a new curriculum, following the principles of Romanesque architecture, of taking the materials that are handy and re-shaping them, to bring the whole thing in line with modern ideas. I also wanted to bring back the kind of personal relationship between the master craftsman and his student, between the artist and his apprentice. In Paris all the instructors were artists. It seemed to be that only in England art teaching was something to be ashamed of and the statement (Shaw's) that 'He who can, does. He who cannot, teaches' gained currency. I had seen enough tradesman and journeymen in art to know not to collect any more.

I wished to strengthen the structure of my staffing. If there was a weak place staffed only by a technician I intended putting an artist to work beside him, so that sparks would fly off to give a new life-enhancing environment. I wished to engage new staff solely on their ability as artists or craftsmen irrespective of whether they had ever passed any examination. Fortunately I had the ability, learned from my father, of being able to make very exact estimates of costing, which appealed to the officials at County Hall who were surprised that an artist could do this.

A man I greatly admired on the staff was Vivian Pitchforth, R.A. He had been a gunner in the First World War and his eardrums had

been shattered by the noise of the guns. He painted big, bold water-colours of his native Yorkshire in which his own personality was very strongly marked. Vivian had a genius for showing a student how to express form in drawing the human figure. His own analytical drawings were brilliant. When he found a student whose drawing of a leg was feeble or fuzzy Vivian would draw the leg in sections, on the side of the paper – most beautiful as demonstrations. Even the worst, dumbest, or most stupid student could hardly fail to improve when they saw where these sections came, so that instead of the leg being flabby, it had real structure in it, bones and muscles. Vivian always had big classes, but he would have no assistant because he said that the assistant would only have spoilt the continuity of his teaching. He was always most kind and encouraging to his students, many of whom came year after year to his classes, and some of them became extremely good.

Another splendid teacher was Eric Frazer, the brilliant graphic designer whose 'Mr Therm' was part of every gas advertisement for many years. In all the work he did, whether wood or scraper-board engravings for the *Radio Times*, line drawings, or posters, his craftsmanship was superb. He lived his work, slept with it, woke with it, taught with it. Frazer was a bulwark in the School, although he was a very gentle, unassuming soul. Eric would not have fought with a fly, but he was so serious and so expert at what he did that not a student spoke or even sneezed in Eric Frazer's class, they were so fascinated and so impressed by this tiny, frail, blond man.

A very youthful designer (younger than some of his students), Ronald Grierson, taught in the Textile Department with Dora Batty. Sir Albert Richardson, R.R.A., the eminent authority on Georgian architecture, told me that when he taught as a young man at Regent Street Polytechnic after coming out of the trenches in 1919, he was able to keep ten minutes ahead of his students, but that ten minutes was all he needed. Young teachers are vital for their life-giving enthusiasm. Grierson was a very brilliant designer, unassuming, extremely quiet, but he taught with the conviction of a thorough knowledge of printing and weaving techniques, and this was invaluable when dealing with industry. Businessmen with factories or mills want designers who can 'do', rather than ones just playing

with 'art', otherwise all the art in the world is quite useless to them. Grierson designed woven rugs, textiles and embroideries.

Teaching in the Sculpture Department was an elderly Scottish sculptor, Thomas J. Clapperton. He had been a very successful student in Edinburgh, had obtained a scholarship to study with Rodin and had become chief assistant to Sir William Gascombe John, R.A., in London, when sculptors were in great demand for war memorials. Clapperton had several very distinguished Scottish war memorials. to his personal credit, among them the figure of Bruce in the Edinburgh Castle memorial. He was an excellent craftsman and one of the best men I ever knew for putting up armatures that did not fall down. He was able to teach students the basic structure of their trade, but to enliven this rather academic attitude, I brought in F. E. McWilliam, considered to be a very bright young sculptor.

In 1938, except for a few odd enthusiasts, art education in Britain was at a very low ebb. There were very few men of my way of thinking in London and no help was likely to come from the Ministry of Education. Camberwell had a large number of technicians but few artists, whilst in his day Lethaby was looking for artist-craftsmen or craftsmen-artists. I was looking for artists. I realized, of course, that in a large Arts and Crafts School one could never get everyone perfect, or all the staff to synchronize. There would be difficulty in getting harmony among such a diverse staff, like bringing together the different motifs of a picture into a single unity.

One of the first people that I brought to Camberwell was Victor Pasmore. His teaching experience was slight, and he himself had never had any kind of serious training in the sense of the Continental art student, his training being largely at evening classes. What did he have of value to my School? He had exquisite taste. Every bit of colour he put together was sensitive. If he could hand out a standard of taste he was bound to have a general effect for good in South-East London. As an artist, I felt that he had no great inner creativity and his draughtsmanship was poor, but he had studied with A. S. Hartrick at the Central School and through him had imbibed a knowledge of French Impressionist painting. Victor was essentially a purveyor of good taste, an ideal person for my Painting Department which had to begin from the phoenix state.

In the early days, when Victor first taught painting at Camberwell as he really saw it and felt it, all the students sensed his value as an artist, and for a long time he was tremendously interested in his teaching at Camberwell. I enjoyed Victor's company; even though we were poles apart in our attitudes to painting we could none the less respect one another's work.

Mr Gautrey, a very respected old gentleman, was Chairman of the Governing Body at Camberwell. He was a distinguished member of the community and had sat on the original London School Board. He remembered the Camberwell Road as a dirt road before macadam, motor-buses and electric trams came to it. He had been an elementary-school teacher himself, but had served on many committees dealing with education, thus contributing to the vast developments which had taken place in this field during the previous fifty or sixty years in London. He was a very positive old gentleman and he felt strongly that, as the largest number of students in the School were printers (many day-release students came from the large number of printing firms in South-East London), the proper man to have chosen as Principal would have been Mr James Wright who, at that time, was Head of the Printing Department. To him it seemed ridiculous that the Department with the largest numbers, and the most practical application, should be subjected to the direction of a Principal who was a painter training people to paint pictures that nobody wanted – an idea that was most strenuously disputed by R. R. Tomlinson.

Trades-union representatives, members of the Federation of Master Printers, plus various sub-committees, came to Camberwell to tell me what to do with the training of printers' apprentices on day-release schemes. I rejected the employers' and the unions' points of view, both of which I considered to be biased. I told them I was not interested in training young people just to earn money or to train them solely to work to trades-union rules. I wanted them to have a cultural training of such a degree of excellence that they would not become unemployed until they reached their old-age pension. In other words, a basic training of such quality that they would not become obsolete in the labour market in a few years only to be replaced by further supplies from art schools and technical colleges.

Their training should provide them with reserves to be used throughout their professional lives.

I had fierce battles with James Wright, the Head of the Department, who refused to support my ideas for bringing any form of modern design into his Department. Mr Wright had the support of old Mr Gautrey.

I wanted to introduce artists rather than art teachers; I also wanted men who had notions about typographical design who would work in with the trade instructors. Eric Frazer was a great success; so also was Jesse Collins who came for a short time before moving to the Central School of Arts and Crafts. Toni del Renzio, who was married to the surrealist painter Ithel Colquhoun, helped to enliven the Department, and was a great help in bringing more up-to-date notions into the Printing Department.

Lithography was in the charge of Charles Mozley who was a splendid craftsman and artist. Henry Moore came down to Camberwell one day to see if we would print a lithograph for him. It was to be a big poster, 'Hands Off Russia', which was to be used in some procession or demonstration. We found a big lithographic stone, crayons and ink, all ready for Moore to make his design. He turned to me to say that he knew nothing about lithography and would I draw the design? 'I'm damn sure I won't. I'm busy', and off I went round the School, leaving Mr Moore with the technical assistant.

With the support of Desmond Hawkins, Hugh Gordon Porteous, T. S. Eliot, Richard Church and Julian Symons I hoped to found a private press at Camberwell making beautifully illustrated, finely bound books with modern typography which, I hoped, would act as a spur, an incentive, for my young printing students. To my surprise James Wright responded to this idea – his professional pride was stirred. So Richard, Desmond and Hugh came down to Camberwell to work out some preliminary ideas for this press. We began by printing books of verse, Ben Jonson's *Penshurst*, and a collection of Desmond's poems called *Easter Garden*; then we printed a little book of Cézanne's aphorisms on painting which Victor Pasmore chose. We became more ambitious and I began to design an illustrated book of modern art. But war came before we were able to get fully into our stride.

Norman Dawson showed me some remarkable paintings by children done under his tuition. They were very different from the results of Cizek's work in Vienna and very different again from my results at Haverstock Hill. As Camberwell had a large Junior Art School, this was a man to have.

Norman suggested that I see A. E. Halliwell who taught at Beckenham. He told me that Halliwell was a born teacher and had developed a course of basic design that was far ahead of anyone teaching in other schools and he had obtained remarkable results from his students. Halliwell arranged to bring his work to my office for an interview, but unfortunately, when he arrived at the School all he found was a crowd of people gathered round a body lying unconscious on the cement floor. On enquiry it turned out to be the Principal of the College. I must have fainted through complete exhaustion. Eventually we met, when I found that this man was an exceptional teacher, and he had a passionate zeal for his work. A. E. Halliwell was an outstanding success. He had been teaching a basic design course under the inspiration of the Bauhaus since 1933. His intentions were to establish a framework upon which could be mounted the whole future of applied design in this country. He had continuously changing variations in the courses which he taught, producing a grammar which every pupil could use in almost any circumstances while allowing the fullest personal expression. Halliwell later took over the Junior Art School as well as teaching commercial art in the Senior School, and the work he produced was tremendous, enabling his pupils to find immediate employment on leaving school. This was a great change from having to interview irate parents who discovered that their children, after attending Junior Art School, were unemployable.

Before I went to Camberwell, Flora and I used to have great discussions with Pamela Travers about the future of the animated cartoon. I was not as enthusiastic about *Fantasia* and *Snow White* as the others and, indeed, I believed that worse would come. Instead of it being an art medium I foresaw the animated cartoon deteriorating into a debased sentimentality. In this I took a gloomy view, but Albert Halliwell was very keen to do something about it. He therefore produced the first serious training in London for the cartoon-

film designer and for many years we sent our students to work for Messrs Hallis and Batchelor who were producing the most interesting animated cartoon films in this country.

The next development was industrial design. It was the logical step from two-dimensional design to three-dimensional. Halliwell agitated for this, but I demurred. When I was at Regent Street Polytechnic I worked part-time in the motor body-building school, and this entailed working on design for car bodies. I had to work with a lecturer from Briggs Bodies (Ford Motor Co.), and the Head Designer for Hooper & Co. (Rolls-Royce) – one mass-produced, the other hand-made. The structure and design of the engine and chassis dictated to a great extent the 'cab' design, and an understanding of the properties of various metals and other raw materials was essential. There was also 'art work' such as painting motor-car illustrations, shiny wheels, polish, aluminium, 'chi-chi' and all. There was no Leonardo da Vinci about this – it was superficial and useless except for advertising. This I pointed out to Halliwell, and told him that if he had an engineering workshop and could design from the first bolt, we could do it, otherwise it would be entirely without depth. What was called industrial design at that time was largely coating objects with highly coloured tin. Halliwell was disappointed. In the end, I gave him the go-ahead to see what he could do, although I left him in no doubt that mere superficiality was not in my line. We had to wait some years before we could see the fulfilment of this idea, but the seeds for the future training of the modern industrial designer in this country were sown at Camberwell. In fact, the battle for a change in the whole of art teaching in Britain was fought and won at Camberwell, 1938–9. *Picture Post* came to take our photographs.

War seemed inevitable. In London preparations for the evacuation of children, Anderson shelters and the printing of ration cards were put in hand ready for the day when the big bombs went off. Technical Colleges and Schools of Engineering would be possible targets. It was recognized that South-East London would be very vulnerable, and every precaution was to be taken. I called a meeting with my staff and students, but whatever preparations we made were based rather on fancy than on fact – there were very large coal cellars under the ground which were supposed to provide excellent shelter. My Junior

Art School was at once evacuated to Chipstead, near Sevenoaks, where we found an empty mansion house in a beautiful park. Flora and Elizabeth went to Selkirk to stay with my mother, and here they were joined by Francis George Scott's family who had been evacuated from Glasgow so that the little house could hardly contain them all.

A decision regarding my family had to be made. As Flora retained her American passport, and many of our American friends had left Britain already we decided that Flora and Elizabeth should go too.

Travelling with my family to Liverpool I sensed that this parting would be for longer than just the duration of the war, but I was fearful of the seriousness of the bombing, the length of the struggle. I watched whilst they boarded the ship and, just as a sailor was going to pull in the gangway, a woman and child ran down it. It was very dark in the dim, restricted lighting of the dock but there was no mistaking Flora and Elizabeth. I moved in behind some railway wagons so that Flora should not see me and would come to the conclusion that I had left the quayside to catch my train back to London. Travelling back I felt how foolish I had been to let Flora go. What I should have done was to lose my job, lose Camberwell School of Arts and Crafts, and go on that boat with them. I hoped that somehow I would be able to get to America.

Camberwell was, of course, completely dislocated. The senior students were mostly called up for military service; some members of my staff joined the Camouflage at Leamington; some became war artists. It was even suggested that I should apply to Mr Dickie (who was in charge of this operation), for a job to paint bombed-out farm buildings. Victor Pasmore asked me what he should do. 'Volunteer, Victor; you'll get a commission. If you don't they'll draft you and you'll end up peeling potatoes.' He took my advice and did very well in the Army until he was stationed in Edinburgh. Then he remembered a painting on which he had been working on his last leave and went home. He was later picked up by the Military Police and taken back to Edinburgh.

Otto Haas-Heije used sometimes to come to see me at the School. He had been giving some lectures at the Reimann School which had, sadly, closed at the outbreak of war. Now at a loss, he, too, had come

to ask my advice. He drew himself up to his full dignified height, clicked his heels and said, 'Villum, in the last war I refused to obey my brother-in-law to fight against England. I *loathe* this man Hitler, but they are interning all aliens in the Isle of Man. Where is that? I have no money and no job, what shall I do?'

'Otto, get to the Isle of Man fast. They'll feed you there and you won't have to pay the rent; then you can explain about everything and they'll probably send you back to London.'

Otto was charmed with the Isle of Man. He wrote to tell me that the Commanding Officer was a most cultured man and that he, Otto, had embarked on rehearsals for a season of Shakespearian plays. He told me that the Italian internees were most enthusiastic about the drama.

Otto returned to London from the Isle of Man to eke out a precarious living during the rest of the war by weaving scarves which were sold to gentlemen of fastidious taste by the most exclusive shops. One morning he arrived unannounced and demanded that I take him at once to see Mr Duff Cooper as he had some important information to communicate. It was urgent. Unfortunately, I could not help Otto, so he bowed punctiliously and left. A few days later Rudolph Hess landed in Scotland on the estates of the Duke of Hamilton and I remembered then that Otto's eldest daughter was married to Count Robert Douglas whose forbears were a branch of the Douglas Hamilton family who had left Scotland to serve as mercentaries in Sweden. Count Robert was a leader of the pro-German party in Stockholm. Otto's other daughter had married a high-ranking officer in the Luftwaffe. Before the war Otto had been invited to attend her wedding which was to be held with great pomp in Otto's erstwhile castle in East Prussia. As his prospective son-in-law was in high favour with Hermann Goering, that gentleman was to be one of the guests. But Otto, then an almost penniless refugee in London, refused to be present at his daughter's wedding if Goering attended. 'Such riff-raff, Villum, I cannot meet such people!' He made it a condition that he would be guaranteed a safe conduct during his stay in Germany and that the leader of the Luftwaffe would not be a guest at the wedding, and this was agreed.

The marriage ended in tragedy; Otto's son-in-law misdirected

bomber routes during the early part of the war so that planes missed their targets over London. Then for his part in an assassination plot against Hitler he was shot. Otto's beloved daughter was forced to commit suicide.

When the sirens screamed over Camberwell those on duty rushed to their posts while the rest of us made our way to the coal cellars. One morning I was rather slow in leaving my office on the first floor. It happened that I had just had a new suit made and was wearing it for the first time. As I made my way down through the Machine Shop in the Printing Department bombs started falling, and someone seized me and dragged me under a big Miehle printing machine for safety. I cracked my head on the cement floor and my new suit was ruined with machine oil. When I had recovered from this shock I remembered the Art Gallery next door, which had a huge glass roof under which about five hundred girls worked, issuing ration books. We pushed forward into the Art Gallery where we found the roof smashed and a crater in the middle of the floor; glass and debris were everywhere but no one was killed, and comparatively few of the girls had to be taken to hospital.

As the number of senior full-time students attending art schools became fewer it was decided to concentrate on the Junior Art School. It was thought that by unifying these schools at Northampton it would be a means of keeping together a certain number of permanent staff, mostly older people beyond military age; so the Junior Art Schools from the Central School of Arts and Crafts, Camberwell and Hammersmith were settled at Northampton. Tomlinson and I worked between London and Northampton. Colleges which had heavy machinery, where a considerable amount of war work could be produced by making machine tools, had to be visited.

The bombing in London became worse. After one very bad night County Hall telephoned every Principal and Headmaster to find out how many were at their posts – 100 per cent had managed to get there.

Tommy came with me one evening to Ilford where I was staying with some friends. As usual he had been working late at County Hall, long after everybody else had gone home, so it was dark before he picked me up. Amongst the maze of houses and bombed wreckage

in the East End it was hardly possible to find our way through in the black-out. However, Tommy knew his London very well, and he thought that if he went up a side street which seemed very quiet, we could work back on to the main thoroughfare and get down to Ilford. It was a very, very quiet street. A warden shouted, 'You bloody fool, where the hell do you think you're going?' and stepped out to stop us. Mr Tomlinson was furious and pulled out his ticket giving him authority from County Hall to go anywhere he wanted. The man said, 'I don't give a damn how much authority you have, if you'll only look at that tree, you'll see where you are. In another minute you may be in another world instead of in this street in London.' A landmine had entangled itself in a small tree growing in the pavement beside the road. It was fixed on a very slender branch and, as it waved in the wind, the two points of the detonator just missed touching the pavement. One extra gust of wind and the bomb would surely slip and the street would go up in the air. Tommy turned white, then green. He backed the car so quickly that we hit a fence.

On another night we planned to sleep in Tommy's Anderson shelter in Chiswick, but before we reached it the sirens blew, so we stopped near a pub next door to the Chiswick Empire. After the All Clear blew we needed a drink, but almost in seconds the pub, from being entirely empty, became so full that it was standing room only. Tomlinson had a wide black hat and white hair sticking out at the side which gave him an air of great artistic distinction. We walked into this mêlée where everybody was demanding beer or whisky and soda or gin – absolute pandemonium. The barmaid saw Tomlinson with his black hat and white hair and myself. She made it perfectly clear that the artistes, the artistes from the Chiswick Empire, must be served first. 'These gents must get their refreshment before they go for the second performance. Now then, ducks, what would you like?' She gave us our large whiskies.

As we left the bar, Tommy remembered how once when he was in Liverpool for an art education conference, he had been on a tram when the conductress came back to him after she had given him his ticket. She said, 'Can I ask you something, guv? Are you the Silver King?'

Then, between bombs and worry about my wife and daughter in America, I collapsed. William Ritchie put me in hospital at Galashiels and it was not until eleven months later that I was allowed to return to Camberwell on the strict understanding that I was not to remain in London at night.

One of my earliest patrons was a Belgian shipowner, Sam Winand, who became a very dear friend. Sam had spent all his professional life in London and during the war lived in a cottage near Guildford. He found me lodgings at Lockner Farm where Dora Pullen, a most kind lady who had a great sympathy for artists, ran a boarding house.

Before coming to London, Flora and I had taken several paintings through to Glasgow to see if an exhibition could be arranged with Alex Reid and Lefèvre. They kept our paintings a long time before finally deciding against showing them. The French partner in the Gallery, M. Bignou, felt that there must be no competition against his French painters, but McNeil Reid had been interested and had been reluctant to say no. He felt that they were so far ahead of anything in Britain at the time, so different from anything else, that there *must* be something in them. So, when the firm was established in London, McNeil was always inclined to include me among the Scottish painters whom he showed in between his exhibitions of fine French paintings.

McNeil asked me if I would accept a private pupil who wished to have some understanding of drawing. I agreed and so Mr Nehru brought his young daughter to study drawing with me. Indira Gandhi (as she became) was a most handsome girl with a brilliant mind. While she worked, Nehru would walk on Primrose Hill, and when she was finished he would come back to collect her and talk about his great collection of Indian sculpture. I wished I could have gone to India to see it.

Unfortunately I did not get on well with another partner at Reid and Lefèvre, Duncan Macdonald, who was a dynamo of a salesman. He came to see my work and picked out an early landscape of the Eildon Hills. 'Paint me half a dozen of these every month and I'll give you a contract.'

'To hell with that!' and I told him to leave my studio.

Duncan lifted his hat and cane, saying, 'You'll never get an exhibition at Reid and Lefèvre while I am alive.'

I never did, but I always remained friendly with McNeil. To encourage me to start painting again after my illness he sent me a student, a young American who was working on Averil Harriman's staff at the American Embassy. Ashfield Link used to come down to Lockner Farm at the weekends and together we painted St Martha's, the hill rising just behind the farm. My paintings, far from being studies of the Surrey hills, turned out to be romantic, even dramatic, evocations of my own Border hills. No matter, we enjoyed our painting and I began to recover from my year's illness. I sometimes used my fellow guests as models. Mrs Duncan was quite a nice looking, youngish woman who sat patiently for me, but when the other guests saw this portrait they were horrified at what I had done to the poor lady. With great concentration, almost without looking at my model, I had painted a portrait of intense suffering, of hunger, of despair. The ghastly face looked out from the canvas as if it were recovering from some fearful neurasthenic shock after having endured a thousand air raids. I had painted a self-portrait of my own nervous breakdown. I called the painting *The Refugee*.

My doctor was worried, and sent me away to Scotland for a few weeks' rest. Two or three years later he confessed that he had had doubts as to whether or not to let me go so far away. In the state I was in he did not expect to see me again but, as I had such a short time to live, and wanted to see Scotland again before I died, he had agreed. He had thought that with my high blood pressure, neurasthenia and bad heart my chances of survival were very poor. He had been delighted to see me on my return.

During this difficult time I often stayed with my cousin Francis in Argyle where he used to take a cottage near Taynuilt on the shore of Loch Etive. Here he would work at his music all summer until it was time to return to his teaching in Glasgow in the autumn. He stayed at a cottage owned by Jimmy Campbell who, after having worked in the meat yards of Chicago, in the Argentine, and in Chile, had returned to farm his own little croft in Argyle. Francis took me down to the village where we looked at the long list of names on the war

memorial. Practically the whole male population of this little High-
land village must have been killed in Flanders. We watched old
Campbell of Lochnell shuffling out of the boarding house in a darned
and faded kilt, the loose heels of his shoes tapping along the road,
the holes in his stockings gaping wide. Lochnell was the last of his
line and was treated with the greatest respect. He was never asked to
pay for his lodgings, nor was his whisky ever charged at the hotel.
Unfortunately Francis made some disparaging remark about the old
gentleman when we returned to Brolas. Jimmy Campbell looked up,
flushing angrily. 'You may laugh at Lochnell, Mr Scott, but if Loch-
nell should ask us, every man and mother's son would follow him.
Every Campbell, man or boy between fifteen and eighty, would go
to fight in the war.' Some days elapsed before Jimmy became again
his natural kindly self.

Francis was fascinated by the Gaelic language and song. On Saturday
evenings he would say, 'Come on, we'll go down to the village and
listen to the men coming out of the pub. If we go early we can hide
behind the bushes and listen to their songs.' The men rowed across
from the quarry on the opposite shore of the loch to spend Saturday
night in the Taynuilt Hotel, from which they emerged at closing
time gloriously drunk. They staggered out of the bar arguing dis-
jointedly among themselves, sometimes bursting into song, some-
times fighting, and then they gathered themselves for the dangerous
crossing of the loch. At Taynuilt, Loch Etive closes into a channel
through which the whole weight of the Atlantic rushes. The quarry-
men climbed into their boat (we could still hear them singing), and
we held our breath as their little row-boat careered through the
narrow throat of the loch, carried them far down towards the open
sea on the great currents of water, until the men gathered their oars,
turned the boat and pulled hard up the loch towards their own
shore. They never made a mistake. All the time we listened to their
drunken voices singing the beautiful Gaelic melodies, songs of time-
less sorrow which drifted across the water in the wonderful light of
the summer's evening. Francis would hurry back to the cottage
where he spent the rest of the night at the piano. By returning again
and again to this Gaelic music Francis tried to get to the root of
primitive being. In some of the songs which he wrote at this time he

seemed to reach the inner voice of all the pain and suffering of the human race.

I used to see Denis and Madame Saurat at intervals during the war years. The French Institute was the hub of the Free French forces then in London, and General de Gaulle made his home with the Saurats on his arrival in London. While the General was a great patriot, he was also an arrogant, impulsive, clever man who was delighted to be surrounded by toadies; the superiority of all things French was inherent in his very bones. Madame Saurat, a lady with a very strong personality, came from Alsace-Lorraine. She resented the General commandeering her household, and she also resented the General's demands that her husband spend his time arranging meetings with the heads of the British Government at the shortest notice to suit the General. De Gaulle's temper was not improved one day after he had sat for several hours outside Lord Halifax's office, waiting to be admitted; Denis had done his best to dissuade the General from importuning Halifax so soon after his arrival in London, to no avail. Francis George Scott, who was staying with the Saurats, rang me up to see if I would go to the ballet that evening with Madame and himself. There had been a frightful row; a dinner party had been arranged (on the General's instructions) for him to meet various people likely to be sympathetic to the Free French cause. Madame was furious that even her kitchen was no longer her own; she refused to attend her own dinner party, leaving Denis to cope with de Gaulle and his important guests while she enjoyed the ballet at Sadler's Wells with Francis. Life at the French Institute was strained until de Gaulle found quarters elsewhere.

Denis Saurat, always terrified of catching cold, looked after his own health assiduously. One night he appealed to Madame to come away from the window where she was watching the effect of some bombs falling in South Kensington, and to please come to bed before she caught her death of cold. That night the Lycée (associated with the French Institute) was heavily bombed and Denis was buried in the rubble for three hours before being rescued; fortunately he suffered no damage, not even a cold, and naturally Madame was unscathed.

Saurat believed that, after the war, a great cultural union could be formed between various countries throughout the world which

would, in some measure, supersede the normal political exchanges which had previously proved ineffectual. His 'Union Culturelle', which he initiated in 1943, brought together an interesting collection of characters; among whom I remember were the French writer Paul Morand, and M. Felix Gouin, who headed the French Parliamentary group in London, later becoming Prime Minister of France for a short time in 1946 before being involved in a great wine scandal.

When Flora and Elizabeth left for San Francisco I was only allowed to send a very small sterling allowance out of the country because of wartime restrictions, but Flora felt assured that her family would help to make up any deficiency. In this she was mistaken; for one thing, her family had lost too much money in the Depression, for another thing they believed fervently in the theory of self-help. I received worrying letters from San Francisco and concocted all sorts of schemes to get money to my family. McNeil Reid tried to get me a position in a New York Art Gallery but, as I was still of military age, this was not possible. I was becoming distracted with anxiety about my family when Christina Huntingdon came up with an idea. Beautiful, intelligent and dynamic, she was married to Lord Huntingdon (who had taught mural painting for me at Camberwell) and had studied with him in Mexico. Her mother was the somewhat notorious Edwardian hostess, the Contessa Casatti, whom Augustus John painted as a feline, demon-eyed witch. She thought she could get me to Rome where I would pick up a large sum of money which I would take to America, keeping a percentage for myself. I had reached such a stage of desperation about Flora and Elizabeth that I would have risked my whole career on this wild scheme, but fortunately, perhaps, this mad gamble was never realized. Instead I received papers from Reno asking me to appear as the defendant in my wife's action for divorce. As this was an impossibility, my friend Phineas Quass had the action stopped. When Flora brought a second action for divorce I gave up my opposition, but when the papers came to inform me that the finding of the court was that I had deserted my wife and child and that she was to have complete custody of our daughter, the bottom fell out of my world.

But work had to be done. The Junior Art School came back from Northampton and Camberwell began to expand again. A great number of men would soon be wanting places in the art schools once demobilization began, and I foresaw a big development at the School.

I went into Reid and Lefèvre's one day. The gallery was a series of rooms leading out of each other, and I could have sworn I saw a chap looking remarkably like Victor Pasmore dive through a door and disappear. I tried the next room but there was nobody there, nothing to be seen. I reversed my steps and ran straight into Victor. 'You know, Victor, I saw you from the first door, it's hardly necessary to chase you through three doors. You don't need to run away from me. What about teaching again at Camberwell?' He accepted my offer with enthusiasm and I said, 'You'd better come down on Monday and get started, Victor, I've got a class for you.'

Young people coming out of the Forces joined the staff at Camberwell – John Minton, Michael Ayrton, Leonard Rosoman, Keith Vaughan, Mervyn Peake, Susan Einzig, Kenneth Martin. I felt certain that all these would have a distinguished future. Each, as a practising artist or designer of merit, was able to bring to their students a creative enthusiasm which was contagious. John Minton was a great success; he and Michael Ayrton were working on a production of *Macbeth* for John Gielgud and they had an exhibition of their drawings for these costumes at the Leicester Galleries.

Leonard Rosoman was a most agreeable, sensitive young man of great talent who, as an artist, was developing fast; Susan Einzig, a gifted young lady of spirit was a splendid asset in the School. Her work with the students in painting, drawing and graphics was a great success. But Michael Ayrton did not live up to my expectations as a teacher. He was an extremely versatile young man, determined to show the world that he was an 'artist', so that he soon lost interest in his students. Keith Vaughan must, I believe, be considered as one of the major artists of his period; Keith had a background of typography and commercial art but was determined to make painting his career; he was a first-rate, conscientious teacher of drawing whose work I greatly respected. His own work, whether in drawing or in painting, has always retained a strong personal character; no deriva-

tion, no imitation, no pastiche, seem the mark of a man of considerable stature.

John Minton taught illustration with Gertrude Hermes whose wood engraving (along with Agnes Millar Parker's) I had greatly admired when I was still a student in Edinburgh, although, after returning to Britain from France and America, my interest in this way of tackling wood engraving had diminished. Gertrude was a good sculptress and a fine draughtswoman in addition to her work as an engraver. Like Vivian Pitchforth, you never had any trouble with Gertrude's classes – she carried out her work to perfection. Gertrude was a handsome woman. Norman Dawson, who had a wandering eye, took a great notion to her, but Gertrude was very happily married to Blair Hughes-Stanton. In later life, when Blair had run off with another young lady, Gertrude was most kind to them, and mothered them both. When both Blair and Gertrude taught at the Central I used to come upon them sitting together on the stairs, as friendly and devoted as if nothing had ever come between them.

Victor Pasmore came to see me to tell me that Claude Rogers was getting out of the Army and was wondering if he could have a job at Camberwell, so I said I thought we could find a place for him. Claude was sleepy and disliked violent exercise, preferring to reflect, to rest, to sleep. In the midst of the School's activity he was borne along reclining, as it were, upon a palanquin. I liked Claude, although he was against all forms of modern art because he was against anything that changed. He liked the model to be in the same position for two or three years; it saved him the bother of having to set up another pose. His paintings were pedestrian and of little importance but he had a unifying influence and his delightfully pleasant nature was a quality that was helpful among young students. He radiated tranquillity. Lawrence Gowing came to work at Camberwell too, and was a great success with his students, who admired him greatly. Gowing was an amusing character and a very shrewd businessman. He was extremely ambitious and determined to make a success of his career. I used to enjoy it when he came to discuss painting in my office.

The School was rapidly expanding. Norman Dawson returned from Canada with a doctorate (he was now to be known as Dr P. Norman Dawson); the surrealist sculptor F. E. McWilliam and Toni

del Renzio (both of whom had taught for me before the war) re-turned to Camberwell; among the younger men two very talented brothers came, Nigel and Neville Walters; Rodney Burn continued to teach drawing and I found a place for his friend Tom Monnington.

Victor asked me whether he could send William Coldstream to see me. He was coming out of the Army and would be needing a job, as Sir Kenneth Clark was not intending to re-start the Euston Road Group. I was not enthusiastic about Coldstream as we had as many of the Euston Road Group as we needed at Camberwell, and I did not want any more 'old-fashioned' artists. I wanted teachers with modern ideas if I could get them, and anyway I did not think Cold-stream would make a good teacher. In my view his paintings were merely illustrations; he did not seem to have any notion of how to handle paint; he used oil paint as if it were watercolour; his portraits were drawings tinted with thin, turpentiny oil paint. None the less I gave him a part-time post as I was short of staff.

During this period I remarried, and my wife (who had been one of my students at the Royal School of Needlework) and I moved to Lockner Farm, which we had bought complete with guests. How-ever, I did not enjoy running a guest-house and the School became too busy for me to remain in the country, so Rodney Burn lent us a basement room in Chelsea. We brought our baby, Claud the cat, and enough furniture to furnish a very small London flat, and we sold Lockner Farm, intending to buy ourselves a country cottage. Claud died from cat 'flu and had to be cremated with full military honours in the boilers at the Royal Hospital.

Soon, instead of the flat, a friend found a house for us just round the corner in Royal Avenue. 1947 was a cold, hard winter; the snow began in November, continuing for five months – it was still snowing in April. Our house in Royal Avenue had once belonged to Mabel Love, an actress friend of Edward VII's and he, we felt, must have installed our antiquated central-heating system which we were de-lighted to find still worked. The only difficulty during that winter of severe coal rationing was to find enough fuel to fire the boiler. My wife used to take the baby to Lot's Road Power Station, returning (when it was available) with a bag of unrationed coke at the bottom of the pram. But this was not enough, and I decided that it would be

a useful opportunity to burn up many of my early pictures. Layers of paint, due to my practice of painting several pictures on one canvas, had cracked; many of the rolled-up canvases had been damaged in travel, or in storage; some had suffered injury through bomb blast during the war; moreover, I was no longer interested in many of these early paintings; I had finished with the work I had been doing ten or twenty years earlier and I wanted to begin afresh with a new outlook. So I kept a few of these old paintings to remind me of the various experiments which I had tried, and the rest helped to keep us warm during that bitter winter.

12

Camberwell: post-war harvest

There was a tremendous rush of students after the war, and I must have interviewed thousands of men and women from the Forces who wanted to take up art in some form or another. The directive from the Ministry of Education was to fit in as many servicemen as possible, to keep them quiet and happy; there was to be no recurrence of the disillusionment following the First World War. We had a splendid group of students, and among so many who later made their name in the world, I remember the jazz musician Humphrey Lyttelton; the cartoonist 'Trog'; Andrew Forge who now sits on innumerable committees dealing with the arts, but whom I tried to persuade to return to his father's farm; Arthur Lucas, who became Head of the Conservation Department at the National Gallery, a world-wide authority who tackled the enormous problems of cleaning and repairing the great masterpieces of the nation. . . .

Nearly three thousand students flocked to Camberwell and extra buses were put on from Camberwell Green; the school restaurant (the profits from which enabled me to start a fund for any impoverished student from South-East London), overflowed and three new cafés were opened opposite the School in the Camberwell Road. Modern ideas spread round London like setting fire to dry hay, and everybody heard about Camberwell. People forgot about the Royal College of Art, the Slade or the Central School of Arts and Crafts, they were completely 'out'. We had a terrific post-war party, more important and exciting even than the Chelsea Arts Ball. Toni del Renzio organized spectacular Can Can girls while Edwin Straker

made fabulous decorations and murals. Edwin asked me about his drawing which he felt was too flabby, lacking structure, and suggested that we should have an anatomy teacher. I had to explain that it would not be possible just then, but pointing out some young ladies cavorting at the far end of the studio I said, 'Meantime, Edwin, you'll have to use the Braille method!'

Students came from far and near, there were thirty or forty different nationalities in the place apart from those from Camberwell, Tooting or Balham. We were practically out to the door, so that everybody crowded in to get an easel otherwise they had to paint long-distance or paint the back of somebody's head instead of the model. The local people of Camberwell complained that it was *their* Art School and they were being squeezed out by these students from Mayfair and other parts of the world. We were even gaining a reputation for training Principals as well as students – Lawrence Gowing left for Newcastle and the same year Norman Dawson took up an appointment as Head of Winchester School of Art, whilst William Coldstream was in training for the Slade. It was a tremendously exciting time, which could never happen again, never be recreated. There were no rules, no very strict courses, but it functioned, and by bringing together such a brilliant and curious composite of talents as it did, Camberwell influenced and changed attitudes; no one could be unaffected. The very contradictions in style and intent of those working there made everyone think, and think again, about what they were doing.

Victor Pasmore used often to come into my office to talk about painting, and I enjoyed his company very much. He was painting his fine pictures of Hammersmith Reach as well as sensitive studies of Camberwell painted from our studio windows. He had written to me from his home during the summer vacation:

. . . I do not expect we shall go away, the effort and the expense is too great. Besides there is the finest landscape in the world here at my doorstep. In the park there are forests, and lakes, which even Scotland cannot boast, and when the mist hangs on the river, behold the most beautiful reaches of the Nile.

I have pondered much upon your remarks about form in space, but am reluctant to believe that modelling is the end of painting. As I look out of the window I can see the stars like little lights hanging in the sky and the trees

spread out like the finest lace – what has all this to do with modelling?

We must beware of generalizing about art. What is required is a belief in one's own reactions before nature . . .

Victor protested against all forms of modern art, saying that all Parisian art was one huge hoax which the French had put over simpletons who had more money than sense. The Euston Road School had been set up to stop the spread of Bolshevism in 'England's green and pleasant land'. He told me that Camberwell would be ruined by modern art and that the cult would soon pass away when people found out what a huge joke it was. He guffawed at reproductions of cubist painting, but none the less he asked me more and more about Paris and the artists of the French School. There was an important exhibition of Picasso's paintings at the Victoria and Albert Museum, and after Victor had seen these pictures he decided that Picasso, instead of being a charlatan and a humbug, was really a very great artist. He tried to persuade me that he himself had already painted Cubist pictures.

A. E. Halliwell was in charge of the Junior Art School as well as teaching commercial art (graphics), in the Senior School. Halliwell taught his students in the modern idiom, and they produced work that was far in advance of any shown in the West End galleries at that time. If he had an especially talented student he tried, whenever possible, to keep them on in the Senior School. Edwin Straker was responsible, in Halliwell's Department, for a course in basic design for ex-servicemen on grants; step-by-step teaching beginning with rectangles and developing with exercises in abstract shapes, textures, form and colour. Edwin also taught two periods of drawing, studied with Victor and talked a great deal with him. Victor was puzzled by Edwin's interest in design and its application to commercial usage, and he came often to see the work being done by the students. In 1947 Victor produced his first abstracts, very similar to our first steps in basic design. When Edwin went to Newcastle he worked with plastics, wood and wire constructions which led him to product and exhibition design. Victor (also in Newcastle), began his constructions in perspex and wood. Not Naum Gabo in Hampstead, but an insight into advertising techniques at Camberwell and Newcastle gave Victor a taste for the 'modern'! This applied art led to a movement

in art schools which tended to prove impotent and sterile as nobody understood its roots. Too often courses were taught by men who had neither the grammar nor an appreciation of the idiom. This seemed to lead to a situation where there were to be seen in exhibitions and dealers' galleries too many examples of paintings which were merely exercises in taste or cleverness without any real feeling.

Victor next took a great notion to practise geometry and the use of the golden section. This he could not grasp so I found him a tutor, William Millar, to go to his studio at weekends, but with little success. A double golden section such as is used in the Velasquez *Infanta* had him so foxed he could neither make head nor tail of it. Despite all his efforts to be 'modern' Victor Pasmore still remains the same decorative painter of good taste, a 'drawing-room' artist. I am positive that if he had stuck to his Hammersmith paintings his work would have attained much greater depth and profundity; instead of an imitation of the work of other abstract artists (not even yet deceased), his painting would always have been his own.

The members of my Governing Body represented the London County Council and the Metropolitan Borough of Camberwell. Among them was Mrs Patricia Strauss, a very beautiful and charming lady who had been, before her marriage, an artist's model. She was most anxious to start off with éclat by getting the staff and students to brighten up all the libraries of the London County Council with mural paintings. I pointed out that the materials for building were very seriously rationed and the difficulties of getting plaster to deal with the London County Council libraries would be so hard that I could see no possible hope of permission being given to use materials for this purpose. What about an exhibition of sculpture in Battersea Park? This would be quite new and would need neither building materials nor indoor accommodation.

The lady was thrilled with this idea and asked me how I would go about it. I said, 'You want to get all the big people assembled to serve on the committee – Sir Kenneth Clark, Philip James, Sir John Rothenstein, Henry Moore and so on. That would be a start.' She asked me if I would serve on it. I was not very keen because I disliked committees but said that, if she wished, I would do so if Mr R. R. Tomlinson was also invited. Tomlinson was delighted and thought

it was a capital notion for the London County Council. The first meeting was soon convened, and Sir Kenneth Clark, our Chairman, announced that all the photographs had been seen. He felt that Henry Moore should have three great figures; then we should choose the less important sculptors like Gertrude Hermes – Jacob Epstein was to be left out. I liked Jacob Epstein and respected his work. He was always most generous towards young artists, putting forward their names whenever a suitable opportunity arose where he felt their work could be exhibited to their advantage. I protested at this exclusion. After all, he was one of the first sculptors to exhibit modern work in a park. I reminded the committee of the Hudson Memorial in Hyde Park, of his carvings on a medical building near Charing Cross Station. I thought it would be wrong if an artist of such an international reputation were to be excluded. The committee decided to include Jacob Epstein.

One day, Victor Pasmore came to see me in great agitation. 'William, is it true that Robin Darwin's coming here? I'm not staying if he comes. Don't let him come, he'll disrupt everything; he'll only want to pick your pocket!'

'Calm yourself, Victor. It's true that I have a letter from Robin Darwin asking if he could join my staff here but I have been making enquiries and I do not think he is a man I would want to employ.' Victor went happily back to his painting class. I had not been keen when Victor had introduced me to William Coldstream and I regretted having given him an appointment in the School. I discovered that he had some notion that drawings should be tiny, about postage stamp size, 'sight size' he called it; so you had a quarto sheet of paper and you had a figure drawing about two inches high. The first year that his students sat for their examinations under the Ministry of Education they all failed in the drawing test. This was so unusual that I had to go along to the Ministry. They were in a great state of fuss because it distinctly said on the examination papers that the drawings were to fill the sheet of paper provided, and they were to make some sort of composition, which were perfectly reasonable conditions. What was I doing allowing such rubbish in my School? It was felt that Coldstream became the self-appointed head of the Drawing and Painting Department. There was an urgency about this

promotion as it was only a matter of time until Schwabe retired from the Slade and Coldstream would step in. Camberwell was merely a platform pending the day when he would get the Slade Professorship. Reports reached us that Schwabe was going this term, but he did not; that he would be going the next term but he did not; Coldstream meanwhile tapped his heels, waiting on Schwabe dying – like Dr Paddy in the *Doctor's Dilemma*, it was a long passing. At last Schwabe decided to retire. Both Tom Monnington and Rodney Burn were anxious to apply for the Slade Professorship. Rodney came to me for a testimonial but I said, 'You'll never get it, Rodney, because it's likely to be a walkover for Coldstream. I think you'll never get it, but you'll get the humiliation of being interviewed and rejected.' I wrote him a glowing testimonial about his draughtsmanship (which Coldstream could not touch for sensitivity). As expected Coldstream walked away with the appointment.

When Coldstream left there was a murmur in the air as to who would go to the Slade with him and therefore denude Camberwell of its staff. I said this would suit me down to the ground. As many could leave as they liked, because there were a whole group of younger artists and painters with a modern outlook coming up, and this exodus (if it took place) would make opportunities for them.

In London there is one essential requirement needed in the technique of selling paintings – you must sit on a committee, several, if you can manage it. The subject is not important so you do not have to worry whether you have any relevant knowledge. Exhibitions sponsored by tobacco firms, newspapers, children's exhibitions, education, anything that comes to hand will do, but the vital ones are Arts Council committees, the Tate Gallery and the National Gallery. Some of my staff were adept at the 'committee game'. A wag put it around that there were now two corners in London, the Poets' Corner in Westminster Abbey and the Coldstream Corner at the Tate. I went to the Tate to investigate, where sure enough, I found a very cosy little corner devoted to Coldstream, Pasmore and some friends.

Since the war R. R. Tomlinson had acted as Principal of the Central School of Arts and Crafts, the London County Council's premier art

college, as well as carrying out his duties as Chief Art Inspector for the Council. The three major art colleges were very well arranged; London University's Slade School which undertook the teaching of fine art subjects had become famous under Fred Brown; the Royal College of Art was primarily concerned with training teachers, and the Central School taught designers and craftsmen. All three Art Schools had the right to grant their own Diplomas, so that the system was very nicely balanced, one being in the world of aesthetics, one dealing with designers and makers, the third with teachers – a reasonable division of labour.

In the early thirties when I first came to London these three Art Schools were all moribund. The Central suffered from inbreeding. Too many men were on the staff who had been either students or worked under Lethaby without truly understanding his philosophy (the disciples failed to understand the Master). The Royal College suffered from weak Principals, and the Slade suffered from Mr Tonks. Such was the state of the Royal College that the Hambledon Report of 1936 suggested the transfer of funds and several departments (those dealing specifically with design), to the Central School of Arts and Crafts which was in a much more active condition, being in a position to tackle the training of designers in a practical manner.

All three Art Schools were unfortunate in their Principals, but the right men are not found growing on trees. It is extremely difficult to find the kind of creative person who would be suitable for such a post; organizing ability by itself is not enough. While they had excellent individual teachers, these Schools lacked any driving purpose which would project them into the twentieth century. Camberwell challenged these senior colleges and, to a very large extent, stole their fire.

The Central School of Arts and Crafts had been a famous art school since its foundation in 1898 under the Principalship of William Richard Lethaby and still had artist craftsmen of superlative skill working and teaching in the studio workshops. In 1943 the School received a commission to make the famous Stalingrad Sword. Evelyn Waugh, in *Unconditional Surrender*, described the scene when the sword was exhibited in Westminster Abbey.

In 1947 it was decided to advertise the position of Principal of the

Central School, and Tomlinson, of course, hoped that I would apply. By then Camberwell was famous. I felt I had done a good job and the School was at the height of its reputation. I had been at Camberwell about ten years, which made it time to move on, but would it not be better to paint full-time as I had always intended? Yes, indeed, but what about the rent and my children's education? The London County Council left me free to paint exactly as I wished, stipulating in my contract that I should so continue, and I was provided with a magnificent studio. When I was first at Camberwell I had a most excellent secretary, A. W. Laird, who was a talented watercolour artist himself and a member of the Senefelder Club. He encouraged me to escape from my office whenever possible, saying that all seemed to be quiet and under control, that he would look round the School and only disturb me if some urgent matter developed. But after the war this was no longer possible, as the School became too busy and my studio was commandeered for the growing number of students. A contract with an art dealer would not allow me the same freedom, only the freedom to paint as *he* wished. I should be expected to spend a considerable time haunting fashionable London drawing-rooms, a task for which I felt myself ill-equipped. Publicity was not my line and I doubted my ability to play the art dealer's game successfully enough to be able to support my new young wife and baby daughter. If part of my time had to be sacrificed away from my painting I considered the running of a successful art college a more constructive use of it.

While William Morris believed in the preservation of the individual craftsman in defiance of the Industrial Revolution, his friend William Lethaby (also an ardent supporter of the arts and crafts movement) saw farther than Morris. He saw a new age of rising wages and standards of living when ordinary working families could afford to buy beautifully made objects. He saw the working class becoming the new patrons of art, taking the place of a small sensitive élite. He wanted all manufactured goods to have quality so that the mass of people would be able to buy useful things to delight the hand and eye. Lethaby wanted to relate the finest craftsmanship, with the finest design, to the most modern means of production. The craftsman was to become the prototype designer.

Lethaby was a genius at finding the right men to teach for him. He never employed 'art masters' as such, but believed in the apprenticeship system, whereby a master craftsman gave part of his time to handing on the knowledge of his skills to young student apprentices. He gathered round him in the early days at the Central men like Edward Johnston, Bannister-Fletcher, J. H. Mason, Francis Adam, Cobden-Sanderson, Walter Crane, Douglas Cockerell, Graily-Hewitt, A. S. Hartrick and Eric Gill. Although both John Singer Sargent and Edward Burne-Jones were among early lecturers there, Lethaby did not believe in teaching painting in a craft school, but placed emphasis on drawing. Painting takes a lifetime to study (or did in those days), but drawing could be used like writing to express everything you wished to say about a design for a house, a silver goblet, a stained-glass window – drawing is immediate communication.

Lethaby's ideas of the studio workshop, part-time teaching by highly skilled professional craftsmen, and his theory of the master/apprenticeship relation in the art school soon spread far and wide throughout the world. Count Kessler came from Germany to study this new system of art education and took back the great printer J. H. Mason with him to Berlin; he even persuaded Edward Johnston to demonstrate his calligraphy in Germany. The Central School became the parent of the Bauhaus. When Lethaby resigned, the life went out of the Central School. There were many distinguished men teaching at the School, but the tendency became more and more to place emphasis on superlative techniques rather than on design and its relation to the modern world. It had become a home for 'preserved' craftsmen.

When I decided to apply for the Principalship of the Central School of Arts and Crafts I immediately came up against problems which did not exist at Camberwell. There was interest in high places with powerful pressure groups behind different candidates. The wood-engraver John Farleigh (who had recently been appointed Head of the Graphics Department) was heavily backed by Sir Stafford and Lady Cripps who greatly admired his work. Now I have no doubt that Sir Stafford was a most able lawyer and something of a politician, but I am certain that he had no notion about art. Farleigh had

designed stamps for His Majesty's Post Office and was well known for his illustrations for Bernard Shaw's *The Adventures of the Black Girl in her Search for God*. Personally I preferred Shaw's own drawings for this book.

Another applicant was Lynton Lamb who made charming, if ineffectual, illustrations somewhat in the manner of Kate Greenaway. He was a more serious contestant than Farleigh as he was backed by the whole weight of the Goldsmiths' Company in the person of Mr George Hughes, Clerk to the Company. The Central School had a very large School of Jewellery and Silversmithing and received a grant from the Goldsmiths' Company. The Hughes party made a strategic error – they tried to lobby the Education Officer, Sir Graham Savage. Sir Graham had had a very distinguished record during the First World War, and it was said that he had captured a German machine-gun post single-handed. In the event he had been severely wounded and sometimes suffered very considerable pain. On these occasions one avoided him but normally, although he could be brusque and irascible, he was never unfair. I admired Sir Graham, although I could see that if one did not stand up to him he could appear to be very frightening; he appreciated neither timidity nor cowardice. The Education Officer sent for his Chief Art Inspector to inform him that there was very strong feeling among the Governors of the Central School of Arts and Crafts against my appointment. Mr Tomlinson said that the appointment would have to be re-advertised if there had been any sort of collusion among the Governors. I was invited to become the Principal (by a single vote), but I knew that there were several Governors and many members of the staff who disapproved strongly of my appointment, so that I could look forward to a somewhat difficult time. Any institution that has been dormant for a number of years does not wish to be woken up. None the less those Governors who had been against my appointment soon accepted the situation and were most generous in their support, with the exception of Hughes, who never forgot that his schemes had gone awry.

Soon after I left Camberwell, a large exhibition was organized by the students at the 'Kentish Drover' in Peckham Rye. The students invited me to open this exhibition, at the same time informing me

that Sir Alfred Munnings was also going to attend. I liked Sir Alfred. He was forthright and spoke his mind, a genuine and sincere man. He could handle paint and had no equal in his time in the great tradition of British horse painters. I tried to persuade them that it would be very wrong for them to ask me to open such an exhibition when the President of the Royal Academy had indicated that he would be there, but the students were firm. Under much pressure I agreed to open it. On the day in question the students, with some members of the staff, worked hard so that the pictures were hung and all arrangements completed at the 'Kentish Drover' by 4 p.m. Claud Rogers, of whom I was very fond, had a tendency to rest from time to time, a weakness of which the students were well aware. As there was a lapse in time between 4 p.m. and 6.30 p.m. when the exhibition was to be opened, Claud looked about for a quiet place to rest. He slipped into the Secretary's office, slid his bottom into the Secretary's armchair, put his feet up on the Secretary's desk and fell into a gentle slumber, his bird's-nest beard rising and falling peaceably. Claud had different ideas from William Coldstream and Victor Pasmore. His great aim in life was to be elected to the Royal Academy and that very year (it was sad to say) he had just failed in election by one vote. He felt happy to say that he *did* think that next year somebody was bound to die and there would be an election for the vacancy and his name would go forward. So Claud slept, his hopes high that when he awoke refreshed and went to the 'Kentish Drover' he would meet the great man himself, Sir Alfred Munnings. The telephone suddenly rang. Claud reached for it and a squeaky voice said, 'Alfred Munnings here.'

Claud, half asleep, replied, 'President Lincoln here', and the squeaky voice said, 'You damn fool, do you know who's talking to you?' Claud suddenly realized his fearful blunder. This was no student's practical joke, but the President himself, enquiring how best to reach Camberwell.

We proceeded to the 'Kentish Drover' where there was a large attendance and the President of the Royal Academy appeared.

After the opening, Sir Alfred tackled me, accusing me of not allowing any of my staff to exhibit at the Academy. He suggested that I used the threat of non-engagement for the following year to dis-

courage my staff from exhibiting. Annoyed, I told him that was utter rubbish. My staff could send as many pictures as they liked to the Academy and, as far as I was concerned, they could get elected or not elected as much as they liked. He insisted that I was the stumbling block in the Academy's progress. Then he suggested I should send in my own paintings.

'Do you really think that I would send my pictures in for you and your selection committee to throw out?' Sir Alfred assured me that nothing like that happened at the Academy. If I liked to phone him he would come round to my studio to see my pictures before I sent them; pictures coming from a man like me would not be subject to a committee throwing them out on to the ashcan in the backyard as I had suggested. At least would I come to the Academy's reception to show there was no ill-feeling? To this I agreed.

Then the wiry little man, looking every inch a jockey, went off to try to persuade Victor Pasmore to put his name up for election to the Academy. William Coldstream had recently publicly refused to be nominated as an A.R.A. Victor was brusque and would not even discuss the matter; in fact, he started laughing. Sir Alfred brushed by Coldstream and ran up against Claud Rogers who had been waiting to get a word in but did not know how to tackle the situation after the incident about President Lincoln. We returned to Piccadilly on top of a bus, Sir Alfred telling me in no uncertain terms what he thought about all this modern foreign painting. What we wanted was British painting. But he was very generous as he gave one of my students a scholarship (from the Turner Bequest, I believe) to paint in the country for two years on condition that he stayed away from the city art racket. And Claud Rogers became an A.R.A.

I have never been a supporter of academies. By their very nature they must pander to the common denominator. It is true that in the first ten years or so the Royal Academy in London exhibited great work because it was founded by great artists like Gainsborough, Turner and Reynolds, but it declined steadily with a long record of bogus superficiality, of sentimental slush, which has seldom touched the needs of the people. Naturally, by a system of elections, the mediocre (or the very clever) hold all the reins of power. This has nothing to do with good or bad painting. When I was an immature

artist in Paris and completely unknown, I had three paintings accepted by the Beaux Arts which were hung on the line of honour in the Grand Salon. On my return to Scotland I had these same three pictures rejected by the Royal Scottish Academy. My father said, 'If you are ever foolish enough to send your pictures to anything of this kind again, you deserve all you get, for it's obvious that your paintings, if they were good enough to be hung on the line of honour in Paris, must have deteriorated in transit to Scotland so that they are right in rejecting them here. Or they have been rejected because there is a possibility of you becoming a menace to those who have already been elected.'

All academies start off with the brightest ideas as they are all founded by bright young men, but I do not think they have any future. The products which they offer for sale will not be required in the changing world in which we live. Other fields of expression, new materials, new ways of seeing, new experiences in a theatrical sense, have all superseded the old 'picture painting'. Those artists that are left behind in the shelter of academies wrap themselves up in a comfortable furry cocoon from which to peer out at the increasingly harsh world without. Burlington House has become the biggest emporium in the world for the amateur artist, rivalling even the art department at Harrods. One must not forget Whistler's comment when dissension and alarm broke out at the Royal Society of British Artists and several members resigned in disgust. 'I see that the artists have departed; only the British remain.' To be a catalyst in the art world, an academy would need an artist of great genius as its leader which is not possible; this would be the very antithesis of what an academy is all about.

13

The Central School of Arts and Crafts

By the beginning of this century the conception of art had undergone a cataclysmic change. With the advent of Cubism in circa 1907, the artist ceased to be satisfied with the exploration of the surface quality of paint, but wished to interpret the underlying structural content of objects and to relate them within their surrounding space. The years before 1914 were pregnant with the explosive ideas in art, music, literature and science which have affected all serious thinking of this century in a positive way. Cubism, Futurism, Vorticism, Expressionism, Suprematism, Dadaism . . . have all had not only a powerful effect on art, but on our every day living. In Germany, Cubism was extended by such non-figurative painters as Klee, Feininger, Marc and Kandinsky in an attempt to give expression to subconscious and spontaneous images. Journeys into a timeless fourth dimension in paint were further developed in the work of the surrealist painters and sculptors, and, profoundly influencing the thought of the time, were the works of Freud, Jung and James Frazer. By extending the boundaries of psychological knowledge their studies confirmed the tentative gropings for a new dimension in art and influenced all subsequent art movements. In this period of extension, science and art became closer together than they had been for a very long time. Adventures in art ran parallel to adventures in the scientific world. Art was beginning to find its lost reality, to become again a necessity of living, an extension of being, until we find that today science and engineering have created new art forms on a majestic scale. A new art that really belongs to life has grown without our ever noticing

that it has happened, in the design for solar heating, for radar, for nuclear experiments, for extracting energy from the sea. This is art on the scale of the Egyptian pyramids beside which the artefacts of the art school or West End gallery seem childishly puny. Art has moved back into the life of our times with a vengeance.

Such radical changes in art in the early years of the century meant a completely new approach to art teaching. A different concept was generated almost simultaneously in Austria, America and Britain by such pioneers as Cizek, Dow, Albet and Tomlinson. Then, following in the footsteps of Lethaby, the founding of the Bauhaus marked a decisive step in showing, in an extremely practical way, how visionary and exploratory art, stemming from the Cubist and Expressionist movements, could relate to industrial arts. The writings of Gropius and Moholy-Nagy profoundly affected art teaching in this country and America. They showed a new grammar by which art teaching was seriously related to the important changes in art values since 1900, a system based on genuine plastic and spatial experiences.

True teaching is concerned with the amount of interest evoked, the amount of curiosity and self-effort aroused, not only by the mass of factual knowledge imparted. For education is a bringing up, a drawing out, a development of potentialities; the qualities of a teacher do not lie so much in his mass of knowledge of any particular subject as in the vital way in which he presents it. The manner is as important as the matter, for it must be stimulating and activating. It is the teacher's privilege and prerogative to keep the minds of his students flexible and active, and the spontaneous combustion he stimulates is the measure of his success.

There must always be a demand on the student whose own critical faculties should be continuously developed. The tendency sometimes is that, having a knowledge of certain aspects of design, the teacher continues indefinitely along the same lines, using the same symbols and motifs which by constant use lose their validity. That which was once new and exciting becomes, in the teacher's mind, stale and merely a matter of habit and habit destroys one's awareness of the activities going on around us. The tendency in all teaching, by the fact of its repetition is to lose intensity and force.

The teacher must be ever ready to respond to intuitions and feel-

ings and to use every possibility of a fresh approach or the use of new media. The more colourful the demonstration, the more arresting the image; the more vivid the elucidation, the better the results which will be obtained. Art is life, so the more life (especially contemporary life and action), that is brought to bear on the students, the more stimulating the results. Unless the teacher appreciates the fundamental changes in the design elements of his own time and evolves his own personal vision, he cannot hope to have an understanding of contemporary needs. Art forms are continuously changing and always need to be revitalized to contribute to the creative power of the future. Teaching, whether it be art or 'drum and trumpet' history, is a process of elimination, leaving only the essentials to be carried forward into the consciousness of the student. The history of the world is thrown out on the midden, so it is perfectly conceivable that Titian is no longer relevant in the history of art. Art teaching should be a synthesis of the grammar of art that has been taught for centuries, but related to our own time. Once, the method of teaching art lasted a thousand years; today a change is demanded every decade. Anticipation of these changes is vital to any progress in art or success in any method of art teaching.

The Central School of Arts and Crafts had suffered from ineffectual principals for a number of years. Jowett was a delightful man with a most handsome presence who painted charming watercolours in excellent taste, but he had no control over the School whatever; the students ran riot. At one Christmas party, they put Jowett out of his own room in order to have a private petting party in comfortable surroundings. Jowett asked James Grant, 'Do you think I should let the students in, Jimmy?'

'You bloody fool, if the students get in here tonight, you're out for good.'

'Will you help me put them out?'

'Tell them to get out!'

Jowett was a man of whom you could expect great things, so he was relieved of his worries at the Central School by being made Principal of the Royal College of Art. Next came Murphy, a silversmith and nominee of George Hughes, the Clerk to the Goldsmiths' Company. Murphy was a fine craftsman who knew nothing beyond

his own craft of silversmithing, lacking all administrative skills. He made the mistake of asking his Heads of Departments what to do, thus giving them greater power than the Principal. Poor Murphy died after only eighteen months at the School.

During the war years when the Central and Camberwell were amalgamated at Northampton, and for a short while afterwards, the reins were held by the able administrator, R. R. Tomlinson, but he could not give the School the whole-time attention that it needed. So, when I became Principal, I found that some members of the staff were under the impression that it was *they* who ran the School. Also while there were many superlatively fine craftsmen on the staff, too much excellent work appeared to be geared solely towards the Arts and Crafts Exhibition Society, and not enough towards present-day living. The challenge would be how to relate this exceptional craftsmanship to modern needs; in other words, how to return to Lethaby's first principles. In the canteen one day I sat down beside two silversmiths, neither of whom spoke to me. Somewhat piqued I said, 'Well, gentlemen, I sat down with you fellows to have an enjoyable chat during lunch, but you seem very unwilling to have any communication. I won't be sitting with you again.'

At last they opened up. 'You see,' said one, 'this is the first time that a Principal of the Central School has ever sat at the table with us. We've only been considered as craftsmen, not artists. We were rather taken aback. That's why we didn't say anything.' The ice was broken.

The School had grown enormously since it was founded by Lethaby and George Frampton in 1896. It consisted of a School of Drawing, Painting, Modelling, Etching and Allied Subjects; a School of Book Production and Graphic Design; a School of Interior Design and Furniture (in which were included Ceramics and Stained Glass); a School of Textiles; a School of Theatrical Design; and a School of Silversmiths' Work and Allied Crafts. A Junior Art School was also attached to the Central, but at other premises.

The original scheme of employing solely visiting teachers had had to be modified to give a basic structure to the organization of such a large school, and a small number of the staff were full-time, but the majority were part-time artists or craftsmen engaged by yearly con-

tracts. The purpose was to have artists relating to the world, not solely to the School. If you have a man like Alan Davie, who becomes a very successful painter and makes a lot of money, the day when he gives in his notice will not be very far off. The man who ceases to make any contribution to the School has no place there, and the great majority of teachers use themselves up in ten years. At a top-level school or college you cannot afford to have anything else but an intense pressure from the teaching staff all the time, more especially when the school is related to industry rather than to the Fine Arts.

Understandably there were a number of the Central School staff, especially those who wanted security because their future was very grim in the world of private enterprise, who agitated through their unions against this system and wanted engagements for five or ten years. I was sympathetic to the view that London County Council should employ visiting teachers on a five-year contract. At the Central (which perhaps was not an art school in the normal sense) the students demanded teachers of a high quality in which they could have faith. The longer contract would give me a means of encouraging a top-grade teaching staff of quality. As the new Principal, I was expected by the Education Officer's Department of the London County Council to reorganize my staff within the first year of my appointment in accordance with any policy I might wish to initiate. In particular I wanted to synthesize the different Schools into a far more integrated unity. I intended also to introduce what were then called 'basic design' courses throughout the School which would be geared to give a grammar of art in such a way that each student could develop any particular medium he or she happened to choose. Then all students, with certain variations in training, could adapt themselves to work in other media.

In Britain during the 1930s basic design courses were started by Jesse Collins and Albert Halliwell. While they were both influenced by Bauhaus teaching, they each brought new creative ideas to the subject. Collins and Halliwell directed their teaching mainly towards Graphic Design while another teacher, Norman Dawson, and myself saw the problems from a painter's point of view. In my case, my teaching of basic courses stemmed directly from my experiences of

the School of Paris at L'Hôte's studio. This could, I felt, give a greater depth and a more imaginative approach to the subject than the somewhat limited (even sterile) approach of the Bauhaus, which by this time was beginning to be a new academy.

A student would often come to a senior art school already cluttered up with a great amount of undesirable and obsolete techniques while still lacking a realistic grammar of art from which he could begin his more advanced study in design. He knew, for instance, about 'shading' but almost nothing about form; he knew something about the shapes of objects but nothing about the relationship of these shapes to their surroundings; he knew that a line is an outline, but little of the varying qualities of line. In many cases he had not yet been taught to use his own eyes.

His training had mostly been taken up with the struggle of literary representation. This to a certain extent is extremely necessary, and a facility for descriptive expression of what he sees is obviously an essential element in a designer's craft, but the student needs to learn that art is not natural representation, indeed that art is opposed to nature. He must learn that art is not only made with pencils and paper, ink washes, or oils and canvas. He must seek out and find endless possibilities for creative designs in the use of odd and ill-assorted materials. He must learn to discard a hundred scribbles and pick just that one which will relate eventually to the design for a chair, electric iron or a piece of jewellery. Just as it takes discernment to distinguish between a good or a bad drawing of an apple, so it takes discrimination in the case of action drawings and scribbles. The term 'basic design' was used to describe a way of teaching the grammar of design and the means of communication in a twentieth century idiom. It was a course of training in the realization of the qualities of line, pattern and form; exercises were spatial experiences, not literary ones, and dealt entirely with the art of space rather than the art of time.

The training in these courses varied between exercises in action drawing and loose scribbling in a completely free and inconsequential manner, and exercises requiring order and precision. There was a continuous transition between order and disorder, fanciful and careful planning, with all the variations of experience that this interaction

can give. The contrast between the precision in the use of formal shapes and the freedom and diversity possible in the play element, act as a series of tensions for the student. A formal, logical art pushed to its utmost can lose its vitality unless it is continuously reinforced by the unexpected.

An unfortunate appointment had been made just before I became Principal. The vacancy of Head of Department in the School of Book Production had been advertised, and the wood engraver John Farleigh had been appointed. This was a blow because the man I would have chosen was Jesse Collins, and I felt I should have been consulted. Jesse was teaching part-time and his work was outstanding. He was a member of a design partnership with Mischa Black, Milner Gray, Walter Landow and James de Holden Stone, which had made a considerable impact on graphic design in this country. While Farleigh was in charge of the School of Book Production I knew that it could never reach the top. Once or twice a term the Board of Studies, which was composed of Heads of Departments and representatives from the staff, met in my office. At these meetings I found Farleigh very unco-operative and inclined to contradict me in front of other members of the staff. This reached a point at one meeting when Farleigh, ignoring me, turned to Bill Robbins, saying, 'It doesn't matter what he says, Bill, we'll just do it the way we always have, the way we like it.' As I was neither Murphy nor Jowett, John Farleigh had to leave the Central School, thus opening the way for Jesse Collins. He did magnificent work in graphic design in the School of Book Production through his understanding of modern design in typography. Jesse made a great name for himself as a teacher while his erstwhile partners, Milner Gray and Mischa Black, carried on a most successful design consultancy under the name of Design Research Unit.

The Central had a long tradition of superb printing, bookbinding and calligraphy. In Lethaby's time, Douglas Cockerell, Cobden-Sanderson, Edward Johnston, Graily Hewitt, Ernest Jackson, Eric Gill and J. H. Mason formed the nucleus of the School of Book Production. William Lethaby felt that the School 'should do great service to the craft generally'. The books printed at the Central School during this epoch remain works of art, but works of art created as

by-products of a zeal for education. Under Mason, all was for clarity and nothing merely for effect, with every page a masterly statement of space and proportion.

The School's reputation grew. Mason designed the new 'Imprint' face for the Monotype Corporation's influential (although short-lived) review of that name. He was also invited by Count Kessler to spend his summers at Weimar, where he made an important contribution to the revival of the German printing industry, with especial reference to Kessler's own Cranach Press.

When I arrived at the Central School, a bible of great magnificence was being bound as a gift to the Emperor, Haile Selassie. Its leather binding, covered with gold and jewels, was as splendid in its own way as the Sword of Stalingrad. It was being made by George Frewin and Douglas Cockerell's nephew, Sidney. M. C. Oliver and Irene Wellington carried on the tradition of calligraphy and fine lettering. Irene was one of Edward Johnston's favourite pupils and in his old age he entrusted her with a commission for Winston Churchill. With trepidation she wrote out the manuscript. On seeing it, he said, with simple truth, 'It's beautiful'. An accolade indeed from such a great perfectionist.

The tremendous revival of good printing throughout the trade, following the inspiration of the many private presses connected with the School, was very much due to the influence of Gill and Mason. The School was printing for a world of reflection and taste, in a time of considered leisure, slower tempo and, therefore, of greater depth. In my time this attitude had to change; the alteration of the title of the department from that of 'School of Book Production' to that of 'School of Book Production and Graphic Design' indicated a variation of emphasis implicit in the twentieth-century's outlook.

To my mind, however, a contemporary approach regarding elements of printing did not necessitate a deviation from the high standards of Mason's perfectionism, but rather the application of those standards to new patterns, forms and techniques. To achieve this integration of design and printing, the printer must possess a greater knowledge of art and appreciate the significance of the designer. It is important that the printer become an artist rather than merely a specialist. Also, as the standard of typographical train-

ing rose, it became absolutely essential that students should be able to do practical work.

Integration between graphic, typographical and printing students was indispensable. To change and alter the basic training provided by the Department required much serious thought and entailed prolonged negotiations with both the Master Printers and the unions. The foundation of pre-apprenticeship and day-release training was established on the advice of the London County Council's Consultative Committee on Book Production, which was drawn from representatives of the Federation of Printing and Allied Trades, Association of Master Printers, the London Bookbinders' Association and the appropriate trades unions. Of all union representatives the printers were the most dogmatic (not to say pig-headed) men with whom I had to deal, despite their keen intelligence. Hour after hour was spent trying to show how the training of apprentices could be improved.

At Camberwell I had cared little for the sensibilities of either the unions or the Masters, but had cared a great deal that these young students should benefit to the maximum from the day-release system of training. Apprentices, of course, do not take life too seriously. We constantly had trouble with the School's only lift which perpetually stuck at the top floor and failed to come down again. I became exasperated – climbing five floors every day to inspect the life classes at the top of the building was becoming a serious problem. Eventually, after strenuous efforts had been made to check the fault, it was discovered that the printers' apprentices were making a habit of jamming the lift in order to have an uninterrupted view of the nude models in the life classes!

There was a tendency to soft pedal, even to discontinue, the system of day-release training for apprentices both in the printing and in the jewellery and silversmithing trades. It was thought that, at least, the apprentices should be removed from the Central School and found places at other institutions. Annoying as they sometimes were, I believed firmly in a continuity of development in education for the apprentice in an environment where art was contagious.

It seemed to me that, instead of curtailing this type of education, it should be vastly extended throughout the country. It should be

possible for far more young people to learn a real skill while still continuing their general education. This could help solve the problem of unemployed schoolchildren who want to do *real* work (which almost all children are keen to do), rather than fritter their time away in uncongenial pursuits. Under-used expensive equipment in Government establishments could be put to a really constructive use. Our highly sophisticated education has, to my mind, been detrimental not only to the children, but to the whole nation.

Jesse Collins made a splendid Head of his Department; he was also a fine and inspiring teacher who had, on occasion, a magnificent Irish temper. I sent Jesse to see R. W. Briginshaw (later Lord Briginshaw), the General Secretary of Operative Printers, Graphical and Media Personnel, hoping that his flamboyant approach would enliven the meeting while leaving me time to tackle other matters. Both were devoted to printing, Jesse with an ardent desire to improve the standard of trade printers and to integrate graphic design, typography and printing in a manner that was relevant to the twentieth-century and Briginshaw, with his conservative, pedantic approach, determined that his apprentices should have the least possible opportunity of 'bettering their stations' by mixing with graphic designers or typographers.

Mr Briginshaw's self-esteem was hurt whenever the Principal of the Central School of Arts and Crafts did not appear personally at these meetings. It was no good pointing out that Jesse Collins had a far more detailed knowledge of the subject than I could possibly have. To keep the peace I had to attend the meetings in person for several weeks. Eventually, after eight years of negotiations with the union a compromise was reached in which the young apprentices were able to receive the full benefit of instruction from some of the finest graphic artists and designers of their time.

In spite of these protracted negotiations regarding the training of apprentices, Jesse Collins made a great success of his Department. The Ministry of Education had at first strongly disapproved of his appointment, so much so that on one occasion the H.M. Chief Art Inspector had sent for us in order to express his severe disapprobation of the teaching methods used in the School of Book Production and

Graphic Design. We were well and truly on the carpet! Jesse's temper did us no good. H.M. Chief Art Inspector drew me aside to suggest that someone else should be found to run the department, someone who was more in touch with his subject.

During the fifties the very best students chose to study graphic design and typography rather than opt for the Fine Arts which seemed only to attract third- or fourth-rate students. Names like Colin Forbes, Herbert Spencer, George Daulby, Allen Fletcher, Peter Wilbur, Allan Ball, Derek Birdsall, Kenneth Garland, Peter Firmin, Mervyn Kurlansky, countless talented young people came to the School of Book Production and Graphic Design. When they had finished the irtraining Jesse co-opted many of these young men on to his staff. That most excellent typographical designer Herbert Spencer told me once that it was a very exciting place to be – the only place where there was an attempt to grapple with the real problems of industrial design.

All the other schools, if they were teaching anything apart from painting and sculpture, were only teaching a kind of pre-war commercial art which was totally irrelevant and it was only at the Central that there were really people, knowledgeable people, involved in teaching what was required by post war society. This was what made it a very exciting and fertile place. One of the important things was that a lot of young people were teaching who were forced to think up their own attitudes quite early in their careers.

Anthony Froshaug was another talented and imaginative typographical designer who taught during the early fifties; Gertrude Hermes, Laurence Scarfe, F. K. H. Henrion and Roderic Barret were among the older staff dealing with illustration and advertising techniques. William Blaker and F. C. Avis, earlier colleagues at Camberwell, came to join the printing staff which already included such fine craftsmen as H. C. Chapman, A. J. Cullen, J. R. Biggs, E. Devenish and L. Vilaincour. Jesse Collins controlled a very big department where it was not possible to teach in the way William Roberts or Vivian Pitchforth taught, a regular visit to each student. Jesse would suddenly decide to concentrate on one student, and would spend upwards of an hour talking to that student. Through his discussion and appraisal he could show the student a completely

different way of approaching the subject so that he would be set on a newly invigorated course for life. Jesse's effect was tremendous and he was something of a Messiah in typographical design. When Jesse Collins decided to retire I offered the post of Head of the Department to Colin Forbes, one of Jesse's brilliant students. This idea was resisted by County Hall who said that to have a young man of twenty-six as head of one of the biggest departments in the School was madness. It was not. Colin did splendidly for a couple of years until he came to tell me that he would have to give up teaching altogether as he was earning more from one of his advertising contracts than he was getting for the whole year from the London County Council. Colin went from strength to strength. 'Pentagram', which was started by Alan Fletcher and Colin Forbes, has become synonymous with all that is best in graphic and product design on the international scene. Through his students Jesse Collins has influenced the standard of graphic design throughout the world.

One of my visitors of whom I was very fond was Barnett Freedman. He used to come occasionally to give a talk to the students. His knowledge of all the varieties of ink and paper used in reproductory processes was phenomenal, and he knew that design stems from economics. As we crossed the hall together I saw the students turn to watch this odd character. Barnett was a Jew from London's East End, and proud of it. As a boy he had studied in the evening classes at the Central under A. S. Hartrigg. Soon he was working as a graphic and typographical designer, but still came to the Central to attend classes in the daytime. There were so many students that no one troubled to check their numbers, and Barnett received his tuition free.

Barnett Freedman used to do very good work for the Baynard Press, and he asked me once if I knew Mr Philips. I said I did know Fred Philips, he was one of our Governors; I respected him very much for the work which he did at the Baynard Press. When I had applied for the Central he had been one of the Governors who had opposed my appointment, but since then he had always supported me generously. Barnett explained that he had done a series of posters which Mr Philips liked very much and suggested a fee of £40 each. Barnett protested that Mr Philips would make an exorbitant profit

out of his work, and explained precisely the price of the paper, the number of pints of ink which the Baynard Press would use (per hundred posters), the detailed labour costs. Fred Philips was so impressed by this knowledge that he agreed at once to the price of £100 for each poster.

Another day Barnett came in to see me to tell me about a commission he had received to advertise a film. He had been driven out to Ealing Studios in a limousine by a very superior chauffeur and offered the most expensive Havanas while discussions continued about a series of large-scale posters. When it came to the subject of price Barnett said that the fee offered was pitiful. He thought of the chauffeur, the limousine, the cigars and his expensive lunch, and his heart bled. He offered, as the film company were obviously so short of money, to do the work for nothing, but the producer's pride was touched on the raw. Barnett agreed to £900 for each poster, and reached across the desk for another Havana.

Barnett learned from his experiences, and told the students, 'You *must* know your job – then you know your own price.'

The entrance hall was the hub of the School, its Piccadilly Circus. Here, behind sturdy Doric columns, generations of students made assignations, or slipped quickly out of sight behind the pillars as the Principal opened his office door. As I came down the corridor I noticed who, of my staff, came habitually late or who, among the students, dashed downstairs to the lavatories with a guilty conscience. I noticed a student from the Jewellery Department who often laid himself down on a bench and looked upwards with an abstracted gaze. He was a large, pleasant young man from West Africa and I wondered why he needed so much rest until I, too, lay down on the bench with my feet up and allowed my eyes to wander upwards – the draught from the front door stirred the skirts of the girl students as they climbed up the stone stairway, giving intriguing visions to any voyeur from below.

I watched a bevy of girls waiting for a boy of great charm, a favourite nephew of the Emperor Haile Seilassie, who cast the spell of his glamorous good looks on all the female sex. He spent a year with us before leaving for Oxford – a brilliant young man. Then a beautiful girl would cross the hall followed, as always, by a 'tail' of young men

like any Highland chieftain. The hall seemed always to be busy with the talk and laughter of young people, a scene of animation, excitement, anticipation.

The Painting School at the Central primarily taught students who wished to specialize in any of the Fine Arts, but the cultural influences from this Department permeated the whole School. In the early days at the Central as well as at the Bauhaus under Gropius, painting was not entirely excluded from the curriculum, but the emphasis was placed on drawing, the reason being that, while some painters advance quickly and use up their talents in a very short time, other painters evolve very slowly. Empiricism is implicit in the study of painting which assumes a long apprenticeship before an artist may be mature. Too long a time spent in painting, therefore, prevents the student from being able to apply himself to the particular craft medium he selects.

Therefore by training in drawing, but not in painting, the student has many more opportunities for trial and error than through the slow application of paint. I wanted drawing to be related to the needs of the individual crafts as well as being a general cultural background. I wanted to make an atmosphere throughout the School where the concepts of my staff could develop. I did not wish to impose my own ideas on my young teachers, rather I wanted to make a climate in which young, potentially original people, could make their individual contribution; where, early in their careers, they could think seriously and constructively about their own work. I hoped that the cumulative effect would give the Central a unique quality.

R. R. Tomlinson warned me about the Painting School. He said, 'There's a chap up there who's most peculiar, I think he's deaf and dumb. He's never spoken to me at all and I don't think he can hear what you say. He's called William Roberts.' I went up to the top floor to meet the staff in the Painting School and was greeted with enthusiasm by Bernard Meninsky who was overjoyed because he thought that at last the London County Council had a Principal who was himself an artist, a man who spoke their language, rather than someone just collecting recipes and handing them out. William Roberts also greeted me. He was a little man with a round, cherubic face like a ribstone pippin. I said, 'I heard that you never spoke to

anyone, Mr Roberts, that you were thought to be deaf and dumb?'

'Nonsense, there's never been anybody here worth talking to. Now you're here it'll be all right. I'll just go back to my teaching.' And he did.

William Roberts, like Vivian Pitchforth at Camberwell, was a most conscientious teacher. Every student had his regular attention and he would draw for them in the clearest way to explain and correct the form or structure of the model. As a young student I had greatly admired a large Vorticist painting of soldiers disembarking by William Roberts which had been exhibited in Edinburgh (it was recently sold for many thousands of pounds), and I was delighted that Tommy's fears were not to be realized.

Of course one could not talk to Roberts about Percy Wyndham Lewis. He became infuriated to think that any credit was given to Lewis at all, and in his opinion, Vorticism stemmed from his own efforts entirely. He had once written and published his own Manifesto on the subject. Wyndham Lewis was to be considered a mere journalist. William Roberts has a definite place of his own, quite separate from any influence which Percy may have had. There has always been an element of caricature in English art since the days of Rowlandson and Gillray, a tradition carried forward by Roberts and Stanley Spencer, by Edward Burra, by Laurence Lowry and David Hockney. There was nothing tentative about William Roberts; he was a most positive personality.

Bernard Meninsky was a particularly fine classical draughtsman for whom I had a great respect. Some of his drawings were superb. He was a great teacher who trained many very fine students. Often he would try to persuade me to come up to his painting classes to teach with him, and sometimes I would be able to escape from my office to do so, but more often I could not spare the time. Meninsky was subject to very great depressions about his own work; his tragic death was a keen loss.

With those two stalwarts were E. R. Bevan, who understood stone and could carve the most beautiful lettering, and Leslie Cole, an excellent teacher who, though of a somewhat 'old-fashioned' outlook, really taught the students 'how to do it'. He knew all about the skills inherent in the medium of oil painting.

One of the older members of the staff who was especially kind to me was the fine engraver William Robbins, who had made his name during the period of the great etching boom. Bill was devoted to the School and deplored any back-sliding among the staff or students that might tarnish its reputation. He therefore took a fatherly interest in his friend James Grant, the Head of the Painting School. James was a dapper little man with a bow tie, his hair beautifully brushed and his pointed beard neatly trimmed, while his merry eyes were full of fun. He made excellent, carefully drawn, pencil portraits which gave him a distinctive place among portraitists, while his charming personality always made him a most welcome companion.

When James staggered into the School after a convivial lunch in a nearby pub, Bill deftly guided him behind the great pillars which upheld our entrance hall, and deposited him in the staff common room, while another man took over the class until James had recovered. James was an enthusiastic member of the Chelsea Arts Club. One of his cronies was Sir Alexander Fleming for whom the whole phantasmagoria of the art scene must have made a delightful contrast to his own more exacting studies, and another was Sir Alfred Munnings.

One morning James came in to report to me that he had spent a somewhat difficult evening. It had started pleasantly enough at the Arts Club until James and Sir Alfred set off from the club in the small hours in a very talkative condition to make their way home in the dark. When they approached Munnings's impressive establishment, Sir Alfred suggested to James that he should just come in and have another 'little one': James thought he should not, but then he thought that perhaps another half-hour with Munnings would be very enjoyable. When they reached the door Munnings had difficulty in finding the key. He waxed sentimental. 'Jimmy, you know, Lady Munnings and I are devoted in every way. We have never spoken a harsh word to each other. Without her where would I have been? Ssshhhh, we must be very quiet as we go in!'

Munnings eventually got the key turned and they opened the door. 'Ssshhhh!' said Sir Alfred, and closed the door very gently. 'Now, Jimmy, the drawing-room is one floor up and we mustn't miss a step because Lady Munnings mustn't be disturbed at this time in the

morning. Ssshhhh! Very carefully, very carefully, Jimmy, and we'll get up to the drawing-room.'

They climbed gingerly up the stairs until James missed a step and there was a great clatter as he fell down the stairs. 'Oh, hell!'

An irate voice from the distant bedroom shouted, 'Is that you, Alfred? Where *have* you been I'd like to know?'

'Oh, hell!' said Munnings, 'the old cow has wakened up . . . ssshhhh . . . she'll raise hell!' James discreetly slipped out of the front door, slithered down the steps on to the pavement and made his way home with care, leaving Sir Alfred Munnings to face his Lady.

Unfortunately, on another evening, James was making his way home from the Chelsea Arts Club when a lamp-post hit him. He was taken to St Stephens's Hospital where it was discovered that the lamp-post had broken his leg. Tomlinson rang me up. 'I think we should pay Grant a visit. From what I've heard he is very seriously ill.'

The dismal outside of St Stephens's Hospital would make death itself seem lively, but we were told that Mr Grant was comfortable and had a sitting-room with a fire in it. Cheered by this good news we climbed several flights of gloomy stairs. Tomlinson opened the door sharply to find James sitting before a depressing little grate, with his leg propped up at an acute angle covered with plaster and bandages. His fire was entirely overpowered by an ever-growing mountain of ash. Mrs Grant rose quickly, shutting her capacious handbag with a sharp click, but Tommy's eyes were as quick as mine to see the transfer of a flask of whisky from James's hand into his wife's bag.

James was an excellent teacher who worked very hard to help his students (who all adored him), but such episodes became too frequent to be ignored. Threatened with dismissal, he promised to reform and he (almost) kept his word. With the continued help of Bill Robbins we managed to steer Jimmy Grant safely to the end of his teaching career when he could claim his gratuity from the London County Council.

Morris Kesselman succeeded James Grant as Head of the Painting and Drawing School, and as vacancies occurred I was able to introduce younger men. Denis Williams, a young West Indian who had held an interesting exhibition at Gimpel Fils, taught life drawing

which caused letters of protest to be written to County Hall complaining that the minds and morals of the young would be contaminated. James Burr, John Plumb, W. M. Nicholson and Peter Corviello were on the staff; Lord Huntingdon taught mural painting while Raynor Banham had his first job to teach history of art. John Minton came for a short time before he left to teach at the Royal College; Keith Vaughan and Merlyn Evans both worked with me for a number of years; Patrick Heron taught life drawing before he left London to settle in Cornwall.

Patrick was full of zest and vigour. I very much enjoyed his discussions about painting and considered his essays on art criticism to be both highly intelligent and lucid; indeed, he was the best critic writing in England during the fifties. This was the time when London first saw exhibitions of the work of American painters who had been experimenting in new art forms during the 1940s, artists such as Pollock, Motherwell and Gottlieb. Young painters in this country could hardly fail to be impressed and influenced by these exciting new manifestations. A friend of Patrick's, Roger Hilton, also came to the Central. Roger taught drawing for about a year before he decided he would join Patrick in Cornwall.

At that time Patrick Heron had a great influence on Roger; both took the new American painting very seriously, so much so that an osmosis took place as Patrick gradually *became* an American painter. As a doubly gifted young man, Patrick had a difficult choice to make between a career in literature or one in painting.

In complete contrast to the work of these young men was that of S. R. Badmin who specialized in the most beautiful studies of trees, and the strangely evocative drawings of Mervyn Peake. As so much of the instruction at the School needed to be of a strictly practical nature, taught by exceptionally skilled craftsmen, it was an excellent thing for the students to come under the influence of an artist such as Peake who lived in a fantastic world of his own, filled with extravagantly grotesque images, both literary and pictorial. Through illness Mervyn found it hard to keep up his teaching, but the presence of such a sensitive, cultivated artist on the staff was of great value. Since his death the publication of his books have brought him recognition, unfortunately, too late.

A much more down-to-earth artist was Paul Hogarth, a good draughtsman whose work was much in demand for book illustrations. Hogarth was often away from the School and I was told that he made visits to Russia.

He developed an ingenious idea for exhibiting his work. First he took a portfolio of drawings illustrative of life in England to show in Moscow; then, while in Russia, he made drawings there which were exhibited on his return at the Leicester Galleries, thus making the best of both worlds. But Paul Hogarth's absences became too frequent so he had to give up his appointment at the Central School.

In my time I was very fortunate in that there was very little political activity of any description among our students. I can remember only one year in which the Students' Union were enthusiastic about Communism.

Of course, all good artists are not necessarily good teachers. Some enjoy teaching for a short while, then, like Roger Hilton or Louis le Brocquey, feel the overriding necessity of doing their own work without any other obligation or distraction.

One of the most distinguished artists teaching painting was Cecil Collins, known in the School as the Beaver. Cecil appeared to be a lunatic, but this was a misleading 'act'. He was crazy, off-beat, but at the same time he was a most astute businessman. I had exhibited with Cecil before the war at E. L. T. Mesens's gallery in Cork Street when Cecil was teaching at Dartington Hall with Mark Tobey. He was an artist for whom I always had a great respect. Every morning as Cecil entered the School he paused on top of the stone steps before signing the register. He saluted the Central School of Arts and Crafts – a serious salute to the great and mighty – then departed for his classroom. Cecil came to the School armed against the weather, wrapped in a bedraggled overcoat with a long, hand-knitted muffler entwined round his thin neck, carrying his rexine bag. The sight of this bag made you feel quite ill – orange peel and bits of apple core left over from yesterday's lunch, jam mixed up with burst tomatoes, cuttings from newspapers, a piece of dead sausage – you couldn't bear the smell. Cecil Collins's background was wrapped in obscurity until he gained a scholarship to the Royal College of Art where he became something of a pet of Ethel Walker's. He posed for her,

cleaned up the studio occasionally and made the rice pudding on which they existed. (Cecil's description of this blurping, glutinous mess which bubbled gently all morning on an old iron stove was hilarious; he made you understand the very soul of that rice pudding.) To her father's horror, Cecil married the most beautiful student at the Royal College.

No one could challenge Cecil's qualities of drawing or the sincerity of his painting. His was no derivative art. He brought to his teaching the high standards which he exacted from himself, and inspired a great devotion from his students with whom he shared his great understanding of art, music and poetry. I think he has to be rated among the most interesting painters of my period.

Cecil was a great friend of Mervyn Peake, who, at that time, was considered by many people to be a trifle mad, and whose writings were thought to be quite indecent, although Cecil felt that these indecent writings were tremendously funny. Christie, the Notting Hill Gate murderer, who had all those women stuffed into cupboards or buried in gardens, was the cause of much joyous speculation in the staff common room. Cecil thought the man must have had the greatest fun strangling them. What sport he had after they were dead!

Cecil came to stay with me in Scotland. Out for a walk one day, we passed an old black-faced ewe with her pair of twins standing beside her, one on each side, who gazed at us sardonically with her beautiful onyx eyes. 'Holman Hunt, with two clients', says Cecil. He conjured pennies out of my small daughter's hair, ears, pockets, or shoes to entertain her.

Old Mr Oliver Brown of the Leicester Galleries was a great favourite of mine. I met him with his wife one Sunday afternoon at Hampton Court studying painting after painting. I felt he must be one of the very few dealers who had a genuine interest in art, enough to enjoy pictures on a free Sunday afternoon. His deafness gave rise to some hilarity among his younger exhibitors. Cecil Collins could imitate him to perfection. A customer, enquiring about the price of a picture, suggested that it might be £50. Mr Brown failed to hear. 'Ah, yes, £500. Yes, indeed, a beautiful painting, the very best period, oh, yes, very reasonable at £500!'

At the Gallery's annual exhibition entitled 'Artists of Fame and

Promise' many fine pictures could be seen alongside more tentative or experimental work. One year Oliver Brown had innocently hung one or two of Ithel Colquhoun's surrealist paintings. A gentleman looked earnestly at one of these, then spoke to Mr Brown, suggesting that he, too, should inspect the pornographic details of the work. Mr Brown was horrified, and seized the telephone. 'Miss Colquhoun, Miss Colquhoun, how *could* you, Miss Colquhoun?'

'What is wrong, Mr Brown?'

'This picture, Miss Colquhoun, it's indecent! You must remove it at once, Miss Colquhoun; bring another one instead. Oh, how *could* you do it, Miss Colquhoun?'

Ithel Colquhoun exchanged the painting for another one. The same gentleman came into the gallery again. 'Dammit, man, this one's worse than the first one!' Mr Brown went to inspect the picture more carefully. Then he sadly telephoned Miss Colquhoun.

'Miss Colquhoun, we cannot have such pictures in our exhibition of "Fame and Promise". How *could* you do it, how *could* you?'

Another splendid artist with a very marked personality was Hans Tisdall. When he was first introduced to me by Alistair Morton (of Morton Sundour, the Carlisle firm who did so much to introduce really fine modern textile design in this country both before and after the war), Hans had already an international reputation as a textile designer. He had come to Britain in the thirties to escape the Nazi insanity and had managed to make his way to the top as a designer of very real merit. Hans had received a most thorough Continental training as a professional artist, and he had a deep understanding of painting coupled with a great knowledge of the history of art. In his professional life Hans could turn his hand to anything; he could paint murals, design textiles or posters, make book-jackets (when Ernest Hemingway had his books published by Jonathan Cape he would have no other designer but Hans), had a great feeling for the making of books and his calligraphy was superb. No matter how difficult a problem, Hans had a solution, as he was a man of tremendous resourceful invention. Neither of us had as much time to paint as we would have liked, but we painted diligently at the weekends. Hans would cross Royal Avenue to see the problems in which I was involved, and his advice was always helpful.

Once, feeling the need for an extra £80, I thought I would design a poster for the Underground. Harold Hutchinson, who was in charge of publicity, agreed to this; but when I began to work on the commission my enthusiasm waned. None of my ideas seemed to be feasible but Hans came to my rescue. By chance, we had chosen as the centrepiece for the poster the statue of Queen Elizabeth I which stands outside the Church of St Dunstan's in Fleet Street. King George VI died and Queen Elizabeth II was proclaimed. My (or, rather, our) poster was a most fortuitous welcome to the new reign, and it remained on the hoardings for about two years.

14
Towards industrial design

In his forthright championship of the old union between artist, craftsman and scientist Lethaby had suggested that '. . . What is needed at the present time is the gathering together of all the several interests concerned with industrial production into a closer association; an association of manufacturers, designers, distributors, economists and critics . . .' In urging a broader conception of creative art and a more untrammelled initiative on the part of British designers, he wrote:

Design is too often regarded as an inexplicable mystery, and it is difficult to get it understood that design does not necessarily mean a pattern drawn on paper, nor does it involve some strange originality. It should be just the appropriate shaping and finishing for the thing required.

It is necessary that we should come to closer terms with design in all our industries, yet it is hardly a paradox to say that we think too much about it, puzzle over the questions involved, and offer frantic solutions rather than serene and confident ones. Design is not some curious contortion of form, or some superadded atrocity, but it should be conceived of as the fitting of means to ends in the production of works which are good each in their own order. The manufacturer must often puzzle over what will sell, and indeed it must be a maddening problem; but let him rather recast the question into 'What is good, what is the best that can be done for a given price?' and the question of design will at once be simplified if not solved.

Lethaby unerringly put his finger on the truth.

A course in industrial design was tentatively started at the Central School in 1938 as part of the School of Jewellery and Silversmithing under A. R. Emerson, with the title of 'Design for Light Indus-

tries and Plastics'. During the war every machine owned by the London County Council was commandeered for the war effort and Emerson was in charge of making tools and spare parts at the Central School. It was comparatively easy to persuade County Hall to allow me to expand this small department into an independent School of Industrial Design. Emerson remained in charge of his School of Jewellery and Silversmithing when, in 1947, Albert Halliwell was appointed Head of this new venture. We were at last able to put into effect those ideas we had dreamed about at Camberwell before the war. We now had the machinery which was essential and we also had an arrangement whereby our students could study plastics and engineering techniques at the North-Western Polytechnic.

In any age, it is true, there are few men of Leonardo's imaginative genius or technical calibre. The general run of artists and art students are necessarily executants rather than composers, interpreters rather than inventors, star performers rather than stars of the first magnitude, and this is a factor to be reckoned with in considering the relation between artists and industrial needs. A similar distinction is to be observed in scientific fields. There are few creative intelligences, but there is no lack of technicians to execute a blueprint. Nevertheless, although there is certainly 'applied science', the analogous term 'applied art' must be recognized for the misnomer it is. The art of devising a new machine in new material by a new process in itself constitutes a new art, and it does not differ essentially from the process by which a picture, poem or fugue is constructed. It has nothing to do with the minor art of decoration. It is perhaps better to regard the problem of the training of art students for industry rather as the training in art of students for specific branches of industry. For since art is a general characteristic of human activity, it suffers most acutely from the defects of that departmentalization to which our education is prone.

To the young designer, design should mean finding out the potentialities and limitations of the particular machine which is to be used in the making of the product, the materials to be used and their possibilities, the cost of raw materials and labour, the relationship to a sellers' or a buyers' market, and the final price to the consumer. The economic position is of the greatest importance, and

I do not think students can ever have enough understanding of this fact. Too much interest and concentration is usually spent on 'art' and on 'design' itself, too little on other essential factors.

For instance, a knowledge of tariffs in different countries enables the designer to assess the relative value of materials, so that he is able to produce in terms of a particular medium something of better quality and design to ride the tariff and sell below the general prices. To anyone interested in the export market this is essential. In a falling market, profits fall while the costs of production may remain high and in such circumstances the designs must be simpler. This designing to reduce costs is a vital function of the designer for industry. High tool costs make for lack of courage in trying out new designs, but should also mean that, once agreed upon, the design should be well ahead of immediate fashion so that it will have a sale over a number of years.

Halliwell began to organize his new department with enthusiasm. He developed most effective and productive relationships with industry, and the new subject was attracting extremely intelligent and able students. We had high hopes that, through this new kind of training, we could raise the standard of design throughout the country and so help our export trade which was, at that time (as now), in dire need of a brighter 'image'. Interesting men came to teach in the department; the industrial designer Douglas Scott, the photographer Nigel Henderson; teachers with specialized knowledge like L. Bruce Archer, D. A. Bowen, Kenneth New, Eric O'Leary, Leslie Harwood and A. Patchett; the silversmith Robert Welch; all contributed to the successful activity generated by Halliwell.

It is essential for a student of industrial design to see beauty in machinery and machine tools. To this end the students attended classes in machine sculpture as well as studying the more orthodox methods of sculpture with Robert Adams.

At Camberwell after the war, I interviewed William Millar, a foreman coppersmith from Daimlers, who had been working on munitions during the war and now wanted a grant to enable him to become an artist. Jock, as he was always called, was a great personality. He worked very hard at his painting and became an excellent teacher, as the students found his enthusiasm was infectious. Jock was the

perfect man to teach machine sculpture which made a link between the purely aesthetic forms of the artist/hand craftsman and the requirements of the industrial designer working within formal limits.

Machine tools were used to create non-functional shapes. The student learned a freedom of approach to machine operations, he learned not to be afraid of the rigidity of the machine, not to treat the machine as a minor god. The student learned what the machine would do for itself, what forms it would naturally make, its potentialities and limitations. He learned not to be intimidated by its precision, but to use this to his own advantage. The new freedom of machinery was parallel with that expression in other arts. An artist can produce a work of art with machine tools as satisfying as any to be made 'by hand' and, in this way the student can find the same 'play' experience in metals as he can in paint.

One day I came upon a very old, obsolete lathe which was being taken away for scrap. The machine had long served its purpose but I thought it could do one final service. I called to Jock Millar to find a piece of metal. When I switched on the power the machine shuddered, trembled and shook, nearly falling to bits, but it produced (all on its own) a most highly original piece of sculpture.

An agitation arose in the Press, and articles appeared on the need to train industrial designers. Questions were asked as to why we had no chair in the subject at one of our universities when it was suggested that in America every university had at least two of these chairs! So I went down to County Hall to look for a travelling grant as I had heard there existed a Principal's Fund to enable one to go abroad to study. The Fund had not been used at all during the war so Sir Graham Savage allowed me to use it, but warned me that there were no passages available. I told him that I already had a booking on the *Queen Mary* as well as a very heavy schedule of visits to Universities, Technical Colleges and Art Schools throughout America, with especial reference to the training of industrial designers.

After wartime Britain, America was tremendously exciting and stimulating. As the Central School of Arts and Crafts had long been famous on the Continent and had been a temporary refuge for many distinguished artists and designers fleeing from Germany in

the 1930s (Gropius had, during his stay in England, been a member of the School's Advisory Committee), I was given a marvellous reception.

At that time, although American art teaching was dominated by Bauhaus methods, there was a great innate vitality in almost all the work which I saw. In New York I spent time with Marcel Breuer, George Nelson, Raymond Loewe and other designers, discussing industrial design. I was particularly impressed by the Pratt Institute. Then on to see Walter Gropius at Harvard and Gyorgy Kepes at the Massachusetts Institute of Technology. At Boston I met Max Beckman and William Constable (a descendant of John Constable), who was most kind. He introduced me to the philosopher William James.

Then to Rhode Island, to Iowa, to Yale (to see the fine Theatre School), to Baltimore, Washington and Pittsburgh. In Chicago I met Chermayeff at the Art Institute and Mies van der Rohe who was then building his great scheme for the Illinois Technical College. On my way West I stayed with Frank Lloyd Wright at Taliesin. In California I went to San Francisco and paid a short visit to Carmel (which I found had grown beyond all recognition since I had given my art lessons in the Square, although it still retained some of its original attraction); then on to Los Angeles. At the Metro-Goldwyn-Mayer studios, the art director showed me round the streets of Wild West houses, saloons, sheriff's offices and barber shops, hotels and hardware stores; ghost town false fronts jostled one another on each street.

For me, the highlight of my tour was my stay at Taliesin. Wisconsin is a great farming state with beautiful rolling hills and rich soil. Driving up to Taliesin one passed fine dairy cattle grazing on splendid pasture interspersed with great fields of well grown maize. In architecture, as in other activities, there occasionally appear men with exceptional independence of thought, free men, great in spirit. Frank Lloyd Wright belonged to these. He was more than an architect, indeed, some people say that he was no architect at all. Both views can be considered reasonable. While many architects dissociate architecture from life, thinking about it as some abstraction unrelated to human living, Wright's ideas on architecture and life were at all times linked together. He was an imaginative Welshman, a romantic

Gael transplanted to America. Orange-box apartment blocks had no appeal for him although he did acknowledge that vast numbers of people could be housed therein. They were buildings, not architecture. Some critics of architecture object to ideas being expressed in terms of bricks and mortar. They feel that revelation through the eye is a matter of reflection, whilst ideas belong to philosophy, therefore it could be said that Frank Lloyd Wright was an impure artist. But, as Christopher Grieve once said to me when we were discussing creativity, 'You've either got it or you haven't and that's the end of it.' Wright had it, so for me he is beyond criticism. Frank Lloyd Wright believed in the practical approach to study. He kept his students busy from five o'clock in the morning driving tractors, sowing corn, cutting hay, and milking cows. They had a rota, taking turns with the cooking and domestic chores, or working on the farm which was run in conjunction with the architectural school.

Wright asked me to talk to the students after breakfast on Sunday morning so, knowing his antipathy to everything British, I began to talk about early Anglo-Saxon and Celtic art. Being convinced that he knew about every other subject in the world as well as architecture he continually interrupted until, exasperated, I turned to him and said, 'Mr Wright, you are a great architect; you know about building. I do not care for giving lectures; might I sit down so that you can continue?' He then let me go on with my talk in peace.

Frank Lloyd Wright showed me round his studios, stopping occasionally to help a student. Two friends from Chicago then appeared to collect me so that I could catch the train to San Francisco that evening. Wright was incensed, and wanted to know why I was leaving Taliesin. He waved his arm towards a range of buildings where I could have furniture workshops, textile studios, a printshop, a stained glass workshop, anything I wanted. He had already drafted a cable telling my wife to come at once; I need not return to England at all. He thought that the London County Council would never do me any good and the only way to be an artist was alone, as the only way to be an architect was alone. Nobody could help and anyway, I was a servant with the London County Council. This was my father's ghost speaking. Frank Lloyd Wright said, 'You'll die a servant unless you quit. Nobody's a servant here. You can set fire to

the building if you like, but you'll have to build it up again.' It was so beautiful at Taliesin and Wright's way of integrating art with the land appealed to me so strongly that I was very tempted to stay.

Wright exasperated almost every other architect in America with his opinionated behaviour, but Mies van der Rohe had a different view. He said that when he himself was young, Europe was at a complete standstill, and architecture was dead. Frank Lloyd Wright was the first man to bring real imagination back into architecture, and when his ideas came into Europe, he brought a renaissance.

Shortly before I left for America, Robin Darwin had been appointed as Principal of the Royal College of Art. Approximately every ten years a great reorganization took place at the Royal College. Under Jowett, delightful man though he was, the students and staff paid no attention to the Principal and carried on their own affairs exactly as they wished just as they had done under his administration at the Central School. So there was great talk of fundamental changes at the College under Darwin – heads would roll, violent upheavals would take place. There was great fear and trembling among the staff and the whole place was in a twitter.

Rumours were rife that the Royal College was to be turned over entirely to industrial design in imitation of the new department at the Central School, no longer retaining its position as the leading art college for the training of first-rate teachers or professional artists. The Ministry of Education backed Robin Darwin with enthusiasm, and money was poured into the College. New machinery (some in triplicate) was ordered on a vast scale without reference to its purpose or use; the staff dining-room was elevated (by the acquisition of a chef) to the rank of a fashionable restaurant; press hand-outs were liberal. The Ministry announced that the Royal College of Art was now completely up to date.

This was reasonable enough if the new Principal had had any knowledge of the subjects with which he was supposed to be concerned; nevertheless, it was hoped that suitable staff would be found as a more serious backing for this 'front'. In 1857 Charles Dickens published *Little Dorrit* in which he introduced us to Lord Decimus Tite Barnacle of the Circumlocution Office. Lord Decimus 'had revived trade from a swoon, and commerce from a fit, and had

doubled the harvest of corn, quadrupled the harvest of hay, and prevented no end of gold from flying out of the Bank'; and whose relatives 'bore testimony to all sorts of services on the part of their noble and honourable relatives, and buttered the Barnacles on all sorts of toasts . . . and they fetched and carried, and toadied and jobbed, and were indefatigable in the public service'. It is an old story.

At a time when Britain was struggling out of the aftermath of the war years we desperately needed men of high professional calibre to head our institutions; in art, men who thoroughly understood the arts of the twentieth century and who could use this knowledge to inspire their staff and students in a forward looking direction. To my mind, therefore, the appointment of Robin Darwin to the Royal College of Art was an ill-judged manoeuvre which would have a seriously deteriorating influence on the College, and the destruction to art education could well be lasting. I considered Darwin to be an amateur artist of no great talent without any understanding of the philosophy behind modern art, who had considerable social and political interests, and who, through his father (the golf correspondent for *The Times*) would have good connections with the Press, with access to the media. I felt that his appointment would be a repetition of that of William Rothenstein, and I foresaw difficulties occurring between us; a confrontation between two opposing characters, between the amateur and the professional, between the social dilettante and the dedicated artist, between Eton and Selkirk High School. One would have to wait and see.

When I was in Los Angeles I received an airmail letter from Tomlinson to say that half of my staff had been engaged to go to the Royal College of Art. What did I propose to do and how long did I think it would be before I would be in London? It would be a fortnight before I would be back at Southampton and I told him I would get in touch with him as soon as I returned. In the meantime he should make the very strongest protests to Sir Graham Savage, the Education Officer, about this unprofessional conduct, especially as I was at that time ten thousand miles away when this piracy took place. Tomlinson asked how I expected to start my autumn term at the Central School with all my staff gone. I felt that he probably exaggerated the disaster, although the staff had annual contracts which were

renewed during the summer holidays, so they were all free through the summer to make their choice.

After the war younger artists who had studied in Paris and had direct experience of the new art forms brought a fresh and vital influence into teaching. The supply of good young artists became plentiful and they needed to be subsidized until they found their feet. To give them a greater chance I made them teach something other than painting, so that this saved them from becoming deadened by continuous teaching of painting or drawing. There is nothing so depressing as a teacher of painting teaching his students how to make the same mistakes that have kept him from succeeding as a painter himself. Most artists have vitality, and this they pass on to their students. If they become successful, they leave the school, to let someone else in. I never asked for any examination qualifications from these men or women, I was only interested in their work as artists. There is a great value in irrelevancy, in the non-practical, as opposed to the necessary restriction of craftsmanship. Any art teaching that is to have a lasting educational value must have as its aim the enriching of the student's artistic sensibilities in order to withstand in later life the continuous deteriorating pressures of the world. No teaching system can be allowed to degenerate by repetition until it is merely a means whereby a student can 'cram' for a job. The unconscious suggestive images of those artists who are sincerely working out the problems of art in their own terms are of the most vital importance. Contact with a Master is the essence of all teaching.

On an engagement for a year it was hard to keep a man who was being offered a much higher salary than the London County Council paid, with much better conditions, with a five-year instead of a one-year contract. I could, of course, do nothing to stop them going. Complaints were made to the Ministry of Education and to the Education Offices about the unethical and unprofessional conduct shown in this wholesale pilfering of staff from another School, when the new Principal of the Royal College of Art should have advertised the positions to see what applications he received from all over the country. The Ministry supported this underhand behaviour, and Darwin replied that he was in the position of having no staff at

all and he had to get them from somewhere. Exactly what Tomlinson had said – from me.

I went with Mr R. R. Tomlinson to the Royal College of Art to demand an apology. By now Darwin had the reputation of a bullying, ruthless type of man, but when we came into his office his face was white and his hands were shaking. He tried to assure me that he did not know that all these teachers were at the Central School of Arts and Crafts. I disagreed and asked for an apology in front of the Chief Art Inspector of the London County Council, which Darwin gave me. Tomlinson was still worried about these depredations from the staff of the Central. 'Tommy, there's no serious business in this whatever. Darwin has cracked my drawing and painting department right open for new young men that know something about modern art. When I went to Camberwell there was nobody but Pasmore, Rogers, Coldstream and that kind of thing, because there was nobody else in Britain with a clue; a lot of new men have come up now that can understand the language that I'm talking.' So Robin Darwin presented me with a new opportunity altogether, although I regretted the loss of some of the staff. I was very sorry to lose John Minton who had come with me from Camberwell.

My visit to America had inspired me with fresh enthusiasm in tackling the Central School, particularly as I felt that much of our work equalled (and in some cases possibly surpassed) that which I had seen in the United States. I wanted each School to develop while at the same time integrating with as many of the other Schools as possible. As a student in Edinburgh I had been drawn towards the study of architecture under Professor Washington Brown, and so was particularly interested in the School of Architecture at the Central. It became the nucleus for the School of Interior Design and Furniture, which also included the Pottery and Stained Glass workshops. This School aimed at training students in three ways – those who wished to study interior design, those who would both design and make furniture and saw themselves primarily as artist-craftsmen, and those who would become designers for industry but would need to know how to make their own prototype designs.

I needed a Head of this School to shake it out of its 'arty-crafty' standards and to bring it in line with modern thinking. A young

Polish architect whom I had taught at the Regent Street Polytechnic applied for the job. Freddie Lebensold (a nephew of the famous Sam Goldwyn) was energetic, tough and enthusiastic, the very man I needed to give a new life to this School. Since their needs were similar, students of furniture and interior design followed a common basic course for the first year. It was a fundamental principle of this course that no student should be asked to work beyond the limit of his knowledge. To ask a student to design even a coffee table without a knowledge of timber, methods of construction, the space occupied by a saucer, or the heights of various forms of seating is not only asking him to do something difficult, it is encouraging him to use wrong methods in his approach to a design problem. It forces him into a wilful creation of form and will possibly seriously inhibit his creative powers. For this reason the creative work in the first year was confined largely to basic exercises in design, acquiring anatomical data relating to furniture, space relationships, dimensional studies of people in movement (the space required by a man putting on an overcoat), costing and museum studies. The students also learned to make competent working drawings; (clear drawing is an excellent aid to clear thinking). By insisting on a very high standard in this we were able to place a large proportion of students in work as draughtsmen during their first summer vacation, in the offices of local authorities, architects or manufacturers, which gave them invaluable practice.

Great value was always attached to the students themselves making their own furniture, thus learning skill in handling tools and appreciating the qualities of different woods and metals. The students developed a critical interest so that, by practical observation and constant reassessment, they were able to modify and improve their design as work proceeded in three dimensions. To my mind all designers should be able to handle the tools and materials for which they are designing on paper. Design instructors made constant visits to the workshops, watched designs in the making, discussing them with the students and with the cabinet-making instructors; these latter also co-operated in debating problems at the drawing-board stage. In furniture the problems ranged from the handmade single piece to ranges of furniture for mass production.

Interior design must be considered in an architectural context and all students were encouraged to realize this. Building construction was taught for one day a week and care was taken that students thoroughly understood the structure of buildings with which their projects were concerned. The student had practical experience in papering, painting and all decorators' work, as well as upholstery. In their second year they were asked to design a simple building so that they had the opportunity to apply their knowledge of construction and to think of a building in its special relationship to a site. Interior problems ranged from simple domestic interiors to more complex problems such as offices, shops and public buildings. Project drawings, working drawings and careful detailing were required. Problems of exhibition design and display were tackled with the specialist staff. Joint projects were also worked on with the furniture design students so that the contact between the two branches was maintained, and this policy was further implemented by lectures in history of architecture and joint model-making classes. Students were made aware of the possibilities in their training and, as we had built up excellent relationships with industrial firms, few students were unable to find employment when they finished their training.

We built up a highly talented staff in this School. Nigel Walters, an outstanding young furniture designer, came to the Central from Camberwell where he and his brother had both started teaching with me. I first met Nigel and his talented wife, Sheila, when they lived, with their charming small children, in a garage at the back of Cheyne Walk. As a little prosperity came their way mod. cons. and a bath were installed, and floor covering warmed up the concrete garage floor. I always remember with affection my first impression of this delightful young family, so full of brilliant promise, aspiring to the very finest ideals in art. Nigel designed elegant furniture for Heal's and won international prizes for furniture design in Italy. He later designed no less elegant ranges of kitchen units and equipment for F. Wrighton & Sons Ltd, which are famous throughout the world. Nigel's fine mathematical brain, allied to a most refined taste and a genuine care for his students, made him invaluable in the School. Early in his teaching career, Nigel found it convenient to combine

the subject of perspective, projective geometry and mathematical aesthetics. This created a disciplined form of reasoning or intuitive methodology. The regular partitioning of space became a preoccupation; it was the most perfect example of design at all levels of evolution and it was one that could be comprehended by a First Year student.

Besides Nigel Walters we had other most able designers on the staff – Robin Day, who designed sumptuous office furniture for Hille; Frank Austin who designed medium-price furniture for the Loughborough Furniture Company and impressed me considerably by arriving at the Central School dressed as if for a City board meeting, striped trousers and rolled umbrella complete, in severe contrast to the higgledy-piggledy garments which seemed to grace most of my staff. Frank Guille who specialized in kitchen equipment and designed mass produced furniture for Kandia and for Meredew; Clive Latimer, a particularly able and intelligent furniture designer and Stephen Garrett, who is now in charge of Paul Getty's romantic Pompeiian art museum on Malibu Beach. One of the older craftsmen, J. H. Brandt, could enhance the simplicity and elegance of the furniture which the students were making with rare sensitivity. Other superb craftsmen were Arthur Sims who joined us from Story's where he had been chief cabinetmaker in the workshops of that highly respected firm; F. Buist and F. Vallely; I remember with esteem the work of A. J. Milne, of Tom Fairs (who taught stained glass), of Denis Ball, James Hull, Sylvia Reid, Robert Nicholson and R. C. Negus, who all taught in the School and helped to give it the vitality which made it such a success.

Of all the staff in this Department one of the most interesting was the sculptor William Turnbull. He had started life working for Thomson's, the printers, of Dundee; he then spent a rough period in the R.A.F. on bomber raids, barely escaping with his life. Because of his distinguished war record it was agreed that he should study art in Paris and, when he came to me for a job, was a very promising and talented young sculptor. He was also a splendid teacher; I never found anyone who could handle the problems of a basic training for first year students with such imaginative insight. His teaching was brilliantly inventive, sensitive, stimulating and enormously pro-

ductive. No sooner did one idea explode, when another dozen followed the first, holding the students spellbound.

We had, of course, our fair share of handsome young women students: one year we had several students from the Far East, from Malaya and Thailand. These ravishing young ladies turned the heads of both students and the more impressionable members of the staff. A very gifted Italian post-graduate furniture student seized the opportunity; he married a most beautiful Siamese girl and went off to live in Bangkok. We learned that his father-in-law owned a teak forest so it seemed to me that this was the perfect answer to a furniture designer's dream.

Among the students in the Furniture Department were a number of Poles who had been given rehabilitation scholarships after their war service. One among them was particularly able. He decided to go to Los Angeles and when I asked him why he had chosen this city, he replied that he had carefully worked out the distance from Poland and thought it was as far away from Europe as he could conveniently go. He found work as a cabinetmaker in a furniture manufacturing company, shortly became foreman, then manager, then a partner in this firm. He sent for all the other Poles as they finished their training and founded quite a colony of Central School trained Polish craftsmen in California.

Another student, Bernard Shottlander, made a speciality of lamps; another one, David Hicks, became a well-known jet-set interior designer; and another, Terence Conran, has altered our whole attitude to buying furniture through his Habitat stores.

After some years the question of the School of Architecture was revived. The Architectural Association was running into trouble, and both staff and students were in revolt. Sir Robert Mathew asked me what I thought could be done. Maxwell Fry, Jane Drew and Wells Coates (all of whom gave lectures to my students), suggested that the staff of the A.A. move in one body to set up a new experimental training course in architecture at the Central. This scheme never came to fruition although there was a period when we collaborated with the A.A. in an interchange of students. The architect's department of the London County Council, under the direction of Sir Robert Mathew and Sir Leslie Martin (the joint designers of the

Festival Hall), were responsible for much fine building throughout London. I both liked and admired Robert Mathew; all through his busy, productive life he remained something of an artist.

In my studio I keep my watercolour brushes in a delightfully painted tin box which was given me many years ago when an Indian delegation had come to Europe in search of architects for the new city of Chandigarh. Le Corbusier was their first choice, but I was asked to suggest other architects to help in this big scheme. When I mentioned Jane Drew and her husband, Maxwell Fry, my Indian guests were in full accord, so my little Indian painted box is a reminder of a tenuous connection with a great new modern city.

Of the architects on my staff whose work gave me great pleasure, there was young Denis Lasdun, who seemed to me to have a very considerable future before him, as he was doing most interesting, exciting work. Trevor Dannat, Peter and Alison Smithson (who had been students, and later became members of the staff) who made a name for themselves as protagonists of 'art brut'; and a much older man, Jacques Groag, an émigré from Vienna, of whom I was particularly fond. He was a most sensitive, cultivated man with an exquisite sense of proportions. Groag's wife, Jacqueline, was one of the most talented textile designers working in this country during the fifties.

One of my post-war students at Camberwell, Gavin Astor, commissioned us to design a study-cum-office for him in his new London home. This was exciting as so little was being done at the time to encourage young furniture designers working in a modern idiom. Nigel Walters designed the furniture while Freddie Lebensold superintended the architectural details, and I contributed a painting. Freddie was ambitious and did not think Britain had too great a future. He turned his thoughts towards Canada. Between Jock Roberts, an old friend from Scotland who had been in the textile business and was newly divorced from Mary Ellis (Ivor Novello's leading lady), Freddie and myself, we concocted a scheme for the development of craft work (weaving, furniture making, pottery, etc.) in the Okanawa Valley in British Columbia. This was to take care of the winter's unemployment after the busy seasonal fruit picking was over. We wrote out a report for the government of the Province,

then considered quite seriously the question of settling in Canada
to superintend our scheme. I understand that something of the kind
of thing we suggested did eventually evolve, but we had no hand in
it. Jock was killed in a climbing accident, I remained in London and
Freddie, having reorganized my Furniture and Interior Design School
and set it on a splendid course, left for Canada on his own. There he
built up a large and prosperous architectural practice.

In his place came Frederick Marcus, who had escaped from
Germany in the thirties but found himself imprisoned in Barcelona
for taking part in the Spanish Civil War. Some time before the war
my friend Richard Church had asked me to help get a passport for
Marcus. Edward Marsh had guaranteed his entry into Britain and
Richard had given him work re-designing his oast house in Kent.
So, after many vicissitudes, Marcus came to the Central School.
Frederick Marcus was a gentle man with a handsome, sensitive face.
He was an excellent architect who enjoyed running his School,
except for the irritation caused by one member of his staff. One
morning I walked through a studio in the Furniture School where
I found, written on a large blackboard: 'Give us the jobs and Mr ——
will finish the tools.' I asked Mr Marcus his views on this. Sadly he
told me of his deep disappointment about a beautifully simple little
chest-of-drawers which he was looking forward to showing me. He
had asked his bête noir to design handles for it, but the handles had
been so complicated that the drawers could not be opened. Marcus
bewailed the amount of good wood that was wasted.

Oh, if only an appointment could be found at the College! By
heaven, through the next post came a letter marked 'Private' with
a Government stamp on it. I thought this was from the Ministry of
Education, but it was Darwin, asking if it were true that this person
had been a student at the Bauhaus. I wrote: 'Dear Darwin, It is
absolutely true. Yours sincerely, William Johnstone.' I did not put:
'P.S. The students wrote on the blackboard . . .' Quite soon our
friend was appointed as Senior Lecturer at the Royal College of Art.
It took Darwin three years to find out that this man was playing hell
with the furniture. It must be said in fairness, though, that Darwin
was beginning to learn to choose better staff (or be better advised).
Janey Ironside made an enormous success of the Fashion School at

the College and, through her talented students, she changed the image of the British fashion scene entirely. This department was Darwin's great success story and I could not but envy him this genuine triumph. Then a few years later, after a period of much dissension and ill-feeling, Janey Ironside left the College. Could he bear no other star but his own?

One fine day there was a knock on my door, a bird's nest beard looked round, and there was Victor Pasmore. It transpired that Victor was in trouble at Camberwell and was to come before the Education Committee for irregular attendances at his classes. Although I was over-staffed, Tomlinson agreed that Victor could join me again at the Central. He would cancel the meeting with the Education Committee. Victor never had, of course, very much of a brain, but he had feeling and taste. His conversion to 'modern art' came from his association with myself and with Albert Halliwell at Camberwell. His own garbled statements on the subject at the Central were the cause of some amusement, but unfortunately, they led to a loss of confidence among the students, who knew perfectly well that he had no genuine basic knowledge of modern art or the philosophy behind it. Fortunately, Lawrence Gowing had an appointment in Newcastle so was able to provide a place for Victor.

The Jewellery and Silversmithing School rejected all forms of modern design as completely irrelevant and useless. Mr Emerson, the Head of the School, complained continuously that all the drawings and designs he ever saw were impractical, and it seemed to me that where you had the most craftsmen and the fewer artists, you had the greatest stagnation. In this School the craftsmen were certainly marvellous – men skilled in working gold and silver; men trained in setting and mounting precious stones; fine craftsmen like George T. Friend or R. A. Massey. Mr Bruno who took time off from his famous firm of Hennells (the eighteenth-century silversmiths), in order to teach and encourage our young apprentices; Francis Adam, a Hungarian who had once been swordmaker to the Emperor Franz Joseph. Adam had helped to make the Stalingrad Sword and was a very old man. His skill and knowledge of precious metals were phenomenal so that to watch him take a piece of silver, literally drawing it out without a joint as if he had been a potter with a lump

of clay, and fashion it into a ceremonial bowl or vase, seemed a miracle. He was eighty when he was still teaching at the Central. I hated to see these great old craftsmen retire when they still had so much to give to the students. We were frequently asked by the London County Council and other Authorities to make important presentation pieces for distinguished foreign visitors. To my mind, the designs for these ceremonial pieces were always dull, lacking in sensitivity or perception, so that I was saddened at the thought of such wasted opportunities.

Sir Kenneth Clark asked me if I would consider Mary Kessel as a member of my staff. A very exotic lady appeared at the Central School for an interview, highly decorative in a Renaissance/Baroque manner, with rings on her fingers and bells on her toes, with flowing skirts and trailing jewellery and appendages hanging down here and there. She seemed to be an emotionally romantic type so I wondered where a home could be found for her, then I thought that we could possibly force her on to the jewellers and silversmiths. Of course, this idea was vigorously resisted by Mr Emerson, who said that for years he had been rejecting artists as being impractical people and he certainly did not want Mary Kessel foisted on him. However, he eventually agreed to give her a trial. Mary did some most interesting work in the School; she and the students made some marvellously outrageous Baroque pieces of jewellery which were glorious in their imaginative flamboyance. Only recently, in the Johnson's Wax exhibition of modern American crafts (shown in 1973 during the Edinburgh Festival), have I seen jewellery of a comparable interest. Mary made a very big contribution to Emerson's Jewellery and Silversmithing Department. We arranged an exhibition of her work, and it was hardly possible to believe that in so short a time any artist could have produced so many gorgeously irrelevant, impractical and exotic objects. Alas, we were far too far ahead of our time; as far as the 'trade' was concerned our exhibition fell stone dead with the exception, to Mary's great delight and encouragement, of Liberty's and Fior who were both interested in buying pieces of this exciting new jewellery.

Mary was a delightful creature, filled both with the romantic enthusiasm of the creative artist, and with the usual artist's depres-

sions. Her paintings had charm and considerable sensitivity. Watching her one day, Jack Beddington turned to me and sighed, 'What a lovely person Mary is, what a tragedy that she ever had to do with art.'

For some time Alan Davie had been tormenting me for a job, but I was in my usual predicament of being overstaffed. Alan and his wife were living on poor relief at William Oley's artists' settlement at the Abbey, New Barnet. Nowhere could Alan find work, and he had to walk all the way to Holborn to see me. My school keepers did not care for Alan Davie. Mr Reilly, who was on duty in the front hall that day, knocked firmly on my door, and said, 'Excuse me, sir, might I remind you that you have an appointment at three o'clock? It's now 3.5 . . . between 3.5 and 3.10, sir.'

So I said, 'Mr Davie, I'm afraid I'll have to ask you to leave.' He went out protesting that I still had not found him a job. But Alan would not give up so easily. He had shown me some most imaginative jewellery he had made, and I had approached Emerson to see what could be done for Mr Davie in his School but, of course, he had rejected Alan out of hand. No doubt he felt that he had had enough with Mary Kessel, but I was determined that he should accept Alan Davie.

Alan had wonderful results with the young jewellers and silversmiths. He worked at such a speed, with such intensity, in such a burst of romanticism that it was marvellous how he kept it up. Of course he could not work at this intensity both in his teaching and in his own painting for ever. As he became more and more successful as a painter he naturally gave up some of his classes, but he did a tremendous job at the Central.

Through the efforts of Mary Kessel and Alan Davie, the Jewellery School improved immensely. Apart from those students who were seriously studying design to make careers for themselves as artist craftsmen or as designers to the 'trade', we had a large number of day-release students who came to us as part of their apprenticeship training from Asprey's, Cartier's, Hennell's or other first-class manufacturing jewellers and silversmiths. After the war there was considerable difficulty in supplying enough skilled labour for the 'trade'. Men left the larger firms of manufacturing jewellers to set up

on their own account, and many of these small firms were suspected of being involved in the very remunerative business of re-setting stolen property. In my own view the manufacturers did not pay nearly enough wages for extremely skilled work so, in effect, put temptation in the men's way. Among our students was one who on occasion was sent to my office for small misdemeanours; he later became well-known as a criminal who was given a very long sentence for his part in a spectacular robbery. He was a talented silversmith with expensive tastes.

During the fifties, design in jewellery, silver or gold work was completely moribund throughout the industry. All that beautiful material and craftsmanship was wasted. This moribund quality not only affected the craftsmen but, even more so, pervaded the masters, so that the trade was as dead as mutton despite the ability of the men who worked in it. It expressed, more than anything else, the decadence in British art. Unfortunately Hughes, the Clerk to the Goldsmiths' Company, who genuinely tried to improve the standard, could do nothing with all the resources at his command since he lacked knowledge of design.

He never forgot the fact that his candidate had not been made the Principal of the School. Thus for a number of years after I became Principal, he reduced the Company's grants to the School.

He also, for some unknown reason, took a dislike against A. R. Emerson, the Head of the Department. Now, while Emerson and I had constant arguments on the subject of design, he ran his School containing about six hundred students extremely efficiently. At one time, Hughes was very much in favour of Emerson; so much so that he supported his nomination as a Liveryman at the Goldsmiths' Company.

Emerson was a fulltime member of the staff and could look forward to a half-salary pension when he retired. Suddenly, at a Governors' meeting, under 'any other business', Hughes suggested that the Principal had too much work to do in such a large School like the Central, and he wanted to propose that Emerson become part-time Vice-Principal so that he could do more of the ordinary donkey work for the Principal. I argued for about three and a half hours against this, but my Governors agreed with Hughes. Emerson was

reduced to being part-time Head of his own School, thus losing some of his pension rights. I was furious – to reduce a man in public service from an appointment which was supposed to be permanent was very wrong. Emerson ran his School well and no fault could be found in his administration. I told him that, if it was the last act I did, I would get him reinstated, but it was three or four years before I had a chance.

15
Styles in conflict

During the early fifties the two galleries most consistently interested in showing modern art were the Hanover Gallery and Gimpels Fils. Peter and Charles Gimpel always had exhibitions of great merit by artists from the Continent and also worked tremendously hard to develop a market for interesting young painters or sculptors from Britain. Once they had made up their mind about an artist they backed their opinion with tenacious loyalty. Sometimes Charles Gimpel would ask me if I could help support one of his artists with a part-time teaching post until he became established in his career. If I liked the exhibition and agreed with Charles that he had promise I would usually arrange a small job for the young man, at least until he held his next exhibition with Gimpel Fils. This worked very well, enabling me to add several extremely talented artists to my staff. On my return from Colorado in 1950, Gimpels Fils asked me to have a small exhibition of the drawings which I had made of the ghost towns in the Rockies. The gallery was to be shared by Lurçat, the great French tapestry designer, William Gear and myself. This idea pleased me, especially as my old friend McNeil Reid had shown no sign, since the war, of including me in any exhibition at Reid and Lefèvre's.

Soon after this exhibition at Gimpels, McNeil arranged a retrospective exhibition of my work at his Bruton Street gallery. My wife met Charles Gimpel, who asked her whether I was busy painting. 'Oh, yes,' says she.

'Then I must come along to his studio to see his work before his

next show with us.' Somewhat embarrassed she had to tell him that my next exhibition was to be at Reid and Lefèvre. 'That'll save me a journey to Chelsea,' said Charles. I had not realized, of course, that Gimpel Fils meant to include me as one of their regular exhibitors, as I thought perhaps that this first exhibition of drawings was by way of being a 'thank you' for helping with some of their young artists. I felt a loyalty to McNeil Reid who had, during the years I had worked in London, showed my paintings in mixed exhibitions whenever he could – certainly when no other gallery would look at them. When he suggested a big, one-man show I had never hesitated. Peter Gimpel thought I had made a stupid mistake. Years later he told me that I had solved a problem for Gimpel Fils, as they wanted a new artist who could really draw and were trying to decide between Bissière and myself when I went back to Reid and Lefèvre. Although Reid and Lefèvre had this very fine gallery they were not primarily interested in modern paintings, their real business being with French Impressionists and painters of the School of Paris, of whose work McNeil had an enviable knowledge. So, from the standpoint of becoming a successful career painter, I made the wrong choice of gallery. But I liked McNeil very much; he was a man with whom one could be at peace.

One of the first artists to join me at the Central School from Gimpel Fils was the sensitive and talented graphic artist Louis le Brocquey. Then Charles Gimpel asked me to see an exhibition by a young man called Richard Hamilton. He was showing a series of etchings of farm machinery in which he had simplified these complicated objects, stressing their linear quality. I liked the exhibition, bought an etching of a reaper, and promised to find a place for this talented young man. I asked Albert Halliwell to take him as an assistant in the School of Industrial Design. While he had no previous experience of teaching I was sure he would have a sufficient knowledge of design which could be linked to other forms of basic training, producing for the students an extension of their knowledge, as well as adding something to his own. He had a fertile mind with an imagination which could readily adapt any style or media as grist to his own mill, and he was certainly a very apt pupil, exactly as I had thought. Before we knew where we were he was giving a lecture somewhere

on industrial design as if he had studied the complicated subject since he was a baby. Halliwell, instead of wanting him moved to another School, was delighted with him until it was discovered that some of the students' work in Hamilton's classes was being removed. This was strictly against the London County Council's regulations, but there was a very good reason for this, apparently, rather unnecessary rule. If any teacher had any trouble either with his teaching or with the discipline in his classes (or for any other reason), and was asked to come up before the Principal or the Education Committee, he could always produce the students' work to show the quality of his teaching. It was really a safeguard for the teacher, especially in the case of visiting teachers where the contracts were on an annual basis, but the rule was a protection both for the staff and the students.

Richard Hamilton soon followed Victor Pasmore to Newcastle. Some years later I looked in to see an exhibition of his work at the Hanover Gallery and I was met with large paintings which seemed somewhat familiar; then I remembered the work which the students were doing when Hamilton taught for me at the Central School. Richard's exhibition was a great success. The Tate Gallery gave £600 for one. Everybody wrote it up, including Herbert Read. What was happening in the art schools (I write specifically about Camberwell and the Central), was in advance of what the art dealers were bringing from Paris, but the work was, of course, only seen by other students or by their parents and friends who were specially interested. The art school had developed past the standards of the art dealers, which is as it should be.

Another artist who had his first show with Gimpels Fils was Eduardo Paolozzi. Paolozzi was a large, hairy Scots-Italian who had been working in Paris. He looked somewhat formidable but was, in reality, a most gentle, kindly and sensitive man. I was certain he was an artist with an inner power which could be transferred to his students, so I took him up to see Miss Dora Batty, who was Head of the Textile School. She was a most cultivated lady, a splendid teacher and a textile designer of long experience, but she was horrified to think that Paolozzi was to join her staff. I asked her to help him work in her School for a month or two until I could find a place for him in the School of Painting and Drawing. Some months passed

until I found my opportunity but, by this time, Miss Batty was most enthusiastic about Paolozzi's teaching and refused to let him leave the Textile School. He had entered into the spirit of the thing with terrific zeal and her students were devoted to him. Paolozzi worked with Miss Batty for a number of years, putting in a tremendous amount of work. He himself became an extremely interesting textile and tapestry designer in addition to his work as a painter and (later), as a sculptor.

One day a friend rang to say that young Alan Reynolds had just had a row at the Royal College of Art with Robin Darwin, and had left. He had held one or two exhibitions at the Redfern Gallery and, for some reason, Darwin had taken exception to the success which Alan had gained with his very beautiful watercolour drawings of plant life. Alan needed a job urgently, and he came to see me with his portfolio. I was delighted both with his drawings and with the man. Alan was a real countryman with a passionate devotion to the growing, living earth. He also had plenty of the countryman's natural guile, the watchful cunning needed to catch a hare, a rabbit or a trout. I hoped these qualities would enable him to survive intact as an artist amidst the London art jungle. At that time there was a lack of artists who could make beautifully drawn studies of flowers or twigs, or leaves, which could be used for very elegant printed fabrics; so Alan was a great asset in the Textile School.

Miss Batty's staff included several young, talented designers: John Drummond and Gordon Crook; Mary Harper, M. Kirby, Mary Oliver and Beryl Coles; Jennifer Wallis, who was a particularly gifted draughtswoman and a specially delightful character, and Anton Erhensweig, well known (since his death), as an art philosopher/ psychologist. Trained as a lawyer in Vienna, Anton had escaped to Scotland when Hitler overran his country. There Anton found work in the dye works of Donald Brothers of Dundee where he learned about the chemistry of dyeing. Eventually he gravitated to Miss Batty's Textile School where he was the technical assistant in charge of the dyes. Anton loved the Central where he became increasingly intrigued by the odd characters among my staff. Anton wrote *The Hidden Order of Art*, a most intelligent work on the psychology of creativity, but unfortunately died as it went to press.

Marianne Straub, who was Swiss, was in charge of weaving. She designed for Warner Brothers who, at that time, were producing very high-quality woven fabrics. She was an outstanding weaver, a supreme perfectionist with an exquisite sense of colour and texture who, to my mind, epitomized everything that is good in the perfect artist/weaver, and I had the very greatest respect for her work. With her Continental training she looked at art in the same way as I did, understanding the problems involved from a similar point of view. There was an empathy with Marianne which I could never find with British-trained artists however talented they might be.

With this staff, the Textile School shot ahead. We held splendid annual exhibitions at which representatives from the 'trade' could buy the students' printed or woven designs. At our first show we found some difficulty in selling to more conservative minded manufacturers. Among our visitors was Harold Wilson, then President of the Board of Trade, who suggested that we should sell only the punched cards for the woven patterns, as from these the manufacturers could understand how the cloth would weave – they could only see in spots. He was perfectly correct, and from then on we had great success in selling both woven and printed textile designs.

One of our most consistent supporters was Lord Marks who thoroughly understood the importance of design as a selling agent. Each year several of our students took up appointments designing textiles for Marks and Spencers. One of my most beautiful and talented students was in charge of the firm's woven fabrics, and became Lord Marks's personal assistant.

Nearly every year Dr Äke Stavenow came from Stockholm. He was a great pioneer in design education in Sweden and had organized the first exhibition of modern Swedish design shown in this country in the old Dorland Hall in 1931. I had seen this exhibition and had been amazed at the kind of work which was being done in Scandinavia compared with that produced in Britain. In the Scandinavian scheme of things, manufacturers understood design and employed artists in their factories, thereby generating a new and vigorous approach. The artist was considered an essential part of the production team, not a decorative embellishment as seemed to be the case in Britain. Äke Stavenow was always a most welcome visitor. When,

in 1959, the new Konstfackskolan was opened in Stockholm by King Gustav, I was honoured that much of the curriculum from the Central School had been used when planning the courses for Sweden's new Art College.

Perhaps my favourite School was the Theatre School. I had loved the theatre as a boy but, of course, had never dreamed when we built our own stage at Greenhead that I would ever be connected with the London theatre. Jeannetta Cochrane welcomed my interest enthusiastically; in me she saw a 'natural' for the West End stage, telling me that 'Binky' Beaumont would be only too happy to give me a part in one of H. M. Tennant's productions. I remembered my mortification when playing with Sir Frank Benson in Edinburgh and decided that an actor's life was not for me.

Jeannetta specialized in period costume which she approached in a most imaginative and excellent way. While she was a craftswoman rather than an artist she taught drawing in a way which was, for me, a revelation. We had a great collection of tailors' dummies, one of which was said to have belonged to Lily Langtry; some had busts that went up in the air, some had busts that fell down; some had bottoms sticking far out, while others were practically straight up and down. From the natural woman to the art woman was a matter of corseting, which raises a point about art being anti-nature. The students learned to draw by cutting paper tailors' drafts; they learned form through pinning the mulls on to the tailors' dummies, designing on the body itself. Cutting was something of a mixture between sculpture and drawing on the flat, but the actual practice of working on the solid, trained the students to express something in the round that would have taken them years to understand through the normal way of drawing the solid forms of bottles or apples, or struggling with the complexities of the nude figure in the life classes. It did help to have orthodox drawing classes also, to gain the ability to express ideas, but the more they worked with the dummies, the quicker the students understood both drawing and form. Edgar Degas had worked on this idea a great deal so that when he was blind he made the most magnificent sculptures by feeling alone. I found this method of training extremely interesting.

I had learned in Paris that very often the greatness of an artist does

not necessarily lie in blowing the whole house up in the air in one vast explosion, but simply in shifting the handle of a door. Miss Cochrane worked with the students on, say, a costume of about 1780, slightly changing the buttons, splitting some seams, tearing up a valuable costume. The process of destruction is a joy, one loves tearing up paper, slashing up old cloth, burning up piles of old newspapers or cardboard boxes – it's great fun to destroy! Then, taking the same suit, the same gentleman's coat with all its decorations and embroideries, adding a gusset, shifting the buttons, a little change in a lapel, they altered it slightly so that neither character nor period was disturbed. There is a genius in just making the waist a little higher, a little lower, a little wider, a little tighter. At the end of their three year course, the students had a very thorough knowledge of costume, from corseting and wigs to the smallest changes of fashion in shoes or buttons. They could also design the most economical and workable sets. This severely practical aspect of the training sometimes alarmed a would-be student. Miss Cochrane would not admit a student who was not willing to sew.

We had a splendid relationship with the London Theatre. Every major theatrical management took our students (Covent Garden, Sadler's Wells, the Shakespeare Memorial Theatre, Glyndbourne, H. M. Tennant's), young people whose work I still enjoy like Susan Spence, Ralph Koltai, Peter Farmer, John Claridge, David Walker and many more. Through this connection with the West End theatre many fine professionals came to talk to the students to give their opinion on our work. John Gielgud used to come; Oliver Messel, Martita Hunt, Flora Robson, Roger Furse, Peter Hall, Edith Evans, Edward Burnham and J. B. Priestley. Tyrone Guthrie took several of our staff and students with him to Canada when he began the Shakespeare Theatre in Ontario. Richard Levin, who was in charge of costumes and sets for B.B.C. Television, used to come to see the Theatre School, to engage students to help in his productions.

Jeanetta was very suspicious of Sir Kenneth Barnes, the Principal of the Royal Academy of Dramatic Art. She said that what he liked was one main actor or actress with a whole lot of other poor stiffs to fill in (just like Sir Frank Benson). As for scenery and costumes, the same scenery did for everything – he had no sense of design in any-

thing at all! In spite of Jeannetta's fears that it would be a waste of time, we did several excellent productions with R.A.D.A., extending this collaboration to the Guildhall School of Music and Drama. Our students designed and made the sets and costumes for the students' productions. I enjoyed this co-operation with R.A.D.A. very much, and in particular, was very interested when the students were adjudicated each year for the Bancroft Medal and other awards. The judges were all men and women of high professional standing, at the 'top of the bill' either in comedy or straight acting. They judged the students' work with tremendous care, all dedicated with great seriousness to furthering the highest standards in their very difficult profession. I used to wonder whether a jury of the arts would be quite as fair and open-minded in their assessment.

I would dearly have loved to introduce a more modern approach to theatre design into the School. I would like to have seen a contemporary Gordon Craig on our staff but in this I was unlucky.

Jeannetta was a most practical woman. She knew how to design a set for a price, and she knew the economics of the theatre. She knew that a set, properly designed, could travel through the whole play – you could take one bit out and slip another bit in – the same bits at the wings did, with minor variations, for a whole series of differing situations. It became like a jigsaw puzzle with the fewest possible interlocking parts. These simple, interchangeable sets were a godsend for touring companies travelling to Glasgow, Edinburgh, New York or Wimbledon. The economy of cost to get the maximum effect on the stage was one of the features of the School of Theatre Design which appealed to me particularly. This was the economics of art on which, throughout my career, I had insisted. The basic element of design is costing – economy of materials, economy of effort, economy of space. I still recognize sets designed and made at the Central School, painted up and disguised, but carrying their years well. Such sets can stand an enormous amount of elaboration in the way of lighting and costumes without the stage appearing to be cluttered up with claustrophobic detail. One of our most interesting opportunities came when Michael Tragmar was asked to design the set for Dylan Thomas's *Under Milk Wood*, and it was a challenge to produce it simply and inexpensively.

Sometimes for charity, or for some official event, Jeannetta and her students would put on a display of the beautiful costumes which had been made in the School. They were displayed in a series of historical tableaux, vignettes of fashion, in which the students wore the clothes they had designed. Each costume was enhanced by gorgeous period jewellery lent us by Cameo Corner – one entered a world of enchantment.

The last time tableaux were performed was at County Hall, when the Chairman of my Governors, Mrs Helen Bentwich, became Chairman of the London County Council. Jeannetta was ill with cancer, and she was in a state of collapse as we watched each scene from the wings. I thanked God when the performance was over. The applause was enormous, everybody was delighted, but Jeannetta herself was very nearly dying in the dressing-room. We managed to get her home and soon afterwards she did die.

Some time previously I had suggested to Sir Isaac Hayward that the London County Council ought to have its own theatre. To this he agreed. As the idea was primarily for the good of the students the auditorium was to be small, the greater part of the money available was to be spent on the most modern stage equipment that was obtainable at that time. No money was to be spent on prettying up the foyer or on any purely decorative schemes. The theatre, named after Miss Cochrane, was barely completed when I retired from the Central so that I was never able to put into effect the ideas I had for its use.

1953 was a busy year. My wife and I had been working on the restoration of a small mill at Ancrum in Roxburghshire, to make a comfortable studio home and now felt it was time to sell our Chelsea house. My first major exhibition since the war was to be held at Reid and Lefèvre's in the autumn and was to include paintings done during the last three or four years as well as earlier work. Then one day there was a pleasant surprise. I received a letter inviting me to give a series of lectures in South Africa on art, industrial design and art education. As these lectures were to be under the aegis of the British Council I went to see Mrs Lilian Somerville for whom I had a great admiration. She had shown a lot of enterprise, had made fearful mistakes, but her heart was in the right place, if her judgement was

not always so sound. I always liked her. I told her that I was delighted to be asked to go, so we set off for the summer holidays on a twelve-passenger Ellerman cargo boat, the *City of Manchester*, bound for Cape Town.

In 1953, apartheid was not as rigidly applied as it later came to be. The Afrikaans universities of Pretoria and Stellenbosch were the only two universities which excluded both Cape Coloured and native students, but there was a great fear of further Government interference in the affairs of the other universities. The Headmistress of a teachers' training college asked me to give a talk on child art, and I asked if this would be available for all the students. I was told that it would not.

'I really don't believe in this segregation. I have to give these university lectures, and this really is not my job.' The Headmistress (a delightful and most intelligent lady), was pressing.

'We'll get in touch with Mr Van Rensberg who's Art Inspector for Cape Province, to see what we can do.' I told her that I would not come to her college unless the Cape Coloured student teachers could come too. Van Rensberg thought this could be arranged.

All the drawings shown at the college were by native children. Suppression intensifies expression, and these children could evoke deep feeling through their art. Someone more qualified in psychology and biology than I could write an illuminating study of the art of the second-class citizen in our age – the Art of the Submerged.

There was at the time a certain amount of anti-British feeling in South Africa which meant that, contrary to what I had understood in London, I was only invited to lecture at the English-speaking universities. So we enjoyed our stay in Cape Town and loved the beautiful farmlands and fine vineyards of the Province. The architecture of the old Dutch farmhouses was a delight. Then on, through the wonderfully coloured hills of the Karoo to the brash, exciting city of Johannesburg, where the air was charged with a highly-strung nervous tension.

Walter Battis, the artist and authority on Bushmen art, arranged an unexpected lecture in Pretoria. On our way there he took me to a native village where the young virgins were repainting their houses with most splendid abstract designs. These young girls brought a

vital intensity to their traditional patterns which was most exciting – a whole village of Braque's paintings. We stayed a week in Pietermaritzburg where the Fine Art Department of Durban University was housed; a town of attractive early Victorian houses with charming verandahs supported with most decorative iron work. Then a visit to the Architecture School in Durban and (what was scheduled to be) our final stay at Rhodes University at Grahamstown, but the Afrikaans-speaking South Africans were determined that my last lecture should somehow be arranged at Stellenbosch. They succeeded in rearranging my schedule satisfactorily to this end and afterwards the professors of Dr Malan's university gave us a delightful valedictory luncheon before seeing us off on our boat at Cape Town.

We had enjoyed our visit to South Africa enormously. We had met many very interesting people from all sorts of ethnic backgrounds, all of whom were working seriously together for the good of their country. We had found that cultural activities were supported predominantly by the Afrikaans-speaking and Jewish section of the community. We had met many fine artists, but we had also found South Africa to be a country riddled with fear. Each group, whether English, Cape Coloured, Bantu, Huguenots, Dutch, Jews, Germans, all were alarmed by the threat of impending evil, all were anxious. Contrary to what I had been warned, everyone was equally kind and hospitable during our stay in their country, with the single exception of a gentleman whom I met in Grahamstown who struck me as a disreputable character. He later became a somewhat notorious Minister of Justice.

As a good civil servant, I handed in the reports of my visit to South Africa to the British Council. General Adam sent for me, and he said it was the best report they had had, and he wanted me to return to South Africa straight away. The Foreign Office would arrange for my transfer from the London County Council and would take over all responsibilities for my pension if I would return at once. 'General, I have done this tour during the summer, but I had better stick to my last.'

'You won't go back?'

'No, I won't go back.'

The following spring we moved from Chelsea to Holman Hunt's

studio in Kensington. This was a splendid working studio. A charming little tree blossomed gaily outside the great north window, and in the garden was a bigger tree which had a notice on it to say that William Thackeray had sat under its branches. This studio was a fine place in which to paint.

I had two exhibitions with Reid and Lefèvre, in 1953 and 1958, another two at the Bear Lane Gallery in Oxford, and twice Gordon Washburn came to choose a picture for the Pittsburgh International (in 1955 and 1958). My paintings were beginning to find a market. Sir Michael Culme-Seymour began to collect my work, and he always bought with a most sensitive discernment. Throughout these many years in which I have enjoyed his friendship I have always greatly valued his understanding and championship – such sympathetic support is of inestimable encouragement to an artist.

Alan Davie looked into my office at the School and said, 'William, Martha Jackson's in London. I'm going to have a show in her New York gallery. She's got room for one more British artist on her list. I think she should come to see your paintings. They should be shown in New York.'

'Alan, I'm too old for such adventures. With your golden beard you can stand up to these American lady dealers. I'm scared stiff. I remember Peggy Guggenheim before the war, and she was a rough little number!' It was nice of Alan, though.

Two or three times Mrs Miriam Topham asked me to go to Liverpool to help judge designs submitted for the bronze statue presented to the winner of the Topham Trophy. The last time I went I felt unwell, and instead of returning to London, I travelled north to Scotland intending to have a short rest at Ancrum Mill. In a few days I was due in Amsterdam to give a lecture on industrial design, an important lecture for which a special stamp had been printed. I thought I would concentrate on writing this lecture in the country.

First I went to see my doctor. 'William Johnstone, I am phoning the Cottage Hospital for a bed for you at once.'

'What about Amsterdam?' I proudly showed him the stamps with my portrait on them.

'If you go to Amsterdam you will be dead very soon. Now I'll arrange for that hospital bed.'

So Paul Reilly flew to Amsterdam in my place and I went to bed with a duodenal ulcer. My staff wrote to cheer me up; Cecil Collins wrote to me with news of the art world.

Dear William,

Hans told me that you have not been well, I was so sorry to hear of it, but Mr Halliwell says that you're a bit better just now, but well doped up with drugs. We miss you at school, and much look forward to your return.

The Art World has been shaken by the appearance of a small round unmentionable object being found in the basement of the Royal Academy, it has been identified, but no statement has been issued. Other art news – News flash: Sir Gerald Kelly's drawers have been taken off by the Social Realists. Sir Alfred Munnings is wearing a hair shirt woven from the tail of the Derby winner of 1900. Indeed there is a state of war. The Scotch Nationalists have left a lot of kilts in the left luggage department at Piccadilly, and the drains of the Ministry of Culture at Whitehall are blocked with Haggis, and a great deal of Porridge has been found around the Altar at Westminster Abbey. There is no doubt that this is the beginning of a concerted movement to bring back the Stuarts, indeed the shop stewards are already here. That is the situation.

Will be writing you again soon but we are busy sandbagging the School against possible attacks from over the Border. . . .

Cecil wrote again, a letter which deeply touched me:

Dear William,

I was so glad to get your letter, thanks many thanks for it. I have been eagerly awaiting to have news of you, and of your progress. This place seems empty without you, and lacks somehow the core around which everything revolves; I miss our talks, and sometimes find myself making for your office.

Do write a report how you are getting on.

The Art World is as seedy as ever, there is no good for man's spirit in it, everybody chasing the 'latest' which becomes old fashioned by the time they catch it. What a period!

There is much one could say on it all. Your prophetic voice saying 'stick to painting', is real guidance and the time will come, chère Maître, when you will be appreciated at your true worth, the outstanding quality of integrity in your work and life is the very high quality that a commercial civilization like ours is slow to notice. You are a man of great courage, in the way you have overcome things, so that your inner integrity is untouched by all your experiences.

Hans will have written you all the news, and I am looking forward to your return to Babylon soon. I hope that you will consider getting a house nearer London, although I know how much you enjoy the land of your Fathers. I have unforgettable impressions of that wonderful landscape all around Ancrum . . .

I have never been keen on sitting on committees, but as Principal of the Central School of Arts and Crafts I served for a number of years on the Council of the Royal Society of Arts and was a member of the Council of Industrial Design.

Robin Darwin also sat on the Council, so it was inevitable that a state of internecine war would develop between us. I was, of course, determined to outwit him at all times, and counting on his bad judgement, I felt that he would be easily exposed. In justification, I felt that he was depriving many people with outstanding talent of honours, prizes and positions that they really deserved. By adroitly manoeuvering his own 'stooges' he prevented really talented people from having the effect on this country's export trade that they should have had. The influence of the Central School on British design was so great that we must have earned this country millions of pounds in the export markets of the world.

The purpose of the Council of Industrial Design was to encourage an improvement in the standards of design throughout industry, with especial reference to the export trade. From its inception the Council of Industrial Design had been penalized through lack of money, but it was even more severely handicapped, to my mind, by the condition that only half of its income came from the Board of Trade. The other half was provided by member firms who, rather naturally, expected their products to receive commendation by the Council and be shown in the Design showrooms in the Haymarket, as of right. Firms with small capital but good products were placed at a disadvantage.

The Council was quite a large body including architects, designers, manufacturers, industrialists and educationalists. There were also the usual sample of representatives from Government departments (the Board of Trade), and other interested parties. Many industrialists were (in many cases quite rightly) suspicious of artists; they could not possibly conceive how they could contribute anything to their particular industry.

These industrialists were thus cagey about supporting the Council of Industrial Design. They had seen far too much superficial covering of machinery which was beautiful in itself and should have been left exposed. They could understand the beauty and mathematics of

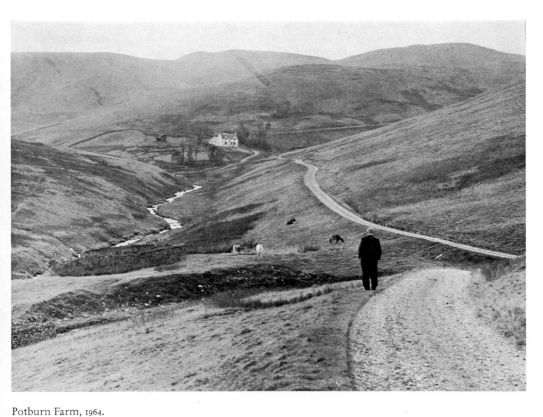

Potburn Farm, 1964.

Blackface sheep at Potburn Farm, 1965.

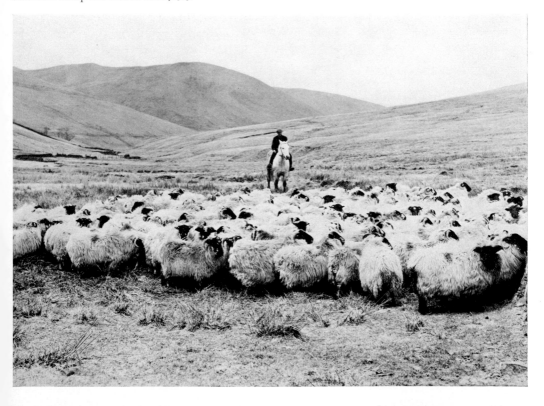

Lithograph from the limited edition of
*Twenty Poems by Hugh MacDiarmid and Twenty
Lithographs by William Johnstone*, exhibited at
the Air Gallery, London, April 1978.

Left: Bull with Cow. Oil on board, 1971 (7 in.× 9½ in.) Property
of Mrs Hope Montagu Douglas Scott.

Below: In the studio at Palace, 1976.

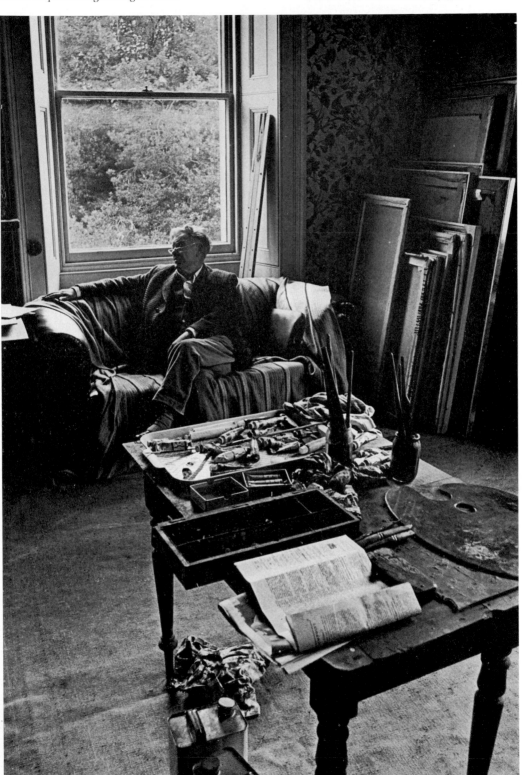

Embryonic. Plaster relief, 1972 (4ft × 3ft).
Exhibited at the Scottish Gallery of Modern Art, 1973.
Property of Mrs Hope Montagu Douglas Scott.

function, and the most economic use of their materials, but they could not understand 'art' (or art in the context in which the word is generally used). A hiatus existed between the Council's vision and its acceptance by the rank and file of manufacturers and industrialists. The word 'design' was a fly in the ointment. The greatest use made of the facilities available through the Council of Industrial Design was by light industries geared, in any case, to a more modern outlook than the old heavy industries which were becoming obsolete in Britain. Many of these firms came to the Central School in February to see the work of Albert Halliwell's Industrial Design students, so that by June, when they finished their three-year course, these students were all engaged. They were trained in such a way that they were immediately of value to any business, since they understood both the problems of industry and the problems of art. I saw these young designers as the spearhead infiltrating British industry with a wholly new outlook on design.

It seemed to me that the Council of Industrial Design was the perfect example of a good idea failing in its real aim through the double frustration of being financially tied to industry on one hand and suffering Government interference on the other. I felt, too, that the Council was unfortunate in its Director, Sir Gordon Russell. He was full of good intentions but I found his judgement of the designs which were submitted for the Council's approval was weak.

Sir Gordon Russell was ably supported by Paul Reilly, who, I felt, did a tremendous amount of hard work without sufficient acknowledgement or remuneration. Paul Reilly was a most sincere man, zealous in his endeavours to improve design throughout the country. He was always most helpful, encouraging both young or experienced designers. He was, I think, handicapped in his work by not being a designer himself. His knowledge came rather through environment (his father had been an eminent architect), than practical experience.

One morning, as I got off the bus at Holborn, my mind was filled with all sorts of ideas, hallucinations, intuitions; I idled by the pavement waiting for a chance to cross the street. Just missing a bus, I got safely to the other side, and as I entered the Central School, a name came into my head – Paul Reilly. I thought, 'Isn't that strange? What put Paul Reilly's name into my head?' Paul was a member of

my Governing Body but I could think of no reason why his name kept filtering in and out of my thoughts. Then an idea came into my head.

I rang up Paul to ask if he were free to lunch with me. When we met I said, 'There's going to be a meeting very soon to decide the new Director of the Council of Industrial Design when Gordon Russell leaves. I'll tell you what will happen. Robin Darwin will suggest that the Council comes within the orbit of the Royal College of Art and will propose himself as the new Director. Gordon Russell will agree with him. It will become a department of the Royal College and you will be doing all the work for him. You must see Russell at once. Tell him you'll resign if he makes it part of the Royal College of Art, and that you'll resign at once if Darwin becomes the new Director of the Council of Industrial Design. If you have a spark of courage, that's what you do.'

Gordon Russell was quite staggered as to how Paul knew about this scheme which had only been mooted in a private conversation between himself and Robin Darwin. Some weeks later Paul Reilly asked me to lunch at his club. Everything had occurred exactly as I had said it would, and Paul Reilly himself was offered the job. I said I thought this was a splendid idea, but Paul was a little curious as to how I *really* knew that this would happen?

While I sat at my desk in Lethaby's office at the Central School, furnished with chairs which he had designed, and hung with his watercolours, I used to doodle on my blotting pad. Exercises in proportion, variations in line, pattern or space whilst listening to parents, to my staff, to the School cleaners, to the caterers, to prospective employers of my students, little exercises to keep myself an artist and preserve myself from becoming an administrative clot. Every day they were swept away into my wastepaper basket like the Indian sweeps away his sand painting when he moves on. Each day I played with opposing motifs – a pen, a piece of string, coins, a rubber – material objects attracted to each other to make a new unity, motifs in search of a single whole. While I discussed the plans for a new extension to the School with the architects from County Hall, I played a private game of Dada on my desk – emptying the contents from my pocket on to the blotting pad, I gradually simpli-

fied the design made by my heap of insignificant trifles. Away went my keys, away went the bus tickets, the pencils, the paper clips, the small change, until only one article remained to dominate my clean white blotting pad. The less is more. Thirteen years of games like this kept my sensitive judgement active, and my desk was my private studio/workshop. Marcel Duchamp made great extensions to the accepted mediums of art. New objects, new materials, became master-pieces in the hands of a great genius. He gave them a new intensity, a different realism, a fresh significance, he opened up an awareness of vast new possibilities. As a student in the twenties, I had been deeply impressed by his anti-art philosophy, a sympathy which I have never really discarded. While I have always been obsessed by the actual tactile qualities of paint, I have never been without a collection of *objets trouvès* – old iron farm implements, skulls, cork, metal chains, convoluted tree roots, tin cans made iridescent by the bon-fire – toys to play with to form compositions, to awaken fresh visual sensibilities.

Crises occurred. The School's boiler was very old, and I used to see the needle on the pressure gauge rising high above the danger level with the nervous certainty that soon the whole ramshackle contriv-ance would explode. This object was tended by an old man from Argyll who had spent his life sailing the Seven Seas in decrepit merchant vessels. During this long servitude he had developed an excessive fondness for Highland whisky. He was assisted by a hand-some young negro from Jamaica. I used to watch the young man heaving coke into the old boiler, and I saw the hatred in the eyes of the Scotsman.

'Murder! There's murder in the basement!' someone shouted. My athletic secretary dashed down to the boiler-room. The Jamaican had revolted against the continual jibes of the old man, there had been a fight and when my secretary reached them, the negro was about to stuff his enemy into the boiler's red heart.

Distinguished people came on occasion to lecture in the School. Sometimes these lectures were a great success as when Osbert Lancaster came to talk to the students, who delighted in his great knowledge and in his wit.

Another successful occasion was when the composer Thomas von

Hartmann came to give a talk on music in relation to art, which he illustrated by giving a recital of his own work. The students thronged to hear von Hartmann. They had heard that he was a great friend of Sonia Delauny, of Wassily and Madame Kandinsky, of Paul Klee, and that he was a contemporary of Schönberg and a contributor to the Blaue Reiter. He had escaped from Russia to work in Berlin where he had known all the avant-garde painters and musicians of the twenties, and he had later moved to Paris with the Kandinskys. On the occasion of his recital at the Central School, von Hartmann was passing through London on the way to New York where he had been commissioned to write a ballet.

On only one occasion that I remember was I ever persuaded to give a serious talk in our lecture hall, and that was when Henri Matisse died in France. A group of students came to my office to ask whether I would not make a speech about Matisse and talk about the great days of the School of Paris when I was a student there in the twenties. I protested that students do not care for speeches, but they press-ganged me into the lecture hall where the whole School was sitting waiting. Normally at Diploma days and other functions my short introductory words, barely lasting two minutes, were grate-fully received for their brevity.

Dan Arbeid looked into my room. He was the technical assistant in the Pottery Department. Dan had had very little education but he had a gift for pottery and he was an excellent technician. He had decided to get married, and asked for an interview to inform me of this very important matter. I wished him every happiness in his marriage, hoping it would be very successful.

'Yes,' says Dan, 'that's not the point. As a technical assistant I only earn so much. I have to work very hard cleaning up the floors, clear-ing away broken pots, filling the kilns and firing them, and mixing the clay . . . I feel I'm as good as anybody else that's doing pottery.'

'Mr Arbeid, that's a very important announcement, are you in a position to make judgements like this?'

'Judgements or not, I'll have to be appointed to be a lecturer to teach pottery because I won't be able to keep my wife on the money I'm getting now, so if I'm to stay here I must be promoted to have enough money to keep my wife.'

'Where are you living now?'

Dan says, 'At the Abbey, New Barnet, where Alan Davie used to live.'

'Would you mind very much if I came to see the environment you're living in with your new wife? You know, you can't just come into my office and demand to be promoted from being a technical assistant. No doubt you have notions that before long you should become Head of the Pottery Department?' Dan said he thought that was possible. Next Sunday I went to see his studio and his attractive new wife. Dan made very good pots and he held exhibitions at which he sold them to many great museums throughout the world; he was an artist among my potters.

Dan was an amusing, attractive character with whom the students enjoyed working, so he was a great success as a teacher. There were other interesting potters in this department which was headed by Dora Billington. Ian Auld, Gordon Baldwin, Nicholas Vergette, William Newland, Kenneth Clark, all doing very individual work. And Dan Arbeid did eventually become head of the Department.

The decoration of pottery and porcelain lends itself to a free style of drawing, doodling or graffiti, which means that the standard of drawing in the Pottery Department should be extremely high. Making pots is a fascinating mixture between achieving perfect form and sensitive embellishment. A difficult art. Fine potters such as Staite Murray and Michael Cardew had been trained at the Central, but now the problem was to bring a new feeling to a fine traditional background of skill. Ian Auld made magnificent sculptured shapes, while Gordon Baldwin had a more romantic approach. The young Marquis of Queensberry studied under Gilbert Harding-Green, then turned his attention to designing for the industry in Staffordshire.

A problem of injustice arose in regard to the salaries which the London County Council paid to its women staff. Dora Billington, Jeanetta Cochrane and Dora Batty, whose skills were equal to, or superior to, any male specialist teacher of whom I could think, were yet paid on a lower rate than other Heads of Departments or Schools. They were second-rate citizens. I found this anomaly both annoying and unfair, so I waged a long drawn out battle to have this matter rectified. My Chairman, Mr R. McKinnon Wood (who

was also Chairman of the London County Council), became irate at my insistence. 'Johnstone, are you for your employer, the London County Council, or are you for the unions?'

'No, Mr Chairman, I'm for education at its very best.' My staff were then paid for the work which they did, not in terms of sexual discrimination.

There had never been much sympathy between myself and Her Majesty's Art Inspectors from the Ministry of Education. I found their systems of examinations tiresome and irrelevant, particularly for the students at the Central School who were, to a great extent, post-graduate students who planned either to be designers in industry or to be self-employed craftsmen. They did not want to become art teachers. I found that in Lethaby's time the Central had given its own Diploma, which was based on the student's whole work during the time he had attended the School. This had fallen into abeyance, so I notified the London County Council and the Ministry of Education that I was re-establishing this Diploma. I pointed out that my students were earning twice as much (in some cases very much more), as a university graduate with an Honours degree; that they were all at liberty to take the Ministry's teaching examination as well as the Central School's Diploma. The assessors for this Diploma were all men and women of outstanding eminence in their professions, people like John Gielgud, Oliver Messel or Roger Furse for the theatre; Robin Day or Ernest Race for furniture; Lucienne Day for fabrics; Hans Schleger for printing. The Ministry could do nothing about it. The Royal College of Art had its own Diploma, too – the A.R.C.A. So, with the Slade, the three most important art schools were outside the Ministry's examination system.

Robin Darwin, who had by now exalted his lecturers to the state of being professors, persuaded the Ministry of Education to elevate the Diploma of the Royal College to the status of a degree. This was a master stroke. With the support of the Ministry it established the supremacy of the degree of the Royal College over all other diplomas or degrees throughout the country, with the exception of Scotland. In their anxiety to establish this new degree at the College, the Ministry forgot that by making the College autonomous they deprived themselves of any power in its affairs, while still contributing very large

grants for its upkeep. The Ministry felt that if they let all Principals have control of their own examinations their own inspectors would have no control at all, and it was only through these examinations that the Ministry could keep any supervisory power over the Principals, teachers and students in the art schools throughout the country.

About every ten years there is a great agitation about the reorganization of art education in this country. A committee was set up by the Ministry of Education to 'examine the examination system for art'. I was asked to sit on this committee, and beside me sat Ernest Race, the furniture designer. Ernest Race was a practical man and after our second meeting on this committee he told me that he could make neither head nor tail of it. What did I think?

'I'm in the same position as you, Race, this is all a kind of planned art master programme. It'll take about a couple of years before we'll get anything resolved. There's the Ministry's Inspectors, and the Principals from all these art schools. These men are all used to calling the roll in the morning, doing this curriculum business week in and week out, so many hours for this and so many for that, with discussions as to whether rubbers should be at the end of the pencils or whether there should be no rubbers at all.'

Eventually a report had to be drafted and, as a result, some modifications were made in the examination system, many ideas being lifted bodily from the curriculum of the Central School. When someone walks on a cow-pat on the byre floor their feet take some of it out here, or through there; someone else's feet take it another way so the whole cow-pat is spread around. There was wonderful red tape and humbug, any original ideas were strangled and you could no longer find where the cow-pat had been dropped.

All this ineffective activity led to the formation of another committee under the chairmanship of William Coldstream. The composition of this committee (to which I was not invited) caused a certain amount of amusement. From my own experience, I was not impressed by Coldstream's teaching. On the committee were: John Summerson, an architect who had a happy sinecure at the Soane Museum in Lincoln's Inn Fields but (so far as I knew), had never worked as an architect – he had never laid an egg in his life – the

bird was without fertility; Eduardo Paolozzi who, as an artist, was of value through his immediate contribution to the students, but who had no real knowledge of the basic needs of art education. Victor Pasmore, whose knowledge of education sprang from half-assimilated and never wholly understood discussions with Albert Halliwell and myself at Camberwell, who had no clue about any organization necessary to supply the needs of several thousand art students throughout the country; and, of course, Robin Darwin. The Headmasters and Principals of some of the provincial art colleges who also sat on this committee at least were serious, practical men, and even if their views were considered old-fashioned, they had a fundamental sincerity.

The committee sat for about two years without coming to any decision until someone in the Government became restless. Further discussions culminated in the Coldstream Report which, in my view, was destined for the biggest muddle that had ever been known in art education. The previous committee might have been stupid, and others even more stupid right back to Victorian times, but the one under Coldstream was the worst of all. There was a great to-do. Certain courses only were to be recognized on a graduate status; for a year all art schools were subjected to inspections and re-inspections, rather like testing for brucellosis. In the autumn when students with grants from their local education authorities came to London to complete their training, they found there were no places for them. The Coldstream Report had made a complete bottleneck by withholding recognition from so many courses in London that these students were denied the advanced education to which they were entitled. It was as if you had a sheep truck for fifty lambs, when five thousand lambs had to be transported from the sale. It was felt that art students lacked sufficient cultural background, that their knowledge of history, English literature or geography had not been well enough taught in their primary or secondary schools. Therefore a great amount of time was to be taken up in the art school curriculum to remedy this defect, thereby depriving the students of much needed time to study the subject of their choice. Staff had hastily to be drafted in to teach these extra subjects. Then it was considered undignified for a Head of a Depart-

ment to actually *teach* – he delegated such a menial task to his subordinates. Secretaries and typists were hired to take down his slightest memo, committees were to be formed to help him change his mind, forms in quadruplicate proliferated on all sorts of different coloured paper, expenses soared. If it had not had such a seriously adverse effect upon the students, the Coldstream Report had a wildly comic side – it was a scenario for a Laurel and Hardy film. No wonder that the art students during the sixties rose in revolt!

Art is a serious subject, taking a very long time of hard study. The Coldstream Report made it almost impossible for any young student in this country, studying at an art school run by the Ministry of Education, to become an artist. Luckily, before the Coldstream Report had been fully implemented, I had resigned from the Central School. A year or two previously R. R. Tomlinson had reached his retiring age and he asked me if I would want to take on his job, but I refused. For the same salary I would have three times as much work running round all the schools in London, with less holidays. I knew that I should miss R.R.T. very much – we had had a long and successful partnership and he had helped to make London art education the most advanced in Europe. I wished him great enjoyment in his retirement during which he intended to begin a new career as a portrait painter. I thought perhaps it was time I, too, retired. Ten years is as long as anyone can make a really constructive contribution to a demanding job and I had then been at the Central for that time.

All my fears about Darwin's appointment to the Royal College of Art had been justified. There had been a lot of blow-hard but no real progress at the Royal College except in the School of Fashion Design. The London County Council now had a weak, ineffective Chief Art Inspector who allowed the Ministry of Education to build up great pressure against the Central School of Arts and Crafts. I found it harder to get good staff, partly because the commercial art galleries were giving more opportunities to young artists, but mainly because the Ministry was enabling very much higher salaries to be paid by the College. I could see how Darwin's tentacles were spreading throughout the country by means of the new art examinations of the Ministry of Education. Robin Darwin and I were the very

antithesis of each other. I disliked the professional élitist movement away from skilled craftsmanship towards 'designing' or 'directing' which savoured too much of the 'Don't soil your hands, Wilfred' school of thought. I saw the artist/craftsman/designer, not as a professor of aesthetics, but as a worker in the arts, someone who enjoyed making beautiful objects with the greatest possible skill. I knew, too, that I could not function in any creative way under the shadow of the Coldstream Report.

The London County Council had left me extraordinarily free to run both Camberwell and the Central in whatever way I had felt best in the interests of the students. To be smothered in cat's cradles of red tape, to be engulfed by ever growing mountains of paper, to be swamped by endless committee meetings would make my work intolerable. As it was, too much of my time had to be spent with architects studying plans and estimates for a large extension to the School. I missed my daily visits to each department, to each studio. I missed talking to the staff and students – perhaps sitting on the stairs with a student to discuss a problem in drawing, or proportion, or line, or colour. Tethered to my office I missed the glorious smell of wood in the furniture workshops where Arthur Sims or Christopher Whaite would show me a beautiful piece of dovetailing or a fine veneer; the smell of leather in the bookbinding workshop where George Fruin had such a vast knowledge of paper and where Sidney Cockerell bemoaned the fact that only old women were interested in the craft of bookbinding, never the attractive young ones; the marvellous colours of stained glass or the excitement of watching John Watson, R. T. Cowern, Anthony Gross or Merlin Evans pulling a fine print from the lithographic or etching presses.

I went down to County Hall to offer my resignation to Sir Isaac Hayward. We entertained a mutual respect for each other. On many occasions he had asked me to go to County Hall to decide on some presentation piece which was to be given to a distinguished foreign visitor. He said, 'Johnstone doesn't shilly-shally. He'll tell us at once which is the best piece of silver.' Once he said that, as he was getting on in years, he would like to have left something as a memorial with which his name would be associated.

I said, 'The County Council has no art gallery, Sir Isaac, for Lon-

don. Would it be possible for the Council to build one and name it for you?'

'It's a thought,' he said.

When I offered my resignation he was not pleased, pointing out that I was leaving the Service before I was due to retire. I told him that my medical report was not too good, that I wanted to spend more time painting, that I wanted to live in Scotland on my farm. He paid me a great compliment in saying that I had changed the whole of art education under the London County Council, throughout the country as a whole, and even beyond. Sir Isaac informed me that he had never asked anyone who sent in their resignation to reconsider it, and he was not going to now, but he was sorry I was leaving. It was my decision.

16

Colorado

In New York, in 1948, I had been told that I must add Colorado Springs Fine Art Center to my itinerary as, in addition to a thriving art school, they had a fine collection of modern art (including a magnificent Brancusi), with a unique collection of New Mexican paintings and sculpture, all housed in a most attractively designed modern Arts Center. So I did manage to stop off for a day and a night, staying in a splendid Wild West hotel. Indians strolled down the streets, while high-heeled cowboys strutted into the hardware stores to collect their weekly supplies. This was the real thing!

At the Fine Arts Center I was delighted to meet Jacques Charlot who was in charge of drawing and painting in the Art School. I had not seen him since our student days when he had earned a reputation in Paris as a very fine painter. In 1949 he decided to have a change from the high mountains and teach in Honolulu so he suggested to Mitchell Wilder, the Director, that he invite me to Colorado Springs to direct the Summer School, assuring him that I belonged to the School of Paris and was not to be associated with the art of either England or Scotland. The London County Council were quite sympathetic about such an undertaking, but it was pointed out with some severity that the Education Authority must be approached in due and proper form. I asked for a fortnight's leave of absence from the Central School at the end of the summer term to allow me to reach Colorado in time for their Summer School, and to this Sir Graham Savage grudgingly agreed.

Before leaving London I received another cable from Mitch Wilder

informing me that I was to speak on the opening panel of the Goethe Bicentenary Celebrations as Aspen, Colorado; did I know anything about him? I did not, so I bought a copy of *Conversations with Eckerman* to study on the boat. Between sleeping off my year's work at the Central and reading Goethe, my wife complained that we had a very dull crossing. We reached New York with £10 (£5 each being the maximum sterling allowance for travellers to America at that time), trusting that Mitch Wilder had sent an advance on my honorarium to meet us at the Astor Hotel in Times Square. Mr Christenbery, the president of the hotel, greeted us with the money, which enabled us to celebrate in style on the Astor Roof. Fat ladies and thin ladies, large perspiring New Yorkers and lanky countrymen visiting the Big City, Jewish shopkeepers and suburban housewives, all jostled and wriggled, while Xavier Cugat beat out his rumba rhythms, oozing sweat throughout this sweltering New York summer night. Waiters rushed hither and thither, colliding perilously with the dancers; enormous plates of food appeared and reappeared on trays held at precarious angles. Waiters shouted, their captains shouted, the floor managers shouted – and in the midst of this glorious noise and confusion we collapsed with giggles.

Mitch Wilder and his charming wife Betsy welcomed us to Colorado Springs. After a few days in which to settle my painting classes, Mitch announced that we were to go up into the mountains for the opening of the Goethe Bicentennial at Aspen. He told me something of the history of Aspen. Walter Paepcke was the boss of Container Corporation of America, an important packaging organization with its headquarters in Chicago. He was a most go-ahead, adventurous businessman with a penchant for advertising. Herbert Bayer, who had been an associate of Walter Gropius at the Bauhaus, was his typographical designer, and between them they put out advertising matter of exceptional quality. Walter Paepcke and his wife bought up the old silver mining town of Aspen – miner's cabins, saloons, the Jerome Hotel, the Wheeler Grand Opera House – complete with much of the Victorian furnishings left behind when the great silver boom collapsed. They began to turn it into a spectacular ski resort, but did not know what to do with it during the summer months. Both Walter and Poppy Paepcke believed in culture and to this end

they decided to devote the summer season at Aspen to a great cultural festival in honour of the Bicentennial of Goethe's death. Albert Schweitzer was to be the guest of honour and most important speaker and the Spanish philosopher, Ortega Y Gasset, was invited to take part as well as many other celebrities. The Minneapolis State Orchestra gave concerts and many important musicians played. It was a magnificent idea.

One day I was told, 'There's a gentleman been here, he's come across from Canyon City and he's keen to know if you're the William Johnstone who was in Paris. If you are, will you ring him at this number?' I rang and it was Max Berndt-Cohen. During the Depression Max found a niche for himself in Sarasota at the winter quarters of the Ringling Brothers Circus. John and Mabel Ringling loved paintings and had bought a large collection in Paris which they brought to Sarasota, building an art gallery for them and, later, founding an art school where you could both paint the circus animals from life and study the Old Masters at the same time. Ribald characters jeered at some of the paintings, denouncing them as fakes, which, it has since been discovered, was not entirely so. Max had written suggesting that Flora and I join him in Florida but by that time we had settled in London.

Max and I had a splendid reunion in Colorado. He was having a great success in organizing an art and drama centre in Canyon City, some fifty miles from Colorado Springs. We set out on an excursion into the mountains in Max's ancient car. As we climbed it became darker and darker until we stopped at a rickety little town called Idaho Springs. Here there was a most wonderful hotel. It had a balustrade along the front for tying up your horses, of which most of the spars were missing, and a verandah with fretwork trimmings to sit on out of the sun, with many of its boards broken away. A frowsy dame came out in a nightdress, barely covered by a tatty dressing gown, to see what we wanted. She said that she had one room with a double bed but she made it a rule that no two gentlemen should sleep in it at one time. She told us how much it cost, but we had never been used to paying high sums like this. 'Well, we let out the dining-room table; if you like to sleep on the dining-room table with your clothes on, I can reduce

it down.' Max, with his lameness, did not feel like the dining-room table.

When we went down next morning the first thing we found on the table was a huge cowboy lying without any blankets over him, dead to the world. He had forgotten to take off his boots and spurs so that his feet dangled over the edge of the table – a puppet without strings. The cowboy snored for all he was worth. Outside on the verandah an old man sat smoking his cigar in the sun. He remarked, 'Good-day, folks!'

'Good-day, a lovely day!'

'Yeah, the sun's shining.'

He looked up to the mountains with his cigar. Max remarked, 'There's gold up in them thar hills, bud.'

'Yeah, there sure is, but I cain' make it no more.'

We sat with him for a little while in the sun before moving off to the drugstore to get some breakfast. Max said, 'William, we've never been in such a beautiful hotel since the days we were in Tangier. If we had the money we should buy it and keep it intact otherwise it'll all be pulled down soon.' The woman said she still had guests, although the real men that came to look for gold had stopped coming. This old boy on the step was the only one that was left.

Culture was not lacking in the mountains. Every town of any size had its opera house where first-class touring companies and famous stars once performed. Surely the most bizarre occasion must have been when Oscar Wilde gave his lecture on 'The Meaning of Art' to the mining community of Leadville for which he received the highest fee of his American tour. One of the wealthiest of all the mining towns in Colorado Territory, Leadville was still actively engaged in mining carbonates when we visited the town. Here at 10,000 feet where one might expect sparkling, clear air fresh from the high peaks of the Rocky Mountain range, even higher mountains closed in on Leadville to suffocate one, while great storm clouds glowered overhead. A black dust from the mines eddied through the streets. It seemed a town of sullen, melancholy depression; a place of claustrophobic fears. Sour and gloomy were the Mexican miners, looking askance at strangers. I could well believe it when we were

told that no Federal agent had ever dared enter Leadville to enforce Prohibition.

Central City was a very different proposition from Leadville, although some of the violence of the old mining days still lingered; we stayed with friends whose gardener had recently been murdered for the sake of his monthly wage. A few years before our visit the University of Denver had taken over the Opera House, the beautiful Teller House Hotel had been refurbished and many of the old Victorian houses in the main street had been bought as holiday houses, complete with their pretty gingerbread fretwork trimmings. Central City was near enough to Denver to make an evening at the opera a feasible proposition during the summer, and while we were staying there we enjoyed a performance of *Madame Butterfly* produced by Carl Ebert. I also joined Ben Shahn on an art panel arranged by the University. The Opera House interior had been carefully restored to its former glory; each seat had been given in memory of a miner resident in the town and one noticed the predominance of Welsh names.

For an artist, those ghost towns in the mountains were an endless source of pleasure. Abandoned mine machinery made intriguing patterns against the skyline; and splendid Victorian sign-writing still survived over the store fronts, although ominous black gashes showed where fire had roared through the timber built streets. Shapes and forms made by the mine dumps, some in great clusters, some singly high up the mountainside told a tale of frustrated hopes or unbelievable wealth. Colours glowed in the sunshine – burnt sienna and light red, rose madder and yellow ochre. After the traumatic upheaval which made the Rocky Mountain ranges, these young rock formations were still settling down into surrealist images of impressive grandeur. As often as we were able we made trips into the mountains.

The following summer we returned to Colorado Springs. Jacques Charlot had decided to remain in Honolulu so there was a vacancy on the permanent staff, and Percy Hagerman asked me if I would like to stay on at the Fine Art Center. Colorado Springs was a beautiful place, in a most delightful countryside; a glorious climate, far more money than the London County Council paid me, and

only about forty full-time students. Why did I hesitate? The Korean war had just broken out, which gave a feeling of insecurity throughout America; my private life in London had nothing whatever to do with the County Council; I could only be sacked if I shot the Prime Minister or exposed myself indecently in Hyde Park. Colorado Springs Fine Art Center was a very different proposition, depending as it did on money subscribed by wealthy patrons. The headaches of fund-raising were not for me. I wondered too what would happen to a middle-aged professor and his family in the Wild West if he ceased to find favour with the Silver and Copper Queens of the city's social set. I decided to remain at the Central School of Arts and Crafts.

That summer (1950) I had agreed to give two public lectures at the Arts Center. My first one I had given before seats of learning. Remembering Ezra Pound's dictum that a postcard is quite sufficient to contain the ideas of one man's lifetime, I had crammed everything into this lecture. Over the years it had received several polishings so that I was quite proud of it. The lecture hall was absolutely packed with students and members of the general public. When I finished I was surrounded with questioners. Mitch Wilder came up to me in a hurry to say that an elderly gentleman wanted to talk to me, and was waiting outside. Would I leave these students as this gentleman was not accustomed to waiting? The gentleman congratulated me on my lecture, saying, 'I guess that, along with Eisenhower and Jacqes Barzun, you'll be one of the three greatest Americans today.' I could not contradict this. He said that he hoped we would see a great deal of each other because this had been one of the most unique experiences in his life. Mr Willard Vinton King had begun his career as a practically penniless young boy opening the carriage doors for the ladies outside the Chase Bank in New York. He opened them so beautifully, was so tiny and so polite, that he became a great pet, and eventually he rose to be a Vice-President of the Chase Manhattan Bank, a director of United Artists and a director of Standard Oil. Mr King, his daughter Polly, and his son-in-law Jan Rhutenberg were very kind to my wife and me. Rhutenberg was an excellent architect with a thriving business designing most interesting modern houses. He (with the help of his father-in-law) had been instrumen-

tal in getting Mies van der Rohe established in America. I remembered that some years before Anton Walbrook (the actor) had called to see me at the Central to ask whether I could help the daughter of a friend of his; she was a talented young painter who had been studying with Nolde in Germany. At the time I could do nothing to help, but it turned out that this young lady was Jan Rhutenberg's daughter. She eventually reached New York where she held exhibitions at the Betty Parsons Gallery.

Mr King, who had been a graduate at Columbia, was a close friend of Dwight Eisenhower. Eisenhower was coming out to Colorado and Mr King intended to discuss with him the founding of a chair of arts and crafts at Columbia University. Jan Rhutenberg had discovered that Gropius was receiving about $15,000 a year at Harvard, so his father-in-law was planning to offer me $500 more. Excited by this news we left Colorado Springs. The Fine Art Center had staged a one-man exhibition of my paintings that summer and had generously purchased a large painting; I had also been given a Fulbright Scholarship, and we could thus afford to stay in New York for a few days on our way home. Sadly Mr King changed his mind about Columbia. When Eisenhower went West he discussed running for President, so Mr King decided to help back him for the Presidency, rather than support a new chair of arts and crafts at Columbia for me. This time I was disappointed; I could not have resisted the exciting temptation to re-found the Central School in America.

We went to see Dr John Millet who lived at Sneydon's Landing where, on an earlier visit I had met John dos Passos and other congenial company. John's mother had been an Abbey and a great friend of John Singer Sargent, so several very fine Sargent portraits hung on the walls of his house. The Hudson River lapped at the foot of his garden while the air was sweet with the scent of lilies in which John's beautiful wife delighted. In these pleasant surroundings we posed our questions about whether to stay in America; if so, where should we live? John was delighted: at once he drove us to see a house belonging to Katherine Cornell, the actress. She had brought a fine old barn from New Hampshire and set it up on a wonderful site on the Pallisades overlooking the Hudson. Funds had run out so she would be glad to rent her beautiful (but half-finished) house.

Aaron Copeland lived nearby, as well as a covey of Columbia professors; we should certainly be in good company.

On my second trip to Colorado as Director of the Summer School, I met Max Berndt-Cohen in New York. He wanted to talk to me about one of his students who had won a Fulbright Scholarship. Max felt that this student was really worth while, the best one that he had ever taught, and he was keen that the greatest possible use should be made of his scholarship. Robert Sowers was a tall, handsome, intelligent young man with a sardonic sense of humour. He informed me that Max thought the best thing he could do was to study painting with me. I said, 'You can't, because I don't teach painting any more. My school is a craft school, a place where by studying a fine craft, you might become an artist. It makes no claim to being a painting school. Mr Sowers, I've been through many of the art colleges and universities in the United States where there are thousands and thousands of people trying to paint, thousands and thousands who should never have started. I'll tell you something – in the whole of the United States I did not find one stained glass artist. Don't you forget that M. Rouault, who many people consider to be a very great artist, started off as a stained-glass designer, and he became such a great painter that he never got his windows carried out. If that was the case with him, it might happen to you. Now, if you want to come to me, I'll give you a place in my college. You can paint as much as you like in your spare time, but you must study a craft so that you can earn money. I'm not going to be connected with unemployed artists – in England we're saturated with them. I suppose there's hardly anybody can burn glass to get the right kind of patina or the right kind of transparency or the right kind of opaque quality. You'd make an enormous success, you couldn't fail, because you'd be the only person who could make a modern stained glass in America. You would have plenty of money, plenty of architects looking for you; you'd be a very great man! If you are one of a hundred and fifty thousand painters from which the dealers cannot tell the good one from the bad ones, you would be in a serious predicament; you would have to clean windows to get enough money to eat, let alone paint.'

Robert did go to the Central School, but both he and his wife dis-

liked England so much that he made very little effort to use his Fulbright Scholarship to much advantage, and soon decided to sail home. On hearing this, I took them both to Canterbury, to Winchester, to Malmesbury, to see the glass at Fairford. I showed them sculpture, wall paintings and glass that changed their views about England entirely. They were fired with enthusiasm and, with the aid of a small part-time teaching job, coupled with living in my basement, they were able to stay on for another year's study. Robert and Terry worked very hard. They were away every weekend studying in cathedrals, libraries, churches, and in the holidays they went to the Continent. They buried themselves in the British Museum studying every early manuscript that could be found. Robert was a fine photographer so, with his photographs, his notes and his studies in the stained glass department at the Central, he was building up a great stack of reference material.

On his return home, Robert made a name for himself in America making splendid stained-glass windows for churches and synagogues His largest commission was the huge glass wall at Idlewild (now Kennedy), Airport, which must be the biggest commission ever given to a stained glass artist. In 1954 Lund Humphries published his first book on stained glass entitled *The Lost Art* (with an introduction by Herbert Read), which was followed by another book, *Stained Glass*, published in New York in 1965. He continued painting for his own pleasure.

Max came to see us off and when he saw me carrying a large black Stetson he shouted, 'For God's sake wear that cowboy hat, William.'

When I started to lift our luggage into the cab the driver said, 'No, no . . . I guess I can lift that. – Jus' don't touch it . . . don't touch it.' I stood by while he opened the door for us; I had never had such a polite cab driver in New York City. When we reached the Cunard quay I reached in my hip pocket for my wallet to pay the man.

'How much does that come to?'

He backed away saying, 'Nothing . . . it's just the greatest thing in the world to see a man from the West . . '

'What?' I reached again for my wallet.

'Fellow, forget it, just forget it. I just don't want nothing for my cab, I don't want no money – '

'But I must pay for the cab." I put my hand to my hip pocket again, but the man became more agitated.

'Don't take your gun out . . . take it easy . . . this isn't the West . . . just don't take it out. Look, don't get worried, everything will be all right. I promise all that luggage will be safe . . . we don't steal it, we won't take it away . . . there's nothing to worry about here in New York. I don't want no money, nothing. To see a man like you going to Europe . . . we're just glad to help.'

We strolled round the upper deck of the *Queen Elizabeth I*. As we passed James Stewart, the film star, and his family, Max began a serious conversation. 'You know, Senator, I guess you've got a plateful of worry on this journey to England. Those limeys sure can get round you up a back street if you don't look out. But, Senator, we can rely on you just doing the very best you can for America.' Everybody turned their heads to watch the Senator from the West. Max kept up his political discourse. 'Ever since we got rid of England, they've always been trying to get America down – you can never trust those limeys. Senator, you come from the West and, by God, you're not stupid guys there – but those English, you've got to watch them.' We continued in this vein until the boat eased away from new York, leaving Max on the quayside waving to the Senator from the West.

17

Green pastures

During my years in London we used to spend as many holidays as we could in the Borders, staying at Midlem, a small village near Selkirk, which commands magnificent views of the Cheviot Hills towards the south. The village postmistress looked after us and I was able to spend all summer painting, mostly watercolours or brush drawings of the surrounding countryside. One year we had come across an old, disused mill at Ancrum, on Ale Water. It was protected by a high sandstone cliff in which were several caves, part of a series of cave dwellings which also occur in the cliffs above Jedwater and the Teviot before all three rivers join the Tweed. This sandstone escarpment would be two hundred feet high, and you could almost read the history of the world in the various coloured rock strata which had been broken away as the river worked its course towards the sea. In my boyhood I remembered being told that a man who did odd jobs about the farms used to live there. In primitive times the site must have been ideal, as it was completely sheltered from north and east winds. One could imagine Neolithic families sitting out in front of their caves, basking in the sun. They could climb down the cliff from their safe eyrie to fish or cultivate the rich, alluvial ground on the opposite bank.

The field adjoining is called the Maltan field, so named after the Knights of Malta. It was once the site of a summer palace for the Bishops of Glasgow and to this day prehistoric flints, arrowheads and hammers, and medieval fragments are turned up by the plough.

We once found a splendid stone hammer bedded into the bottom of the old mill lade. The arms manufacturers of neolithic times must have had to carry their heavy wares a long way – it is forty miles or so to the nearest place where such stone can be quarried. This romantic environment seemed an ideal place in which to make a studio house and, fortunately, we were able to buy the derelict mill with its three acres for a very nominal sum from the Duke of Roxburghe. We converted it into a comfortable small house with a huge studio, and made a garden. We planted several thousand young spruce trees as this was the time when one was supposed to be able to make money selling Christmas trees. We cut down dead trees and brushwood on a small island in the river and joined it to the mainland by a rustic bridge to make a perfect Watteau scene. We were photographed by *House and Garden*.

Disaster came one wet summer when the river rose and rose and rose. Terrified we saw the water overflow the river bank and flood across our field towards the house. The river poured down the old disused mill lade past the studio door, the kitchen garden was awash and we were completely surrounded by water. We sandbagged the front door and watched as the waters crept nearer the house. Somebody waded through the flood to check the water level on a post which we had marked in the morning, and each time the level was higher. By lunchtime water was seeping in under the floorboards; nervously we discussed evacuation but by 3 p.m., it was falling. Next morning we could see the extent of the damage. The house was safe but the smell from the flood water under the floorboards stayed with us for many months and the kitchen garden was ruined for that year. Our pile of timber for winter burning was washed away and our little bridge had floated downstream, luckily held by a length of wire attached to a tree. In exchange the river left us a beautiful piece of driftwood, marvellously weathered by the water, more sensitively carved than almost any modern carving, which we named *Ale Water Venus*. We set to work to build a dam across the mill lade, helped by Patrick, an Irish farm worker. We spent days filling in this dam with stones and cement; my limbs ached with the labour. As we sat down with a bottle of beer apiece to recover I sighed, 'Patrick, by the long shears of Gordon, the high toor lan

umphan, the Twelve Holy Geese that picked the grass of Moses's grave...'

'And that I would myself, sir,' says Patrick.

Many years before, a young man, Jimmy Dagg, had taken a farm near us at Greenhead. It was his first venture into independence and he had very little money, so my father helped him cultivate his land during the first season until Jimmy could afford to buy his own horses and implements. Jimmy Dagg was a splendid farmer; he did so well at Temple Hall that he bought a large farm near Lauder.

It so happened that Jimmy Dagg's younger brother, George, had also become a successful farmer. He farmed near Ancrum and was kind enough to send his foreman to plough our rough and neglected acres. George came to see us, and he looked at the work we were doing. Every holiday we spent sawing down branches, building dykes, planting trees, digging the garden. He thought that the same amount of effort should be used to make money and said that if I would buy a farm he would look after it for me until I retired. I remembered what my father had told me before he died, 'You can never succeed no matter what kind of a Principal in a college you are, because it is not possible. You belong to the land and some day, no matter how you resent it, you will have to go back to that land; you will be compelled to do it.'

As the art committees proliferated, becoming more and more amateurish, extravagant and ridiculous, the more I felt I wanted to escape from the art education business before I reached an age when, instead of walking out of the Central School of Arts and Crafts, I would have to be carried out in a box. One day George rang me to say that he had found a farm for me. It was a neglected farm with the most splendid growth of thistles – where good thistles grow, other good crops will grow too. George Dagg quoted the old farming adage, 'one should live one's life as if one were to die tomorrow, but farm as if one were to live for a hundred years'. We put on nine hundred tons of lime.

Then I had a stroke of luck. Foot and mouth broke out in Northumberland which stopped a consignment of fine Aberdeen Angus bulls going north to the Perth Bull Sales. The restrictions were

only lifted in time for them to be sold at the second St Boswells sale when everybody had already bought the bulls they required. George Dagg bought one named Bardolph of Ashley Manor for £260; his half-brother had been sold to the Argentine for £26,000, but Bardolph was a half-inch short all round although his conformation was perfect. I took the train to Scotland to see him. Bardolph's mother was Princess Beatrice, his father was Prince Marcus of Hampton Lucy and his ancestry included the bluest blood in Aberdeenshire. He was beautiful. George Dagg bought some attractive blue/grey heifers for Bardolph and we were in business.

Satchells was a marginal farm of about 415 acres at an elevation of between 700 and 1,000 feet. It was a fifth-rate farm. It had a 74-acre field facing the sun, but this old pasture had been used as a tank-training area during the war; the grass had been badly cut up with great holes which had filled with water and now grew rushes instead of grass. Any field or house in the North which faces south has a special value. There was another large field of ninety acres which, at one time, had been open drained; the drains had filled in and that also grew rushes. Rushes are not a profitable crop. We learned that in the Hungry Forties, when unemployment was rife and after the Napoleonic wars, the Government had subsidized a big scheme of hill drainage. We used to come across the remains of that old drainage system, but, alas, the tiles used were far too narrow and were also laid too deep to be of very much practical help in draining our hill land.

Bardolph bred beautiful calves and our sheep stock improved both in quality and productivity. With lime and basic slag our hay crops increased enormously, and friends came from London to help build a new hay shed and a big cattle court. We planted shelter belts on the hill and built a new bungalow for our shepherd. We began (contrary to expert opinion) to plough up some of the old pasture, taking crops of oats and turnips off each field before re-sowing with permanent grass. Our turnips were enormous and our cattle thrived on the oat sheaves. The horns of a blackfaced sheep are the perfect lever to slacken fencing wire. We used to watch from the farmhouse as an elderly ewe walked down a fence deliberately testing the wires in between each stob to find a loose staple. One lever with her horns,

the wire was slackened and she was through to the next field where the grass is always greener. So we repaired our old fences and made new ones, mended dykes and built sheep-folds.

There are three kinds of farmer – the man who gets a good farm in first-class heart and condition, takes the guts out of it and moves on to another one, leaving the first one sucked dry; then there is the farmer who cannot make any profit because he is always improving the farm; in between there is the businessman farmer. He has a great understanding of his land so he neither treats his farm as something out of which to get the last penny, nor does he waste his time putting money into some scheme that is going to take years to show a profit. George Dagg was in this class, an extremely shrewd, practical farmer, but I was one of the second type – all our profits whether from farming, from painting, or from my salary were to be spent on making Satchells a highly productive, well-managed breeding farm.

Coming home from the Agricultural Show at Kelso with Nigel Walters, we gave a lift to an old shepherd, one of the best of his breed. Nigel learned that status is relative. We discussed the Show.

'Ah, if I may say so, sir, great stock at Greenhead when your father was alive, great stock, and the horses!'

'Well, Bob, what about me?'

'I wouldn't like to insult ye, sir, but ye ken, ye've come down. Ye haven't got the property.'

'This is pretty serious, Bob.'

'I have to be honest. Ye wouldn't like it if I said ye were fine when ye're not. Ye are down from your father, sir.'

'What about Satchells?'

'No, no . . . well, since ye've got Satchells . . . mind, your father would never have had Satchells . . . but it's aye a start, ye ken. Ye're coming up again.'

'Thank you very much, Bob.'

'It's no ill-meaning, sir.'

Our oats ripened late and sometimes had to be cut slightly green, although they dried as the stooks stood in rows in the field with the wind blowing through them. We let the ewe hoggs and some old draft ewes on to the stubble field. A day or two later a tremendous

snowstorm blew up suddenly. The wind blew from the east, driving the snow in drifts before it so that on the morning of November 22nd, we woke up to see nothing but deep snow. We went to look for the ewe hoggs in the stubble field and none were to be seen. The snow had drifted over the top of the dykes, covering the young sheep who had tried to shelter in the lea of the stone wall. Here they all were, piled on top of each other in three layers, their own warm breath having made an igloo in which they had survived the night. We made a track through the snow across two fields towards the steading and safety; then we began to dig out the sheep one by one. Each time we freed one to set her on the track for home she turned back again to rejoin her companions in the snowdrift. We cursed the sheep, we cursed the snow, we cursed the wind which blew more and more snow on to the dyke; we cursed with exasperation and venom. Only after several hours did we manage to dig out all our young sheep and lead them to safety near the house. One elderly ewe died.

In spite of our late harvests the stackyard was filled each year with neatly built round stacks. To build a stack which will successfully withstand wind and rain throughout the winter requires skill. The art is to keep the head of the sheaves high in the centre of the stack so that, when the stack is thatched with straw, the rain will run off. The higher you build, the harder it is to keep your balance on the steep, slippering incline, while at the same time being careful to see that the sides of the stack rise in a straight perpendicular without any unsightly bulges. This is all achieved with the help of gratuitous advice and much satirical comment from those on the ground who are forking the sheaves up to you. A good stacker can put in grain quite wet and it will dry out during the winter.

At Greenhead, if my father had more grain than we would need to feed the cattle through the winter, or if we were short of money, he arranged with Charles Trotter to come with his threshing mill. This was a great excitement. The night before we were going to thresh we would hear Charlie's steam engine pulling the threshing mill up the brae. In the dark you could see sparks flying from the funnel and faint light shining from the oil lamps as Charlie manoeuvred his engine into our narrow field entrance. In the morning all was

excitement and bustle. One man forked the sheaves down from the stacks, two women cut the bands, another man fed sheaves into the drum of the mill. Cloudsof chaff were blown out at the back of the machine on to a sacking sheet and it was my job to clear this away. All day I worked in a whirlwind of flying chaff, my eyes smarting from the sharp needles of cut straw, my legs prickling from thistles as I climbed over the heap of chaff to pull away straw bales which piled up at the back of the 'buncher', an additional machine attached to the rear of the threshing mill. Our throats became parched with dust, our limbs exhausted with the non-stop effort of keeping up with Charlie's machine, our heads befuddled with the continual noise of the engine and the machinery. We longed for my mother's good dinner. We used to thresh about eighty bags a day (in those days a bag weighed two hundred-weight), but our record was one hundred and thirty bags. My father took samples to the grain merchant at Galashiels to bargain over the price, and then one of my pleasantest jobs was to drive the cart into the town each week with a load of grain, which gave me the opportunity to sell my poached rabbits to the fishmonger in Bank Street.

We only once threshed at Satchells. This time the threshing mill was towed by a tractor, Charlie Trotter's steam engine having succumbed to the First World War. But the noise, the dust, the flying chaff, the laughter, the cursing, the beer, were all just as I remembered them. Trestle-tables were put out in a shed and my wife ladled out thick lentil soup, stew, steamed pudding and beer to all our helpers, followed in the evening by a substantial tea. We drank to the glory of the harvest and the fecundity of the earth.

At Satchells I was far away from art exhibitions, art teaching and art galleries. I was back to the basic material of the creative artist – life and death. As I walked across my own fields, watching the changing light over the great expanse of the Border country, listening for the violent winds and fearing the winter snows – the weather which can bring desolation and death – my mind was far away from an educational committee meeting or a union meeting regarding the Printers and Allied Trades. All that was gone and forgotten. In the struggle with the elements I had no time whatever to read the art criticism in the Sunday papers. I was back again in

my boyhood, rejuvenated. This was the biggest thing of all, irrespective of the profits or losses, this fact of really living again. I painted pictures to celebrate my freedom and to celebrate my feelings for the land.

After we had built the shepherd's bungalow we had to turn our attention to the farmhouse which was found to be riddled with woodworm. During the glorious summer of 1959 we camped out in one room while the inside of the house was gutted. By Christmas we had a new inside to our little farmhouse, pictures hung, wall-to-wall carpeting laid, a new oven cooking our turkey. The woodworm had seemed a disaster, but the planning of the new interior had been great fun. We had, as an American visitor reported, an old Scottish farmhouse outside, with an inside which seemed like Park Avenue.

My wife began wheeling barrow-loads of manure to make a garden. In the evening we walked over to the cattle court to feed our cows. There is nothing more peaceful than to sit on a bale of hay in the cowshed watching your cows at their evening meal. Each cow with her own character, some gentle, another aggressive and pushing, one shy, another obsessively maternal. A cow's whole personality seems to be conveyed by the movement of her ears. One cow, named Flossie, had long black fringes from her ears. She had a wild, uncertain nature stemming from her Galloway forbears, coupled with excessive motherly feelings. Her maternal devotion was aroused when each and every cow was near calving, and when she delivered her own strong calves, her jealous possessiveness knew no bounds. She would charge anyone who came within two fields of her calf and an enraged cow is far more dangerous than a bull; but even Flossie became more gentle with the years. Watching the cows' bellies swell, listening to their gentle, steady munching of hay and oats, smelling the satisfactory smells of straw, of hay, dung and cow, was one of the happiest times in the winter day.

On a small marginal farm such as Satchells it is a mistake to have too much machinery. You use it for only a few weeks in each year, and the rest of the time it depreciates, through idleness, in a most remarkable way. We did indeed have an old reaper and a baler of prehistoric vintage, by the name of Cleopatra, which let out blue smoke and caused the farm worker who operated her to emit colour-

ful language, but a reasonable tractor was essential and our tractor foundered beyond repair. The previous year my wife had taken a great notion to buy a painting by the Belgian artist, Constant Permeke. This was to be purchased from the Marlborough Fine Arts for the sum of £700, to be paid up by instalments; Mr Hans Fischer thought that it was not nearly enough to have one Permeke, that it would be just as easy to have three more Permeke's, on instalments. We had walked down the Burlington Arcade and up Bond Street three or four times before we could gather enough courage to buy this one beautiful painting. It was a magnificent picture by, perhaps, one of the greatest Belgian artists in modern times. Then the tractor collapsed and we sold the Permeke for £1,450 to buy a new one. My bank manager said, 'Wouldn't it have been very much better to have bought the other three Permekes and got rid of that farm?' This remark was greeted with profound silence. The Permeke today would be worth £40,000 (perhaps even more), so the bank manager, that deadly enemy of all who borrow money, was correct. So infatuated were we by the farming, that we refused to see the wood for the trees, and we wasted the potential capital appreciation on the Permeke to buy a second-hand tractor whose life would not be very long anyway because it had had a fair amount of usage before reaching us!

Long ago, as a boy, I had ploughed the whole of my father's forty-acre field by myself. With my pair of Clydesdale horses harnessed together at the correct distance, the big and little wheels of the plough adjusted, the coulter properly angled, holding both the reins and the plough handles, I cut the first furrow. I was alone with the sky, the land, my horses and the need to change the whole character of that field. The sharp coulter makes a line through the turf; the wing of the plough turns the furrow over to make form; the rows of furrows become a pattern; the field changes colour. As the horses move slowly across the field they and the plough are an extension of one's own being; we become one with the field.

A few years ago there was a fashion in art circles for taking photographs or making drawings of sections of ploughed land, of exploded earthworks, of man-made lines running across great stretches of open country. To a countryman who has been brought up in a

landscape of great stone dykes traversing the hills for mile upon mile, who hears the blast of the local quarry exploding regularly at five o'clock for the next day's work, who sees lines of electric cables cutting across his favourite view from his bedroom window (albeit the pylons are splendid examples of modern sculpture), who has himself planted acres of fir trees to make new patterns on his land, these manifestations must seem very old fashioned. He must consider them a great waste of money for no constructive purpose whatever. The only thing new about these ventures must appear to be the advertisement attached to them. They are, perforce, art-works of city-bred people.

Many artists nowadays do not look at nature for their motif. They are artists of the big cities, urban artists as opposed to earth artists. Being born and brought up in the country I have remained all my life a countryman, something of a peasant anarchist, and nature, in its widest sense, has always provided me with the motif for my painting. I have looked at the Border landscape for so long that I seem almost to have become part of it. There is the nature you look at, and the nature that you are yourself, and you are part of the same. To an artist, the value of nature is not the value of a photograph or the look of the trees and leaves, the hills or flowers; it is one's response to an inner vision. In a way I sometimes feel that the visual image passes through me almost without any conscious intervention on my part. The resulting painting does not have any apparent superficial representational image, it is a search for an extension in depth, for the movement beneath the surface. So Satchells was a marvellous place for me to paint, and I worked hard. My old friend McNeil Reid had retired from his gallery so (in 1960 and 1964), I held two exhibitions at the gallery in Cork Street owned by his son, Graham. Both exhibitions were (for me), financially and critically successful, and I felt that my work had taken great steps forward.

I also held two exhibitions in Newcastle at the Stone Gallery which was then a most progressive and adventurous gallery, and was invited to contribute to the large spring exhibitions held in Bradford. My patient bank manager was overjoyed. When an artist's work is shown publicly his whole life is laid bare. He cannot but be curious

as to the response it elicits from those who take the trouble to come and see his exhibition. Naturally enough, there will be only a very few from whom the artist can expect a complete sympathy and understanding of his work – the sensitive connoisseur with judgement is as rare as the good painter or sculptor. An intangible relationship, an empathy, exists between the viewer and the work of art which is akin to the creative process itself. Graham Reid told me that during one of my exhibitions in his gallery a man came in and sat for two hours in front of a large canvass, utterly involved in it.

At the Bear Lane Gallery in Oxford a young American post-graduate law student from New York became fascinated by a small painting of mine, very dark in colour, into which you felt you could move and become absorbed in the very paint. He came into the gallery every day for a month to study this little picture. It must have meant a great deal to him as in the end he bought it to take home to America. One year (I think it was in 1955), I had a painting included in the Leicester Gallery's annual show 'Artists of Fame and Promise'. A lady came into the gallery, went straight to one of my pictures, bought it and walked out, never stopping to look at anything else. I only knew her as 'the Lady from York' but I hope she has had many years of enjoyment from her purchase.

Artists have a compulsion to paint, they cannot help themselves. If, in so doing, they give pleasure, or enlarge the experience of someone who buys his work because he loves it (because he, too, cannot help himself), rather than because it is the fashionable thing to do, or because he thinks his purchase will be a fine investment, this indeed is a real satisfaction. The first-rate collector (or collector-dealer) participates in the artist's work in a constructive and imaginative way. Such a participation is, naturally, absent from committee buying. Artists, of course, have always been keen on money and many have been excellent businessmen. They are not interested at all in the garrets of romantic legend. As they consider that they have a greater appreciation of beautiful surroundings than anyone else they feel that they deserve to be in receipt of such moneys as might supply the necessary background to this fantasy. One cannot imagine Rembrandt enjoying being made a bankrupt and spending the rest of his life in poverty. Nor can we imagine such a businessman

as Picasso voluntarily sacrificing the obvious pleasures that money can buy. Frequently, from the point of view of the real development of the artist's work, he pays too high a price. He paints what his dealer tells him he can sell: '. . . too much yellow is unfashionable . . . Soulages is impossible to sell, no one wants black just now . . . you must remember that your contract was for light-toned colours. You are painting quite differently now than two years ago . . . it would be so much better if you were to go back to your pink skies . . . our lady clients were *so* enthusiastic . . . hot, glaring colours are only for the South American market . . . we would have to reconsider your contract . . .' To most dealers the artist is a much more marketable product when he is dead.

To me, one of the saddest aspects of modern art dealing which has developed since the last war is the growth of the vast art fairs held at such centres as Basle or Düsseldorf. It is true that much modern artwork specializes in demonstrative expression, regardless of any contemplative worth – the art of a painter such as Morandi, whose work is more of a spiritual act than a physical one, is not required at a fairground. Here all is showmanship. Artists are much cleverer than the old-fashioned conjuror, they can bring different coloured rabbits out of the hat instead of only white ones. Too many modern art practitioners are akin to the old-fashioned 'buskers' who used to enliven the gallery queues outside the West End theatres. Dealers foregather, fashions in art are set, world commodity prices are fixed, the dual international currency of art is discussed. The dealers could as well be bargaining over the price of piebald ponies as the tinkers do each July at their Fair on the Green at St Boswells. Travelling people for generations have come from all over Scotland and the North of England to exchange information and gossip, cement family ties, sell the odd pony or car. St Boswells has more to do with the business of being an artist than either Düsseldorf, Basle or Venice.

McNeil Reid suggested that I leave farming for a few days to accompany him on a trip to Paris. His son, Graham, had opened his new gallery in Cork Street, and McNeil was anxious to see how much support he would receive from the French dealers. We visited many well-known dealers to see magnificent paintings either in their galleries or in their private apartments. McNeil was treated

with the greatest respect by his French colleagues (he wore the rosette of the Legion of Honour in his buttonhole for his services to French art), who wholeheartedly regretted his retirement from Reid and Lefèvre. We went to see Louis Carré, and in his fine gallery we found M. Moltzau writing out a handsome cheque for some paintings by Jacques Villon. Laughingly, his wife told me that her husband had promised her a trip to Paris to buy clothes before the winter. They could not resist coming into Carré's gallery to see the Villon's, and they had spent all their time looking at paintings so that, tomorrow, she was returning to Norway without having bought any new clothes. She told me that her husband used to get into trouble with his father for spending all his money on pictures. Then, when shipping was in a bad way he had sold his collection for over a million pounds, enough to buy a much needed new ship. Then they had started on another collection.

That evening Carré sent his new Rolls to fetch us for dinner at his beautiful home at Rambouillet. We discussed the reasons for some artists being so successful while others, apparently equally talented, never become known, still less make any money out of their art. The great art dealer explained it thus: you have three men painting the same kind of art, the same kind of picture, whether it's landscape, portraiture, figure painting, abstracts or whatever. Along comes A and the dealer picks on him because he thinks this artist does something he can sell. He puts his money on this artist, gives him a contract, and promotes him. Then along comes B or C, both better painters than A, but both working in a similar métier. The dealer has already expended money on A and cannot afford to lose it, so he makes certain that nothing is done to help B or C succeed. I thought of how Peter Dawson complained about Zwemmer giving Henry Moore his exhibition while leaving out Peter whose idea it had been. But Zwemmer could not be bothered with two people in the very difficult market of modern art, so he went for Moore; whether he was right or not is beside the point.

One afternoon, McNeil brought Lawrence Lowry to tea at Satchells. About ten years previously he had asked me to look in at the gallery as he had some pictures that he would like me to see. McNeil had been in Bourlet's about some frames when he noticed a stack

of paintings. He asked whose they were and what was happening to them. Bourlet's man said they were to be returned to the artist who lived in some place in the Midlands. McNeil told him to send them round to the gallery as he thought there was something in them. Neither of his partners liked them but, if I would say what I thought, it would help the Gallery to decide about them. I went into Reid and Lefèvre to see these pictures. 'McNeil, you'd better take the lot and give the man a long contract. He's in the splendid English tradition of Rowlandson and Gillray. He's genuine.' So Lowry got a contract with Reid and Lefèvre in which he was to provide the gallery with industrial scenes from the Midlands, while McNeil agreed to look after his income tax forms, buy the painting materials that he needed, shop for gramophone records or any other similar items that Lowry wanted. The paintings which he made of the sea, the countryside or of single figures in isolation were not included in this contract.

Some years went by and Lowry's reputation slowly grew. At the Stone Gallery, Mike Marshall complained to me that he had received a somewhat uppish letter from Reid and Lefèvre (McNeil had retired by this time), when he had written to ask if he might exhibit some of Lowry's paintings in Newcastle. They had firmly refused permission. 'But, Mr Marshall, write direct to Lowry. Ask him if he would let you have some of his seascapes and farm scenes. There are lovely ones of country lanes and others of solitary figures in back alleys. Ask him if he'll let you have these. They're outside his contract with Reid and Lefèvre.' Lowry was delighted at the idea. He became very friendly with the Marshalls and, at that time, used to spend a part of each summer painting the sea at Sunderland. In 1976, the Royal Academy held their big retrospective of Lowry's work and I was amused to read certain 'Letters to The Times' in which it was suggested that several of the paintings shown were forgeries – paintings of the sea and the countryside. I am afraid that these critics either knew too little about Lowry's work or had not had the opportunity to read his original contract with the gallery!

At Satchells I had forgotten about being an 'art educationalist' (horrid words), so it was a pleasant surprise to receive an invitation from Lamar Dodd, of the University of Georgia, to become his

'artist-in-residence' for a year. Unfortunately I had to refuse what would have been a most interesting and delightful job, but the following year (1961), UNESCO asked me to make a report on art education in Israel. It's purpose was to indicate what re-organization was needed at the Bezaliel Art School in Jerusalem to bring it in line with modern art teaching, how it should be related to other training centres in the country, and how modern craft and design training could benefit the economy of Israel.

There was, I found, in Israel, considerable affection for the British. A lady, whose husband was a professor at the University and an acknowledged authority on the Cabala, took me to see King Herod's tomb. We looked over the barbed wire on to the Garden of Gethsemane. She assured me that we had met a thousand years ago and that in some future life we would again be together. The lady was charming. She had been a member of the Stern Gang during the War of Independence, and she told me that if ever Israel went to war again she hoped it would be with the British as they were so nice. She said that during the Disturbances you knew where you were. There was very little firing at breakfast-time, then a cease-fire to allow everybody to do their household shopping, another light burst of fire during the afternoon when all were resting, and some more in the evening after dinner. An occasional big blast would wake everyone out of bed, but such a bomb might or might not have been thrown by the British. My friend was of the opinion that this was an absolute dream world – war conducted on such highly civilized lines, with such proper behaviour. She noted, too, that the British soldiers were so handsome.

We had worked very hard for several weeks and it was thought that, before my wife flew back to Scotland to look after the farm, we should have a trip to Galilee. This was a wonderful excursion. On the road we passed an occasional camel, saw shepherds herding their flocks of sheep (black and white, with ears like Bedlington terriers), and watched Arab villagers using the old wooden plough to cultivate the thin topsoil of this upland region. Down in the Jordan valley, on the way to Tiberius, the soil was so rich that it yielded three crops a year. As we crossed this fertile valley great clouds drifted across the sky in wonderfully strange formations.

Two cloud bodies met and, as they collided, it seemed as if a tall figure grew up between them, ascending into heaven. This spiralling cloud figure, burnished by the winter sun, shone with a gold radiance above the banks of pink clouds.

Outside Tiberius we visited the Temple of Caperneum, the site of an old Jewish synagogue, a wonderfully peaceful place by the shore of the Sea of Galilee in the shadow of Mount Hermon. You could easily imagine a group of country folk come to listen to the great preacher, and receiving miraculous food to sustain them before their long walk home over the hills to their farms.

Before dark (in case the lights of our car attracted Syrian bullets), we drove round the Sea of Galilee to a kibbutz on the opposite shore. This was a wealthy community farming splendidly rich land. They had built a concert hall to seat 3,000 people, and everyone in the area downed tools when Isaac Stern came to play. Meanwhile, as the young men came in from the fields for their tea, we noticed that on every tractor was a rifle balanced behind the seat. As the light faded we enjoyed our supper: fish from the Sea of Galilee, and chips. Sadly my time in Irsael came to an end. M. Gauthereau, at first deeply suspicious of me as a Scottish artist (a Frenchman should have been the natural choice), now suggested that I mgiht like to remain in this lovely country and work with him in UNESCO. Why go back to the rain and snow of Scotland? My wife could stay there to see to the farm. Anna Ticho, a very fine artist of the older generation, offered me a delightful Arab house a few miles outside Jerusalem where I could paint. Instead I came home to write my report (Teddy Kolek had warned me that hundreds of reports were stacked away in the Prime Minister's Office where they remained unread), and to help in a cold, hard lambing at Satchells.

Lambing in good weather can be a joy. There is nothing more delightful than to watch a newborn Blackface lamb struggle up on its wobbly legs to make its way towards its mother's teats. The little tail wags with pleasure at the discovery of warm milk, while the ewe licks her offspring and the sun dries the lamb's soft, curly white wool. The lamb lifts up its small black head to survey the world and it makes an experimental prance to test the strength of its legs. You leave the pair together, the ewe, deeply content, the lamb with a gay

acceptance of the wonder of its world. Each birth renews one's own optimism. Too often the lambing season comes before the snows have melted. East winds blow from the Continent and driving, tempestuous rain dashes new-born lambs to the ground, grass fails to grow and the ewes have little milk.

Success in helping a ewe with a difficult birth, when she licks her lambs clean and sighs in relieved gratitude, is balanced by the tragedy of young lambs too weak to fight for life. Hopefully you bring the lamb into the house, rubbing it gently to start its circulation. You put it in the oven or lay it beside the radiator. Sometimes Lassie, our dear Border Collie, helped by licking it. You feed the lamb carefully with tiny sips of warm milk and brandy. You wait and hope. With good fortune the lamb lives and is re-united with its mother, but at other times the lamb has no heart for life. However often I have watched a lamb die, I can never accept its agonized cry of death; it sears the heart. The ewe knows that she is going to die. She regards your clumsy efforts to help her with contempt, and her eyes wound you into a humble acceptance of your incompetence. She dies with pride and resignation.

Death comes sometimes very suddenly to livestock. Ten minutes after you have looked at your herd and all seems well, a fine cow can be dead from tetany. It takes a most sensitive glance to see the slight shiver that moves the animal's hide before her magnesium content drops fatally, and she is dead. One morning, after opening the doors of the cattle court to let out the cows, we watched the young calves boxing and playing together. Bardolph's progeny were splendid, enabling us to increase the price of our calves each year against the general trend of lowering prices for stock. Our pride was in our biggest calf who was the most lovely grey colour, and we looked forward with great pleasure to the time when we would bring him forward at the autumn sales. In the sunny morning we watched as he chased another calf down the hill. Suddenly he rolled over, and was dead. Alas, one made mistakes which led to loss; we once fed wet oat sheaves to the cows to find one dead with colic the next morning. There is nothing more maddening than one's own stupidity.

Death comes slowly, too. One lambing my wife and daughter

were faced with a series of sick lambs who developed miserable sores on their feet and around their mouths so that they had difficulty in sucking. For several weeks they nursed these poor lambs, trying to discover what was wrong. No one in our district knew, no one had ever seen this disease before. Terrified that it might be foot-and-mouth, we took one up to the Veterinary College in Edinburgh where they told us it was a sickness called 'red-foot', endemic in certain areas of the Lammermuir Hills, and was fatal. We had introduced this disease by buying a tup (ram) from the Lammermuirs. All we could do was watch the pathetic end.

We learnt much from Robert Muir, our patient vet, who battled through the deepest snowdrifts at all hours of the day or night to rescue a calving cow or to lamb a ewe whose twins had become inextricably mixed up or who was carryng a single lamb with an impossibly enlarged head. He taught my wife and daughter how to look after calves with pneumonia or the dreaded white scour, how to dose cattle, how to deal with a ewe's prolapse, how to detect a calf that had a hole in its heart, how to pick up the signs of Johannes's disease. Meanwhile we talked about poetry or painting, or listened to his marvellous stories of the countryside. He became a great and valued friend.

Satchells Farm was in the district hunted by the Buccleuch Foxhounds. I had no real antagonism to foxhunting; in my boyhood I had enjoyed the friendship of George Summers, the Duke's huntsman, who was a splendid character. It so happened one afternoon that the cows were gathered outside the cattle court, waiting to be let in for their evening feed, when hounds ran by, followed by several riders who galloped through the pregnant cows. One horseman misjudged a gate, broke the spars and parted company with his horse. More important, one of my heifers started calving. Each year we had at least one field sown out in young grass. It was a wet farm, difficult to drain, so that if horses galloped over a young grass field their hoofs sunk into the soft ground right up over the pastern joint, nearly knee-deep in the yielding earth. The holes filled with water, rushes grew, all our trouble and expenses of ploughing and re-seeding went for nought. Furious, I withdrew my permission for the Hunt to ride over Satchells. While I did not wish anyone to

lose their sport, I was determined to make Satchells into a first-rate stock farm rather than a fifth-rate one. Bad manners on the hunting field were not going to interfere with my ambition.

During the following season we went into the Buccleuch Arms at St Boswells to have a chat and a drink with Donald Wares, the landlord, a large, shrewd man whose company I much enjoyed. He broached the subject of the Hunt. According to Donald, five of the Hunt servants had come into the bar recently, absolutely tired out, gasping for a double whisky and a pint of beer each. Donald had been sympathetic, enquiring how they came to be so tired after a day's hunting.

'Tired out, Christ', says one, 'my arse is so sore I canna' sit doon. D'ye ken where we've been? We had to get up at three o'clock this morning, it's five miles from Lilliesleaf to Hassendean and the Master said we'd have to patrol the whole of that road in case a fox crossed. Christ! Did ye ever hear such nonsense in your life? Mr Johnstone at Satchells said that if a fox crossed the road between Lilliesleaf and Hassendean he'd never let the Hunt on to Satchells again. I've been out there since four o'clock this morning, riding back and for'ard. My arse is so sore I canna' sit doon, but we'll be gieing oor notice in. He'll not try that on again.' Donald told me firmly that I might have fun with the Master and his followers, but *not* with the Hunt servants. So I bought them drinks when I next met them at the Buccleuch Arms and let the Hunt ride over Satchells again the next season.

Labour at Satchells was a problem. We needed a man with a knowledge of breeding cattle, of sheep, of ploughing, of fencing, an understanding of what is known in the advertisements as 'general farm work'. To find such diverse skills in one man was hardly possible, certainly not in a man whose wife would be willing to live on our somewhat bleak upland farm. Our first shepherd was a plausible rascal. Our next came from East Lothian, was kind, pleasant and lazy. He was dominated by his wife who was a first-rate countrywoman who could turn her hand to anything. She brashed thistles in our young woods and helped set up stooks in the harvest field when the water from the rain-soaked sheaves ran down our arms and our wet fingers froze in the biting wind. Under her supervision we loaded the tractor bogey with great skill so that enormous loads came in

safely from the harvest field with the shepherd's wife balanced on the top, waving the last sheaf triumphantly. Untiringly she forked up the sheaves to Willie while he built the stacks. In the house her voice was loud and piercing through caring for a deaf mother for many years. She expressed wonder at how much 'condescension' appeared on our windows and regretted when she could no longer help in the house because her 'haricot' veins were so bad. Willie was excellent at feeding pigs (perhaps all fat men who enjoy their food may be), but one morning our two little piglets escaped. It is inconceivable what a turn of speed a young pig has, what cunning strategy he can marshall in the cause of freedom. He can dash across a field, dive through your legs in the opposite direction, go to ground in a tiny space where you cannot possibly seize him – indeed, there is nothing of a pig that you *can* seize except his back leg. He has no wool to catch, no horns, no tail to speak of, a smooth body slippery with muscle. Furthermore, pigs are individualists, they do not run in packs, but each seeks freedom as a separate and distinct entity. Four grown adults spent the morning chasing two small piglets, the six of us looking exactly like a Giles cartoon, until we eventually trapped our quarry, one in a drain, the other entangled in a roll of wire netting. Willie's wife caught a back leg, deposited the piglet in the sty and collapsed with shrieks of laughter. Undefeated and always cheerful, she was a splendid descendant of generations of bondwomen from the Lothians. When they decided to return to their own countryside we were sorry to see them go.

Then there was the Pole, a hard-working man whose wife was known locally as Madame X. She was wildly extravagant, so lived on credit. Soon, when her creditors began to gather, the Pole moved on to another county. After him came Willie Hindmarsh, a little Northumbrian miner who knew about sheep. One summer his brother came to help with our hay. We were stacking the bales in the hay shed when a telegram came to say that his youngest child had been killed, run over by a travelling shop outside his house. Later in the week we took Willie and his wife back to Ashington for the funeral. The baby was laid out in its pram in the sitting-room, the little waxen head framed by the lace frills of a small pillow. We examined the bruise which had killed it, and neighbours called in to chat while

cups of strong tea were pressed upon us. The fire blazed in the small crowded parlour, and in the suffocating heat was the smell of decay. We fled.

Our next help was a splendid man who could plough so skilfully that one did not need to tile drain the hill and this was an enormous asset on our wet soil. He could also dig a post hole to within half an inch of the space required – you had only to drop in the new post and it fitted perfectly. The spring of 1963 was a serious time. Snow and ice remained for weeks, no grass grew for the sheep, the cattle could not be put out of the cattle courts and our stocks of hay were running down. The foxes were hungry. One of the great delights of the spring is to watch young lambs playing in the fields, racing and chasing each other along the hedge backs. This year no lambs played. 'Hell,' said Alex, 'the snow *must* come to an end.' But that winter it did not. Alex became so depressed that he gave up farm work altogether and we lost the best man we ever had. All our workers contributed something to the farm and from each one we learned a new and different skill.

Farmers are said to be the greatest grumblers. They have the weather continually against them; they have wastage – too many turnips one year, too few the next. They have death among their stock; fluctuating markets; declining profits; incompetent politicians. They are also incurable optimists. We bought an Ayrshire cow from a local dairy herd. She was not a young cow, and the great quantity of milk which she gave us seemed to be that flush which comes for a short period in a cow's later life, an Indian summer. She produced good calves until the time came when we had to send her to the abattoir for slaughter. Here it was discovered that she was riddled with tuberculosis. How she had passed the regular tests I do not know.

Officials from the Department of Agriculture descended on us in force. All our cattle were tested, re-tested and tested again, and the strain of waiting for the final results was almost intolerable. Bardolph was condemned, and so also were about a third of our fine cows, even some young calves. The day they were taken away I never left the house. At least with tuberculosis (unlike foot-and-mouth), you do not have the animals buried on the farm under a mound of

quicklime, never entirely to disappear from your consciousness – that must be very dreadful. Gloom and despondency settled on Satchells. In the years that followed we gradually built up our herd again. Another bull followed Bardolph, an ugly brute who, none the less, bred good strong calves, but never again would we achieve a bull of Bardolph's distinction or pedigree. New heifers came into the herd, but for us Satchells was never quite the same again.

We decided to sell Satchells and move to a bigger farm – from 400 acres to nearly 4,000 acres of hill land. We moved for that most fallacious of all reasons for undertaking a new venture – more money for less work. Potburn and Over Phaup were two fine sheep farms at the head of Ettrick Valley carrying a stock of South Country Cheviot sheep on their south facing slopes, with Blackface sheep on their north facing side. We would have two shepherds so that my wife and daughter would only have to help at the big handlings – lambing, cutting, clipping, dipping. As a boy at Greenhead I used to watch the changing colours as clouds and sunshine passed over the hills of Ettrick and Yarrow. I had read James Hogg's strangely surreal poem 'Kilmeny' and had painted with Tom Scott in Hogg's 'long valley'.

Ettrick Pen is one of the highest hills in the South of Scotland and has the same haunting quality as Glastonbury Tor or the Wrekin. It appears before you wherever you drive in that part of Selkirkshire or Dumfries-shire. When you climb to the top on a clear day you can see to the west across the Irish Sea. All around are mile upon mile of magnificent rolling hills, softly rounded fe-male hills burgeoning with primeval fecundity; a landscape of silence save for the occasional bleating of sheep or the high, clear whistle of their shepherd. Sometimes the valleys fill with mist and you are in a magic world that has defied time and place forever. It is as if you were at the beginning of the world: pure and new.

Potburn had two houses. The farmhouse, a substantial stone built house perched on a granite ledge, dominating the head of the valley almost like a romantic German schloss; at one thousand feet it was said to be the highest inhabited farmhouse in Scotland. Further up the valley was a small cottage, a 'butt-and-ben', for the shepherd and his family, but our shepherd had twelve children so

he lived in the farmhouse while we only used the cottage during the lambings and lived at Cossars Hill. James Hogg's brother had once herded at Potburn and lived in this cottage.

The history of hill farming is dominated by stories of great storms which form the background of legend. 1795 was a winter of disaster for the hill men of the South of Scotland. Hogg wrote that there was to be a gathering of the herds' Literary Society at his brother's cottage when each shepherd was to read an essay or a poem which they had written. They had ensured that their sheep were all right and then each shepherd walked the twenty miles or so over the hills with their dogs to spend a convivial evening at Potburn. They gave no heed to the weather. James Hogg himself was herding at Blackhouse in Yarrow. He walked over to Ettrick but, so he tells us, became suspicious that a storm was gathering in the hills. He visited his parents at Ettrick Hall; then, instead of continuing up the valley to Potburn, returned to Blackhouse to take care of his own sheep. The shepherds assembled in our little cottage never thought about a storm but spent a happy evening, literary and bucolic, until the early hours of the following morning when they started for home with their dogs. Then they discovered that snow had completely blocked the door and windows of the cottage and they were trapped. What of their flocks? That storm killed about two thirds of the sheep stock of the Border hills.

Some days later when the farmers had counted their losses and had fearfully taken toll of the damage, they began to consider that the nucleus of this great storm appeared to centre among the hills encircling the cottage of Potburn. They remembered the meeting of those shepherds for, doubtless, an unholy reason. Someone had seen a shaggy black dog whining outside the cottage door – an evil omen. They remembered stories of witches' covens and black magic, of evil spirits commanding the spheres. Not one of those shepherds dared show his face at a sale or a market for more than a year after that disastrous storm.

The few years we were at Potburn were years of hard winters and difficult lambings. The east wind blows directly up Ettrick in the spring bringing late snows and killing the grass. You can be blocked in for several weeks at a time which, provided you have stores of

food for yourself and hay for your sheep, is no great hardship. Lambing is, of course, the high peak of the shepherds' year. Officially we employed two shepherds, a father and his eldest son, but during the lambing our staff was augmented by the shepherd's wife (a tiny woman of great energy and enthusiasm), eleven younger children (no matter if the two youngest were merely toddlers, they could each hold a bottle for a motherless lamb), and my wife and daughter. One spring a snowstorm came late in the lambing, on May 3rd. We had shed in most of the ewes who were still to lamb and these were safely in lower enclosures, but there remained one large hirsel on which we expected ewes to lamb that night.

At 5 o'clock next morning when we were ready to go to the hill, we found a thick fog and a foot of snow. Nothing could be done until eleven o'clock when the fog lifted sufficiently to risk starting out to discover what catastrophes had befallen our ewes. In the fog the kind, familiar hills withdraw themselves into secrecy, even enmity, behind the subtle, treacherous movement of tenuous mists. You walk carefully, fearing bog, calling frequently to your companions, listening always to the sound of a hill burn which will lead you in safety back to the main valley if, in your circular meanderings you should find yourself on a different hill, or even a different farm. You walk in a primitive, apprehensive, surreal, world. Everyone was glad at the end of the morning when we gathered at the head of the valley to laugh at our fears and console ourselves that no great disaster had befallen our sheep. My wife came in last, from the wrong hill, bearing a fine newborn lamb whose twin had died in the snow and whose mother needed more help than she could give her.

The first count of lambs comes when they are gathered for cutting. Then you are faced with your first serious financial statement of the year and know exactly how many ewe lambs will have to be retained in the flock, how many there will be for a second or third draw, and how many wedder lambs there are for the sales in the autumn. In July our shepherds insisted on clipping all the sheep themselves with hand shears rather than hiring a contractor, so at 4 a.m. on a day that promised to be fair, sheep from several hirsels were gathered. We had no large shed in which to keep the sheep dry if rain came, so often we had to wait for several days for a favourable

chance. Then all was bustle, noise and confusion until the work settled to its own rhythm, catching, clipping, bisting (P for Potburn) gathering up the fleeces and rolling them. Beer helped, then dinner; later, tea. After tea further long hours of work until all the sheep gathered that morning were sheared and sent out to rejoin their lambs. We watched them making their way back to the top of their own hirsel for the night, showing up very white against the hillside without their wool, their lambs following them, worried, and still suspicious of the sudden change of shape, colour and smell of their mothers. The day's cacophony of bleating died away in the stillness as the twilight of a northern summer's night settled among the hills.

On Eskdalemuir there is a Tibetan monastery founded by exiled monks when China overran Tibet. Peaceable men, they walk the hills to meditate in what the herds call their 'dressing gowns'. Many people from the big cities find quietness and tranquillity here, away from the strains of their busy lives. Here is calm and meditation. On unfenced hills, the sheep flocks keep to their own hirsels if they are well herded. Each flock makes their way to the top of the hills in the evening and down again in the morning. They do not mingle with their neighbours. Occasionally one finds a stray sheep and the clipping is a good time to return such animals to their owner. One morning we took a wandering ewe across to a neighbouring farm in the Land-Rover. This farmer had very large sheep farms with several days' clipping to organize. When we reached the farm we found great activity in his yard. A large barrel of beer was standing in a corner, the shearers were working at great speed and all the monks from Eskdalemuir had been co-opted as reinforcements. They had rolled up their 'dressing gown' sleeves and were working with a will. I noticed a beautiful (and famous) London model rolling fleeces with the shepherds' wives. It was a Brueghel scene from before the Reformation when the monasteries controlled all the great sheep runs of Scotland and the North of England.

Summers in Ettrick were delightful. No luxurious scent from Grasse can compare with the scent of the flowers on the hills, the scent of heartsease and thyme. No flower is as elegant as the lovely Grass of Parnassus, a white perfection balancing on the finest of hair-thread stems. Bog cotton and orchids, sundews and the brilliant green

mosses that warn of the danger of bog, all give incomparable charm during the long summer's day. Sitting on the warm, aromatic grass listening to the constantly changing prattle of a burn murmuring its ageless secrets, watching the larks, tremulous in the high, clear sky. Hearkening to the tragic cry of the whaups as they circle over-head, lamenting forever their lost Eden; hearing the laughter of the herd's children playing in the river . . . too lazy to paint or draw, too lazy even to pan for gold as more enthusiastic (or more patient) men have done before at Potburn . . . a perfect hill day.

Our sheep stock improved with the introduction of better tups. We renewed march fences and planned to plant shelter belts, fenced large enclosures to give us greater control of the sheep during lambing and tupping, and we planned to build a bigger shepherd's house so that we could move into the farmhouse. But I became ill and my kind doctor in Selkirk who had once rescued me from a duodenal ulcer felt that this time it was impossible. If I were so stupid as to live twenty-eight miles from the nearest town at my age he could do nothing for me. If I wanted to survive I must sell, let, get rid of, this great farm at the end of nowhere, at once. So I sold Pot-burn, regretfully, to a forestry company who gashed the sides of the hills to make roads, ploughed them vertically so that the soil pours off the hills after rain or snow to flood the lower valley, and planted them with spruce trees which will end up as newsprint or toilet rolls. Forestry companies provide little local employment. I felt shame at causing the destruction of a great sheep farm, but my doc-tor was adamant – this time I was to retire and take life very easily indeed.

18

Mine eyes to the hills

When one is eighty, one speculates occasionally on the odd chances which have governed one's actions during that length of time and one is forced to the conclusion that very little success or failure is due to personal competence or ineptitude, but that the Goddess of Luck has been the dominant influence throughout those years. At the races you merely gamble with money, but with art you gamble with your life. Luck has been kind to me. I had the luck as a child to be born in the country so that my art has always belonged to the earth, not to the city, not to urbanization. I had the luck in the little town of Selkirk to work with a genuine painter connected with the French artists of the Barbizon School. Artists are like horses and must be bred from a good pedigree – no horse can win the Derby without a blood line from the great stallions of the past, so no artist has much chance of becoming really good unless he has good teachers who hand on to him his inheritance from the finest art of the past.

I had luck with my teachers, with William Ritchie and Tom Scott, with Henry Lintott in Edinburgh, with André L'Hôte in Paris. I had luck to work among talented students, young artists like Giacommetti, Leo Stein, Germaine Richier. I had the luck to meet many creative people at moments in my life when their influence was of great value to me, Julio Gonzales, Xavier Martinez, Frank Lloyd Wright, Alfred Orage. My farming training gave me an independence of mind and the tenacity to keep working at my art for seventy-odd years. I dodged the art dealers by teaching, but had the luck never to be compelled to do much full-time teaching. One has

somehow to survive intact as an artist between the battery-hen world of the dealers and the exhaustion caused by prolonged teaching.

I was lucky in that when I became the Principal of two large art colleges it just so happened that at that particular time I had a gift for something that was completely absent in England – the luck of Time and Place, in which you yourself hardly need to do a thing. The spirit of the time is unseen, it percolates through what you do like a little hill burn that cannot help itself running into the sea. I had the luck, too, in meeting throughout my career private patrons of the greatest sensitivity and devotion to art who were able to feel deeply what I was trying to express. In London I met Sam Winand and Sir Michael Culme-Seymour Bt; in Scotland, Hope Scott. Renoir reminds us that the emotionally perceptive collector is rarer even than the artist of quality.

During my life I have been a dodger, always attempting to achieve freedom in art, to escape from fixations, to evade conclusions, to leave options wide open. I disliked the thought of being trapped, in the sense of becoming subservient to the purposes or ideas of someone else. This freedom which is so loosely talked about does not really exist. What is freedom of expression? No matter how much freedom you imagine you have attained, you are still encompassed or enclosed in some way. One is confined by the tools one uses, by paint or plaster or nails or bits of string, by photographic techniques or the vagaries of the computer. Every method of working has its own discipline (non-discipline becomes sterile with devastating speed), from which there is no evasion; neither can you escape your own history or your own environment, whilst lack of technical knowledge and skill can be a most frustrating restriction. By breaking through all immediate limitations, one finds that one has built up a whole new set of cages but without rules there is nothing against which to rebel and rebellion is essential for the growth of any tradition in art as in any other form of life. French thinking tended to emphasize the danger of novelty for its own sake, teaching that by constriction you could achieve a clearer direction and a deeper intensity in your work – the freedom of limitation.

Looking back over my years of painting I remember the excite-

ment, as a young man, of the many experimental paintings which Flora and I worked on in Selkirk after our studies in Paris, most of which were either re-painted, destroyed or sawn up into more portable sizes. I had already begun to move away from neo-abstract paintings with an undercurrent of cubism into imaginative, surrealist paintings more true, perhaps, to my Celtic background. The surreal qualities in these paintings had been present in my work even before going to Paris. I have a painting, *Dawn*, done in Edinburgh while I was still a student, which foreshadowed much of the work which I did during the later twenties and thirties such as *Seed*, *Conception* and *Point in Time*. I wanted to associate line with both pattern and form. In these years I was less involved in landscape and was trying to express a feeling of continual change, the idea of death harbouring life, of all things being a continuum, evolving, self-renewing. Nothing is static or permanent and we were living through a period of great upheaval. Some people even thought there was an element of prophesy in these paintings.

I moved more and more towards a surrealist image in landscape, sometimes digressing into pure landscape painting, sometimes using landscape in a suggestive, imaginative way, but always seeking an extension of the medium itself. I tried to use paint in a way that would either do more for me, or that I could do more for it, or with it. I wished to eradicate any kind of dogma, either political or artistic, from my work, and to fall back simply on what paint would do itself. Paint, being a reality in itself should speak for itself, which took me back to what I had felt as a child when I had tried to paint my collie, that I should rely on the medium itself to express what I felt about painting. Unconsciously I allowed the paint to dictate to me so that I learned to accept every chance indication or suggestion that could be used or incorporated into my work. One does not change a way of working abruptly. There is indecision and much harking back to previous statements before one has the courage to go forward to a new position. There is a time of lay-about, of inner debate, of reluctance to paint at all, a time of doubt about art itself and its future.

Sometimes I had to compel myself to paint, to regard painting as something you *do* in the same way as a workman gets through

his job by simply working at it. At times this 'driven-on' painting turned out to be far better than if I waited for 'inspiration' – interest develops with the physical effort. Sometimes such a powerful response is generated that the act of painting becomes a frenzy. Art can be a deep and powerful magic; the first brush stroke acts on the bare canvas as on a magnetic field and an activity is set up, a secret force is released by that first movement. I work in a world of unknowing, a world of mysterious suggestion. Afterwards I can never explain what has happened to me, but I am certain that at one time I become something of an artist, while at other times I am no artist at all. At all times I revert to painting nature – not nature as something separate from myself in a visual sense, but nature which I am myself. At the same time as I may be painting a 'view', I may also be painting my guts. My range of vision has extended from the simplicity of outward nature to my inner spirit, my subconscious, which is nature in depth.

During the war I could not paint at all. It was not until 1943 when I stayed at Lockner Farm that I was able, after a four year interval, to begin again. The romantic landscapes which I painted then never really satisfied me. I felt that I was only painting a superficial view, that I was not making the landscape a part of me, I was not *doing* anything to it. It is true that those paintings were doing something for me in the way of a therapy after my year's illness, but I was not conscious that they were doing anything for me in the development or growth of my art. All the great landscapes ever painted have been by artists who *did* something *to* their view. When I returned to London in 1947 I became obsessed with a more classical or formal approach.

I have frequently criticized young artists for allowing themselves to become commercialized in ways in which their talents become atrophied or debased. However, Poussin, a great commercial artist, can be a perennial inspiration for any painter with surrealist leanings. In his big studios he had a vast army of assistants painting toenails and draperies, eyes and trees and dogs, marble slabs and Roman senators, cupids, pyramids, nude ladies and cornucopias flying about in space; all made up into a conglomeration of junk, intertwined in a happy *non-sequitur* of classical events. So I went back to Poussin,

to Uccello, to Titian, striving to reiterate the importance of perspective and the structural attributes of the cube, cone and cylinder. Picasso, when he needed some strut on which to hang an idea, or needed simply to be refreshed, did not copy any contemporary work; instead he used something from a great master of the past. He built up an enormous vocabulary, a whole encyclopaedia of bits and pieces, culled from earlier painters, to strengthen his own work. The trick is to make every Old Master work for you.

I have always been deeply interested in form in painting, probably because of my upbringing among the Border hills. You cannot paint these subtly contoured hills without attempting to understand their anatomy; their sensuous feminine curves cover sharp, elemental bones. There is always, for me, a sexual metaphor in these barren hills. As you drive over Carter Bar into Scotland you see before you a fecund landscape of great classical grandeur. Out of the flat plain erupts a succession of female shapes, sometimes elusive seen through a tenuous mist, at other times, in the early sunrise, insisting aggressively on the power of the womb. I tried to give a new life to the clichés of the circle, triangle, cube, cone, sphere and cylinder by using these ramshackle props in a fresh approach to the analytical study of this landscape. Eventually these austere statements gave way to a more exuberant approach, a turmoil of colour built up with large brush strokes to suggest the strength and anger of a mountain landscape, while still trying to show the underlying form. These paintings hark back a little to the rock formations in my early painting *Dawn*, as did a series of paintings known in the family as my 'Underwater paintings'. Without doubt painting has a lot to do with sex. My metamorphic earth odalisques certainly contained a submerged sexuality.

All through my life I have re-worked old ideas. It is like breathing, there is a forwards and a backwards, you take up ideas worked out or discarded years ago, and sometimes on a second or third try you add something to the original thought. The paintings which I copied as a child from Bibby's catalogue have come back to me all through my life.

Perspective, that sleight of hand by which you are invited to walk into a picture and become part of it, as Watteau insists that you

join his elegant picnickers within his canvas, had always intrigued me. I had used it in a modern way throughout my teaching and now I used a linear perspective in the very simplest way to convey distance, to express solids in space. One of those paintings is in the Toronto Art Gallery, another belongs to the Colorado Springs Fine Art Center. The one which, to me, seemed the most interesting was a picture based on Titian's classical theme of *Sacred and Profane Love*. This painting, which was an important statement for me, now belongs to Lord Astor of Hever. I remembered how, when I was a student, Henry Lintott used to point out all the varied techniques used by the great Italian master. Taking Titian's painting as a basis, using elements of the human figures, I took opposites and irrelevancies and brought them together into a new unity; using a form of surgery on a traditional composition, I gave it a fresh life in the idiom of my own time. Having begun my operation, the painting developed by itself, finding its own motif. Humpty-Dumpty had a great fall – can the artist put him together again?

Although I could never have become a successful manufacturer of board-room portraits, portraiture has always interested me. I would like to paint portraits in which my paint could release an invocation of the basic reality of my sitter as opposed to superficial 'realism'. Portraits which would seem to be suggestions evocative of unexplained qualities within the sitter; reality which is deeper than mere external perception. So I painted a portrait of Olga, Sam Winand's wife. Olga sat in our Chelsea basement with the half light filtering down from the streets on to her handsome, fine-boned head. She was the perfect model and my quickly painted portrait did contain something that was authentic, something of that truth for which I was searching. Many years later I painted a series of portraits of Hope Scott to be called *Portraits Emerging*. These paintings, although a great deal of careful drawing was used, were not meant as mere physical resemblances. Rather, I wanted to explore the essence of the spirit of the person concerned, to portray the inner quality of my sitter as opposed to an objective portrait. This subjective art has something in common with the subtleties of early primitive arts whereby symbolism retains the aura of the spirits to be represented.

During the years that I was Principal of Camberwell and the Central, my painting time was limited, which meant that I painted in short bursts at weekends and holidays. Often images would haunt my mind for weeks before I could use them, so that I was never able to develop an idea as fully as I wished in a sequence of paintings; two or three pictures had to suffice. The next time there was an opportunity to work, a different image demanded attention, so that during these years my work often varied between the austerely classical and the exuberantly romantic. I hoped that one day I would be able to pick up those notions again and work on them continuously as a proper, professional painter should, plucking the guts out of each motif until it becomes a boring routine. I never did.

Farming gave me the time I needed to paint when I wished. At Satchells (1957–65) I enjoyed the freedom to play with colour, nonsense pictures, gay pictures, joyful pictures. But pictures, too, like the *Ploughed Field* which symbolized for me the fertility of the earth in each changing season. I have always enjoyed painting on a big scale and in 1959 I painted two large canvases (54 inches by 96 inches), which became known as *Northern Gothic I* and *II*. One of these was predominantly black and white, expressing unconsciously the colours of the farmlands in Ale Water valley as snow withdraws its protective covering from the bare winter fields. The other was more expressive of the early northern light of spring. Both paintings took me a long time and were built up with many layers of paint which gave them a rich and complicated patina, in contrast to the more tachiste techniques which I had been using on other paintings. The *Northern Gothics* were, for me, an important stage in my painting development.

In spite of farming frustrations during the years at Potburn (1965–70), I painted a series of pictures which I called *Rain in Ettrick;* these grey, almost monochrome, paintings were, perhaps, the fruit of much personal depression. Why, after all, should I continue to paint? Why paint just to stack canvases in rows against the wall in a spare bedroom? Was it a silly pastime for an old man? Since both MacNeil Reid and his son Graham had retired from art dealing I had no London dealer, and Mike Marshall in Newcastle had turned from modern art to dealing in the Pre-Raphaelites. So probably no

one would ever see my paintings again. I decided that I would paint no more, but just enjoy the countryside and maybe learn to play draughts or whist to pass away the time. Bernat Klein told me firmly that this was nonsense and furthermore, he would bring his London dealer to see my paintings.

So Alwyn Davis arrived. I liked him but, as usual, was frightened of a contract. The Scottish Arts Council bought a large painting and an early picture of mine, which I had painted in 1927 at Selkirk, was included in an exhibition of 'Three Hundred Years of Scottish Painting' which Douglas Hall (Keeper of the Scottish National Gallery of Modern Art) had organized to tour Canada in 1968. When this picture returned from Canada it was bought by the National Gallery.

This renewed interest in my work was most cheering, and I rose like the proverbial trout to the fly, forgetting all about my resolution not to paint any more! Then in 1968, as I was convalescing from illness, two letters came within a few days of one another. The first was from a young man, Allan Harrison, who had bought several paintings of mine at exhibitions in Newcastle in 1961 and 1963. He was enthusiastic about art and had a considerable natural taste for quality in painting. He wrote to say that he was opening his own gallery and would be delighted if his first exhibition could be of my work. The second letter was from the Scottish Arts Council (under the Art Committee's chairmanship of Douglas Hall) to ask if I would agree to a retrospective exhibition to be held at their new gallery in Edinburgh. Allan Harrison planned his opening with great flair and expensive publicity. He saw that I appeared on television, that my name was plastered on the Newcastle hoardings; he produced a most expensive catalogue and organized an enormous dinner party to celebrate the opening of his new gallery.

My old friend Norah Graham, who had, so long ago, tried to launch me as a fashionable portrait painter and who had never lost her faith in me as a painter of distinction, announced that she was coming to Newcastle to see the exhibition; furthermore, she was bringing a friend with her. I wondered who Norah had press-ganged into accompanying her on the long train journey from Edinburgh, but arranged that the pictures should be seen under

peaceful conditions before the opening. The ladies arrived at the gallery and Norah's friend turned out to be Mrs Hope Montague Douglas Scott, who, when I was a young man, used to live at Carterhaugh, on the Duke of Buccleuch's estate of Bowhill. I remembered her pushing her bike up the steep slope of the West Port into Selkirk to collect her shopping at the end of the 1914–18 war when she was newly married. Norah used to say, shaking her head vehemently, 'I do believe, William, that Hope Scott is the only person in the whole of the Borders to have the slightest feeling for art,' and she sighed in exasperation. Hope, having travelled to Newcastle under pressure from Norah, fell in love with my paintings, and that October day changed everything that I could have expected in the last years of my life. She became not only a most generous patron but a talented student, the kindest of friends and a most wonderful companion. Her enthusiasm and sympathetic understanding rekindled my passionate zeal to work.

The Scottish Arts Council exhibition caused me some misgivings. The last exhibition of my work in Edinburgh had been in 1934 and had been a total disaster, so that very few people in Scotland had ever seen my work. I knew none of the Scottish art critics. The exhibition was beautifully hung in the Arts Council's Charlotte Square gallery and Douglas Hall had also arranged a supporting exhibition of drawings in another gallery. I looked forward with great pleasure to seeing my old friend Dr Äke Stavenow, who was coming from Sweden to open the exhibition, but I wondered nervously whether anyone at all would turn up for the private view. The day before the opening I had met the critics, and one, from the *Glasgow Herald*, told me that he had been most loath to come as he had assumed that the Arts Council had dug up the work of some elderly artist to try to get him enough sales so that his widow would be able to pay for his funeral expenses. Martin Baillie, a serious and constructive critic who is, himself, a painter of considerable integrity, found he was mistaken and wrote the first of many articles in most generous support of my work. The private view was crowded. As Christopher Grieve and I manoeuvred our way through the throng we passed a portrait of Francis George Scott, our old friend and mentor. 'God, William,' said Christopher, 'he's still watching us.

His eyes are following us all round this place. But what a teacher! We both owe him a lot.'

The exhibition went on tour and reached the Morley Gallery in South London. Douglas Hall had experienced great difficulty in finding a gallery in London willing to show it, as, although Scotland is flooded with exhibitions from London, it needs great persistence for a Scottish exhibition to be accepted in the South. The London critics ignored it.

Meanwhile we had left Ettrick Valley and settled ourselves in a new home near Jedburgh. Instead of the old Scottish farmhouse with ample outbuildings for which we were looking, we bought a handsome stone house of the 1880s in Glasgow Palladian style, built for a prosperous sausage manufacturer from the West. Every house has its innate character, and Palace, from the very first, has been a happy and congenial home, a place in which to work well. I began painting at once. The exhibition's last showing was to be at Glasgow, in the Kelvingrove Art Gallery. This was something of an honour, as the city seldom gives exhibition space to the work of any individual living artist (it is often forgotten that Glasgow's art collections rival those of any European city), and I looked forward to this event. Luck was against me; we enjoyed ourselves one afternoon at the Kelso races and the following day I became seriously ill with a virus infection which I had picked up in London. Martin Baillie was very nearly right when he presumed that the Arts Council was raising money for my funeral expenses! But I was determined to get to Glasgow where Hope Scott was to open the exhibition. Who could resist the thought of being driven through central Glasgow in a cavalcade of shiny black limousines to a splendid luncheon given by the City Corporation? Not I. I came home with pneumonia which took me all that first winter at Palace to shake off.

The Scottish Arts Council retrospective exhibition in 1970 succeeded in several ways. Firstly, I was accepted as a serious modern painter with long roots in Scotland, and the critics were generous in their praise. So often in London my work as a painter had seemed (in the eyes of the critics at any rate) to be overshadowed by my work as a teacher or administrator, but in Scotland I was only to be judged as a creative artist, not as an 'educationalist' at all. Secondly, young

people showed an interest in my work, and thirdly, my painting *Point in Time*, which had meant so much to me (1927–30), found a permanent home in the collection of the Scottish National Gallery of Modern Art, through the great generosity of Hope Scott. Fourthly, I had the distinction in this modern age of having my work 'preached agin' by a most serious minister at a little Border church.

Two years later, Douglas Hall arranged an exhibition of oil paintings and watercolours, executed since 1970, which was shown at Stirling University and several other galleries. At this time I became deeply interested in the properties of plaster, the rough variety which is used on internal walls of houses. In paintings made during the twenties I had incorporated areas of rough cement as a contrast to flat tempera and oil paint in some pictures, and the feeling for the naturalness of the very simplest materials had never left me. I had also, during many years, made collections of *objets trouvés*, usually weather-worn tree roots, calcined sheep skulls, old iron implements with marvellously coloured surface patina – great ditching spades of splendid heraldic shapes that were commonplace in my boyhood but which are now no longer used (indeed hardly any man can now lift them) – and these I planned to incorporate in some formal way. I became so interested in my plaster bases that I left out my *objets trouvés* and concentrated on making a series of bas reliefs in plaster.

A young friend, George Turnbull, who knew about the exact properties of plaster, came to assist me, and together we produced about twenty pieces in a very short time. Working with such a quick-setting medium one has only seconds in which the plaster is completely malleable with a builder's trowel, so everything depends on speed and chance. As Douglas Hall once wrote: 'As any gambler knows, chance is nothing without the skill to anticipate and exploit it.' I was enjoying myself enormously when Douglas came to see what I was doing. Immediately impressed by these unusual pieces, he suggested that a small exhibition should be held at the National Gallery of Modern Art. We called the exhibition 'Genesis'. I wrote for Douglas Hall a short note in the catalogue trying to explain the reasons why I had made these bas reliefs:–

I have from childhood been much affected by the great and wonderful poem that is 'Genesis'. 'In the beginning God made heaven and earth . . .' for billions

of years there was only silence and timelessness, broken sometimes by hugely creative upheavals. In the great expanse of years many tentative attempts at life must have been made, yielding strange shapes and movements. How long before those six days of creation was there a beginning? Creativity in art is short: children paint beautifully for a few years, poets achieve greatness in a few brief poems with magnificent imagery, the painter sees a lyric intensity in a tiny watercolour. To me art has always to have a meaning: it must have depth, intensity and dedication. Nor have I ever believed in beauty; great art is often highly unpleasant, a revolt, both revealing and disturbing. The earth has been a very great creative mother for the artist, the poet, the composer; but the material of the soil can produce its own art. With these thoughts I made my plaster reliefs in order to find confirmation of my conviction that the medium of plaster would itself reveal its own miracle. I knew that in myself I must produce a condition, relaxed and free from thought or deliberation: that which would be produced through my hands would then be from my inner self and completely unconscious. I throw the lump of crude, wet plaster on the smooth, polished surface: a gesture of creation, a brief experience of the variation of a simple earth movement . . . and the plaster sets.

The winter of 1973 was a busy one. Two films were made of my work; a short one for Border Television and a much longer one, commissioned by Hope Scott, from Sidhartha Films. I cannot talk about myself as an artist, I can only do, so this film was about William Johnstone as a craftsman – drawing, painting in oil and watercolour, making plaster reliefs. The film was produced by William Landale and directed by Suzanne Nield, with marvellous camera work by David Peat and music especially written by the young Scottish composer, Maxwell Geddes. As an old man I was often tired and wondered why I had ever become involved in film making, but this young, talented team were most patient with me so that it was both a refreshing and exciting experience to work with them. After such hard and enthusiastic work we were all delighted with the result. *Point in Time* (named after my early painting which makes a dramatic appearance in the film) was a film about a working artist which had a genuineness, an originality, which made it something apart from the usual run of films about artists. When it was shown in London a producer offered me the part of King Lear in a Shakespeare Festival in Devon!

Throughout the winter I had at the back of my mind a plan to paint a large picture, a primeval eruption of paint and colour, a

romantic tour-de-force. When the spring (1975) came I gathered my energies, flung all caution away, and poured paint on to my large canvas in a paroxysm of emotional excitement. I painted with tremendous speed, almost unconsciously. When I stopped to see what I had done, I dared not touch the painting again. Before the paint was dry, Douglas Hall took it to the National Gallery of Modern Art, naming it *Celebration of Earth, Air, Fire and Water.* I was completely drained, emptied of all emotion and what further painting I did that year was dull, without life. The greatest triumphs cannot be explained because the artist is unaware of what he is doing. The product comes from the inexplicable, from magic, from the psychic, the beyond reason, the irrational.

My work on the plaster reliefs had been a very exciting thing for me. It is a material which has a distinctive character which forces one into spontaneous expression if, for no other reason, than because it dries so quickly. It has a stark simplicity that is very close to the earth – very immediate, like the creative act itself, yet timeless. So, again with George Turnbull's help, I began another series of reliefs. This time I used colour on some of them, the colour of dead leaves and lichen, of leaf-mould and dung. George watches my eyes, and he knows whether we are going to be successful or not. If not, we give up, drink sherry and enjoy the pleasures of meditation, of quiet. These things have a strange life of their own even when you give them only the slightest touch. It's something which is to do with the whole meaning of being an artist rather than a tradesman. There's a mystery, some kind of unseen thing about it, not a matter of technique or period or style or any of those things. It's an inherent or instinctive thing.

A moving, variable light, as of the winter's sun dying in the afternoon, enhances these plasters in a most extraordinary way. They become activated by the changing shadows and remind me of my boyhood sitting on the hill at Greenhead before the lambing, watching the great clouds piling up in the west. Suddenly they broke in heavy rain, or as suddenly, the sun shone again. I watched those clouds making shifting patterns as they moved across the forms of the hills. One place that looked quite flat would suddenly appear round or, as the sunlight struck it, change its shape entirely; then

as the cloud moved gently down the valley the same place would regain its level uniformity or disappear into shadow. There is a vast difference between the dynamism of a living spirit in a work of art and the purely superficial abstract patterning of much work. A feeling for life has nothing to do with representation, it is a thing of the spirit rather than a classical expression of 'beauty' as, say, the Greeks saw it in the age of Pericles. Life bursts out of the abstract form of the master potter's bowl which does not have to be realistic to be alive. In my plasters I made no attempt to idealize women or to express cloud movements, only to grope for a living movement, an image which might take shape. There is a mask to cover up identity, a renunciation.

Over the years, calligraphy has always played some part in my work. The pen or brush in a linear motion could spark off an idea, or calligraphic line might be superimposed over a painted structure to give another dimension; nor is this element absent from my recent ventures with plaster. Perhaps the association of linear form with Celtic art is part of my artistic heritage. Always I have made drawings of the Border landscape which, by now, has become so ingrained in my system that whatever I do my own countryside comes through. My art is, therefore, not really 'abstract' art, although it is certainly abstracted from my own landscape – elemental, but located geographically in the Scottish Borders. It is a landscape made up of patterns like a patchwork quilt, of subtle colours with sudden dark shapes of spruce woods; as you move up into the Cheviot Hills it changes to a landscape of form, a movement from pattern into form. There have nearly always been strong abstract elements in my work because I believe in the effectiveness of the simplest possible expression – the less is more.

I was delighted to receive as a birthday present in 1974 a most beautiful architect's drawing table, and in excitement, we drove to Edinburgh to buy reams of the finest drawing paper. It seemed sacrilegious to destroy the pristine clarity of these lovely sheets of paper, such marvellous quality, such inviolate whiteness! This barrier had to be broken and for two years I enjoyed myself enormously making large drawings in Indian ink and watercolour.

They began spontaneously. I started with a blank mind, then my hand made movements, but always controlled. The exercise of wit is vital to the art of drawing. Out of confusion you try to find those images which are right for you, then you throw out the rest. You become lost in a forest, an undergrowth of brambles, roots and bushes. How to discard? The artist has almost no personal judgement on his own work, and is in a dilemma about what to keep and what to throw away. Ten to one you throw away just that very thing which would lead you to some newer adventure if only you could have seen its value. All the time you have to keep yourself refreshed with variation and change. Some drawings become complicated, some are simple, some just fragment into nothing so you tear them up. You cannot expect winners all the time. There must be action and reflection, excitement and peace, tension and quietness. Sometimes by working on a drawing, by adding to it, an unexpected interest develops and inanimate objects become re-vitalized with a new fertility. You capitalize on accident. There is sense, common sense and nonsense and, of these, nonsense is the most effective, indeed absolutely essential. A small spot of blue sings on the paper, magnetizing the whole area. You add a black line and it destroys your image so, exasperated, you flood the paper with water and more ink. Something quite different appears, but you have lost that initial pristine conception. A fresh, immaculate sheet of paper humbles you once more. The strongest revelation of landscape, of course, never lies in a straight reproduction of all the elements in the view. Rather, you must exercise judgement and discern which elements are essential to that which you wish to express, and what are superfluous, what can be eliminated. With experience I can anticipate so that the final resolving on paper becomes a natural expression of what I see with my mind and feel with my hand. It is an emotional experience.

The same applies when I draw a flower or a tree. You cannot just draw or paint flowers, you have to give them even more intensity than they already possess (Monet and Georgia O'Keefe and Nolde knew this very well). The drawing or painting must communicate and lead the mind beyond the surface of what the eye perceives. If it doesn't, it is dead and better thrown away.

In Paris, during the twenties, so many divergent theories assaulted the young student (just as they do today), that it was difficult to grasp from amongst this froth and turmoil those ideas which are important for one's own personal development, discarding those which would lead up blind alleys. The croquis classes at Colorrossi's or the Grand Chaumière became a safeguard. It needed tenacity to keep drawing from two o'clock till eight o'clock five days a week, never letting up through the most depressing times of exhaustion. Drawing the model standing, sitting, walking about the studio, lying on the couch; one-hour poses, half-an-hour poses, ten minutes, five minutes, continually moving poses, through it all one could not help produce one's own innovations instead of absorbing someone else's notions. Sometimes one would make a drawing, after days of bad work, that seemed to be a real improvement, one that might lead to further developments, to a fresh approach, one that was worth keeping. Drawing seemed to be the rock on which the house was built. If you came to a dead end in painting you could fall back on the endless variations of drawing and this discipline would keep you on the rails.

I still believe that the recipe (if such a thing exists), for any kind of serious study in the Fine Arts lies in the continuous study of drawing. It is a long and often tedious business; so many barriers have to be broken down. Any kind of intellectualism, thought process, any kind of formula have all to be discarded until a simplicity of drawing is achieved that almost ignores the subject. You have to relieve yourself of consciousness, allowing your hand only to dictate the situation. I believe experience in drawing is the best way to develop your personality as an artist (in the deepest sense), to avoid the pitfalls of imitation and plagiarism. Copying in the imaginative sense by selecting from a Master something that he himself failed to realize and capitalizing on this in your own work is true derivation, true tradition. Matsuo Basho (1644–1694), addressing himself to his colleagues, said that one should never imitate what has been inherited from one's forbears, but should strive after that for which one's forbears strove. Although these words were spoken with reference to Haiku poetry, they are equally valid in connection with all art.

Of course, there are exceptions. Paul Cézanne was defeated by drawing. The Beaux Arts always get the blame for continually rejecting him as a student because this great genius could not pass their drawing examination but from their point of view they were absolutely correct. While an examination may be entirely wrong if the student cannot pass it, he fails. If your horse only comes fifth in the Derby you cannot say that he has won. Cézanne's drawings are marvellous in feeling although pellets can be shot through their construction. However, he learned how to get round this weakness, how to circumvent this difficulty in structure. He learned how to place his colours, whether watercolour or oil, round the edges of those objects which he could not draw, so that his colours drew for him. In this, without any knowledge of what he was doing, he unconsciously anticipated pointillism. One of his great master-pieces at the Courtauld Institute shows very clearly what trouble he experienced when he tried to draw a pipe. In the beautiful paint-ing of two men playing cards one can see that he must have tried about ten times to put that pipe into the man's mouth before he could make it stick satisfactorily between his teeth! Drawing is writing. We all draw a description of ourselves when we write our name on a cheque. All calligraphers know this whether they be Chinese, Persian, South American or medieval European scribes. The brush stroke used to describe a donkey grazing in a field is synonymous with that describing the symbols used in an alphabet. Drawing is a basic technique.

In his development from an art student into a mature artist, the student struggles to find structure in drawing, to find the edge of the shadow. He discovers internal drawing, by which I mean the various planes and facets of form revealed by light and shade. Finally, he makes experiments, omitting part of the line defining the edges of the figure, incorporating shadows and parts of the background, until the finished drawing becomes more than the conventional formula for the representation of nature. Only the student who has truly matured ever attains this advanced stage. Most students are unable to forget the conventional outline formula; they might be called the outliners or mappers. Their outline, in spite of their efforts to draw true to nature as they conceive it, fails to give the

appearance of form and their line, however varied from thick to thin, is not expressive. The poor draughtsman thinks backwards, whereas the creative draughtsman thinks forwards. To think backwards, to use the stuff of memory, is much easier than to conjecture, to exercise the creative faculties. Naturally the former practice has the larger number of adherents.

So in painting from the life the student too commonly tries to get the outline and the pink-and-white complexion painted while ignoring the background and the effect of light. Some stay with the pink-and-white all their lives, others see the planes of form, the effects on the object of lighting and of the background's form and colour, and the effect these have, too, upon the object. They discover that all must be included as one whole upon the canvas. The adventurous spirit moves always along new paths, exploring, discovering and, from this search and study, finds new forms. In the past we have had visual experiences expressed by artists on flat surfaces as patterns; we have had art expressed in most complicated geometry, as solids, as objects in space, in the flat, in the round and solely in the mind (conceptual art).

The emphasis during my lifetime has, to a great extent, been an insistence on the importance of space both as an element within a painting or sculpture or as an external experience. In a very short time the emphasis may be completely different. It is in this continuous variety, in this changing way of things seen, or felt or experienced, that the artist finds his stock-in-trade. Looking out of the window at the colour of a ploughed field is an aesthetic experience; a completely opposite perceptive sensation can be found in looking at a picture in which you cannot associate anything with objects previously seen, but in both cases there must be an element of discovery. One has to remember that one's eye is not one's own. No one person sees in exactly the same way as his neighbour. The eye is part of a complicated mechanism made up of different organs each registering a different image or symbol. Even the hairs on one's arm have their own identity and, in one way, have nothing to do with the rest of one; they are like trees growing in a landscape. One's eye can one day see beauty in a particular way, but that same realistic vision or imaginative symbol will mean nothing to one on

another day. In the world of the spirit there is always something the eye does not see.

Up to the nineteenth century, the tradition of painting was one of clear continuity. An art student found his method of training in being an apprentice to a Master. He was taught to mix paints, prepare canvas or wood, to draw figures for the Master to lay in, to glaze, to scumble; he learned how to deal with curves and straight lines; he studied how the eyes should be placed in the head, how to put figures in perspective and how to fit in architecture and buildings. He learned to produce pictures which were portable objects for worthy patrons be they rich farmers, clerics or wealthy merchants. Pedigree painting is like pedigree stock. Both can become so inbred as to become completely valueless and effete. The vitality of a tradition is, therefore, produced by the malcontent, the maverick. It is said that Donatello spoke once to Uccello in these terms: 'Why do you persist with this modern art or perspective when you can make an excellent living like the rest of us are doing with academic art that people can understand?' From flat pattern Uccello pushed us forward so that we could walk into and through the canvas. Tradition does not mean the copying of previous works, nor the imitation of imitations previously used, nor the reiteration of symbols which have ceased to have meaning. Tradition means the vitality and continuity of that experience which remains dynamic.

Freud made us conscious of our own being, and the beginning of self-expression in art made us all too aware of our 'personalities'. (In previous eras the craftsman and the artist had no need of the props of psychology – they had a sure conviction of their importance within their society.) So we now, in large measure, disregard technique both in painting and drawing. We seize a brush, plenty of paint and a bottle of turpentine: it trickles down, we scrape some paint off and put more on, and the chances are that the more we put on, the greater will be the success of our painting – we have, at least, achieved self-expression. This is no criticism. In this form of expression, technique is not completely abandoned, but the traditional methods to which we have been accustomed have suddenly disappeared and we feel shocked that the structure

of the platform on which we have so much relied in the past has been taken away. We have lost our background and are left isolated.

While the techniques and methods of the past seem to be in abeyance, there remains that inner quality of the individual artist which must be the essential value and the essential criterion. Now we are at a point where we have children untutored, painting by feeling rather than by seeing. We have an attitude that little children should remain as little children which, in my view, is both unhealthy and unnatural. At the same time we have mature artists also painting by feeling, without seeing, and this is parallel with childishness, so far removed from the childlike simplicity that Brancusi lauded. When we come to deal with art teaching in higher education we are compelled, I believe, to think in terms of the past, of the various methods of the great masters who have made significant changes in our visual language. We have also to think in terms of work and of craftsmanship. I see education not as an end, but as a process. I do not see it only as a training in those attributes of the human mind which enables a man or woman to earn a living. Education for a job is a technical matter, and in this sense it is only useful up to a certain point, only to those who can use it to project it further. Education in its fullest sense is a training in the art of living. A training in visual and manual sensitivity is a vital part of an education designed to develop a complete person.

In our modern age, visual perception has become an urgent necessity. If I returned from a long retirement to tackle again the subject of art education I should suggest the immediate closing of a great number of art colleges because I feel that, in their present form, their function has ceased to be relevant. There is a beauty in the constructive power of the philosophy of anarchism. A ruthless elimination of obsolete ideas is needed, an eradication of the superficial, the irrelevant, the worn-out, the diseased, the futile, the repetitive. I would get back to base and have only schools teaching skilled crafts to the very highest standard. Skill is now needed, rather than self-expression.

As for the student who is determined to become a painter or a sculptor with the talented dedication so to be, let him first (if he is lucky), find an artist of quality with whom he can work as an appren-

tice. Then let him find a painting of a great master whom he admires and learn to copy this, for in so doing he will learn more in six months about the technical skill needed to become a painter than by spending years in some of our art schools. He must draw continuously. Perhaps as a change from these disciplines he might assist a bookmaker or become a teller in a bank for a short time, as both these occupations will help him in later life to deal with the exigencies of art dealers and the art market.

As a boy under the tutelage of Tom Scott, I became intrigued with prospecting for arrowheads and hammers and listened to his stories of ancient forts and burial mounds with fascinated attention. The lure of archaeology is that of the jigsaw-puzzle enthusiast combined with the excitement of the super sleuth. In later life Gordon Childe became my idea of the supreme Sherlock Holmes. The quick and the dead – we would know nothing of our early history on this earth if it were not for the obsession of humans with death and the future life, for without this religious passion for the ceremonial of death, all the small details that build up our picture of past lives would be lost. Inherited legends and taboos bind a tribe together, the history of a nation binds its people together and, although we may laugh at inherited taboos, we obey them.

I was fascinated by this obsession of our ancestors with the rites of death and their certainty of life ever after. This necessity for having in the afterlife the same slaves, food, animals and wives as on the day one died, giving a continuity of time past with time future (with only the very slight inconvenience of physical death), held an ambivalence in which one moved into worlds in which one forgot which was time lost – time present – time future. Which was the quick and which the dead? Time and space became one. In this merging of death into life the artists employed in the glorification of the tomb, the makers of funerary images, the painters of mummy cases, the mural painters and effigy makers, might well not be the artists of darkness (of death), but rather the artists of the resurrection (of new life).

The earliest attempts at drawing are the graffiti found on odd pieces of slate, stone or bone. These scratchings seem to be Man's first experience as an artist. They were the work of men who were

skilled craftsmen in the making of stone hammers, chisels or axes, men who were accomplished in the use of simple tools for functional purposes. If, then, these makers of tools were so skilled with their hands, were these doodlings as naïve as we think? Did they get pleasure from drawing freely without the restriction of function? Did they get some kind of satisfaction just from looking at the various qualities of line, the variety of tempo and speed of one line against another? The child, when he draws something that looks like a circle and says, 'This is the sun', has made a discovery, his scribble is proof of experience and is a revelation. He has gained, through an intuitive and instinctive response, the power to express a conception or image.

'Unless we are as little children we cannot enter the Kingdom of Heaven' is paralleled by the sculptor Brancusi who said, 'When we are no longer children we are already dead.' If the artist loses the child's wonder and awe, or lets his own intuitive innocence become smothered, he can no longer create a living work. Man's early graffiti developed in several ways. Paleolithic man, the contemplative artist, devoted his life to the art of painting. This was art for art's sake with a vengeance. The realization of the visual arts was so powerful that it was practised generation after generation, century after century. Neolithic Man, the constructive and functional artist, was primarily concerned with the making of things. His decorations were formal and essentially related to his material. The intellectual approach made the beginnings of an alphabet, the symbols of enormous power. All these divergent means of expression retained an element of wonder, of magic, and very soon in Man's history, the visual image was used as a means of control and manipulation by both the political and religious leaders of tribal unities. Parallel with this early appreciation of line we find a great feeling for form. It would seem that this appreciation of line eventually develops into an understanding of the solid and it is from a progression of this kind that we get the tremendous understanding of form displayed in the Bewcastle and Ruthwell crosses.

In his role of interpreter, the artist played a powerful and vital part in the triumvirate of religion, science and art. The artist was indispensable for from his conceptions grew the whole mystique

of the priesthood. His evocation of an inner spiritual image is always greater than that of the most powerful and verbose politician. The greatest totalitarian states fear the query inherent in every artist's work. As the power of the priesthood died the artist's function changed from that of visual interpreter of the spiritual life, to that of propagandist for the glory of the church. The priesthood declined, art became merely decorative, and men followed the quest for scientific knowledge. The artist became frankly humanist and painted for the glory of the flesh; life as we know it, here and now, not as a preliminary part of a future living. In our age, science is the dominant member of the triumvirate, but dominant not so much as an answer to the search for exact knowledge, as the extension of an unanswerable mystery.

In any age the artist responds unconsciously to the spiritual environment of his time, reinforcing it with his own response. This communication is always being reiterated, even when we do not understand. The artist now responds to the mystery and imagination of science on two planes, the spiritual plane of personal vision and mystery, and the more pragmatical plane. Apart from those artists who are able to relate themselves in an immediately practical way to solutions of the problems of everyday life in an industrial age, there must be artists of the highest calibre to give a pattern and inspiration. The 'useless' painter, the one who apparently cannot relate in any way either to industry or any other aspect of utilitarian life has an analogy with the pure scientist or higher mathematician, neither of whom produce anything concrete, although their discoveries may eventually lead to some far-reaching effect on our world. In the adventures and imaginative dreams of such minds, may be the germs of a whole new conception of life. Such an artist must provide new spiritual experiences, new mutations and unities for the human spirit, new adventures into the unknowable. These artists, few though they must necessarily be, are the spearhead of the metaphysical relationship between art, religion and science.

The artist, being thoroughly muddle-headed, tries to combine a spiritual essence with decorative, propaganda and humanist elements in his work. A clear thinking man could work out this confusion reasonably, but the artist struggles along with his some-

what messy materials in the desperate hope of clarifying these problems. To do so he is perfectly justified in using any media he can find if it can help him to resolve his confused mind. The artist uses the tactile media at his command, in an attempt to express his thoughts through the slow and difficult process of painting, because he is not equipped to deal with them in any quicker or more logical process.

Painting is a method of thinking and feeling; it is a form of empiricism depending on instinct and intuition. Art, whether it be painting, music or literature, is always a struggle, an attempt to give shape to the intensity and vitality of an inner power. In each age only a very few artists survive into the next period. In fact today it seems hardly possible for an artist to survive even one decade. One thinks of the walls of the Louvre covered with paintings dedicated to the glory of Napoleon, or the yards and yards of Italian propaganda church painting with which one becomes so bored! How few of the several hundred competent artists of the fine Italian schools of painting have survived to mean anything at all to us except as museum objects – they are mostly just 'furniture' paintings.

Out of every age some paintings can evoke an inner communication, can achieve an empathy which is not subject to analysis or diagnosis – they become timeless. A painting is an act of consuming passion, an act of love, a positive assertion of life. When this violent eruption of masochism is over, the struggle which was the life of the painting is done. The picture becomes an antique. It is only living while it is the medium for the painter's expression of life. The act of painting is everything, a consummation and a death. A very great, a very rare artist can, in some strange way, transcend this barrier of death, and in some of his paintings can carry his life forward in time. From artists such as this, tradition grows, their unrealized dreams being brought to fruition by a later painter, who in turn, leaves unanswered questions.

Civilizations grow by accretion of the common modes of interpretation of the nature of things. Within any civilization there exists a more or less complete system of accepted standards. In its art these standards form the type peculiar to any stage. The character of any school of art must change, suffering inevitable progression

and decline. This change proceeds normally with minor variations, but eventually the structure itself is no longer responsive to the deeper intuitions of the mind and a violent reaction occurs, sometimes in the form of a deliberate anti-art movement such as Dada. As the tempo of man's existence on earth appears to have increased, so these movements of violent reaction in art have increased in frequency.

Since my days as Principal of Camberwell I have loved the making of fine books. The orderly presentation of type on a beautiful paper, allied to sensitive illustration and well-made binding, appeal to my sense of design, of fitness for purpose. As a student in Edinburgh I had tried my hand on a lithographic stone and spent hours of boredom cleaning it to produce the perfect surface, but my results were always disappointing. On several occasions I had wanted to make illustrations relating to poems by Hugh MacDiarmid with the hope that we might publish them in a limited edition, but these plans all proved abortive until in 1975 we both agreed that a final attempt should be made.

Determined not to be beaten I went back to school to learn my subject. William Cardwell of the Carlisle College of Art generously agreed to teach me. Eventually I began to enjoy myself sufficiently to forget about technique, so that the plates I produced had an individual quality. We were determined to make a beautiful book. Alas, when the time came to print those plates it was discovered that something had gone wrong with the ink and they were unusable. After two years' work this came as a bitter shock. Nearly desperate, I made a new series of plates, working at a furious speed and using all the experience I had gained from my practical lessons at Carlisle. At last I felt I could understand the medium and use it freely; indeed I now began to be so interested in lithography that I can see the medium becoming an obsession. We – the typographical designer James Gardiner, the binder Fiona Campbell, the late Hugh Mac-Diarmid, the printer Kenneth Duffy, the lithographer William Johnstone – were well pleased by the completion of our book, hoping that it would rank as one of the most beautiful books to be produced in Scotland. Plans are afoot to make many more.

I am lazy. I lie in bed in the mornings watching the crows busying

themselves about their nests among the tree-tops outside my window. I speculate on their ordered, yet complicated, social structure; I watch their effortless movements making continuously changing black patterns against the light sky. In the early morning I hear a pheasant's warning shout as a fox slinks past the back of the house. A rabbit sits in the sunshine carefully washing itself. A stoat plays on the edge of the wood, lithe and elegant. The blue/grey cattle move gently towards their drinking trough and I see the morning dew glistening on their subtly coloured grey hairs. In another life I would not be an artist. I would choose instead to spend my life studying the behaviour of animals, their social systems and means of communication. I would like to understand their world in the same way as these beasts of the field and birds of the air understand us. I watch a blossom cross the window, gently floating in the sunshine, a little petal from a white flower floating to nowhere, into death. Today the snowdrops and aconites are brightening the wood under the old yews and winter hibernation must cease. Paint, turpentine, indian ink, watercolours are all waiting for me. As I go to my studio I hear my father saying, sadly, 'Ah, Johnstone, think what a great farmer you might have been!'

Bibliography

HERON, Patrick, *The Changing Forms of Art*, Routledge & Kegan Paul, London, 1955

PAGE, D. D. (Ed.), *The Letters of Ezra Pound, 1907–1941*, Faber and Faber, London, 1951

EHRENZWEIG, Anton and the Central School of Arts and Crafts, Monograph, private publication, London, 1959

HARDIE, William, *Scottish Painting 1837–1939*, Studio Vista, London, 1976

GAGE, Edward, *The Eye in the Wind*, Collins, London, 1977

HALL, Douglas, *William Johnstone*, Edinburgh University Press, 1980

Art and the Artist, University of California Press, Berkeley and Los Angeles, 1956. Includes an essay by Anton Ehrenzweig

Index